LENS ON علدسة على سورية
SYRIA

A Photographic Tour
of Its Ancient and
Modern Culture

DANIEL DEMETER

Foreword by **Joshua M. Landis**

Just World Books

Charlottesville, Virginia

Just World Books is an imprint of Just World Publishing, LLC.

Cover and interior design and typesetting by Diana Ghazzawi for
Just World Publishing, LLC.
Cover photos by Daniel Demeter.

Publisher's Cataloging in Publication
(Prepared by The Donohue Group, Inc.)

Demeter, Daniel, author, photographer. | Landis, Joshua M., 1947-
writer of supplementary textual content.
 Lens on Syria : a photographic tour of its ancient and
 modern heritage / Daniel Demeter ; foreword by Joshua M. Landis.
 pages cm
 LCCN 2016942708
 ISBN 978-1-68257-074-6 (trade cloth)
 ISBN 978-1-68257-007-4 (trade paper)
 Syria-- History-- Pictorial works. Historic buildings--
 Syria-- Pictorial works. Historic sites-- Syria--
 Pictorial works. Syria-- Description and travel.

 DS93.2 .D46 2016 956.91-- dc23

Contents

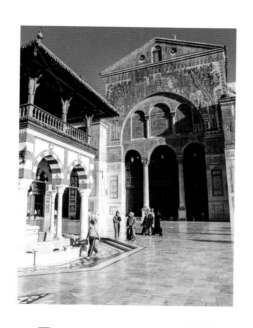

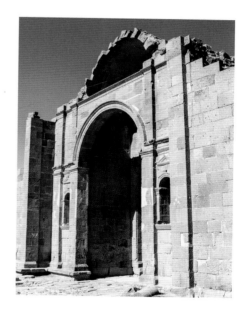

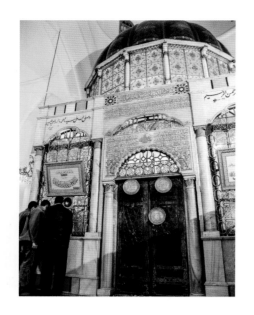

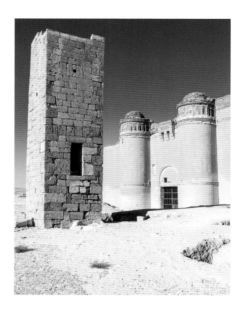

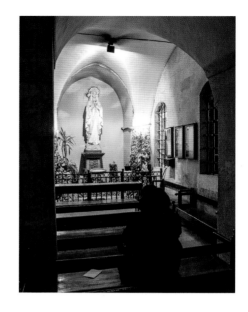

Foreword

Daniel Demeter captures the arresting beauty and sophistication of Syria's architectural heritage. And he does it in the nick of time. Hanging over this book is the specter of Syria's civil war. The reader cannot but be weighed down by a profound sense of both nostalgia and foreboding. So many of the world treasures portrayed in this book have been damaged—a number beyond repair. Syrians, undoubtedly, will wrestle with the most complex emotions. The beauty catalogued here only sharpens the grief at so much artisanship and heritage lost. All the same, the reader quickly forgets the turmoil of the present as the sheer magnitude of Syria's monuments and rich history transports us.

This is a book that Syria has long needed. Most travelers have relied on two other works for their exploration of Syria: Ross Burns's *Monuments of Syria: An Historical Guide*, which was first published in 1992 and Warwick Ball's *Syria: A Historical and Architectural Guide*, first issued in 1994. Demeter's book magnificently supplements both volumes. The scope and richness of his photographs surpass anything that has gone before. Demeter's immense artistic talent illuminates every page. He finds a happy balance between the monumental photos and the gorgeous nature ones, between those teeming with human activity and those depicting the solitude of a Roman arch standing alone in a desert sunset. In short, he captures the complex cultural fabric of Syrian life, adding an entirely new dimension to this work. So many of Syria's archeological monuments, like the religious architecture, remain part of Syria's lived environment. Demeter captures the diversity of Syria, its religious and ethnic groups, and its once-thriving economy. He breathes life into the historic monuments by providing the context of local manufacturers, market scenes, and religious ceremonies, as well as the often-arresting hodgepodge of clothing that combines tradition with the latest styles. His academic rigor underpins the luminous photographic journey and turns this exploration into a *tour de force*.

Syria was famous for its lack of fame. Despite having some of the best-preserved Roman, Islamic, and Crusader ruins, not to mention the best preserved Islamic cities and traditional covered souqs, in recent decades the country has been visited by only very few Westerners. The number of tourists visiting Syria did increase somewhat during the decade before the uprising of 2011, but still, many fewer Westerners had explored Syria than other Middle Eastern destinations like Turkey, Israel, or Egypt. There were many reasons for this. For decades after winning independence from the French in 1946, Syria was beset by political instability. Some twenty coups, successful and unsuccessful, rocked the political landscape and kept the country off the beaten trail. In 1970, Hafez al-Assad, a military officer and a member of Syria's small Alawite religious minority, seized power. He brought welcomed stability to Syria but at the high cost of curtailing political freedoms and imposing a gray, one-party dictatorship that was closely allied to the Soviet Union. In the 1980s, a visitor was hard put to find a decent restaurant or a well-run hotel. Frequent wars with Israel and support for the enemies of Israel, such as the Palestine Liberation Organization and Hezbollah, kept Syria in constant trouble with the West.

5

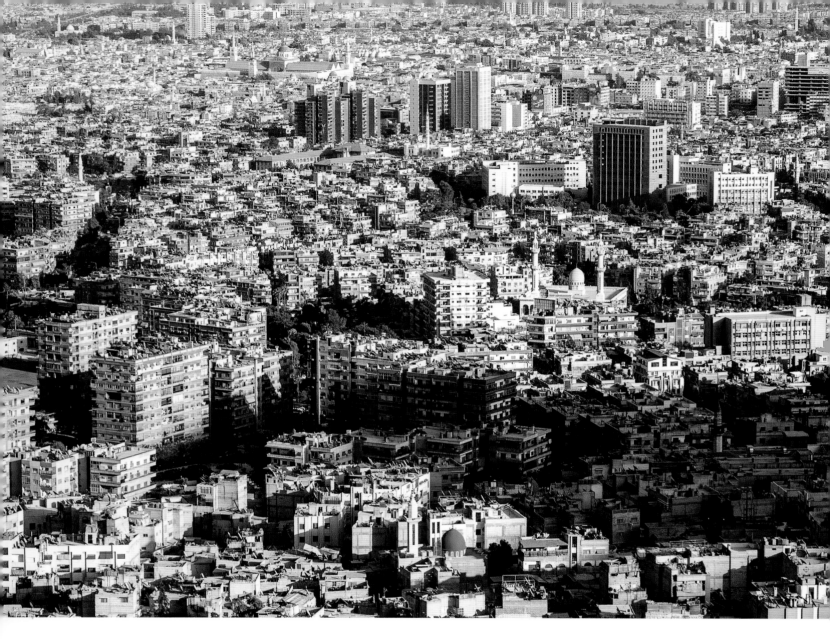

Syrians had to negotiate the economic and diplomatic sanctions imposed by Washington as well as the frequent strictures imposed by their own Baath Party rulers. Westerners, by and large, stayed away. But those who were unperturbed by the furrowed brow of defiant Arabism found in Syria a country of extraordinary treasures and a people of exuberant warmth and old-world hospitality. Like many others, Daniel Demeter fell under the spell of Syria's bewitching charms.

Almost exactly 100 years earlier, T.E. Lawrence ("Lawrence of Arabia") had similarly succumbed to the country's appeal. As a budding archaeologist, he had made his way to Syria—then a part of the Ottoman Empire—to study Crusader castles and soon was drawn into the British government's World War I machinations there. At 27 years of age, he wrote of the significant commercial city of Aleppo:

> [I]t is a point where all the races, creeds and tongues of the Ottoman Empire meet and know one another in a spirit of compromise. The clash of varied characteristics, which makes its streets a kaleidoscope, has imbued in the Aleppine a kind of thoughtfulness.... It is typical of Aleppo that here, where yet Mohammedan

feeling runs high, there is more fellowship between Christian and Mohammedan, Armenian, Arab, Kurd, Turk and Jew, than in, perhaps, any other great city of the Ottoman Empire, and more friendliness, though less licence, is accorded to Europeans on the part of the average Mohammedan.[1]

It is worth revisiting Lawrence's description of Aleppo at the last years of Ottoman rule because it captured a unique quality that was soon to be transformed by the victorious Allies' breakup of the Ottoman Empire and their support for the creation of a modern, majority-Arab Syrian state. Daniel Demeter has equally captured the city, its monuments, and social mosaic at the end of an era and at a crucial turning point into an unknowable future. Much of Aleppo now lies in ruins. Like all of Syria, it is changing with terrifying speed. As this book goes to publication, Aleppo is Syria's most destroyed urban center. The rebel-held portion of the city has been depopulated by constant bombing and artillery fire. Neighborhoods that once were home to two million people now house only ten percent of that number.

Throughout Syria, the war is flattening society. The old mosaic has come undone. A new, religiously inflected nationalism has begun a "Great Sorting Out," separating the various ethnic and religious communities, one from the other. It is not unlike the great sorting-out process that took place in Central Europe during World War II. In both cases, multiethnic and multireligious empires have been transformed into separate polities in a process that is long and bloody. Minorities are crushed or ethnically cleansed. The warring parties seek to create a homogenous political community and root out elements that they deem not be trusted.

In Syria, the large Jewish communities of Damascus and Aleppo were the first to be driven out. That happened soon after World War II, as they found themselves caught between the hammer of Arabism and the anvil of Zionism. Today, it is the turn of other minorities. In 1945, ethnically Arab Christians counted some fifteen percent of the population, and Armenian Christians four percent. Today, the country's Armenians have nearly all left, and the Arab Christian community has shrunk to no more than three percent of the population. Assyrians (also largely Christian), Yazidis, Ismailis, and Druze are also leaving in droves. In 2016, the war has become a grinding struggle between three major groups: the Assad regime, which is led by Syria's Alawites and backed by the region's major Shiite

actors, but which also retains the loyalty of many members of other Syrian communities; the broad and disorderly spectrum of antiregime groups that are overwhelmingly (and in many cases, very militantly) Sunni Arab; and the Kurds who have carved out a long strip of land along Syria's northern border. It is too early to tell if Syria will be united again any time soon, within its previous borders. But whatever the future will bring, this beautiful tome will remain as an essential resource for those seeking to document and understand its architectural and monumental heritage, and as an uplifting homage to Syria at the end of an era.

JOSHUA M. LANDIS
June 2016

1. T.E. Lawrence, "Syria, The Raw Material, 1915," in *Arab Bulletin*, 12 March 1917.

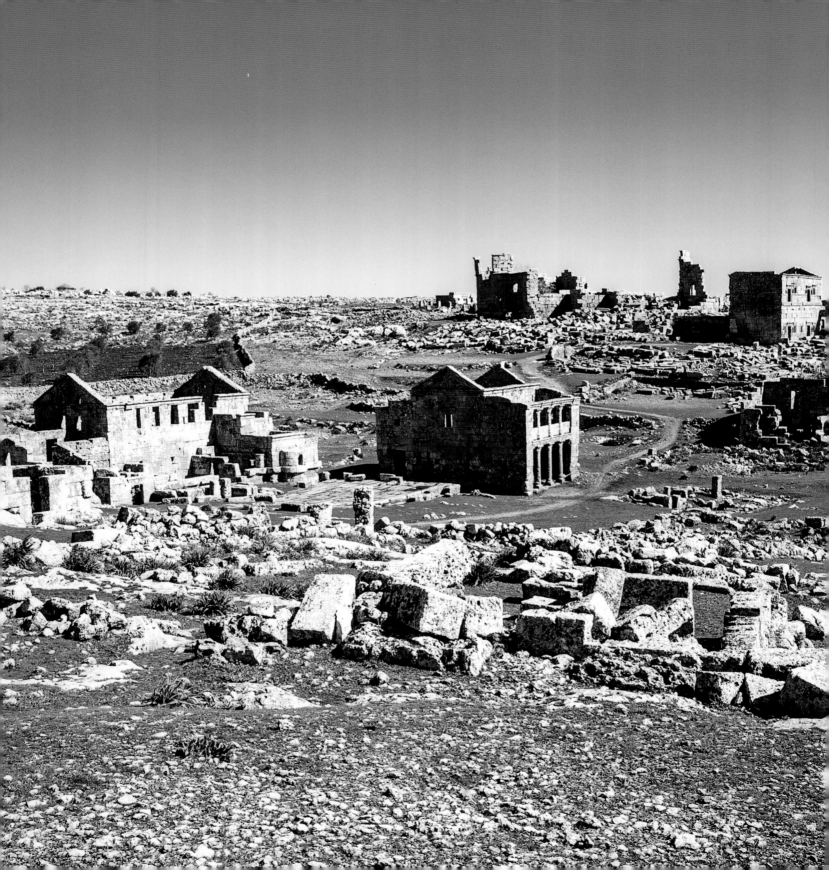

Introduction

Syria has captivated travelers for centuries, inspiring visitors with its wonderfully rich heritage, fascinating history, vibrant markets, delicious cuisine, stunning landscapes, well-preserved archaeological sites, imposing castles, and remarkable array of religious shrines and places of worship. Those who have had the opportunity to visit the country have found its residents to be among the most welcoming, hospitable, and kindhearted people in the world. From the labyrinth of narrow alleyways of the old city of Damascus, to the colonnaded streets of the Roman-era desert city of Palmyra, to the bustling traditional markets of Aleppo, even a brief visit to Syria could leave a lasting impression. Many of those who have had the opportunity to explore the country in greater depth have discovered an extraordinary people and a diversity of cultures for which they developed not just appreciation, but also a deep affection. I was one of the many travelers who discovered Syria in that way, an experience that compelled me to return to the country again and again.

From a young age, I felt a desire to travel and explore, a feeling that was intensified by my sense of alienation from what I saw as a shallow and materialistic culture in Southern California, where I had grown up. Inspired by friends who had backpacked throughout Europe, I set out on my first overseas journey at seventeen years old. During the next decade, I traveled independently and at my own expense to over three dozen countries throughout Europe, Southeast Asia, the Indian Subcontinent, and the Middle East. Along the way, Syria captured my heart.

When I was 23 years old, I planned an ambitious journey that would take me overland from Egypt to China over the course of eighteen months. It was on this trip, in 2003, that I was first introduced to Syria. I was intrigued from the moment I arrived. Here was a region that had witnessed the dawn of human civilization, with some of the earliest permanent human settlements and the first developments of agriculture. It saw the rise and fall of a succession of empires over the course of many thousands of years. Yet, it maintained a humble and unassuming atmosphere. Nowhere else in my travels had I encountered people so welcoming and hospitable. The leisurely pace of life was a refreshing alternative to the overly frantic lifestyle of the West. I developed a strong appreciation for the country's cultural diversity, multilayered historical and archaeological heritage, and physical geography encompassing fertile plains and river valleys, expansive deserts, soaring mountains, a Mediterranean coastline almost unknown in the West, and much more. As my itinerary took me to neighboring Turkey, Armenia, Georgia, and Azerbaijan, I increasingly found myself reflecting on my experiences in Syria. Soon enough, I cancelled my plans to continue traveling overland to China, refocusing my journey instead on exploring this part of the Middle East in greater depth. On that trip, I spent many more months traveling throughout the region, basing myself in Syria.

I returned again to Syria in 2006, this time with the intention of living there on a more long-term basis. Basing myself in the old city of Damascus, I remained in the country for two years. Combining my interest in Syria's heritage with my

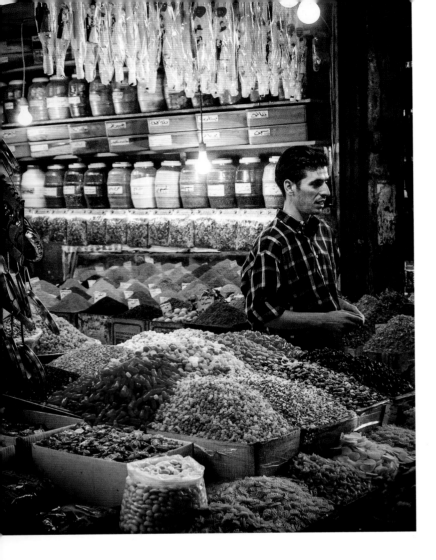

country, and lovely beaches along its coastline. Over time, I compiled a collection of over 30,000 images.

Traveling on a tight budget to some of the most remote locations in the country, I often had to improvise to reach my destinations. Much of my exploration of Syria was done by hitchhiking or on foot. While these modes of travel were often challenging, they introduced me to places and people in the country that I would have never interacted with otherwise. I came to know Syria's geography and its complex demographics intimately. Every town and village had its own story that contributed to Syria's rich tapestry of cultural heritage. Much of what I came to appreciate about the country was learned from the countless Syrians who invited me to join them in food, drink, and discussion in their shops, homes, or even in the fields where they tended to their crops, their orchards, or their herds. I also joined a wonderful hiking and camping group organized by the late Frans van der Lugt, a Jesuit priest who devoted nearly 50 years of his life to helping Syria's poor and disabled while he worked for interfaith dialogue. Through Father van der Lugt, I was introduced not only to seldom-visited regions of the country but also to the remarkable collective that he headed, which promoted religious coexistence and sought to reconnect Syrians with their country's rural communities and with its rich and diverse cultural heritage.

While I was in Syria, I found a growing demand for English teachers. Syrians were to eager learn what was seen as the foreign language most crucial for future career and academic opportunities, since here, as in Lebanon, English was supplanting French as the principal foreign language. I taught English classes at a local language institute, an initially daunting task for an introvert like myself who had no experience as a language instructor, and found it a fantastic way to immerse myself in the local community. It helped to finance my stay in Syria, enabling me to pursue my interest in studying the country's history and culture. I slowly picked up a little Arabic, learning to read the alphabet and engage in some admittedly limited conversation. While my rudimentary Arabic came in very useful when I was navigating the rural countryside, the people of Damascus were often excited to practice their English with me. This presented me with the opportunity to develop lasting friendships with Syrians from a wide range of backgrounds. Through lengthy discussions in our homes and in the city's parks and cafes, discussions that often extended deep into the night, I learned a lot about the diverse perspectives that Syrians held, as well as the cultural heritage that they shared and loved.

passion for photography, I spent much of my time visiting, documenting, and photographing Syria's wide range of archaeological, cultural, and natural attractions. I contributed articles about these attractions to a local English-language magazine and began developing a website dedicated to the country, feeling an obligation to share the beauty of Syria with the world. With my website, Syria Photo Guide, I hoped to encourage others to travel and experience the country by providing a resource for those interested in learning more about its cultural and historic sites. I was able to document hundreds of sites throughout Syria, from its most famous monuments such as the hilltop Crusader castle of Krak des Chevaliers and the black stone Roman amphitheater of Bosra, to scores of lesser known treasures that included fortresses tucked away in Syria's mountain ranges, ancient churches and monasteries in its remote hill

Over the years, I met some Syrians who strongly embraced their particular religious or ethnic identity, and others who considered themselves secular, casting aside religious and ethnic distinctions as unimportant or even as impediments to social progress. I came to understand more about, and appreciate, the wide range of views found in Syria's society. I spent time with shopkeepers, university students, archaeologists, artists, Kurdish laborers, Iraqi refugees, Palestinian activists, devout Muslims and Christians, secular nationalists, and communists, each of whom provided their own unique perspective on this fascinating country. I had a few interesting encounters with Syria's intelligence agencies, which may have been suspicious of my intentions in the country. Being American at a time when the war in neighboring Iraq was deeply unpopular, politics were an inevitable part of my daily conversations. Syrians rarely hesitated to share with me their opinions on U.S. foreign policy, though they attempted to do so in the most polite and open-minded of manners. It was a bit more challenging to unravel the complex relationship Syrians had with their own government, as they often wanted to present a positive image of their country to strangers. With patience, however, many Syrians shared with me both their concerns and their hopes for the future.

The most life-changing experience of my stay in Syria came in the summer of 2007, when in a crowded internet cafe in Damascus, I laid eyes on the beautiful woman who would become my wife. Our shared love for the city where we met was soon enriching the love we felt for each other. I returned to the United States in January of 2008, but soon traveled back to Syria to help my fiancée arrange her visa to join me. We left Syria in March of 2009, journeying back to California to begin our new life together. Since then, we have frequently reminisced about the wonderful days that we spent in Damascus, and the fond memories we hold of that city and its people. My time in Syria inspired me to further my education in history, archaeology, and cultural anthropology, and I have continued to immerse myself in all things related to Syria. As I have studied the country's rich history in greater depth, I have found an even greater appreciation of the remarkable places that I documented during my time there.

The modern state of Syria is less than one century old, yet the territory it encompasses tells the story of human civilization dating back tens of thousands of years. This land was home to some of humankind's earliest developments in agriculture and animal domestication, and hosted its first permanent settlements. As those settlements grew into towns and cities, some of the world's earliest city-states emerged, and with them came

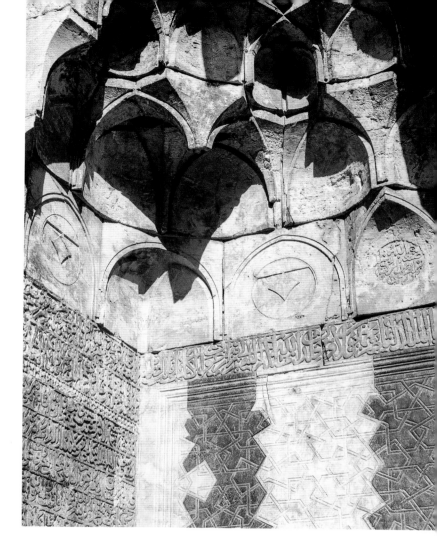

complex political and religious hierarchies. Over the millennia, Syria has witnessed dozens of civilizations rise, conquer, rule, and collapse. The ancient Akkadian, Amorite, Hittite, Egyptian, Phoenician, Aramaean, and Assyrian cultures all played influential roles in Syria's long history. The earliest forms of written language originated among these ancient civilizations, with the first alphabet developed by the Phoenicians along the Mediterranean coast. The Greeks fought the Persians over this prized territory for centuries, eventually giving way to the Romans and later the Byzantines. The Greeks, Romans, and Byzantines all constructed large, lavish, and increasingly well-engineered cities. Their legacy continues to influence the urban planning of Damascus, Aleppo, Homs, Lattakia and other cities, two thousand years later.

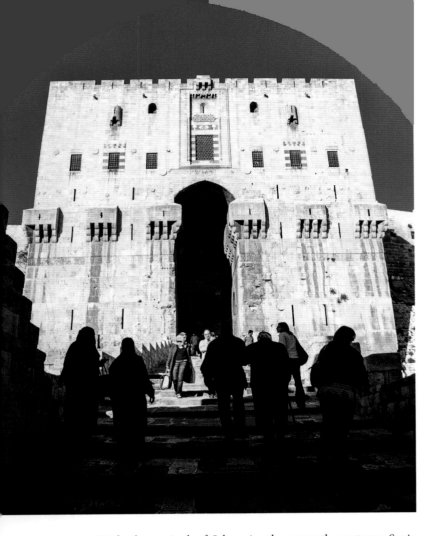

War I, Syria fell under the French Mandate, which lasted until Syria achieved full independence in 1944.

This long and complex history is reflected in the broad range of ethnic groups and religious sects found in modern-day Syria's population of roughly 23 million people. Predominantly Arabic-speaking and Sunni Muslim, Syria's dominant culture has been heavily influenced by the Umayyad, Seljuq, Ayyubid, Mamluk and Ottoman empires, from their architecture, literature, poetry, and social customs, to their religious views. Spread throughout the country are numerous smaller communities of religious minorities that have survived throughout the centuries, maintaining much of their own heritage and traditions. The Alawite sect, an offshoot of Shiite Islam, has inhabited Syria's coastal mountain region for hundreds of years alongside another Shiite sect, the Ismailis. In the south of Syria, the Druze sect, an offshoot of Ismailism, makes up the largest community of the mountainous province of al-Suweida.

Syria's Christians belong to over a dozen different churches, most of them wholly indigenous and tracing their lineage back to the earliest communities of believers converted and organized by St. Paul after his turning-point conversion on the road to Damascus. Many of these churches boast their own patriarchs and their own fiercely guarded liturgy and theology. Throughout the nearly 1,400 years of Muslim rule before the arrival of the French, these churches survived, and often thrived, despite their minority status. Some of these Christian communities have maintained their regional dialect of Aramaic, the most common language of the region during biblical times, both for liturgical use and for everyday communication within their communities. Syria's Christian population was estimated to be around 2.5 million prior to the outbreak of violence in 2011.

During the harsh years of World War I, Syria provided refuge to tens of thousands of Armenians, Assyrians, and members of other ancient indigenous churches, as they fled from genocide in Turkey. The north of the country also hosts long-rooted communities of Kurds and Turkmen, both of them distinct ethnic minorities who retain their traditional language and customs. Syria's long tradition of hospitality has been replicated in times of more recent troubles, as well. For many decades after the Arab-Israeli war of 1948, Syria provided safe refuge and full economic and social rights to Palestinians displaced by the establishment of Israel. In the years after the 2003 U.S. invasion of Iraq, well over one million Iraqis fleeing instability and violence at home found a warm welcome in Syria. The same was true in 2006, when many Lebanese citizens fled Israel's devastating bombing campaign of their country.

With the arrival of Islam in the seventh century, Syria became host to the first capital of the Muslim world, when the Umayyad rulers established the seat of their caliphate in Damascus. Their rule was short-lived, however, and over the centuries that followed Syria was fought over by other Muslim dynasties: the Baghdad-based Abbasids, the Cairo-based Fatimids, and the Turko-Persian Seljuqs. During the 11th century, as invading Crusader armies threatened the Muslim world, the Syrian cities of Damascus and Aleppo became crucial bastions of resistance to this threat. The successive Muslim dynasties of the Ayyubids and Mamluks invested heavily in these cities, and the Crusaders were pushed out of their final foothold in the Levant in 1291. In the early 16th century, the Ottoman Turks, building upon their defeat of the Byzantines at Constantinople (now Istanbul), extended their empire to Syria. They would remain in control of the country for a remarkable four hundred years. After the defeat of the Ottomans in World

When I last departed Syria in March of 2009, I could not even imagine the devastation that would be inflicted upon the country so soon thereafter. It has been agonizing to witness the destruction of the Syria that I knew and loved. I have watched the ongoing conflict with a deep sense of loss and sadness. I think about the hundreds of villagers and townspeople throughout Syria who offered me their guidance and hospitality. Their generosity often seemed to know no limits, as they insisted I join them for tea, meet their families, stay for a meal, or even spend the night. They invited me into their homes and shared with me their lives. As hundreds of thousands of Syrians have died and millions have been displaced, I despair at the fates of all the wonderful people of Syria. During my time there, I repeatedly noticed the great pride that my Syrian friends, colleagues, and hosts took in the fact their country was a place where people of different cultural, religious, and ethnic backgrounds could live together in peace. It has been almost unbearable to have to watch from a distance as that peace and coexistence has been shattered.

The level of damage inflicted on Syria's cultural heritage and archaeological remains is difficult to comprehend. There has been deliberate, targeted destruction of hundreds of monuments, particularly the tombs and religious shrines of all religious traditions. There has been inadvertent damage to hundreds of other structures, collateral damage in the battles raging throughout the country. Finally, there has been widespread looting and illicit excavation at hundreds of archaeological sites. These acts not only damage artifacts but, more importantly, they also destroy the historical record and make it nearly impossible for archaeologists to perform future research at these sites. The artifacts that are looted lose their assured provenance, and thus their rightful and invaluable place in research and in human knowledge.

Some may say, skeptically, that these are just stones. This view ignores not only the wealth of knowledge that archaeologists, cultural anthropologists, and historians can reveal about human civilization through their research of these sites, but also the symbolism that these monuments hold for Syrians, and the deep psychological impact that their destruction brings. To many Syrians, these were the symbols of a rich culture that stretched back to the earliest days of civilization. They were sources of pride and dignity, for while much of humanity still consisted of hunter-and-gatherer societies, Syria's ancestors were building some of the world's first cities and greatest monuments. In all of human culture, symbolism plays a significant role. People attach great meaning to monuments that they believe represent their cultural identity, and the destruction of those monuments can be devastating.

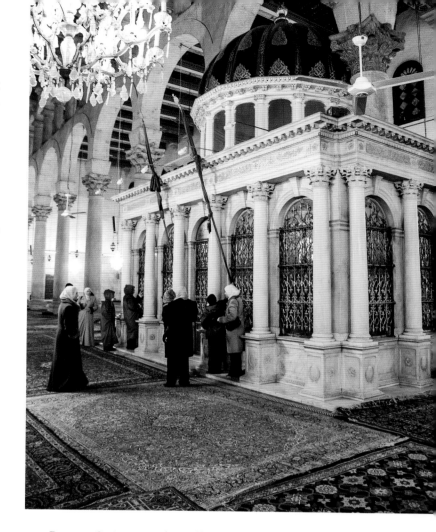

Because Syria is an ethnically and religiously diverse country, its people share a national identity based on the concept of a common history and cultural heritage. This has helped keep Syria together, providing a sense of unity and maintaining cohesion between its various religious sects and ethnic groups. Sites like the ancient city of Palmyra were important in that any Syrian, regardless of religious sect, ethnic group, tribal background, or political affiliation could share in them a sense of pride. Without these and other unifying symbols, the entrenchment of divisive sectarianism may be inevitable. Those who promote the destruction of historic monuments and other items of cultural meaning do so with a purpose, which is to fracture communities by destroying the symbols that once unified them. By doing so, extremists appear more powerful than the identities that those symbols represented, and they can terrorize and intimidate into submission those who once gave these symbols value. Restoring these ancient sites means a lot more than simply rebuilding old structures. It also serves to

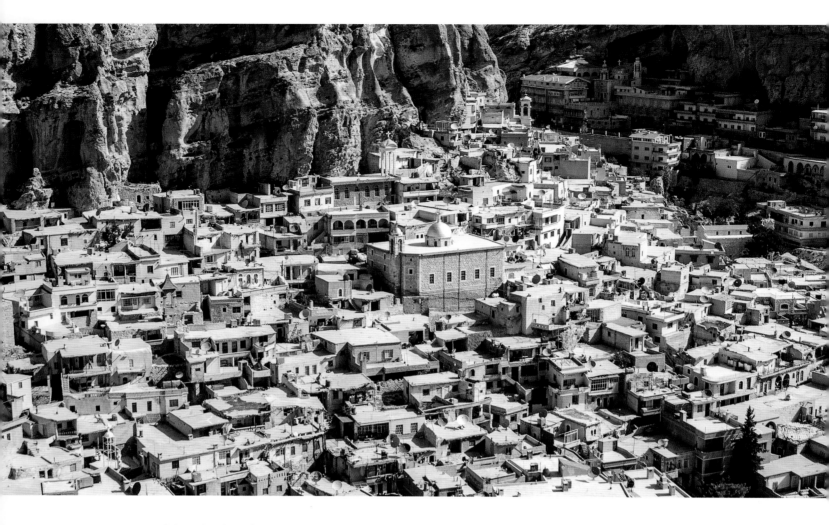

restore a sense of shared cultural identity and heritage, and as an act of resistance against the destructive forces of war.

I hope that this book can provide a reminder of the immense beauty and rich heritage of this country that is gradually being lost through the senseless violence and destruction of war. With any luck, future editions of this book will document the progress being made to restore and rebuild Syria's heritage sites, rather than merely noting, as I have had to do in far too many captions here, their destruction.

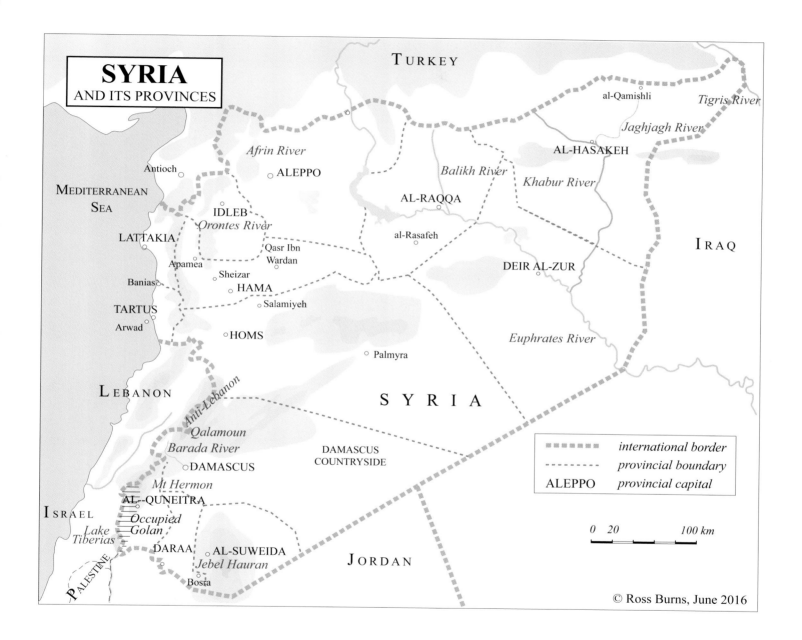

SYRIA
AND ITS PROVINCES

TURKEY

al-Qamishli

Tigris River

Jaghjagh River

Afrin River

Antioch ○

○ ALEPPO

AL-HASAKEH

Balikh River

Khabur River

MEDITERRANEAN
SEA

IDLEB

AL-RAQQA

IRAQ

Orontes River

LATTAKIA ○

al-Rasafeh ○

Qasr Ibn
Wardan ○

Apamea ○

○ Sheizar

DEIR AL-ZUR ○

Banias ○

○ HAMA

○ Salamiyeh

TARTUS
Arwad ○

○ HOMS

Palmyra ○

Euphrates River

LEBANON

Anti-Lebanon

SYRIA

Qalamoun

Barada River

○ DAMASCUS

DAMASCUS
COUNTRYSIDE

▪▪▪▪▪	*international border*	
- - - - -	*provincial boundary*	
ALEPPO	*provincial capital*	

Mt Hermon

AL-QUNEITRA

ISRAEL

*Occupied
Golan*

0 20 100 km

*Lake
Tiberias*

DARAA ○

○ AL-SUWEIDA

JORDAN

PALESTINE

Jebel Hauran

Bosra ○

© Ross Burns, June 2016

15

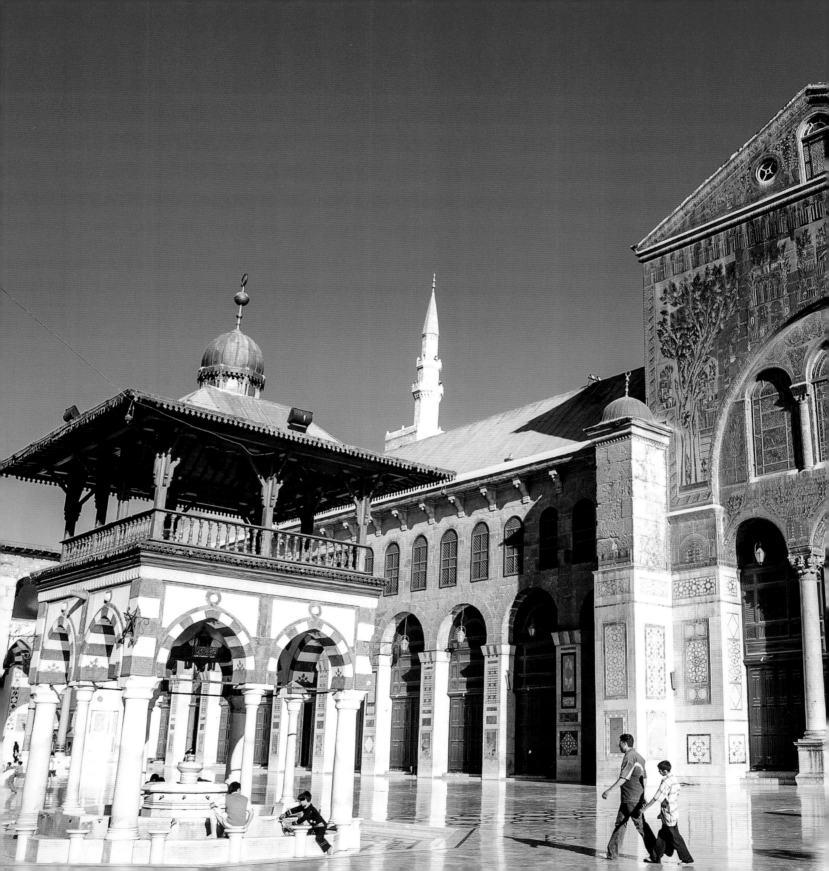

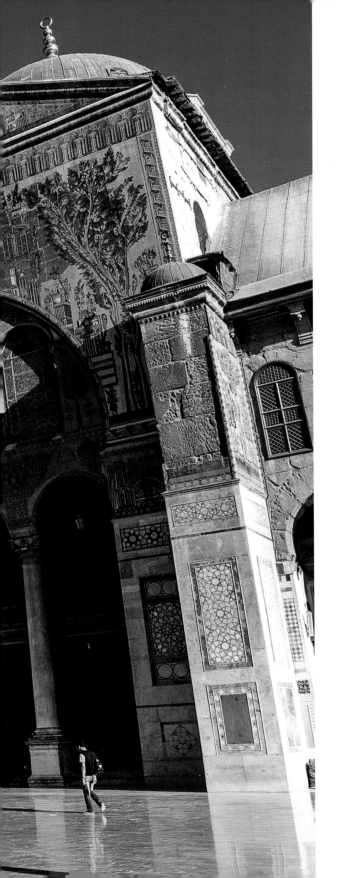

Syria's capital, Damascus, is among the oldest continuously inhabited cities in the world. The city lies at the western edge of a broad expanse of desert. The Barada River flows rapidly into the city from the mountains to the northwest, enabling early agricultural settlements to prosper here. Originating at the freshwater spring of Ain al-Fijeh, the river passes through Damascus and empties into the Ghouta, an oasis east of the city. The Ghouta hosts several smaller towns and villages amidst its intensively cultivated agricultural land. The soaring, rocky mountain of Jebel Qasioun dominates Damascus from the north, while the foothills of the Anti-Lebanon range rise rapidly towards Syria's mountainous border with Lebanon to the west. Damascus has a semiarid climate characterized by dry, hot summers and moderately cold winters with modest rainfall.

Few excavations have been possible in central Damascus, but archaeological evidence suggests that the Barada River basin has been inhabited since at least 9000 BCE. Clay tablets unearthed at the archaeological sites of Mari and Ebla, in the Deir al-Zur and Idleb provinces, both mentioned Damascus in the third millennium BCE. Further records documenting the city in 1350 BCE were discovered as far away as al-Amarna, Egypt, suggesting there was commerce between the two cities. In early times, Damascus was ruled by a succession of Amorite, Aramaean, Assyrian, Neo-Babylonian, and Persian kingdoms. Then, in 332 BCE, it was conquered by the forces of Alexander the Great. The Greeks established a plan for the city that was further developed during Roman rule beginning in 64 BCE. The Roman and Byzantine empires maintained control over the city for 700 years, a period during which it experienced great prosperity and development.

Arab Muslim forces captured Damascus in 635 CE, and it was proclaimed the capital of the Umayyad Caliphate by Muawiyah ibn Abi Sufyan in 661, making it the administrative center of the Islamic world. While Umayyad rule lasted only 90 years, it was responsible for building the city's best-known monument, the Umayyad Mosque, in 706. The city declined in importance under the Abbasid and Fatimid dynasties that followed, as they maintained their capitals in Baghdad and

دمشق

Damascus

Cairo, respectively. In the late 11th century, as the threat posed by invading Crusader armies grew, Damascus reclaimed a central role in the region. It became a symbol of resistance to the Crusaders, whose repeated attempts to capture the city were unsuccessful. Its economy flourished during this period, and its population swelled with refugees. Under the Ayyubid dynasty, founded by Salah al-Din in 1174, many of the city's great mosques, religious schools, and mausoleums were constructed. The Mongol invasions of later centuries inflicted substantial destruction on the city, but the ruling Mamluks rebuilt Damascus and contributed much to its architectural heritage. In 1516, the ethnically Turkish Ottomans conquered Syria. For them, Damascus was principally important as the last major population center on the pilgrimage route to Mecca. They constructed religious buildings, hostels, public baths, and communal kitchens to serve the massive caravans traveling south on the annual pilgrimage.

Today, Damascus is home to over two million residents and is the country's political and cultural center. It is referred to locally as al-Sham (which is also the historical name for Greater Syria), rather than by its more formal Arabic name, Dimashq. From the moment I first arrived in Damascus in March 2003, I was captivated by the city. It was begging to be explored, with many of its historic monuments hidden away along nondescript alleyways. The most modest looking eateries often prepared mouthwateringly delicious food. The most unassuming doorways could lead into stunning, elaborately decorated residential courtyards. Despite its deep history and rich cultural heritage, it was a humble and unpretentious city. The people of Damascus took great pride in their city's distinguished past, but they displayed none of the arrogance that proud inhabitants of other cities sometimes show. They greeted visitors with kindness and patience, creating a peaceful and welcoming atmosphere. Shopkeepers were as interested in socializing with their customers as they were in doing business, and friends would spend hours in cafes discussing the issues of the day. This leisurely pace of life defied expectations for a city its size. Damascus had an independent spirit, its people choosing to enjoy life and not be consumed by it. Even after I'd lived there for some years, Damascus was always able to surprise me. The city was slightly chaotic, a bit worn and rough around the edges, but it had a unique charm that I experienced nowhere else in the travels I have made to dozens of countries around the world.

Most visitors are introduced to the old city of Damascus through Souq al-Hamidiyeh, which has become its western entrance. This bustling and colorful covered market largely follows the original Roman axis of the city, extending to the former Temple of Jupiter, now the Umayyad Mosque. Other markets extend in all directions from Souq al-Hamidiyeh, with sections specializing in a wide variety of products including clothing, textiles, spices, books, stationery, jewelry, cosmetics, traditional medicines, housewares, and more. The area features nearly two-dozen Ottoman-era khans that historically provided accommodation to trade caravans. Often constructed on a monumental scale around a large central courtyard, these buildings display the elegant architectural style of the period. Traditional public baths, or hammams, are often found nearby. Between this commercial district and the Barada River, which forms a natural northern boundary to the old city, lies the Damascus Citadel. While not as imposing as many of the country's other fortresses, it was crucial to the city's defense against the Crusader and Mongol invasions.

The most prominent monument in Damascus is the Umayyad Mosque, which manages both to inspire great awe and to provide a calm, peaceful environment conductive to spiritual renewal in both its indoor and outdoor spaces. Having served as a place of worship for more than 3,000 years, it perfectly symbolizes the country's long history and diverse culture, incorporating architectural elements from the Roman, Byzantine, Umayyad, Abbasid, Ayyubid, Mamluk, and Ottoman eras. Significantly altered throughout antiquity, it was the greatest building project undertaken by the Umayyad Caliphate, and endures as a testament to this important period of early Islam. The surrounding western neighborhoods of the old city have been richly endowed with mosques, madrasas, and mausoleums that commemorate the city's Seljuq, Ayyubid, Mamluk, and Ottoman rulers, as well as the palaces in which they once resided. Over time, these monuments extended beyond the old city walls, into the western neighborhood of Qanawat, the southern al-Midan, and the northern Saroujeh. South of the old city, the cemetery of Bab al-Saghir hosts the tombs of several prominent figures of early Islam, including relatives and companions of Mohammed.

The old city is a maze of cobblestone lanes that wind through quiet residential quarters where numerous large and elaborately decorated private residences, built over the centuries for prominent families and wealthy merchants, are hidden behind nondescript walls whose plain surfaces give no hint of the riches that lie within. Traditionally constructed around an open courtyard with fountains and small gardens, many of these beautiful homes are now accessible to the public. Dozens have been renovated to serve as restaurants, cafes, concert venues, nightclubs, art galleries, and museums in recent decades. Once neglected, the old city has experienced a

revival, becoming a destination for entertainment and recreation among Damascenes and visitors alike. This trend is most firmly established in the old city's northeastern quarter, the historic center of its Christian community. Many important churches are also found here, near the ancient city gates of Bab Touma and Bab Sharqi, the latter marking the eastern extent of the Street Called Straight.

The modern metropolis of Damascus extends from its historic center in every direction, with the most desirable neighborhoods located to the west. Government offices, embassies, university campuses, entertainment venues, upscale hotels, and shopping centers are mostly located here. Much of the modern city was planned during the French Mandate period, and is characterized by wide, tree-lined boulevards that intersect at broad traffic circles distinguished by prominent landmarks. Many of the modern areas of the city feature large parks, fashionable cafes, restaurants, and shopping districts. The northern districts of the city climb the steep, rocky slopes of Jebel Qasioun, the mountain that overlooks Damascus. One of these neighborhoods, al-Salhiyeh, was first developed in the Ayyubid era. Originally separated from Damascus by agricultural land, it contains a large number of the city's notable historic monuments. Its original residents were non-Arab migrants and refugees, though their descendants long ago assimilated into the Arab culture of the city. Further up the mountain, dozens of cafes and restaurants provide unforgettable views over the entire city.

The capital is one of the most demographically diverse cities in the country. It has been predominantly Sunni Muslim since the Umayyad period, and the community follows a wide range of religious traditions. The practice of Sunni Islam in Damascus has been heavily influenced by Sufism, which takes a more mystical approach to the faith. The city has a sizable Christian population, centered in the old city district of Bab Touma and the nearby modern neighborhoods of al-Qassaa and al-Ghasani. Shiite Muslims have long maintained a small presence around important religious shrines, such as al-Seida Raqiyeh Mosque in the old city neighborhood of al-Amara. The Druze have also had a long history in Damascus, and today their community is centered on the southeastern suburb of Jaramana. The Alawite minority has grown over the past several decades, and is largely concentrated in the city's northwest. The city's Jewish population was once centered in the southeastern neighborhood of the old city known as Harat al-Yahoud, though most emigrated to Brooklyn, New York in the 20th century.

Damascus was a major destination for Palestinian refugees of the 1948 and 1967 wars, who settled in several camps to the south of the city. Some of these, such as al-Yarmouk, later developed into major urban areas. The 2003 war in neighboring Iraq, and the instability that followed it, led to hundreds of thousands of Iraqis migrating to Syria. The majority settled in and around Damascus, particularly in the suburbs of Jaramana and al-Seida Zeinab. Damascus has a sizable Kurdish minority and also hosts small numbers of other ethnic groups such as Armenians, Turkmen, Circassians, Chechens, Albanians, and Bosnians. Some areas of the city have an open and cosmopolitan atmosphere, while others maintain a more conservative and traditional character.

The historic neighborhoods of Damascus have largely been spared the destruction inflicted on the old cities of Aleppo and Homs since the Syrian conflict began in 2011. Mortar attacks have definitely left their mark on some of the old city's monuments, but most of its architectural heritage has remained undamaged. Unfortunately, many of the city's outlying neighborhoods and suburbs have suffered grievously from the conflict.

Souq al-Hamidiyeh

Most visitors are introduced to the old city of Damascus through the popular Souq al-Hamadiyeh. Wandering through this bustling covered market, crowded with Syrians and foreigners alike, was always a captivating experience. The present layout dates to an Ottoman redevelopment in the 19th century, but it largely follows the original axis of the Roman city.

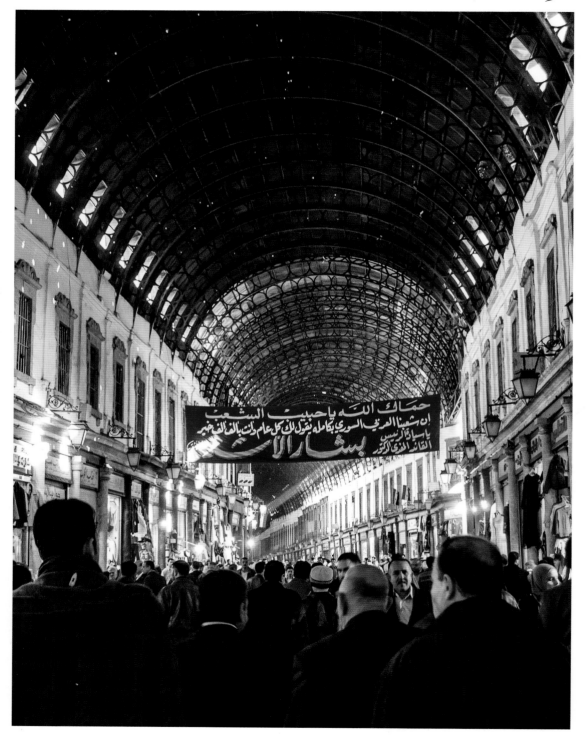

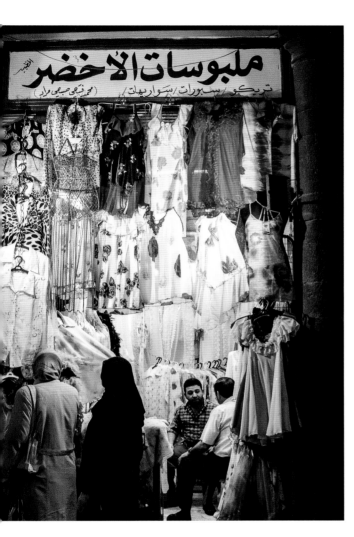

Most of the shops in Souq al-Hamadiyeh sell clothing and other textiles, in a variety of modern and traditional styles.

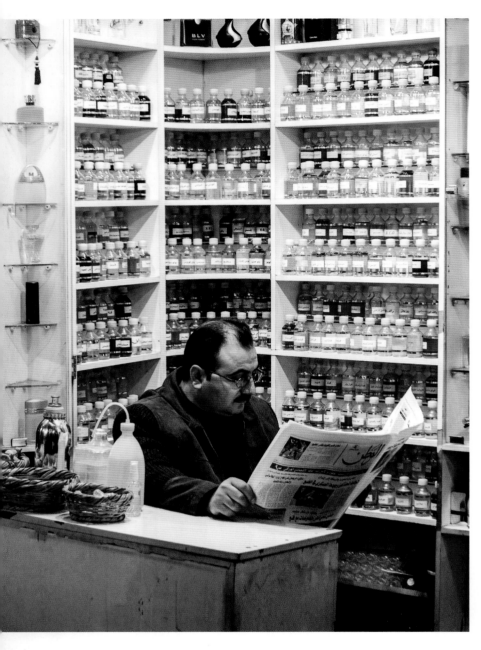

The market's perfumeries could create convincing imitations of almost any popular fragrance.

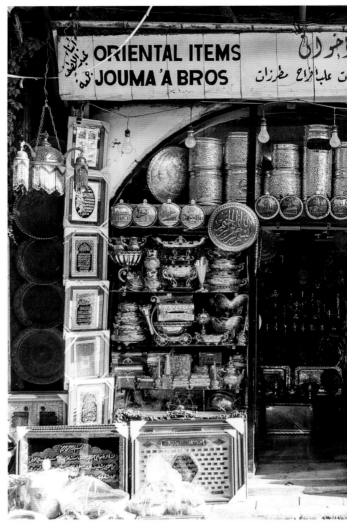

Prayer beads and other religious items are sold by several vendors at the eastern end of the market, near the Umayyad Mosque.

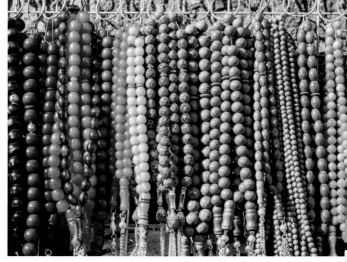

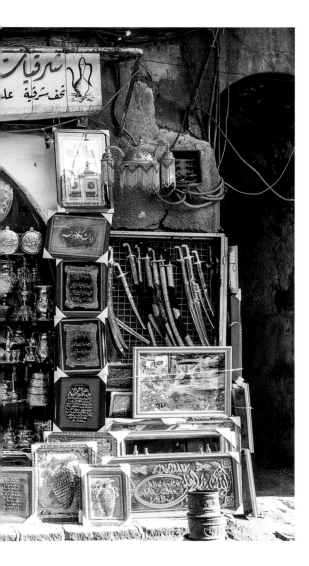

This quaint souvenir shop specializes in decorative metalwork, a trade of Damascene craftsmen passed down through generations.

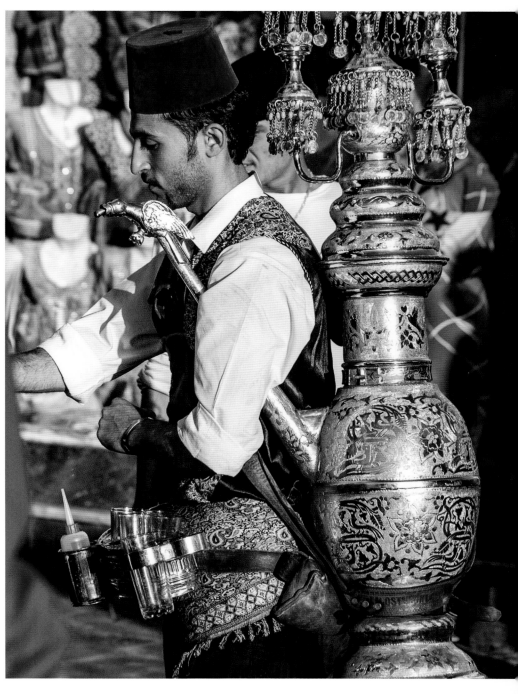

Vendors in Souq al-Hamadiyeh offer refreshing drinks to shoppers on hot summer days.

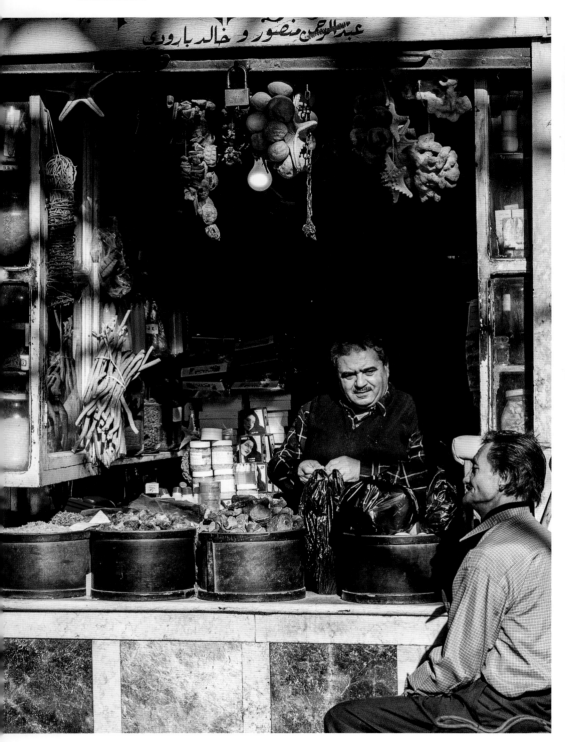

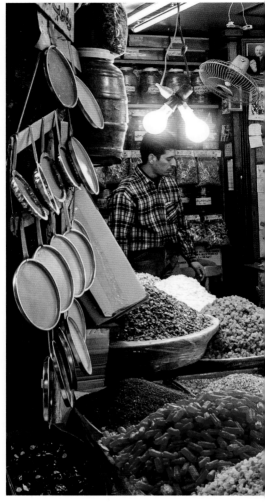

The most colorful market in Damascus is Souq al-Bazuriyeh, featuring dozens of spice vendors and candy shops. During my photography excursions, I was often drawn to this market, its vibrant atmosphere enhanced by the aromas of cumin, coriander, thyme, cinnamon, clove, mint, and other herbs and spices.

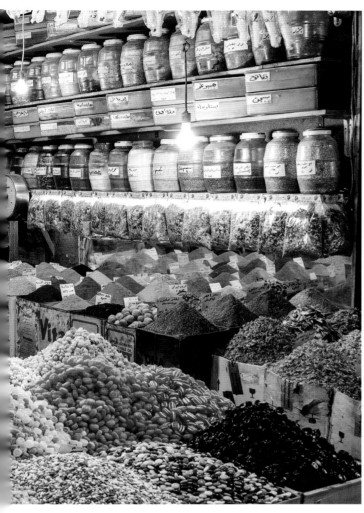

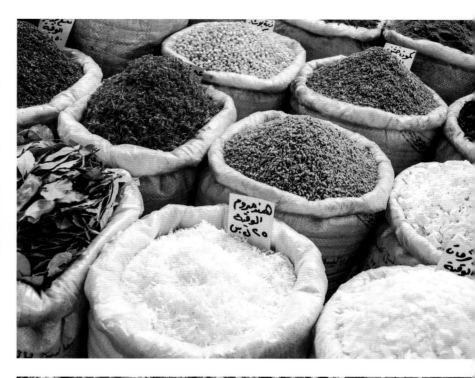

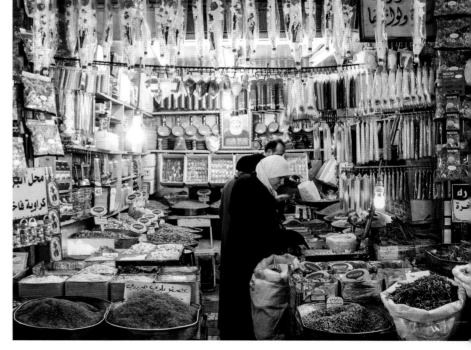

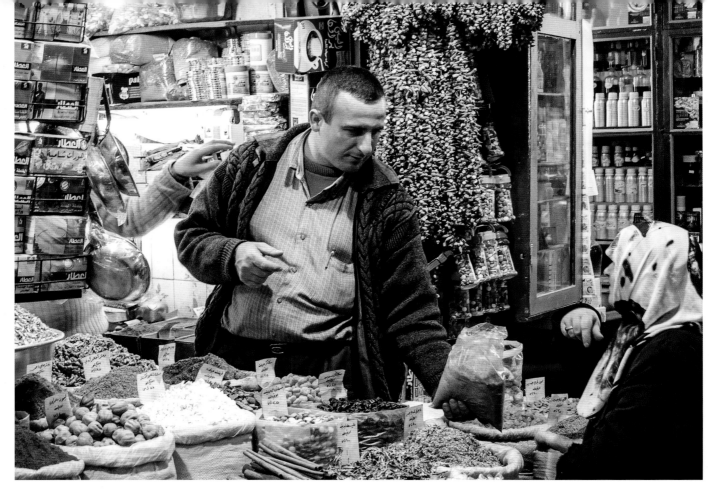
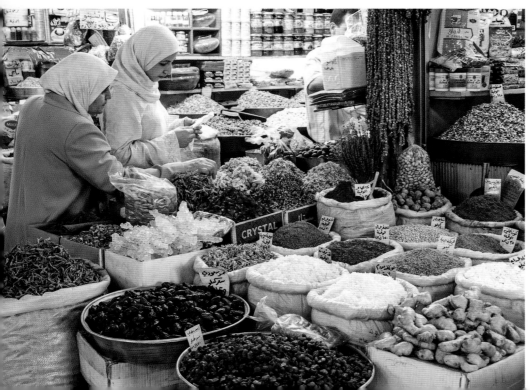
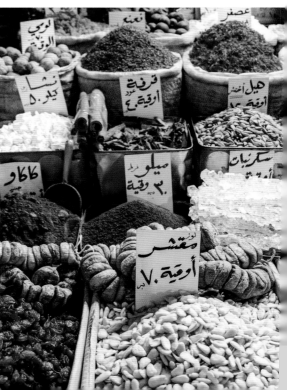

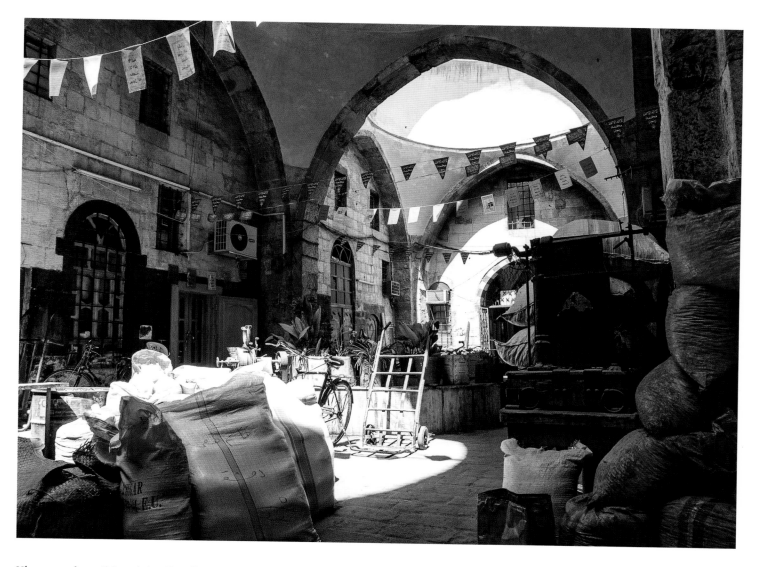

Khans such as this originally offered accommodation to large trade caravans and functioned as warehouses for their goods. Today, most simply serve as extensions of the surrounding markets, containing workshops and storage space for nearby businesses.

Khan Assad Pasha

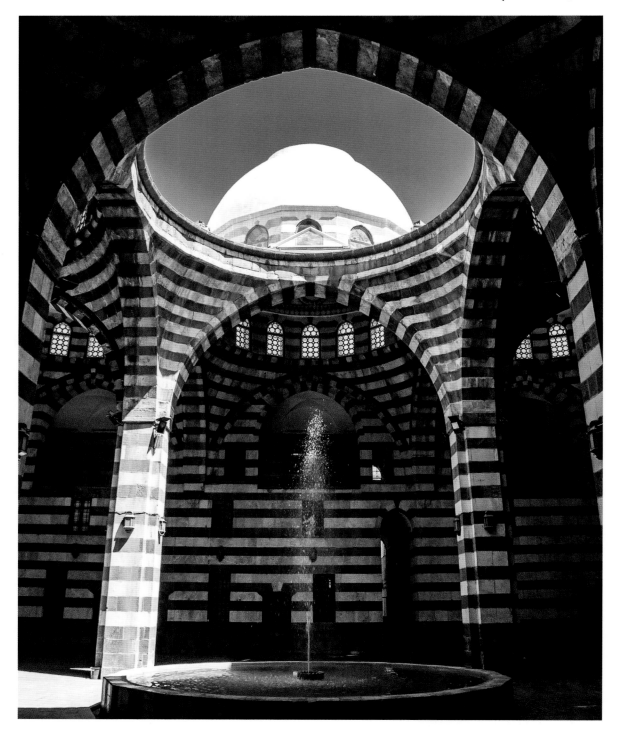

Located in the spice market, Khan Assad Pasha is the largest of the several dozen khans in the old city. It was constructed in 1752 under Assad Pasha al-Azem, who served as Ottoman governor of Damascus for over a decade. At 2,500 square meters in size, it features a large central courtyard and is covered by eight domes.

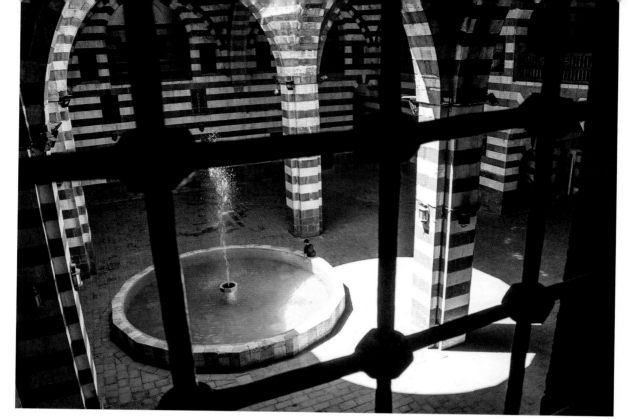

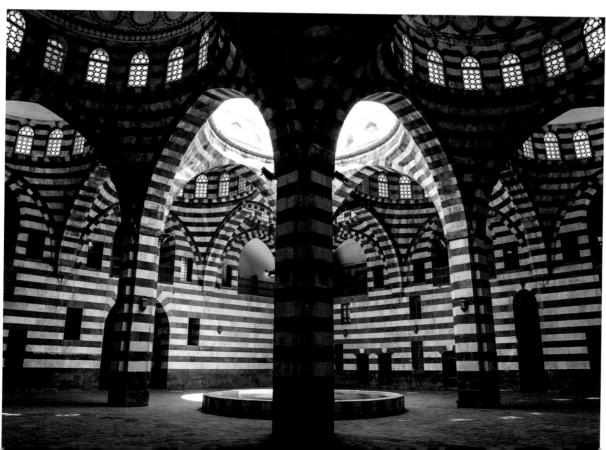

قصر العظم

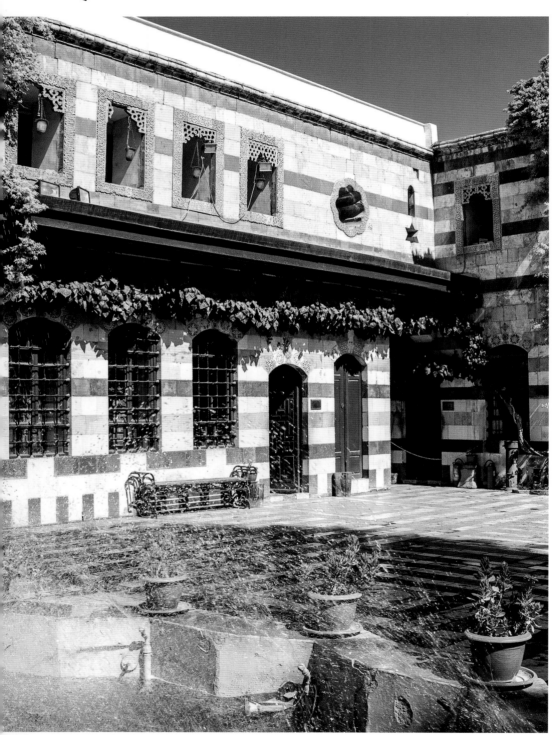

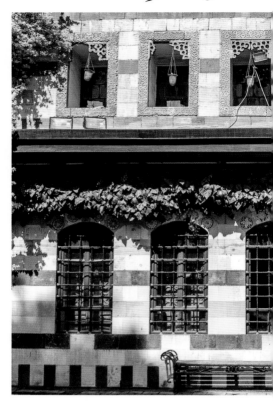

Damascus is rich in traditional domestic architecture, of which the ornate Qasr al-Azem is the best known example. Assad Pasha al-Azem built this palace in 1750, using the foundation of an earlier mansion belonging to the Mamluk governor Tankiz. Qasr al-Azem now houses the Museum of Popular Traditions.

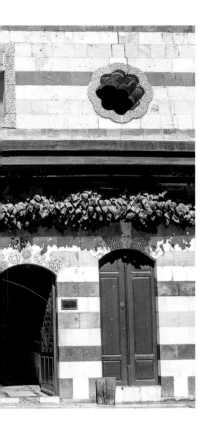

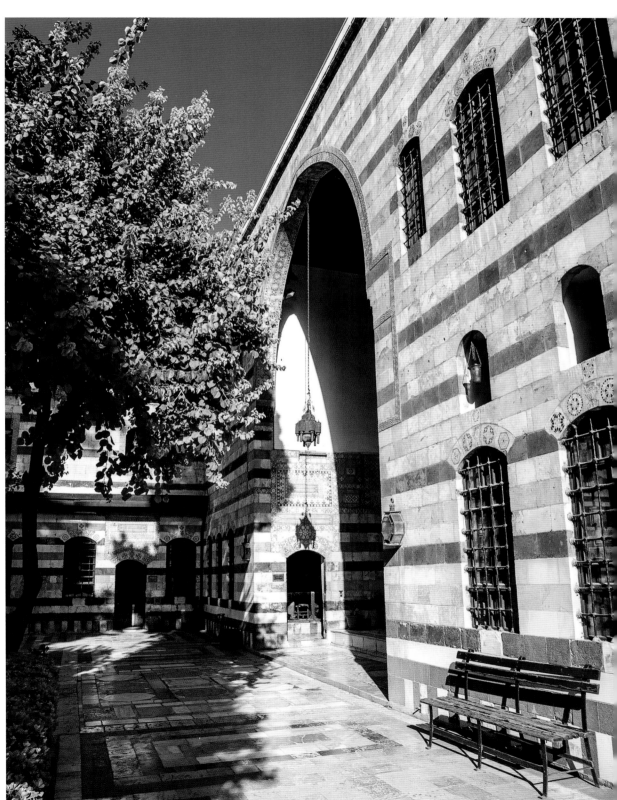

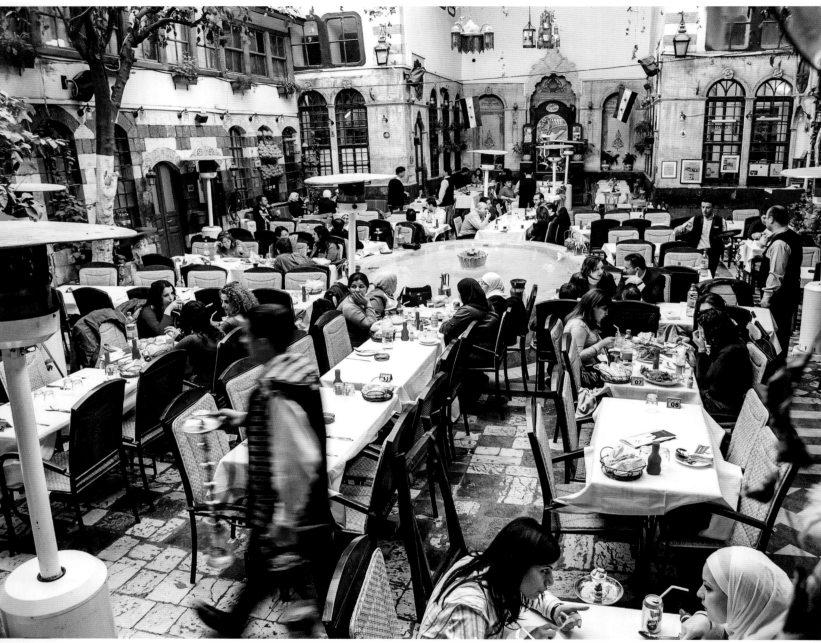

For decades, restaurateurs and investors have recognized the potential of these traditional residences, with their large open courtyards and charming atmosphere, as ideal locations for cafes and restaurants. The beautiful Beit Jabri was one of the first to establish this trend.

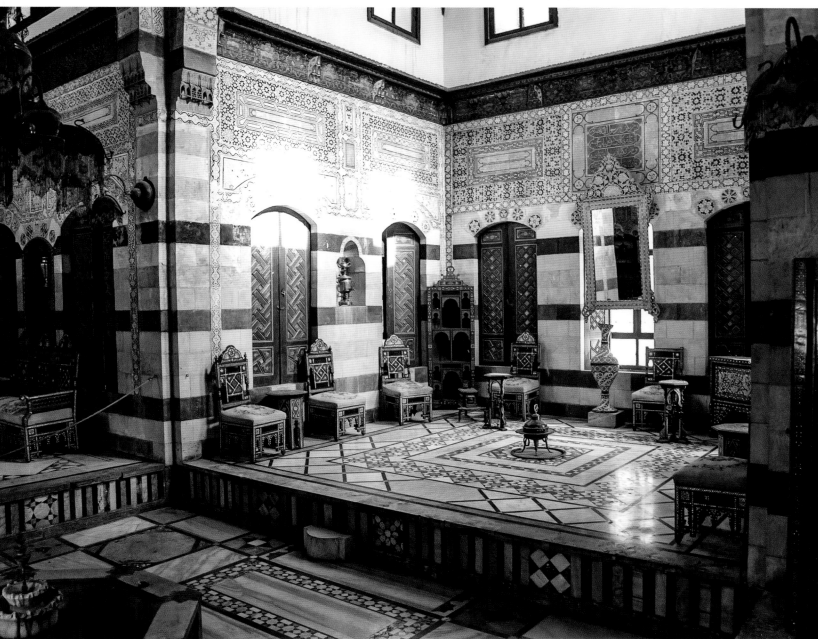

Beit Khalid al-Azem is another Ottoman-era home that once belonged to the prominent al-Azem family. This luxurious residence was constructed in the 18th century in the quiet neighborhood of Saroujeh, a short distance northwest of the old city. It covers 3,136 square meters, making it one of the largest historic residences in the city. It is open to the public, serving as the Damascus Historical Museum.

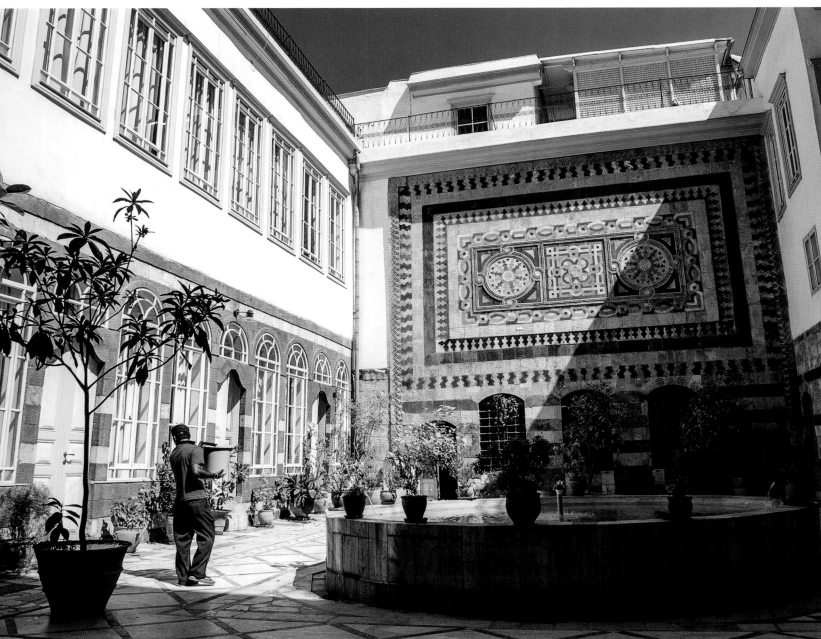

Beit al-Aqad is a beautifully restored Damascene house formerly owned by a wealthy family of textile merchants. On the northern end of its large rectangular courtyard is a striking facade featuring elaborate stonework from the Mamluk era. The home has both summer and winter reception halls.

Maktab Anbar

مكتب عنبر

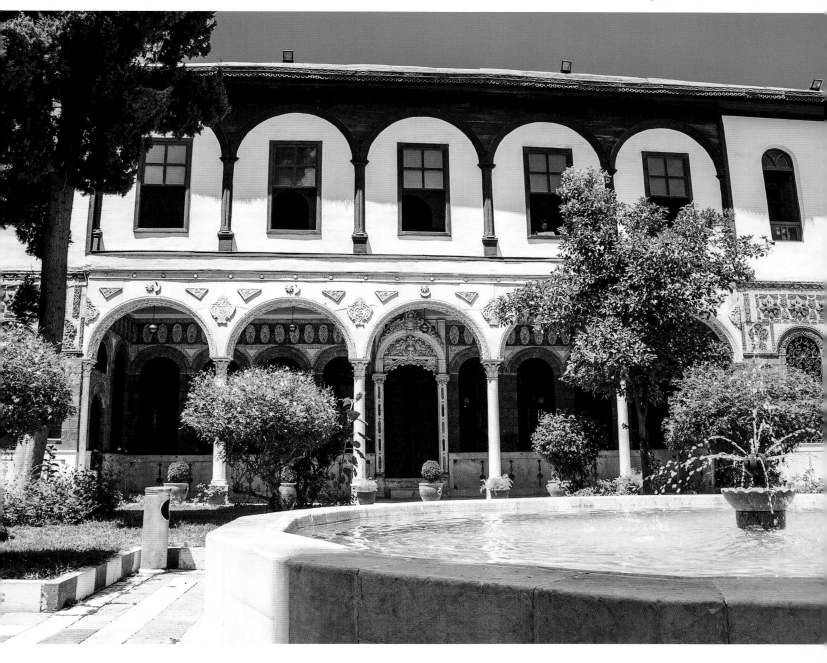

Maktab Anbar is the largest historic residence in the old city, covering an impressive 3,825 square meters. This palatial home was constructed for Yousef Anbar, a wealthy merchant, in the mid-19th century. With a beautiful garden courtyard and elaborate architectural details, the residence now serves as a cultural center.

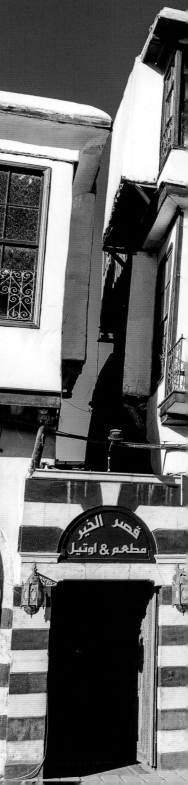

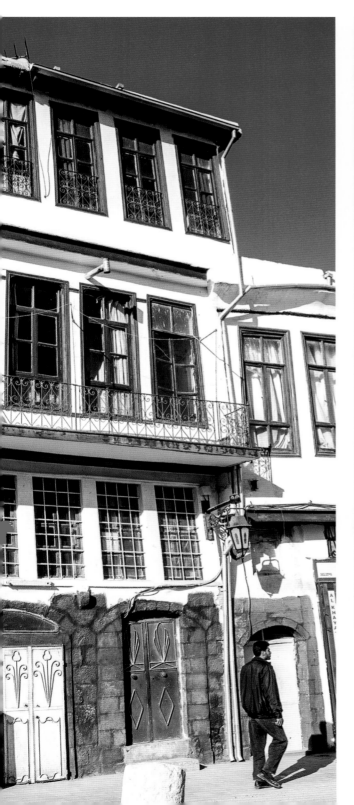

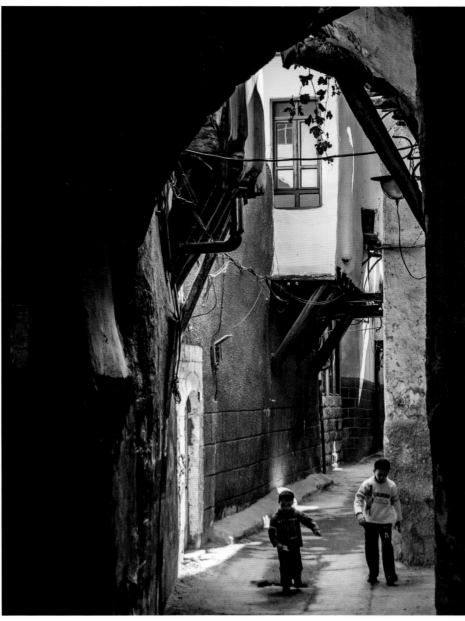

One of the most enjoyable experiences Damascus offers is to wander through the maze of cobblestone alleyways in the old city's residential quarters. I spent countless hours exploring these narrow lanes, immersing myself in the daily life of its residents.

Damascus Citadel

<div dir="rtl">قلعة دمشق</div>

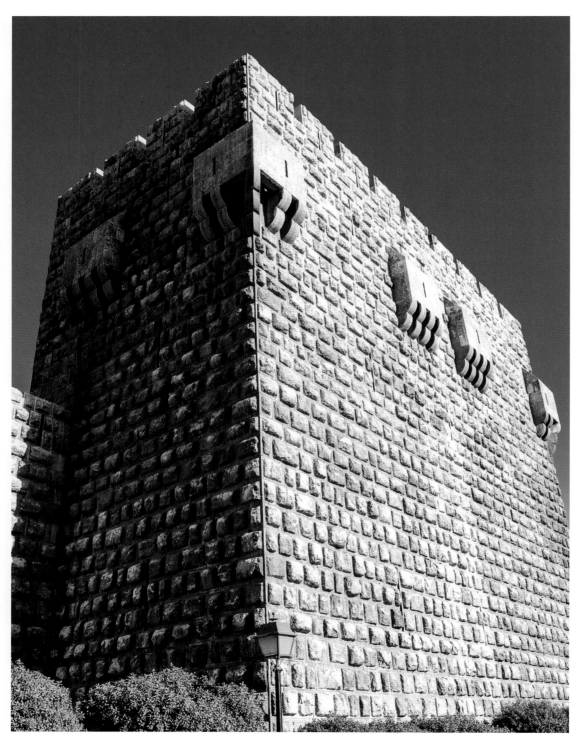

While not as imposing as its counterpart in Aleppo, the Damascus Citadel was central to the city's defenses from the late 11th century through the Ottoman period. Built on flat ground with no natural defenses aside from the Barada River bordering its northern walls, the fortress was besieged, destroyed, reconstructed, and expanded several times over the centuries.

Bab Sharqi

The old city was once surrounded by extensive fortifications that included walls, towers, and gates. Many of these structures survive intact, often concealed within markets and incorporated into residential buildings. Some of the fortifications date back to the Roman period, including Bab Sharqi, the city's eastern gate, which is the only one that largely retains the original Roman design.

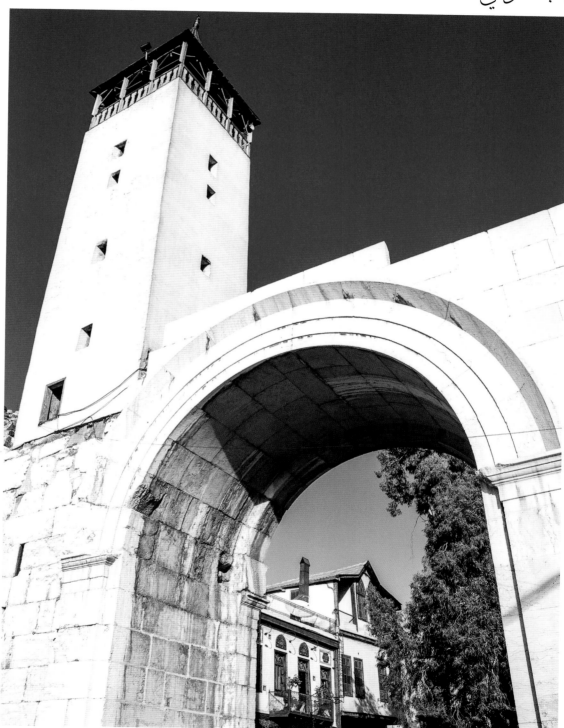

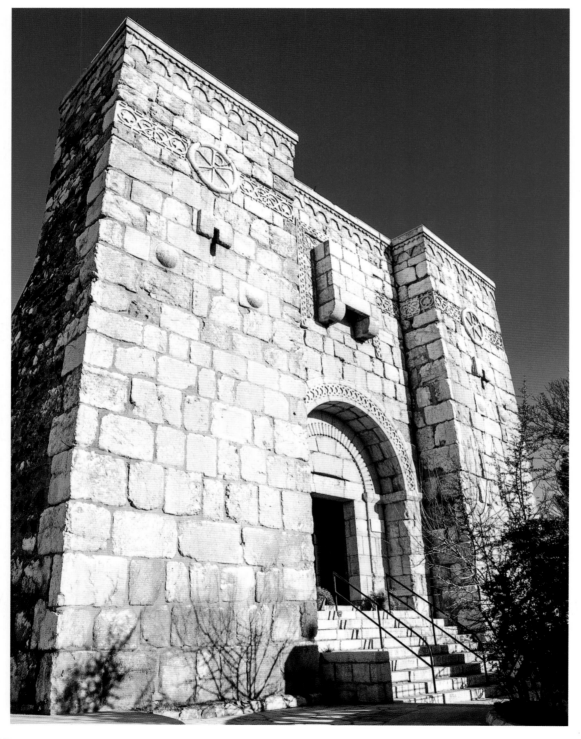

St. Paul's Church is a Greek Catholic chapel constructed in the 20th century from the remains of Bab Kissan, the historic southeastern gate of Damascus. Little remains of the original Roman gate, which was reconstructed under the Mamluks in 1364.

al-Zeitoun Church

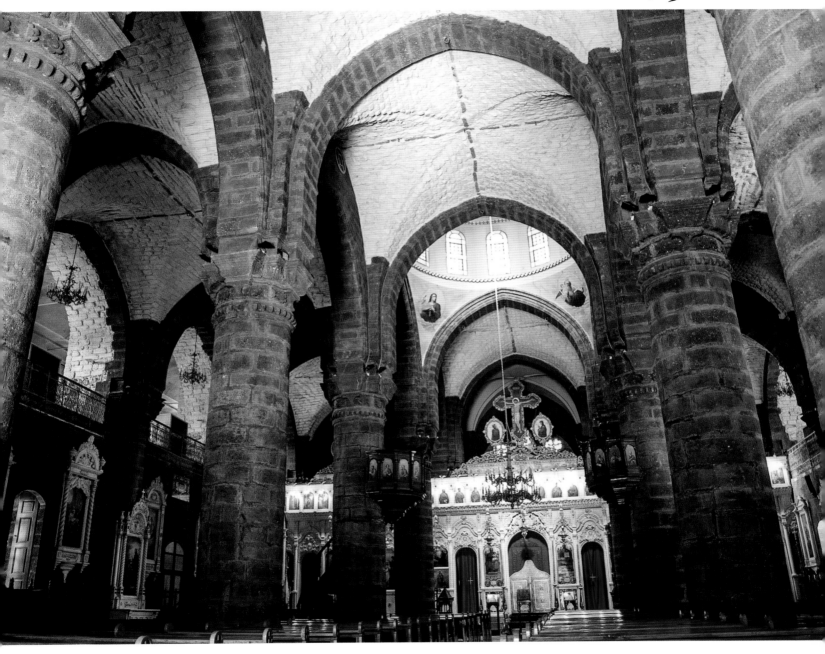

Al-Zeitoun Church, in the old city neighborhood of Bab Sharqi, is the seat of the Greek Catholic patriarchate and one of the most attractive churches in the city. It was built in 1833-1834 from the black basalt found in the desert region southeast of Damascus.

Church of St. Hananiya

<div dir="rtl">كنيسة القديس حنانيا</div>

One of the best known Christian sites in Damascus is the Church of St. Hananiya, a small underground chapel. According to local tradition, the church was originally part of the Roman-era home of the biblical Ananias. The modest chapel, thought to date to the fifth or sixth century CE, is comprised of two small rooms with bare stone walls that reflect the humble beginnings of Christianity.

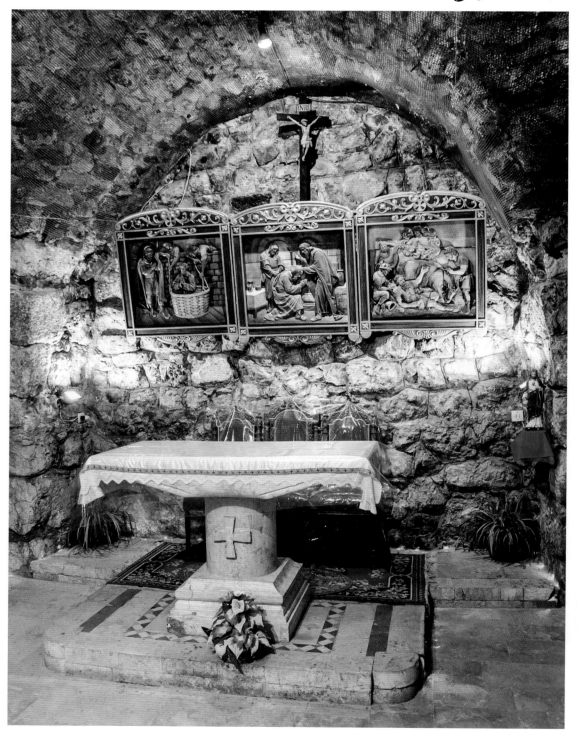

al-Seida Raqiyeh Mosque

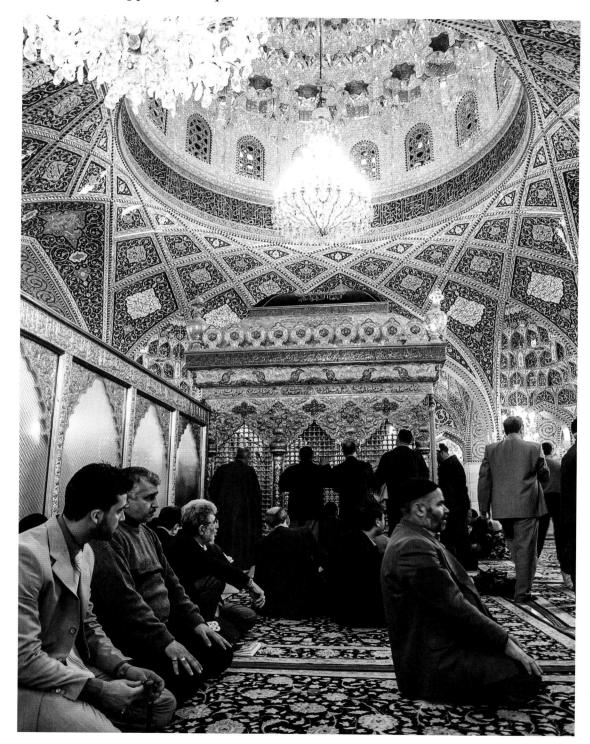

Al-Seida Raqiyeh Mosque houses the tomb of Raqiyeh, the daughter of Hussein and great granddaughter of Mohammed. It is a popular pilgrimage destination for Shiite Muslims. The site was originally marked by a simple mausoleum until Iran financed the building of this modern shrine in 1985. Its interior features unrestrained use of blue ceramic tile and mirrors, contrasting sharply with the more subtle decoration traditional to Syrian mosques.

al-Madrasa al-Aadiliyeh & al-Madrasa al-Zahiriyeh المدرسة العادلية والمدرسة الظاهرية

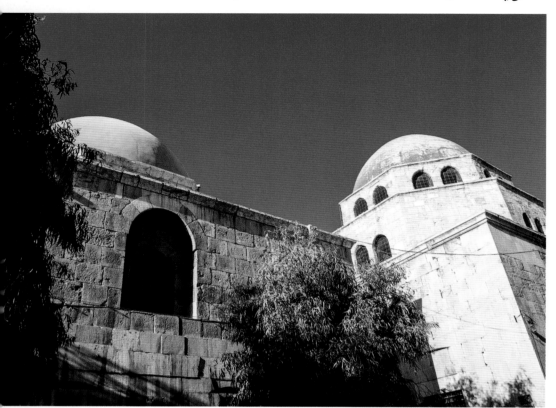

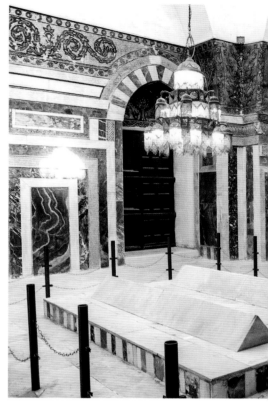

Al-Madrasa al-Aadiliyeh (left in the above photo) and al-Madrasa al-Zahiriyeh (right in the above photo) are among the most remarkable monuments in the old city of Damascus from the Ayyubid and Mamluk periods, respectively.

Construction of al-Madrasa al-Aadiliyeh began in the late 12th century and was completed 50 years later. It was built to serve both as a religious school and as the mausoleum of al-Aadil Seif al-Din, the younger brother of Salah al-Din. After Salah al-Din's death in 1193 and the later infighting among his sons, al-Aadil became the Ayyubid Sultan of Syria and Egypt in 1201 and ruled for nearly two decades.

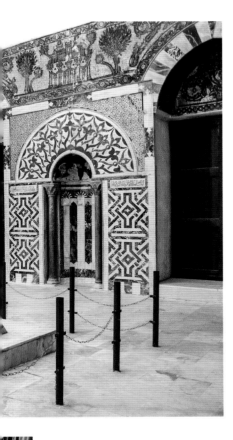

Al-Madrasa al-Zahiriyeh houses the tomb of Sultan Baibars, a Mamluk ruler. An accomplished military commander, Baibars was responsible for several successful campaigns against the Crusaders in the 13th century as well as the critical victory over the Mongols in the Battle of Ain Jalut. This complex, comprising a religious school and mausoleum, includes a striking entrance portal and a beautifully decorated interior with detailed mosaic work.

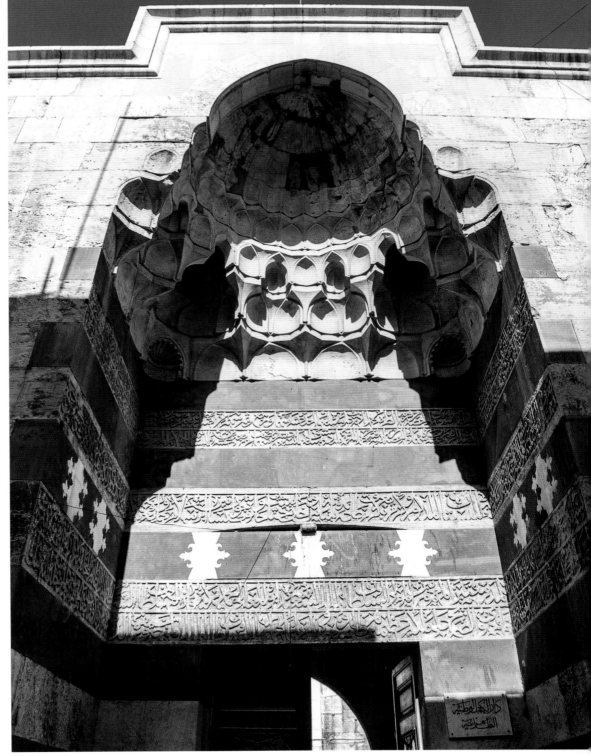

45

Tomb of Salah al-Din

قبر صلاح الدين

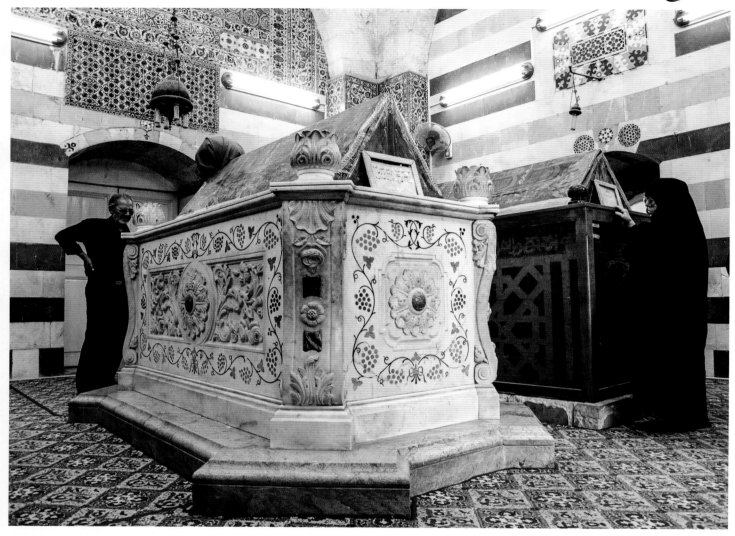

The most renowned Muslim leader to challenge the Crusaders was undoubtedly the 12th-century Kurdish military commander Salah al-Din, who would later rise to power as Sultan of Egypt and Syria. He led several successful campaigns against Crusader-held territories, culminating in the recapture of Jerusalem in 1187. His tomb is located just north of the Umayyad Mosque, though little remains of al-Madrasa al-Aziziyeh that once contained it.

al-Bimaristan al-Nuri

<div dir="rtl">البيمارستان النوري</div>

Al-Bimaristan al-Nuri was established by Nur al-Din in 1154 as a hospital and medical teaching center. The building features an elaborately decorated entryway, a large courtyard with a central fountain, and beautiful carved stonework. During my time in Damascus, it housed an interesting museum dedicated to the history of Arab achievements in science and medicine.

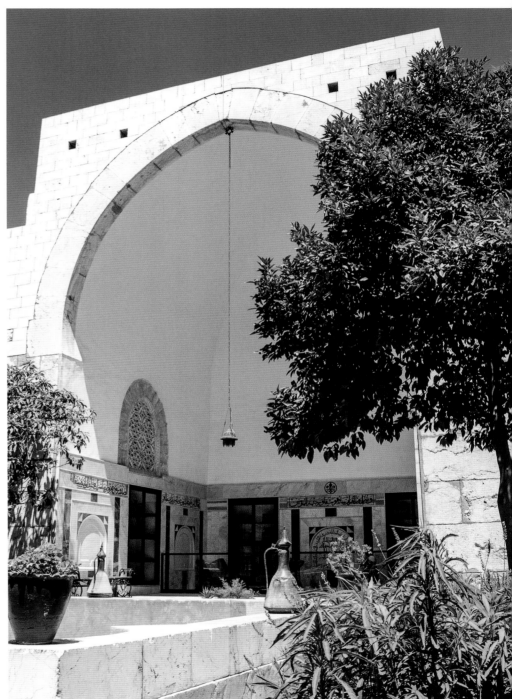

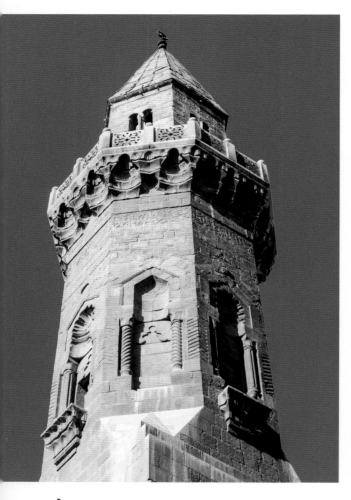

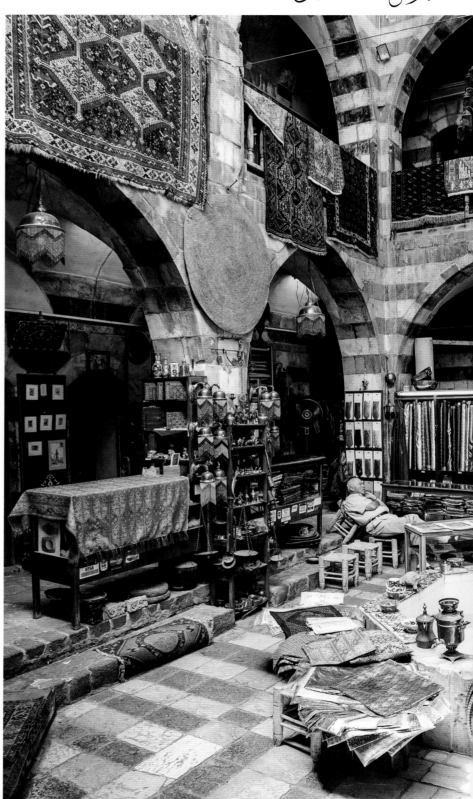

West of the old city, Tankiz Mosque has an octagonal minaret that is one of the finest examples of Mamluk architecture in Damascus. The building was constructed in 1317-1318 by the Mamluk governor Tankiz, who ruled the city from 1312 to 1340. The site had previously hosted the Church of St. Nicholas.

Madrasat Abdullah al-Azem was a religious school constructed in 1779 by a member of the prominent al-Azem family. While no longer functioning as a madrasa, the small mosque on the southern side of its attractive courtyard is still used for prayer.

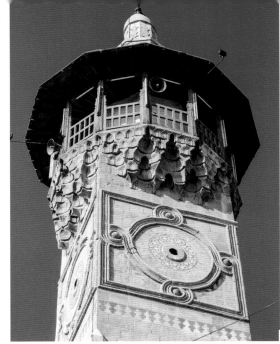

The minaret of al-Qalai Mosque was construct-
ed in 1431, the last to be built in Damascus us-
ing the square design of the Mamluk tradition.
I judged it one of the most attractive minarets
in the old city, with detailed ornamentation
that rendered complex geometric patterns in
fine stonework.

Built in 1348 to commemorate a Persian merchant,
al-Ajami Mosque was intended as both a religious
school and a tomb for its founder. It features distinc-
tively elaborate stone masonry over its doorway.

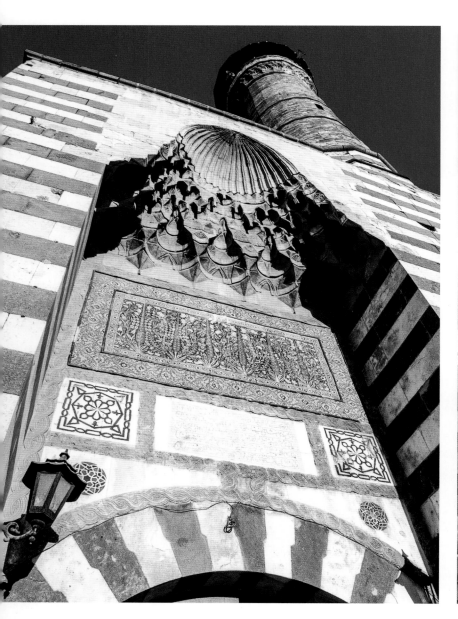
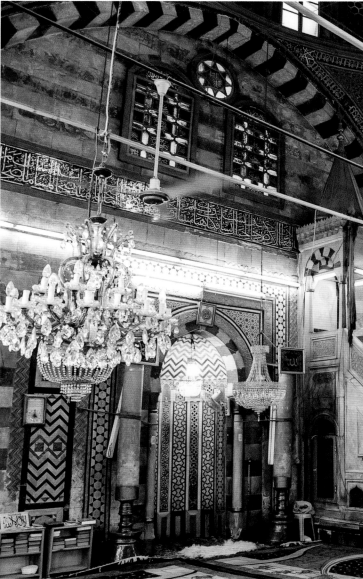

Distinctive for its heavy use of decorative ceramic tiles and minaret of green and blue enameled brick, al-Sinaniyeh Mosque is among the most attractive in the city. Constructed under Sinan Pasha, an Ottoman governor in the late 16th century, the mosque's tranquil courtyard and richly embellished prayer hall provide a welcome contrast to the crowded and chaotic commercial district that surrounds it.

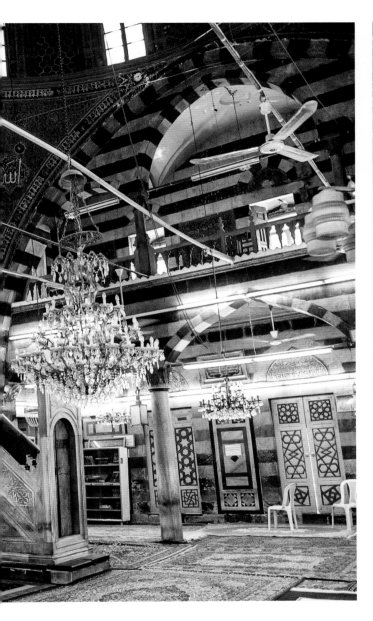

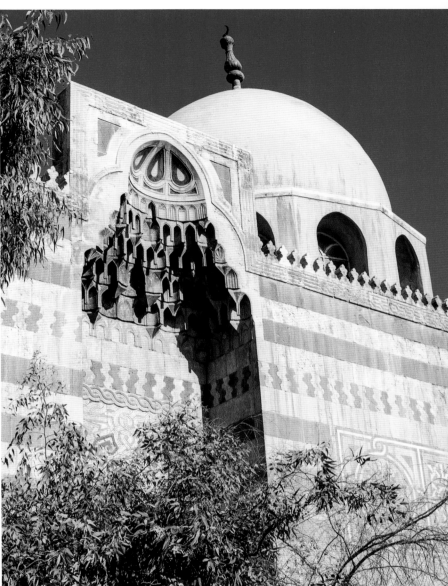

Located just southwest of the old city, al-Sabuniyeh Mosque was built between 1459 and 1464 by a wealthy merchant. Its facade and entryway utilize the alternating horizontal bands of black and white stone common to the Mamluk period, along with decorative panels of complex geometric patterns.

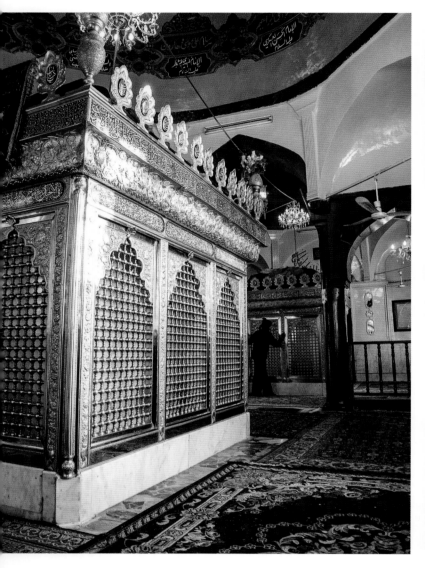

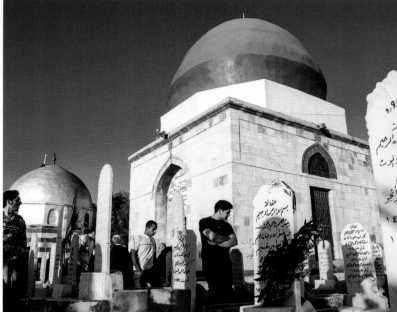

Bab al-Saghir Cemetery, located south of the old city, is the most noteworthy of the many historic cemeteries in Damascus. It has been in use since the beginning of the Umayyad period. Several tombs are attributed to prominent figures in the early history of Islam, including relatives, descendants and companions of Mohammed. Shiite pilgrims, primarily from Iran and Iraq, regularly visited the site.

al-Tekiyeh al-Suleimaniyeh Mosque

جامع التكية السليمانية

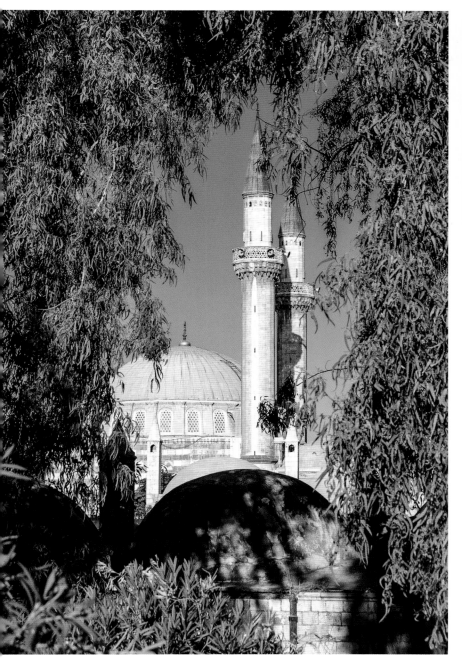

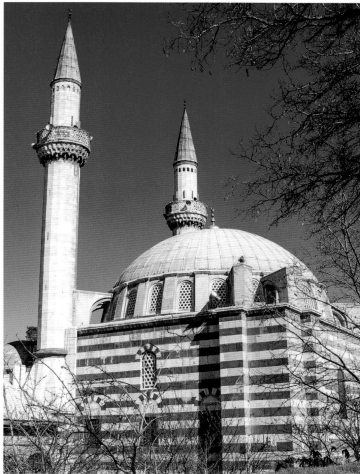

Al-Tekiyeh al-Suleimaniyeh Mosque was designed by the prominent Ottoman architect Mimar Sinan and is considered one of the finest buildings of that period in Damascus. Construction of the complex began in 1554 to serve the annual pilgrimage to Mecca. With its large open courtyard, fountain, and gardens, it provides a quiet and peaceful public space near the busy city center.

53

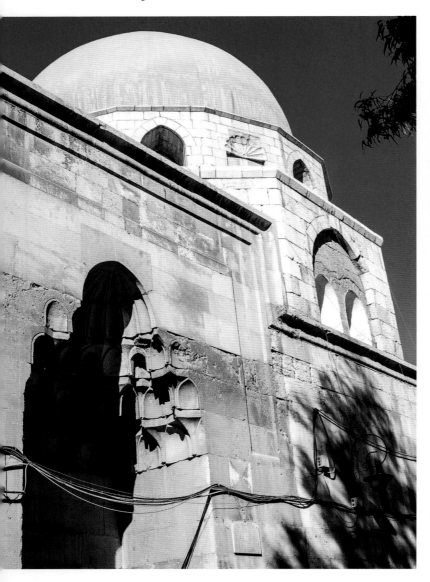

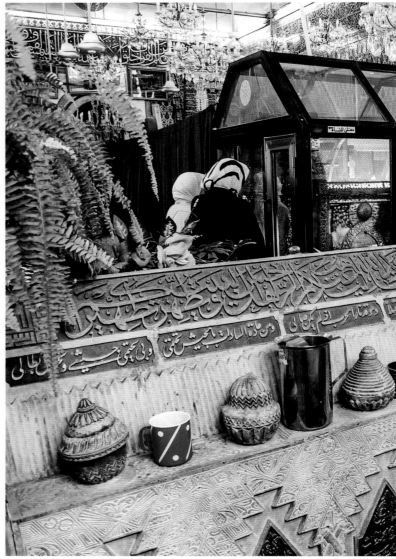

The northern Damascus neighborhood of al-Salhiyeh was first settled in the 12th century by non-Arab Muslims including Kurds, Circassians, and Cretans. The agricultural land that originally separated it from the old city of Damascus has long since been built upon. The district is rich in historic monuments, particularly from the Ayyubid and early Mamluk periods. This mausoleum, al-Turba al-Takritiyeh, was built for a 13th century Mamluk official.

The best known monument in al-Salhiyeh is Mohi al-Din Bin Arabi Mosque, containing the tomb of renowned Sufi mystic Ibn Arabi. Born in Andalusia in 1165, Ibn Arabi gradually moved east, finding a more receptive atmosphere for his teachings in Damascus. The mosque was constructed in 1518 to encourage the practice of Sufism. It features a mix of late Mamluk and early Ottoman designs.

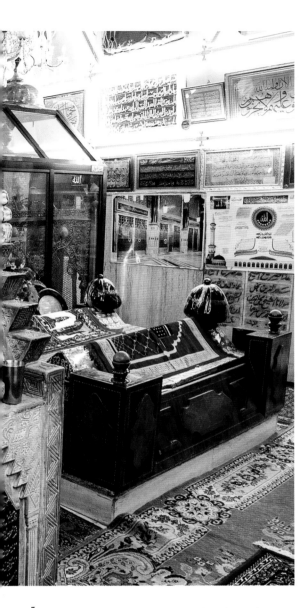

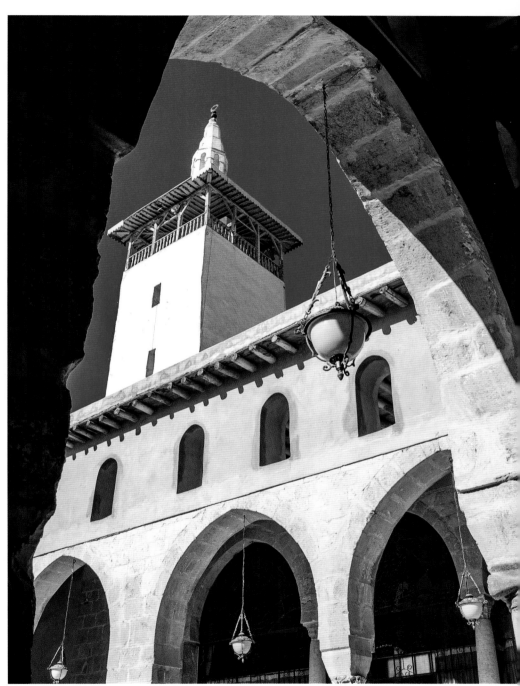

The oldest mosque in al-Salhiyeh, and the second oldest in Damascus, is al-Hanabaleh Mosque. This mosque was built between 1202 and 1213 and was the first major building project to be undertaken during the Ayyubid period. The rather austere exterior of the mosque hides an attractive courtyard and prayer hall modeled after the Umayyad Mosque.

The National Museum in Damascus is the largest and most important museum in the country. I gained great insight into the country's history by exploring its extensive collection of ancient artifacts. Its entryway is a reconstruction of the gateway to Qasr al-Heir al-Gharbi, an Umayyad-era palace in the desert southeast of Homs.

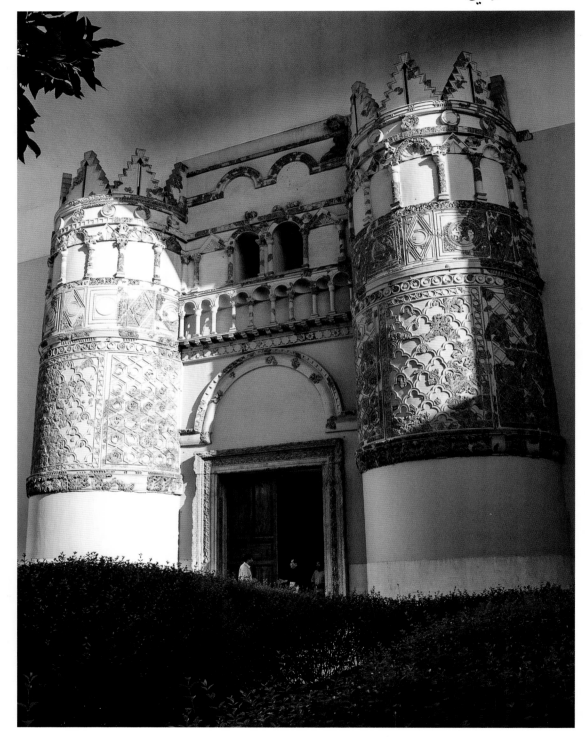

Jebel Qasioun

جبل قاسيون

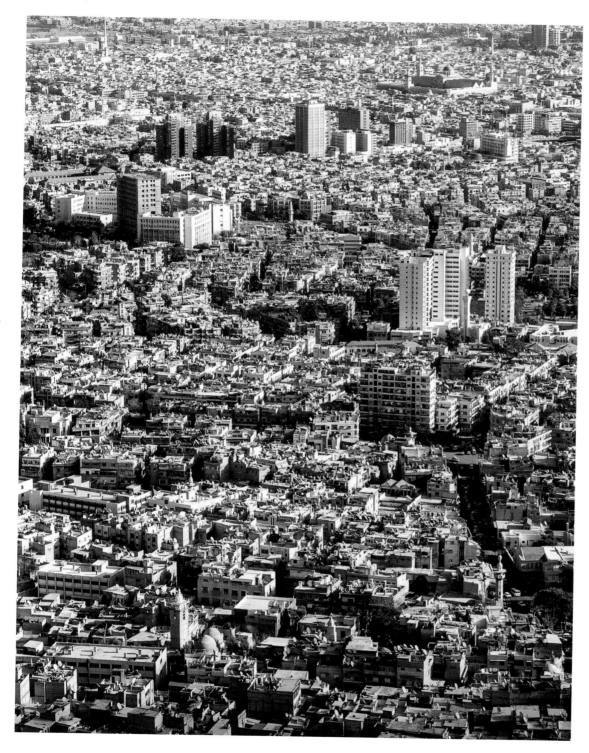

Overlooking Damascus from the north, Jebel Qasioun offers unforgettable views of the city. Numerous cafes and restaurants near the top of the mountain provided refreshments after the strenuous hike from below, a trek that I'd often undertake after spring showers had cleansed the city's air.

Umayyad Mosque

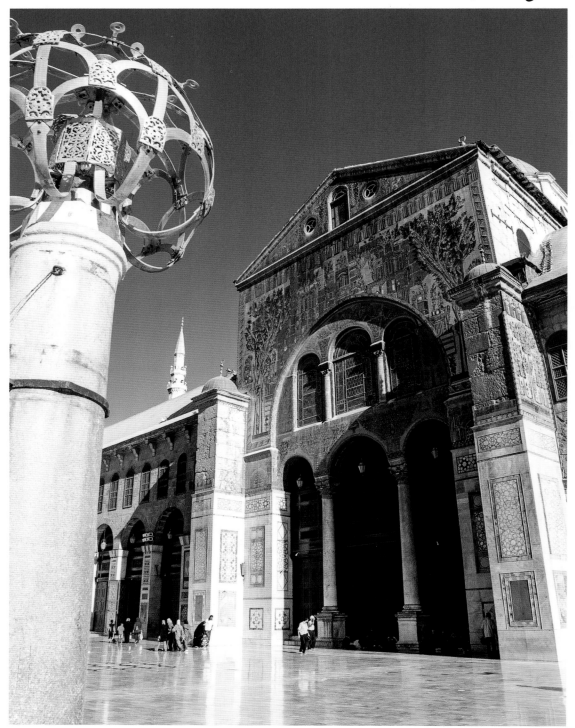

No other monument better symbolizes Syria's rich and varied cultural heritage than the Umayyad Mosque of Damascus. The site has served as a place of worship since the Aramaean period, which began in the late 12th century BCE. While significantly altered throughout its long history, it survives as the greatest monument of the Umayyad Caliphate and one of the most extraordinary mosques in the world.

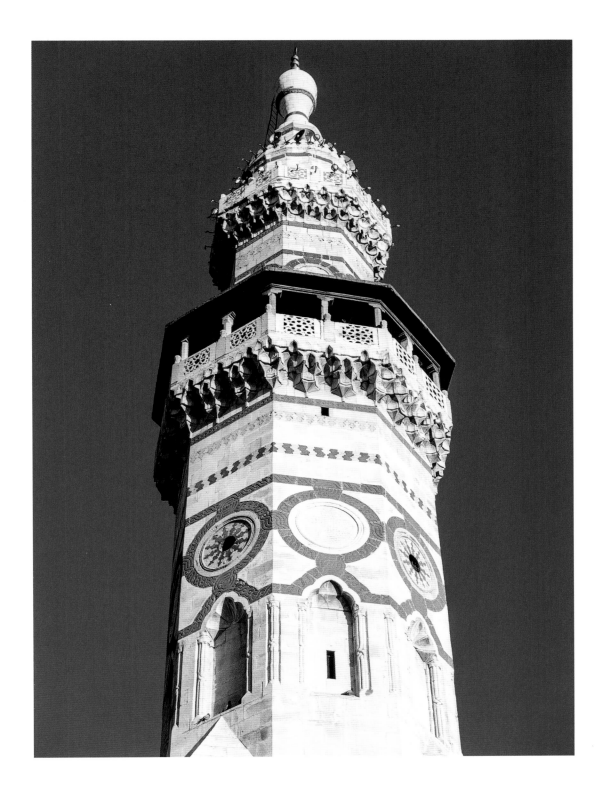

The Umayyad Mosque's southwestern minaret was built in 1488 during the rule of Mamluk Sultan Qaitbay, and is sometimes known as the Minaret of Qaitbay. Octagonal in shape, it has the most intricate decoration of the mosque's three minarets.

The Dome of the Treasury was constructed under Abbasid rule in 789. Supported by eight Roman columns, this octagonal building once held the mosque's revenue and other valuables. It, too, is richly adorned with mosaics.

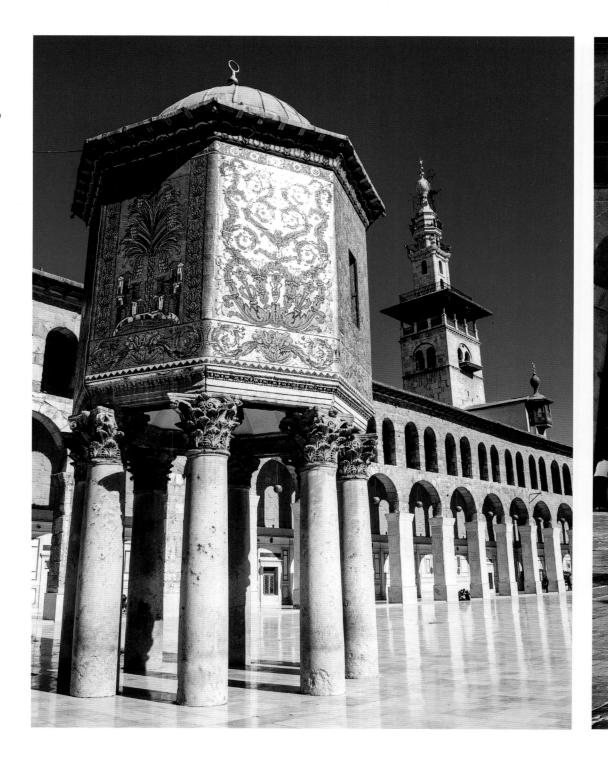

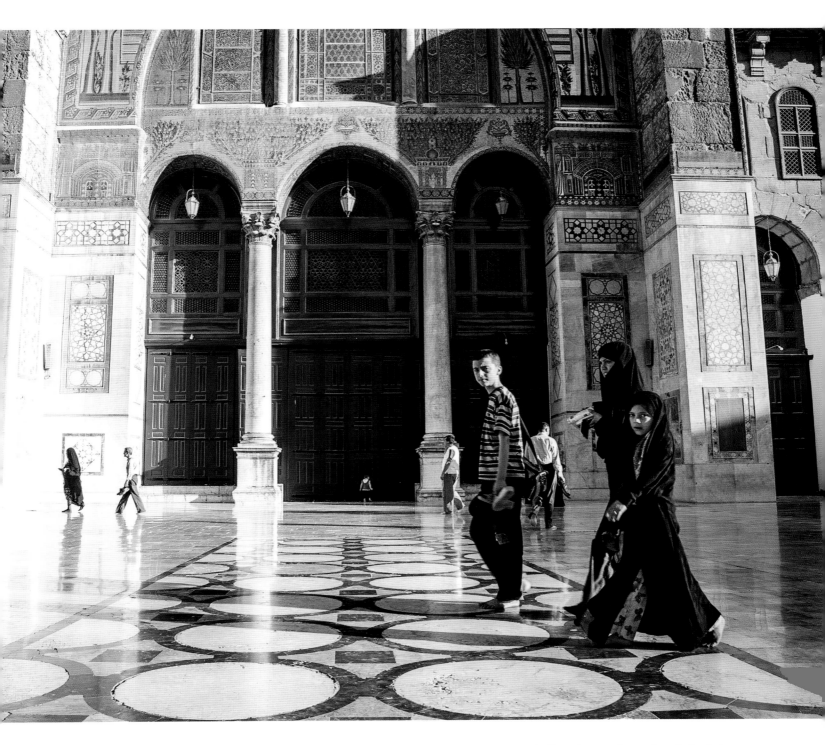

The mosque's enormous courtyard is enclosed by arcades on three sides, with the prayer hall to the south. Its facade is elaborately decorated with detailed mosaics depicting both nature and city scenes. The artistic style is typical of the Byzantine craftsmen hired to create them in the beginning of the eighth century.

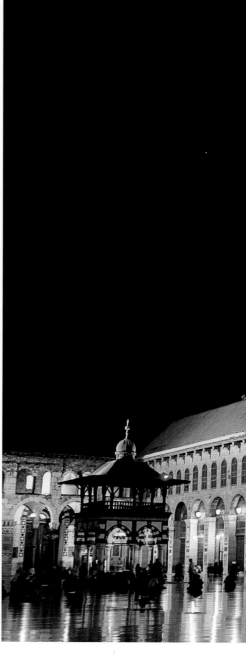

The Umayyad Mosque's northern minaret, the Minaret of the Bride, dates back to the Abbasid period. Constructed in 831, it is the building's earliest surviving minaret. Traditionally, the muezzin would make the call to prayer from its upper platform.

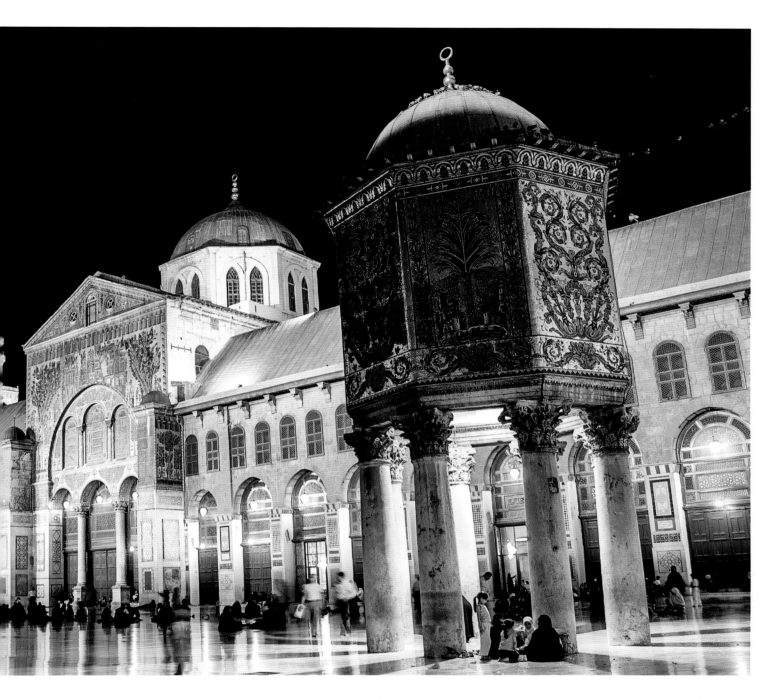

Occasionally, the mosque's courtyard would remain open to visitors into the evening. Admiring the prayer hall's exquisite facade under a star-filled sky on a warm summer night was an unforgettable experience.

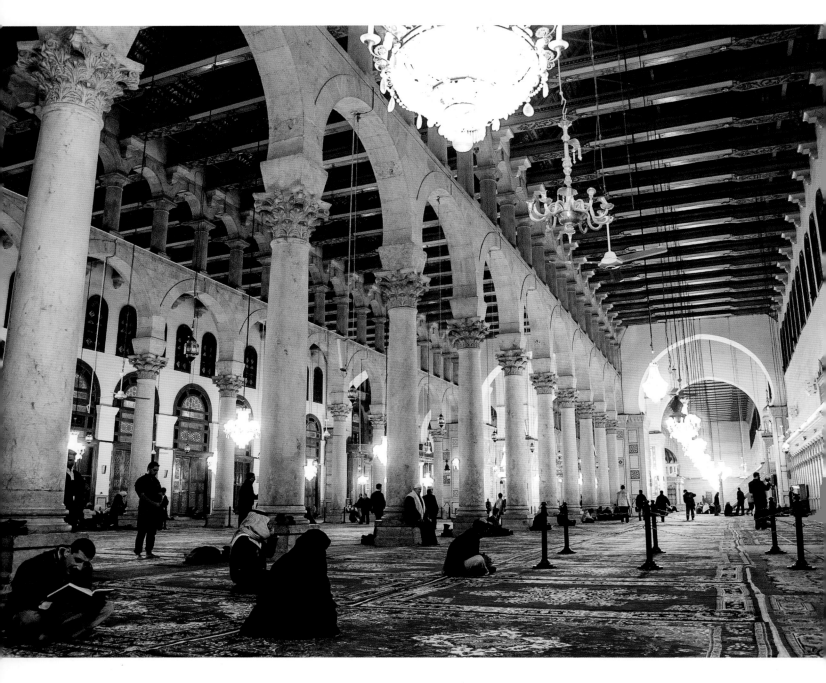

The mosque's interior is composed of three arcades divided by two rows of Corinthian columns. A large dome, 36 meters high, soars over the center of the prayer hall.

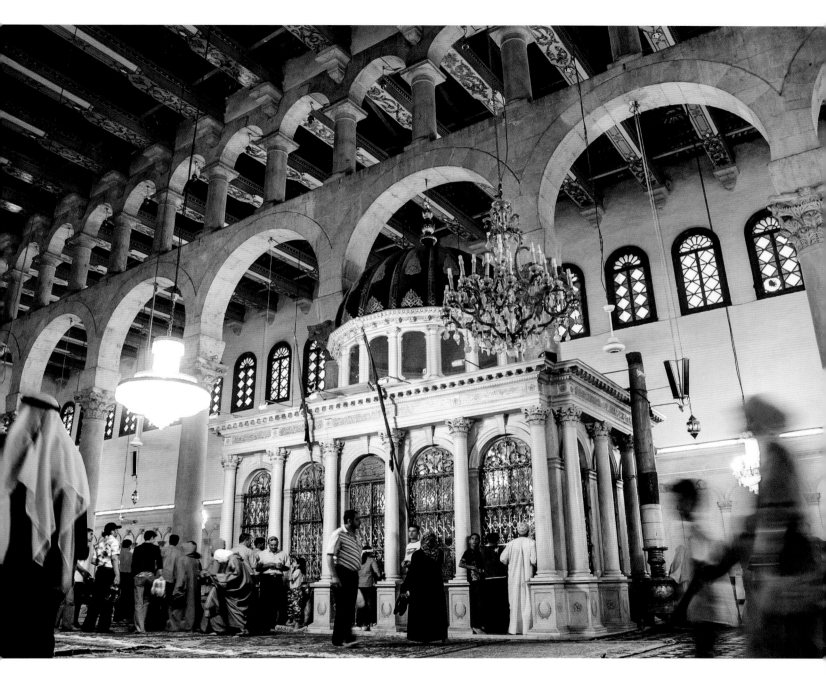

At the eastern end of the prayer hall is a shrine dedicated to John the Baptist. According to local tradition, this was the burial place of John's severed head, a claim supported by the Catholic Church. After an earlier mausoleum was destroyed by fire in 1893, this marble monument was constructed during the late Ottoman period.

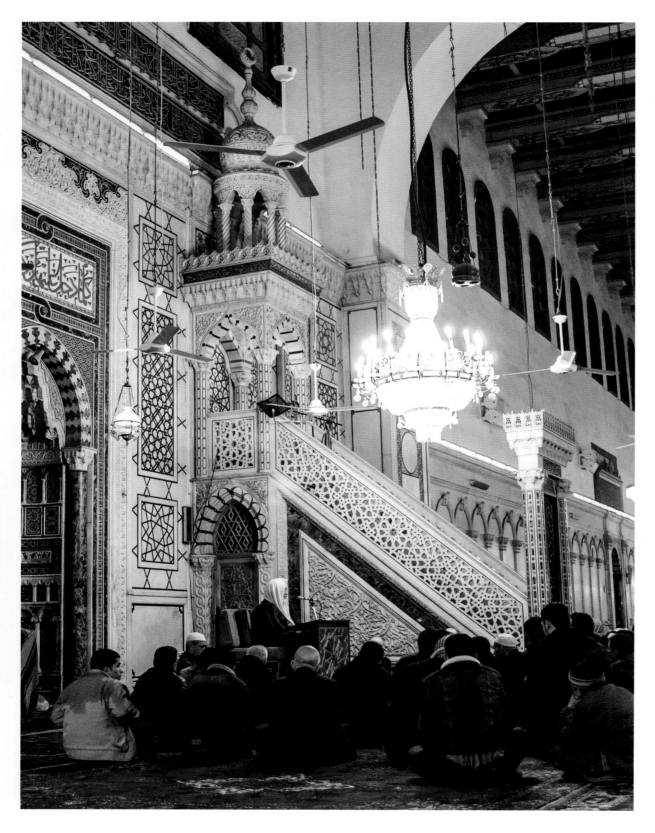

The principal mihrab, which indicates the direction of Mecca, and minbar, which serves as the preacher's pulpit, are centrally located along the southern wall of the prayer hall. They are both intricately designed and their decorative masonry shows extraordinary craftsmanship.

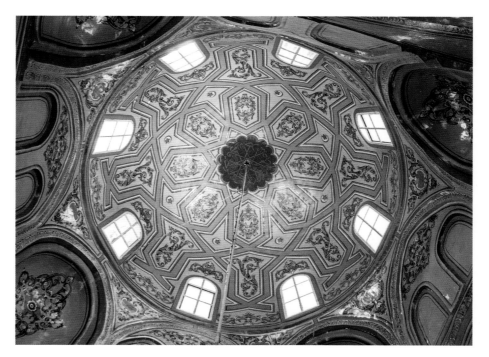

At the eastern end of the courtyard is a domed chamber containing a shrine dedicated to Hussein, grandson of Mohammed. After Hussein died in the historic Battle of Karbala (Iraq), his head was brought to Damascus along with the women and children taken captive. Tradition holds that the head was kept in this chamber by Umayyad Caliph Yazid I, who sought to ridicule Hussein and other followers of his father, Ali. Over the centuries, this shrine became an important site of pilgrimage for Shiite Muslims.

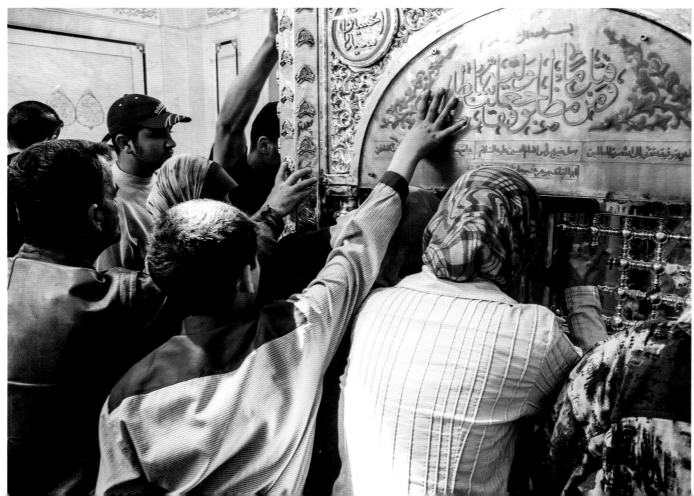

The Umayyad Mosque is a popular destination for both local families and visitors from throughout the region, making it an ideal location to people watch. These images from the mosque's environs provide a glimpse of the more traditional and conservative segment of Syrian society, though they are not representative of Damascus's much more diverse population.

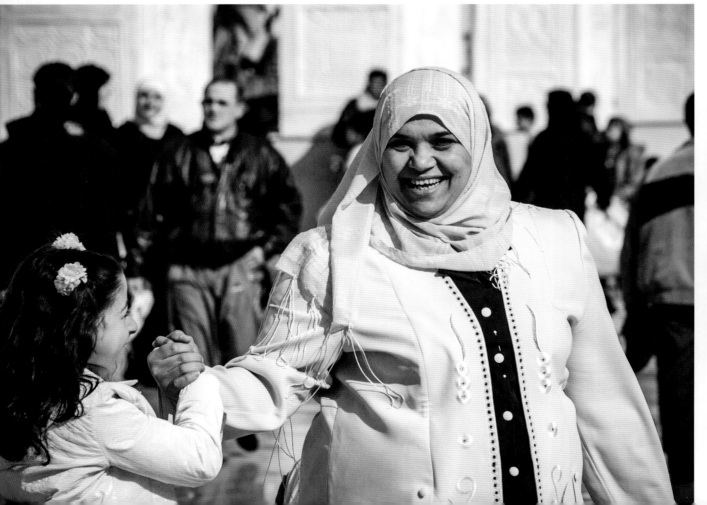

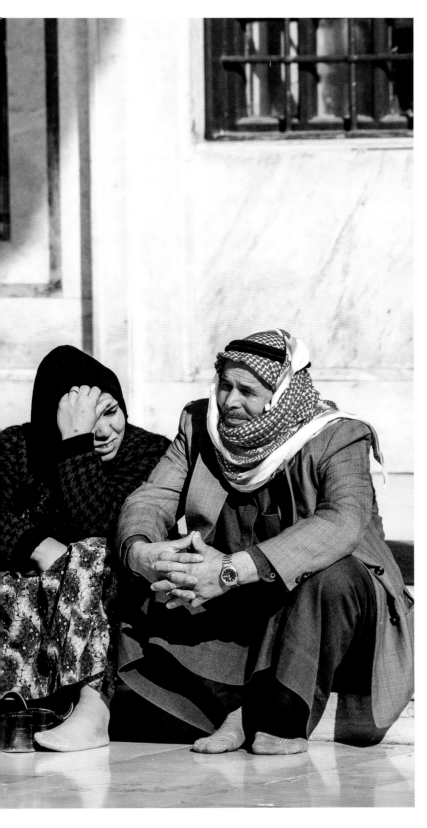

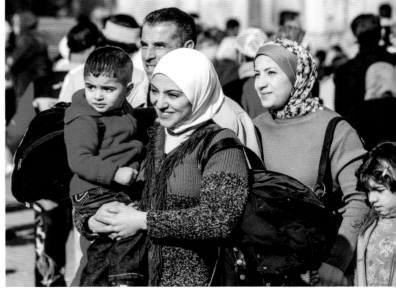
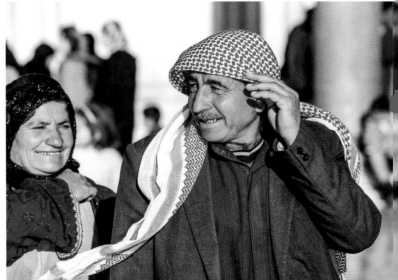

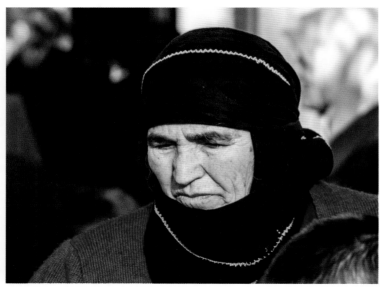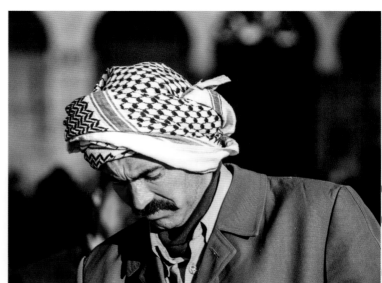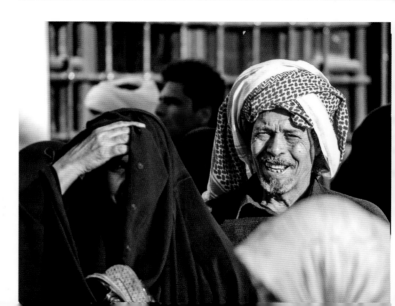

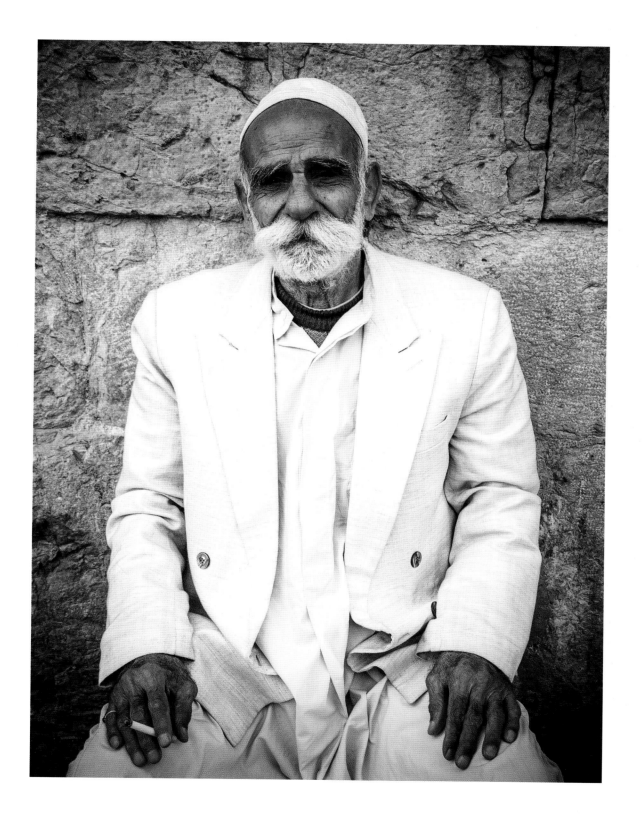

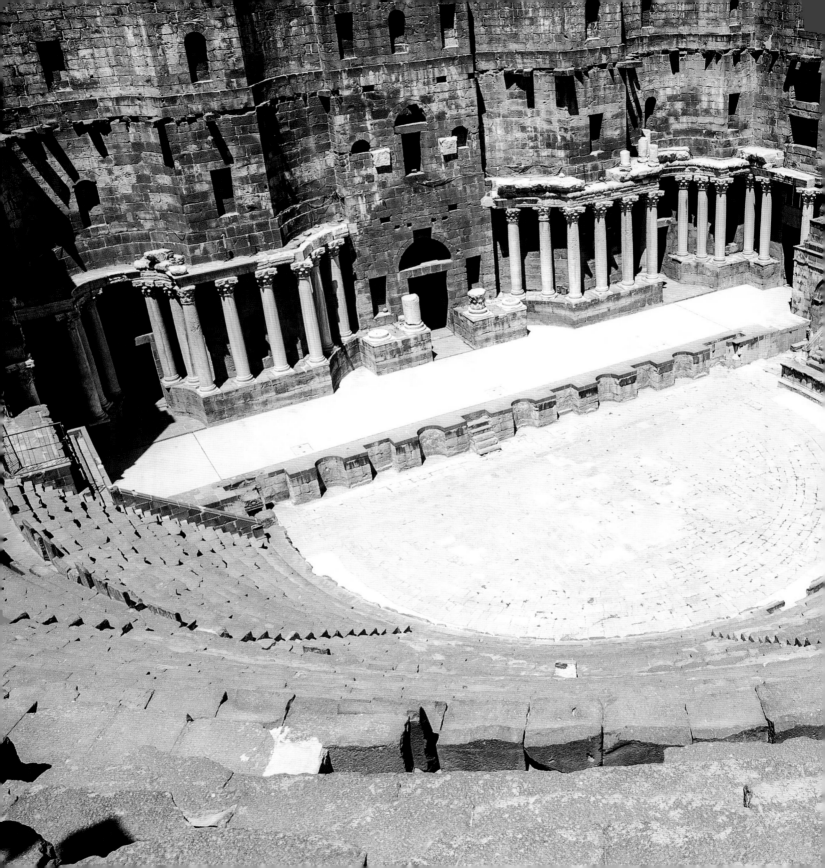

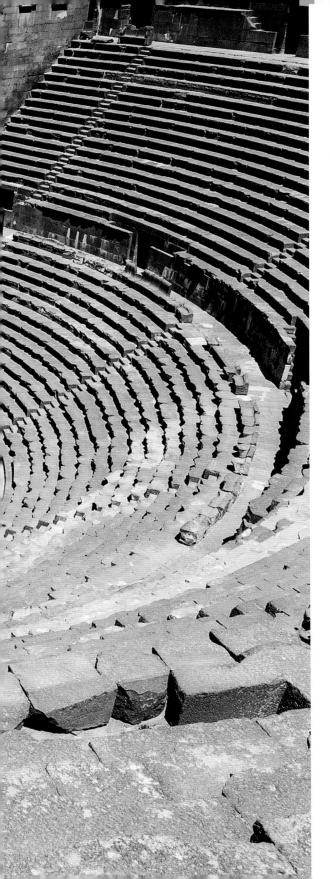

The south of Syria, including the countryside around Damascus and the three southern provinces of al-Suweida, Daraa, and al-Quneitra, features a rich diversity of demographics, cultural heritage, and landscapes. The area is home to most members of Syria's Druze religious minority. Many of the country's most important Christian monasteries, churches, and shrines are found in the region, with an ancient, Aramaic-speaking Christian population inhabiting a small number of remote mountain villages. Notable tombs and historic religious monuments from the earliest periods of Islam are also found in this part of the country. Southern Syria's archaeological heritage is extensive and varied, ranging from Neolithic settlements to complete Roman and Byzantine cities. Its geography consists of rocky mountains, broad agricultural plains, and barren volcanic wilderness.

In a suburb southeast of Damascus, the mosque of al-Seida Zeinab marks the burial place of Zeinab, the granddaughter of Mohammed and daughter of his son-in-law, Ali ibn Abi Talib. It is an important place of pilgrimage for Shiite Muslims, who venerate the prophet's family line. Built in 1990, the modern mosque has architectural features similar to those found in major Shiite shrines of neighboring Iraq, including a gold-leafed dome and heavy use of beautiful blue ceramic tile. Further from Damascus, the charming mountain resorts of al-Zabadani and Bludan were long popular with the city's residents, providing an escape from its sweltering summer heat. This mountainous region, the Qalamoun, is also home to several ancient Christian communities, including small populations that still speak a dialect of Aramaic, an ancient Semitic language with a written history of over 3,000 years. I enjoyed exploring the region's attractive churches and monasteries, many of which date back to the Byzantine period, with some converted from even earlier Roman temples. The picturesque town of Maalula, and the fortress-like monastery overlooking Seidnaya, were particularly memorable, as was the friendly and welcoming monastic community of Deir Mar Musa.

The landscape southeast of Damascus and in the two southern provinces of al-Suweida and Daraa is characterized by the black basaltic stone found throughout the area, deposited long ago by now-extinct volcanoes. This is part of a larger geographic region known as the Hauran, extending into the northern

الجنوب

The South

provinces of neighboring Jordan. Nowhere is this landscape more dramatic than the breathtaking site of Jebel Seis, where an Umayyad fort was built at the foot of an extinct volcano. The same black basalt was also used to build many ancient Roman and Byzantine towns and cities throughout the southern provinces, and continues to be a valued construction material today.

Several dozen Roman and Byzantine archaeological sites can be found in the province of al-Suweida. The remarkably complete Roman city of Shahba was fascinating to explore, as the town's inhabitants had adapted its ancient buildings and city planning for modern use. Not far away, the village of Qanawat is rich in Roman and Byzantine antiquities, including a small theater, fountain, temple, cisterns, tombs, and highlighted by a well-preserved basilica complex. Intriguing Roman and Byzantine remains can also be found at Shaqqa, Atil, Salim, al-Mushanaf, and Sia. The town of Salkhad features an imposing Ayyubid-era fortress and a distinctive hexagonal minaret, while al-Qaraya is the hometown of Sultan al-Atrash, who was a leading figure in Syria's struggle for independence during the French Mandate period. I learned a lot about the region's long history from my visit to the museum in the friendly provincial capital, itself named al-Suweida.

Most residents of this province are members of the Druze sect, which originated as an offshoot of Ismailism. The faith was founded by Hamza ibn Ali ibn Ahmad, a scholar and mystic who preached in Cairo in the early 11th century. He initially found support from the ruling Fatimid caliph, al-Hakim, but the Druze were heavily persecuted under his son and successor, Ali al-Zahir, who judged them a threat to his rule. Many adherents of the faith fled Egypt to Syria, Lebanon, and Palestine at that time, and the sect became very secretive, no longer admitting new members. Druze migrants, mainly from Lebanon, settled the province of al-Suweida in the 19th century. The Druze also have a sizable community in the Damascus suburb of Jaramana and in the Israeli-occupied Golan Heights. While this ancient community is now well-integrated into the wider Syrian culture, many of their religious traditions remain closely guarded. When I met a Druze elder in the village of Shaqqa, I learned about the sect's belief in reincarnation, one of several tenets that separate their faith from mainstream Islamic traditions.

To the west, the province of Daraa is largely agricultural, with its towns and villages scattered across a vast plain of cultivated fields. The province is socially conservative and predominantly Sunni Muslim, with some small Christian communities on its eastern edges. It, too, features a wealth of Roman, Byzantine, and early Islamic sites. The provincial capital of Daraa features fragmentary remains of an ancient Roman city, the stones of which were recycled to construct its earliest mosque. The town of Izraa hosts what is believed to be the oldest church in Syria that still performs religious services, dated by inscription to 515 CE. Many of the province's other towns and villages, such as Nawa and al-Sanamein, have archaeological remains dating from the Roman and Byzantine periods, as the region was an important agricultural center even in those times.

The highlight of the Daraa province is the magnificent ancient city of Bosra, named a UNESCO World Heritage Site in 1980. The site had already been inhabited since the early Bronze Age, when the Nabataeans made it their capital in 70 CE. Nabataean rule was short-lived, as the Romans captured Bosra in 106 CE and made it the capital of their Provincia Arabia. Bosra saw significant growth during the Roman era, when many of its notable monuments, including its enormous amphitheater, were built. In 634, it became the first Byzantine city to fall to Arab Muslim forces. Several mosques and religious schools were built in the centuries that followed, and during the Ayyubid period, the amphitheater was enclosed within imposing fortifications. The city's population dwindled in the Ottoman era, which saved most of its remains from modern development. Exploring the ancient city was fascinating, as so many of Syria's historical periods were represented. The Nabataeans, Romans, Byzantines, Umayyads, Fatimids, Ayyubids, and Mamluks all left their mark on the city's architecture, leaving behind colonnaded streets, defensive walls and gates, cisterns, palaces, public baths, churches, mosques, and madrasas. When I visited Bosra's massive Roman amphitheater, I found it remarkably well preserved, and the acoustics still nearly perfect!

While the province of al-Suweida has remained relatively stable throughout Syria's ongoing conflict, the other regions covered in this chapter have been less fortunate. Daraa was a focal point of antigovernment demonstrations, and numerous battles have been waged in and around the city. Significant damage has been inflicted on its historic mosque and neighboring archaeological remains. The ancient city of Bosra has been impacted by the conflict, with reports of damage to several of its monuments. Fighting has also raged in the Qalamoun Mountains, resulting in widespread destruction of the town of al-Zabadani. The towns of Maalula and Yabrud have witnessed clashes as well, with some churches desecrated by extremist militants. The mosque of al-Seida Zeinab has been a frequent target of bombing attempts.

Not covered in this book is the southwestern province of al-Quneitra, much of which has remained under Israeli occupation since 1967.

al-Seida Zeinab السيدة زينب

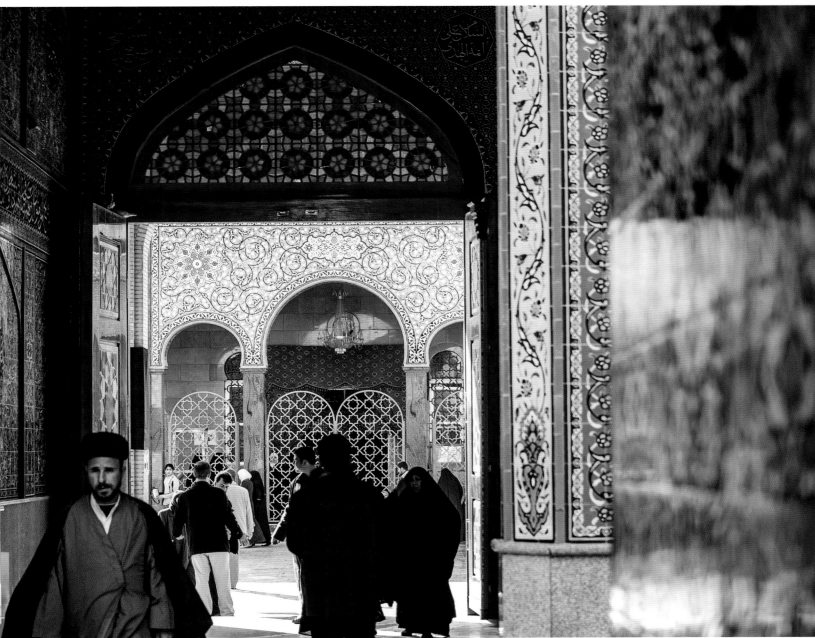

The mosque of al-Seida Zeinab is the most important pilgrimage site in Syria for Shiite Muslims. It houses the tomb of Zeinab, the daughter of Ali and granddaughter of Mohammad. The shrine attracts visitors from throughout the Middle East, particularly from Iraq and Iran.

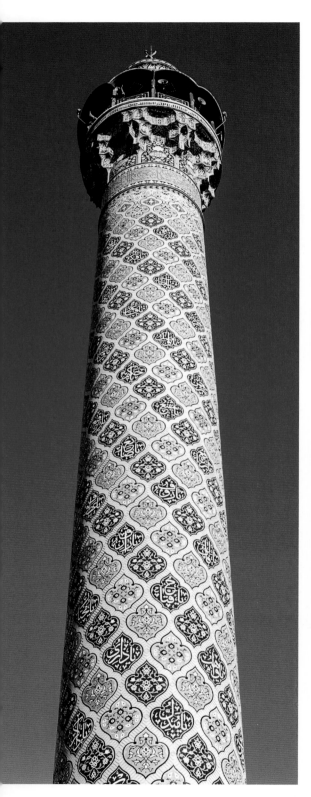

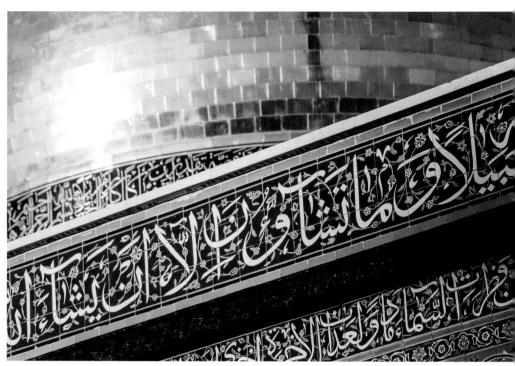

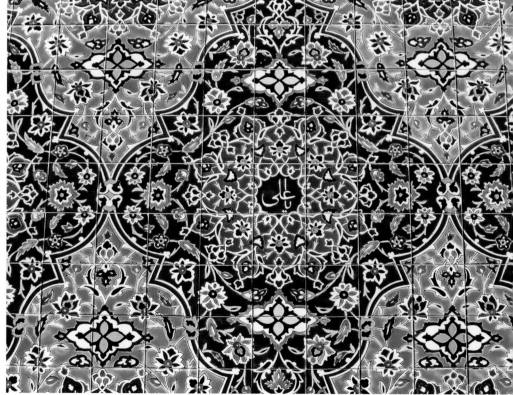

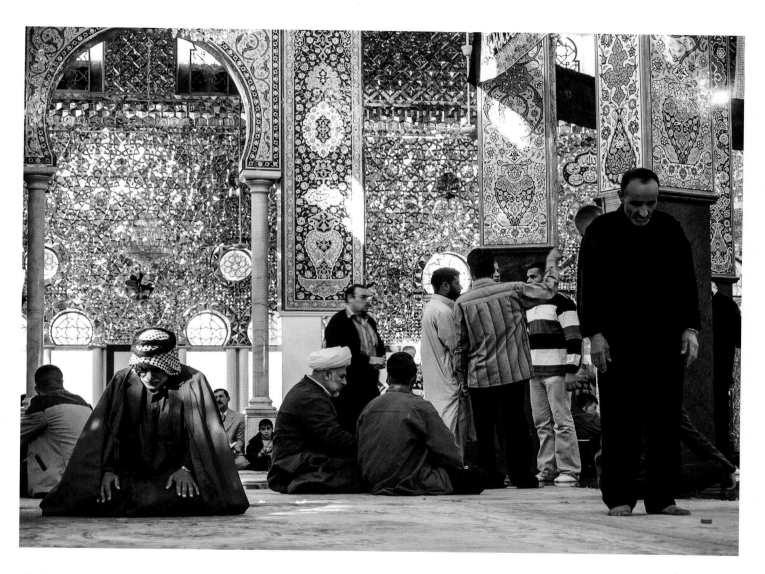

The interior of the mosque is elaborately decorated, featuring an abundance of mirrors and ceramic tile with geometric patterns and floral motifs and bands of Arabic calligraphy

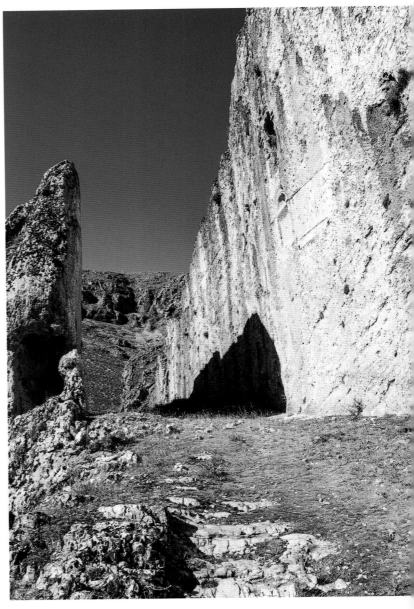

In the Qalamoun Mountains west of Damascus, towards Lebanon, is the village of Souq Wadi Barada. Here, overlooking the Barada River, the ancient road that linked Baalbek to Damascus during the Roman period was cut from the solid rock. Several inscriptions and tombs can also be found carved into the surrounding cliffs.

al-Zabadani

الزبداني

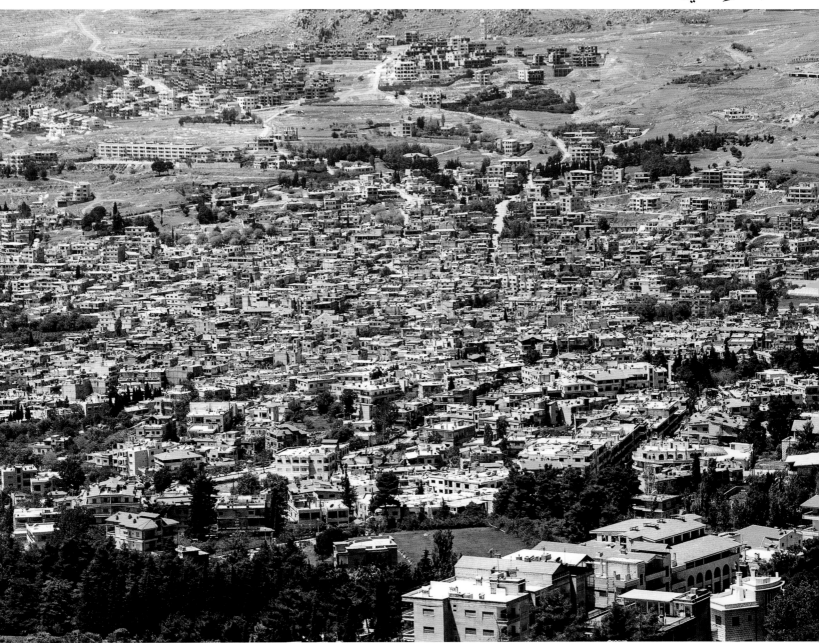

The town of al-Zabadani, located near the Lebanese border and the Barada River, had long been a popular mountain resort for the residents of Damascus. During the summer, it was often crowded with holidaying Syrians attracted to its cool weather. Regrettably, the town suffered much destruction during the early years of Syria's conflict.

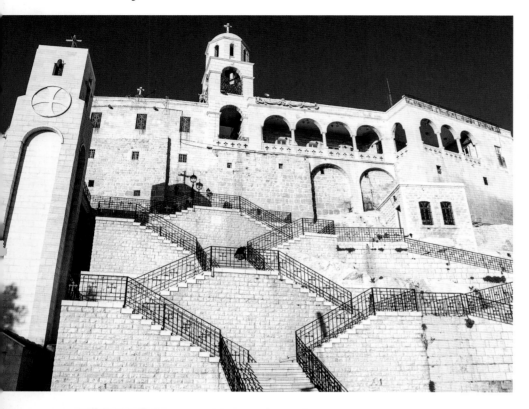

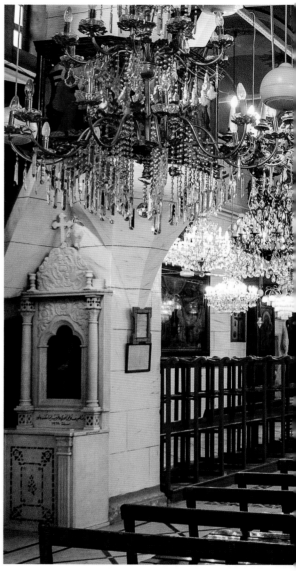

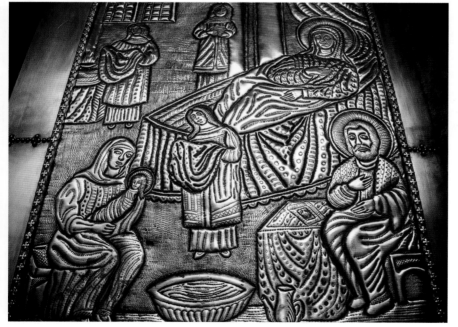

According to local tradition, the Greek Orthodox monastery overlooking the small Christian town of Seidnaya was originally founded by Byzantine Emperor Justinian in the sixth century CE. It was an important place of pilgrimage during the Crusader period and remains so today, attracting Christian and Muslim visitors from throughout Syria.

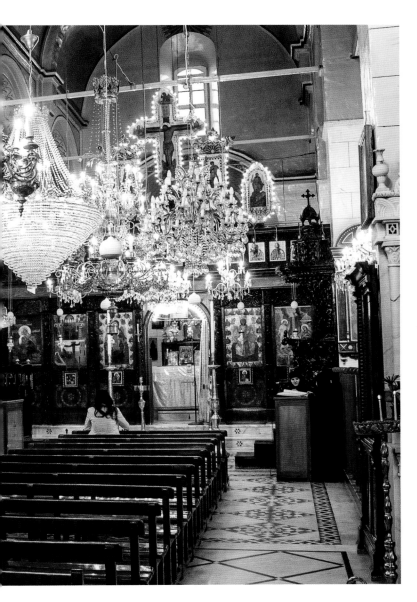

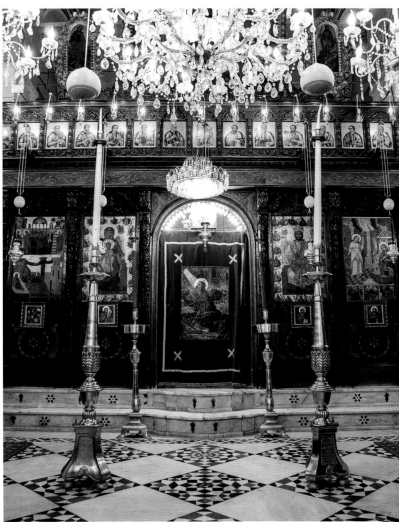

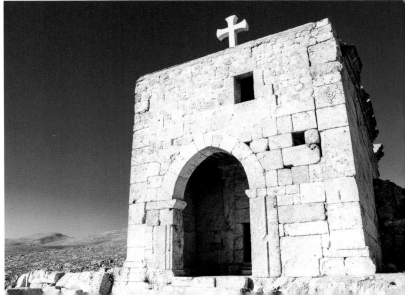

The small chapel of Deir Mar Touma, a short hike uphill from Seidnaya, was established over the remains of an earlier Roman temple. The building almost fully retains its original design, with the later addition of an apse on the eastern side.

Maalula

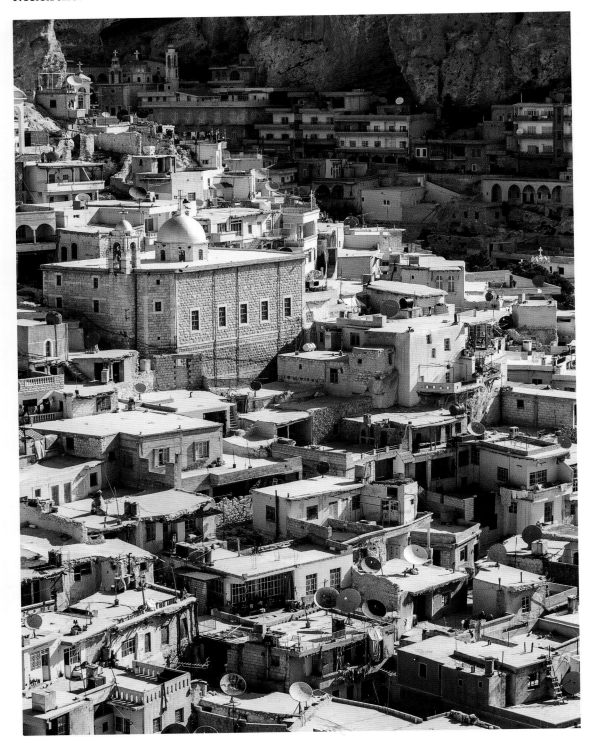

The small town of Maalula is one of the most picturesque in Syria, nestled on the slopes of a rocky mountain canyon. It is home to one of the world's few remaining communities of Western Aramaic speakers. Inhabited since at least the Roman period, Maalula has a rich heritage and several interesting churches and monasteries to visit.

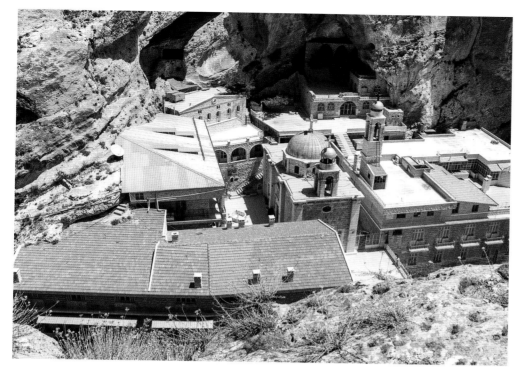

Maalula's Deir Mar Taqla, a Greek Orthodox nunnery, is dedicated to St. Thecla, locally believed to have been a disciple of St. Paul the Apostle and promoter of his teachings to women. According to local tradition, her burial place is in a cave chapel overlooking the monastery.

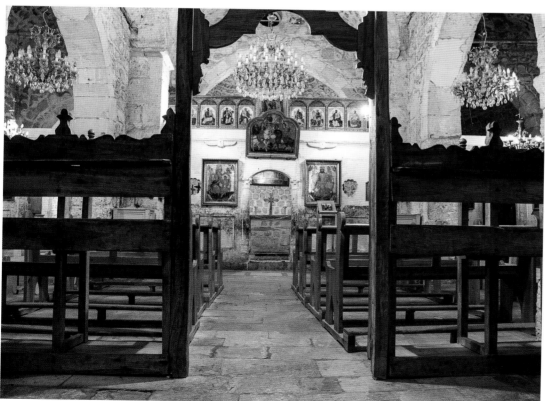

Overlooking the town of Maalula is Deir Mar Sarkis, a Greek Catholic monastery that was constructed over the remains of an earlier pagan temple from the Roman period. Dedicated to St. Sergius, the monastery's church was built during the Byzantine period in the fifth or sixth century CE.

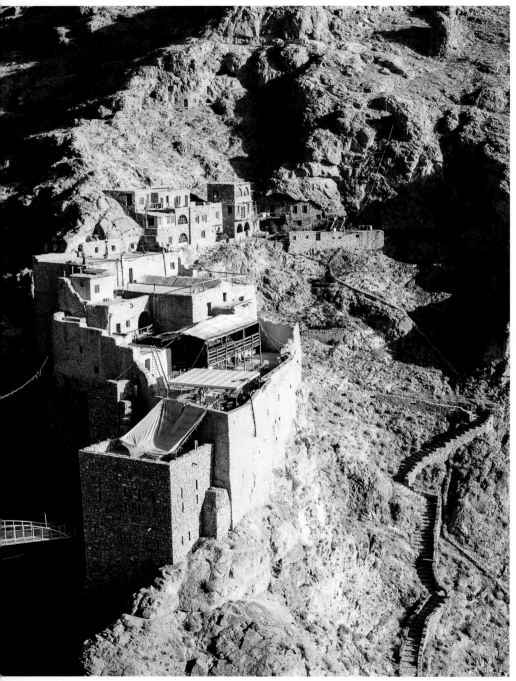

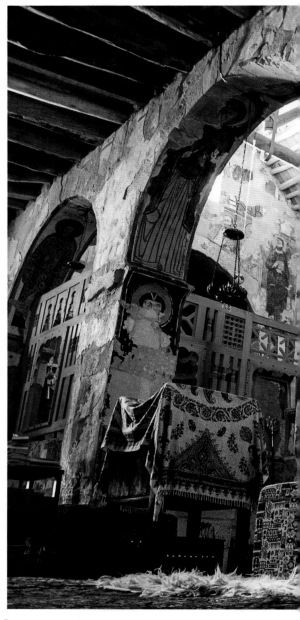

Deir Mar Musa al-Habashi is a remarkable sixth century CE monastery concealed within the rocky mountains east of al-Nabk. In recent decades, Jesuit priest Paolo Dall'Oglio lovingly oversaw its restoration and its emergence as a vibrant community of interfaith dialogue that welcomed vistors and sojourners of all religious faiths.

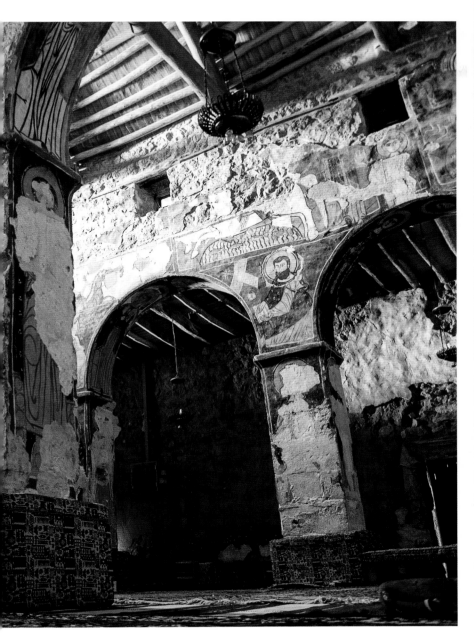

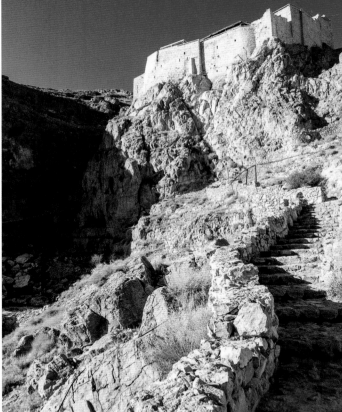

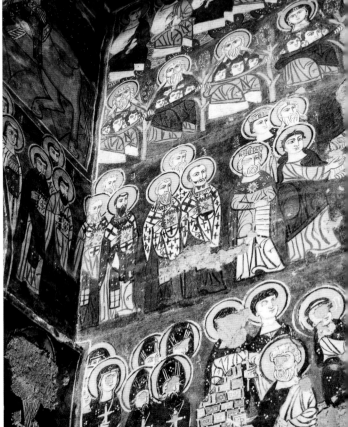

I found that the interior of Deir Mar Musa al-Habashi's otherwise modest church featured rich frescoes dating back to the 11th and 12th centuries. These had been carefully restored over many years by a joint team of Syrian and Italian experts.

Jebel Seis

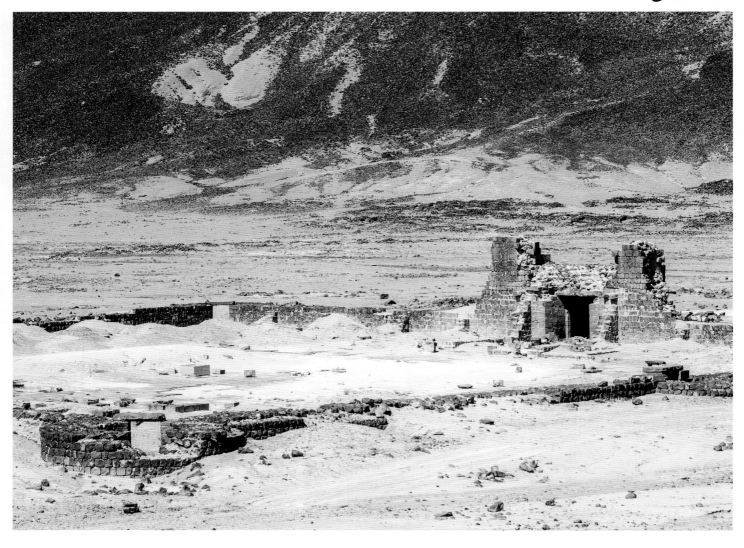

One of the most remote sites in Syria is the early eighth century Umayyad fortress located at the base of the extinct volcano of Jebel Seis. While the archaeological remains are fascinating to explore, it is the stunning landscape, stark and desolate, that leaves a lasting impression.

Shaqqa

Shaqqa, a large village in the province of al-Suweida, was an important settlement in the Roman and Byzantine periods. Extensive remains include a palace, basilica, monastery and several other structures, some of which have been adapted for modern use by local residents. One such building is used as a meeting place for the Druze community.

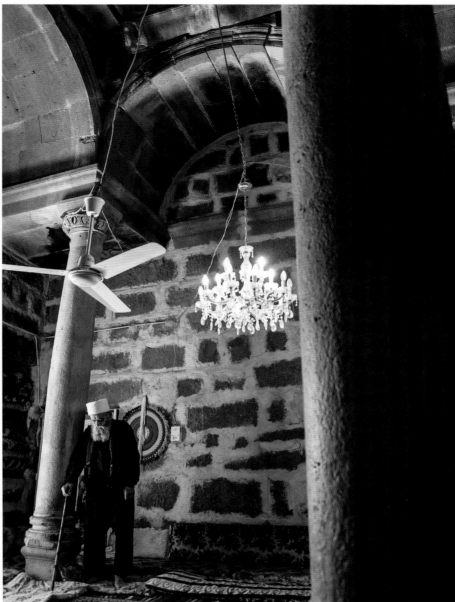

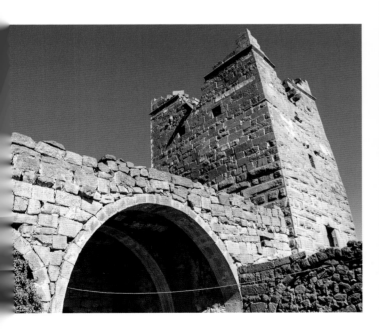

Shahba

 شهبا

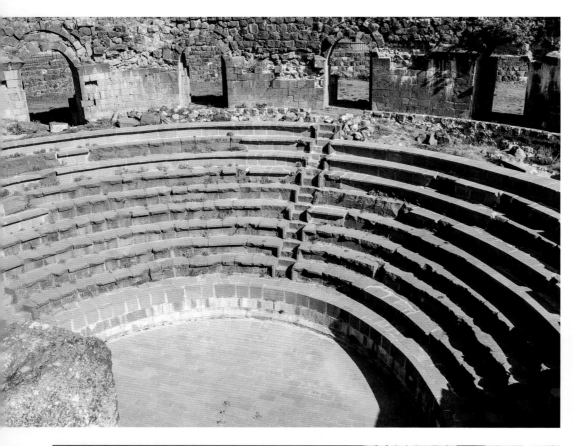

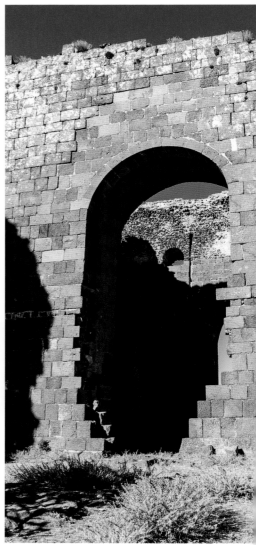

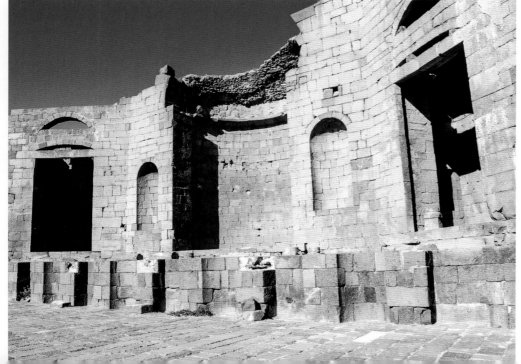

The residents of Shahba inhabit an almost complete Roman-era city in the southern province of al-Suweida. It was constructed under Philip the Arab, a Syrian native who became the Roman emperor between 244 and 249 CE. I found that the city's theater, temple, forum, exedra, baths, and defensive walls were all well preserved.

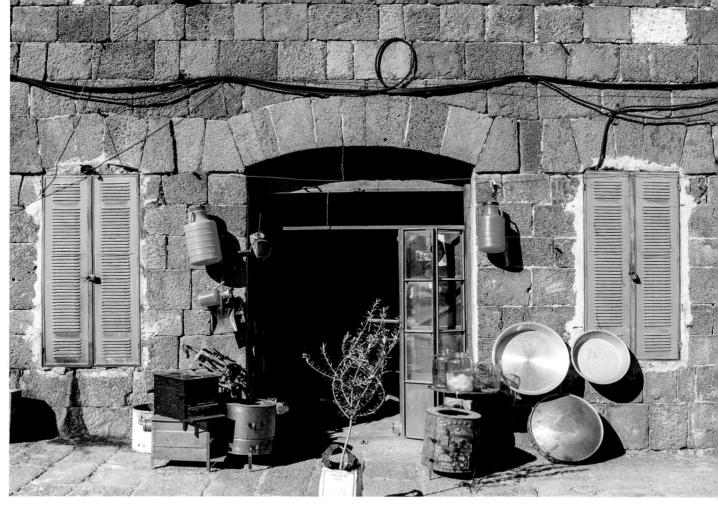

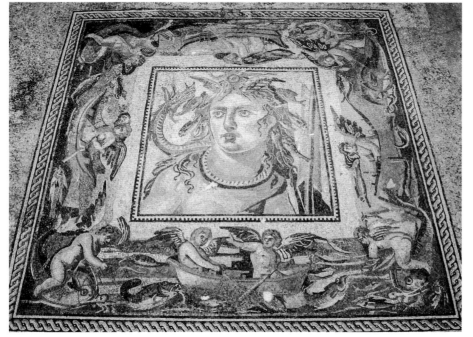

Many of Shahba's Roman era commercial and residential buildings have been adapted for modern use. A small museum in the town houses several phenomenal mosaics discovered at the site.

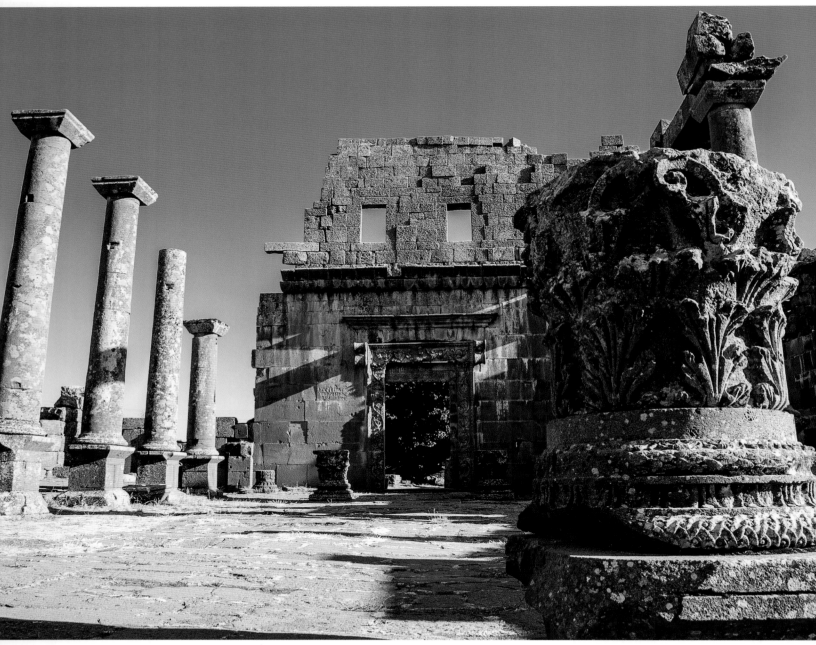

The village of Qanawat features extensive remains from both the Roman and Byzantine periods, including a theater, fountain, public bath, tombs, and a large church complex that was adapted from an earlier Roman temple. The settlement flourished during the fourth and fifth centuries CE, and it became the seat of a bishop.

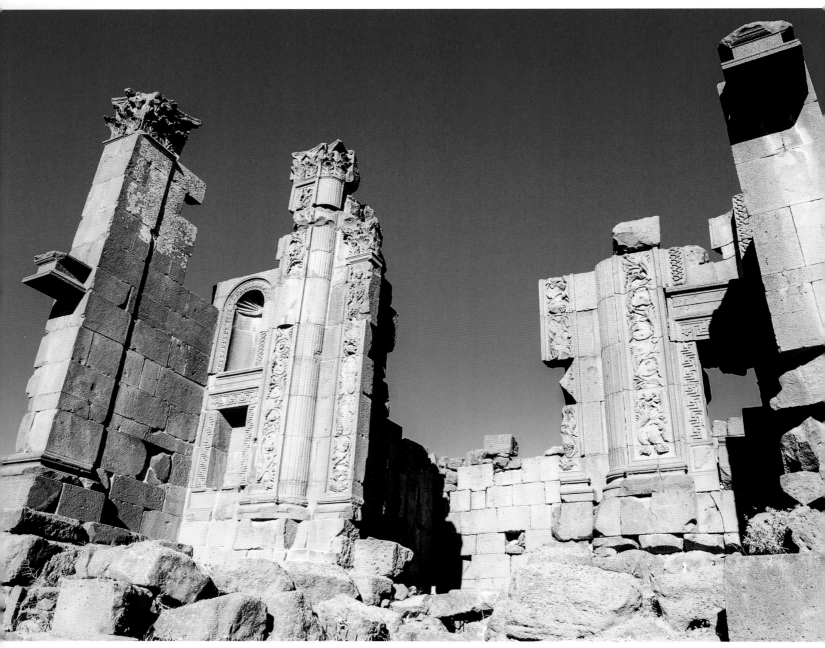

Two Roman temples, almost identical in design, can be found in the quiet village of Atil. They are both very well preserved, retaining beautifully decorated facades with fine detail. The southern temple was constructed in the second century CE, while the northern one dates to the early third century CE.

Salkhad

صلخد

A crumbling Ayyubid-era fortress, built inside the crater of an extinct volcano, overlooks the charming small town of Salkhad. The castle offers broad views extending to the Jordanian border and beyond. In the town itself, a rare hexagonal minaret dated to 1232 is all that survives of an Ayyubid mosque that once stood here.

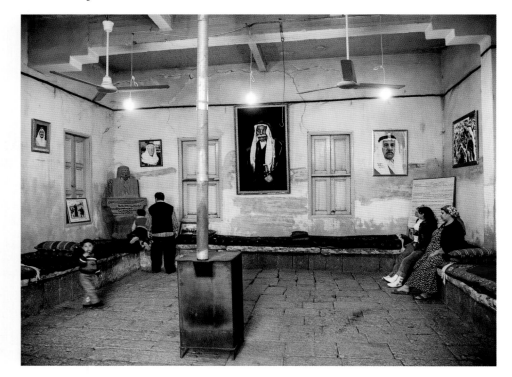

The small town of al-Qaraya is best known as the hometown of Sultan al-Atrash, a prominent leader of the Great Syrian Revolt of 1925-1927 and one of the most influential figures in the struggle for Syrian independence. His home remains preserved as a historic site, next to a memorial tomb built in his honor. Nearby is a beautiful tomb and shrine (bottom photo) dedicated to a local Druze religious figure.

Daraa

درعا

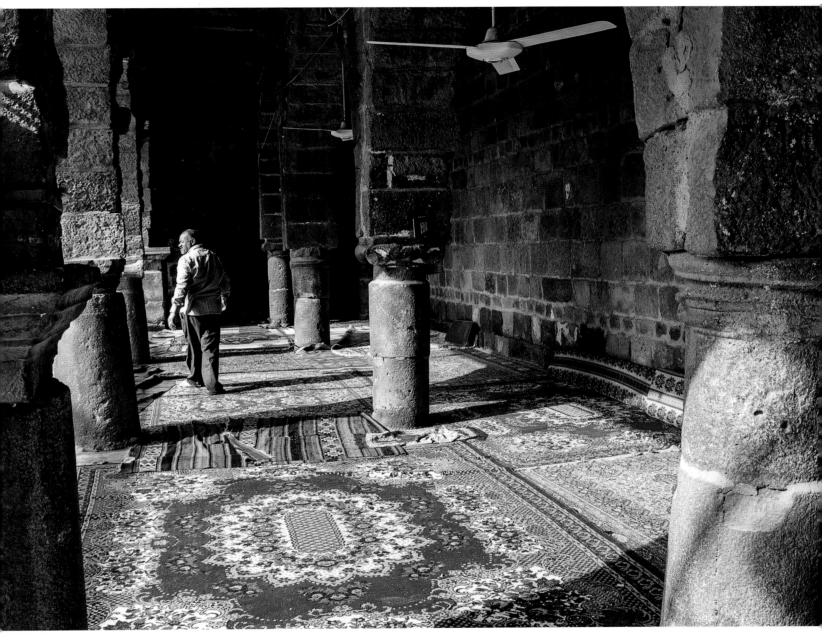

It has long been assumed that the mosque of Daraa's old city is one of the earliest in the Muslim world. Much of the masonry used to build it was salvaged from an earlier Roman settlement, and the remains of a Roman theater, temple, and colonnaded street are all found nearby. The mosque and surrounding neighborhood suffered significant damage during the early years of the Syrian conflict.

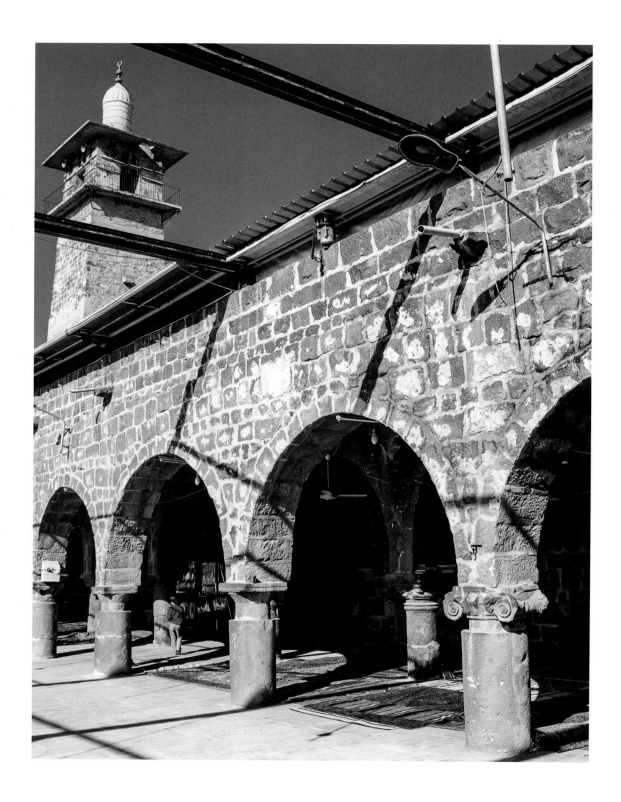

Tel Shahab

Northwest of Daraa, on the Jordanian border, is the modest village of Tel Shahab. The village has origins dating back to the Bronze Age, and many of its surviving structures date to the Ottoman period. The area's main attraction is its nearby waterfall, located in a fertile valley that is a popular picnic spot.

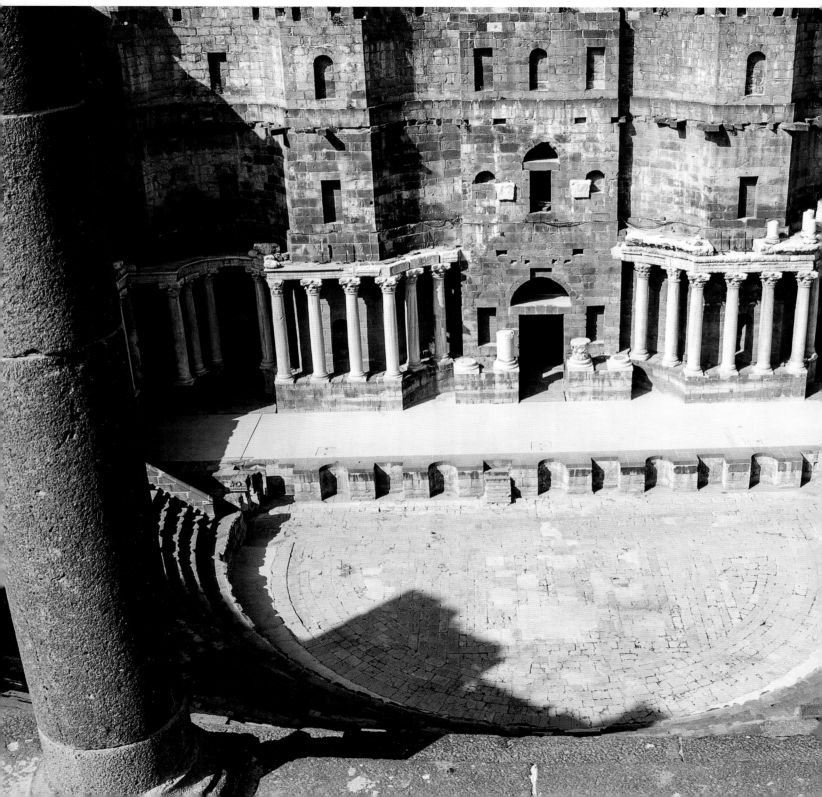

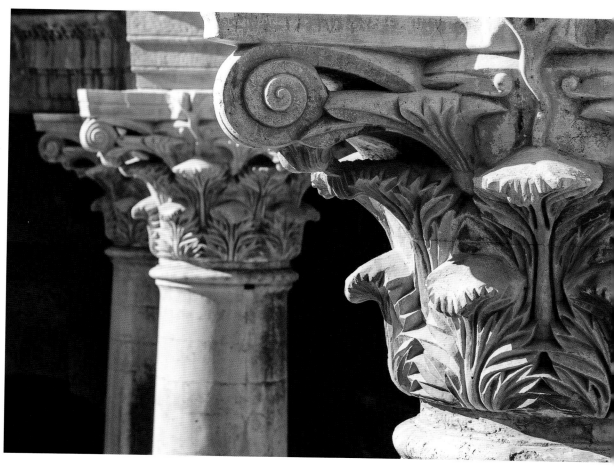

The ancient city of Bosra, a World Heritage Site, contains extensive remains from the Nabataean, Roman, Byzantine and early Islamic periods, capturing the richness of Syria's history as comprehensively as any other site in the country. Its enormous Roman theater built from black volcanic stone is one of the largest and best preserved in the Middle East.

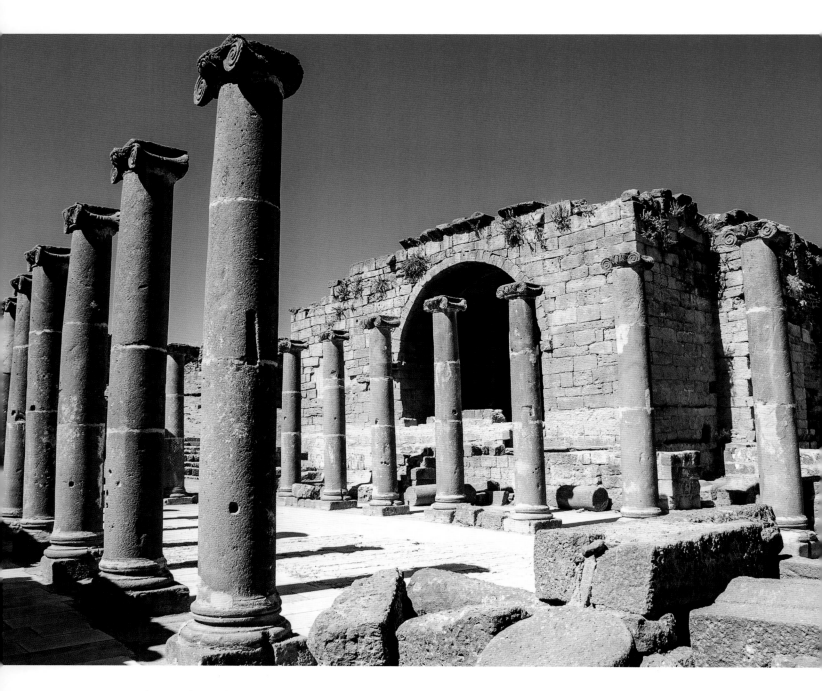

Bosra's massive southern baths were constructed during the Roman period and remained in use until at least the eighth century. To the north, the Mamluk-era Manjak baths were built in the 14th century to serve pilgrims traveling to Mecca.

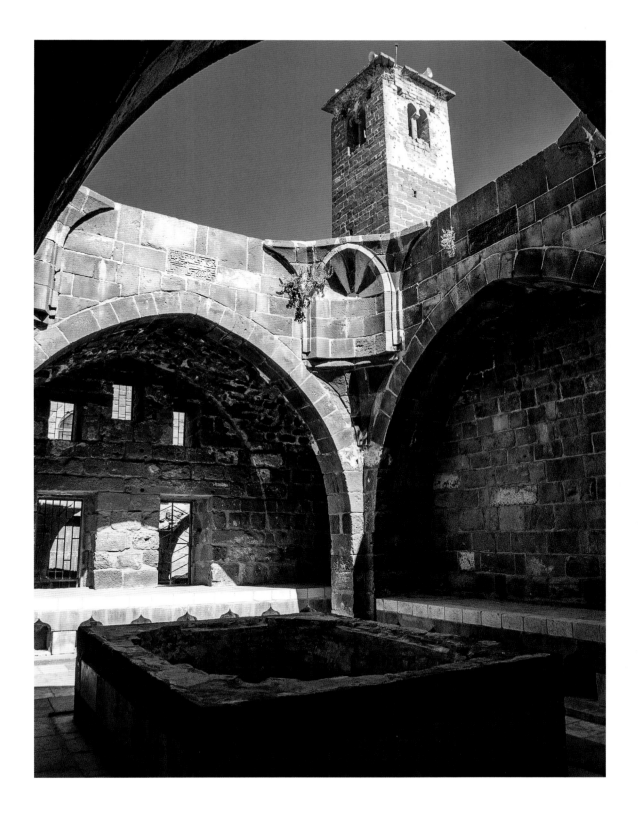

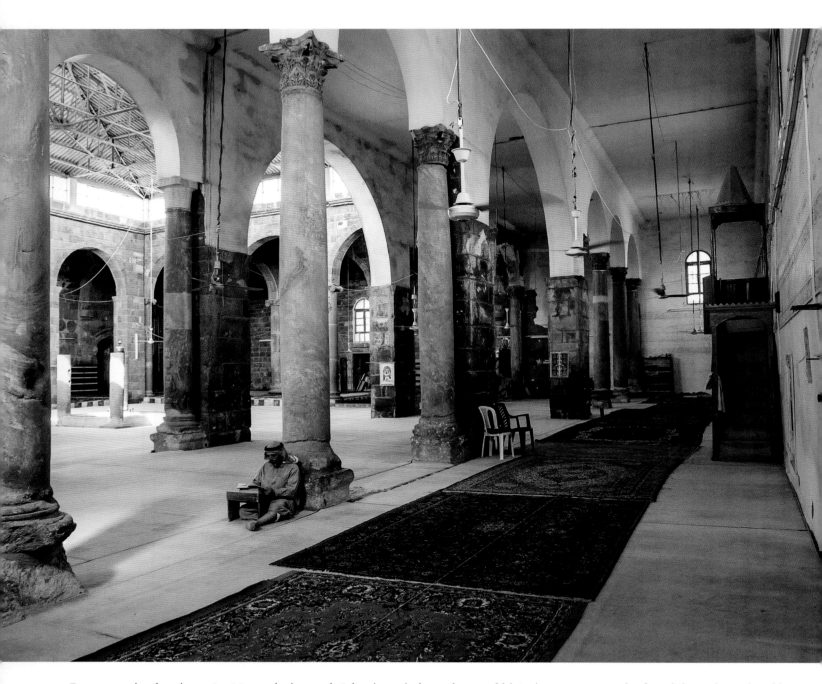

Bosra remained an important town during early Islamic periods, and several historic mosques can be found throughout the old city. The Mosque of Umar is the largest of these, constructed in the early eighth century incorporating many Roman architectural elements.

Izraa

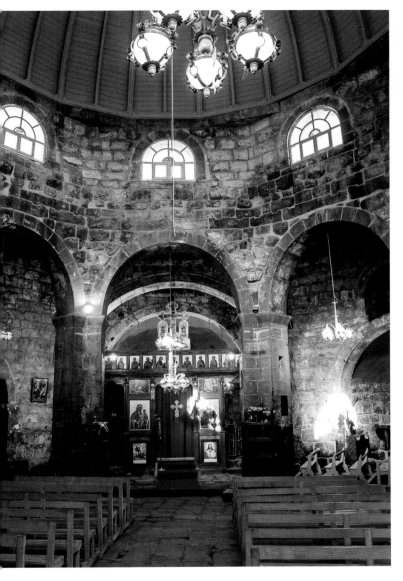

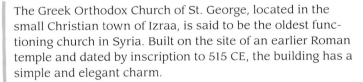

The Greek Orthodox Church of St. George, located in the small Christian town of Izraa, is said to be the oldest functioning church in Syria. Built on the site of an earlier Roman temple and dated by inscription to 515 CE, the building has a simple and elegant charm.

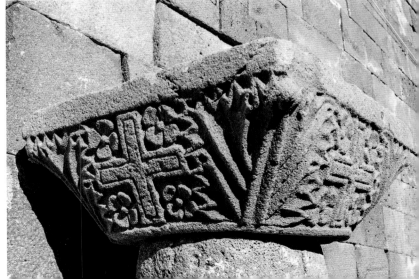

As the Orontes River flows north from Lebanon towards the al-Ghab Plain, it passes through Homs and Hama, Syria's third- and fourth-largest cities. The Orontes has been a source of prosperity for these two cities, and the surrounding countryside, for many thousands of years. Consequently, the region has been heavily contested throughout its long history, as rival armies fought for control over its fertile territory and the strategically important Homs Gap that separates the mountain ranges of Syria and Lebanon. Among the many important military engagements to take place here was the Battle of Qadesh, fought between Egyptian and Hittite forces in 1274 BCE. Many of Syria's most impressive fortifications survive in these two provinces, including massive castles constructed by Crusader, Ismaili, and Arab Muslim forces during the Seljuq, Ayyubid, and Mamluk periods. Based in their stronghold of Sheizar, the citadel of al-Madiq, and the cities of Homs and Hama, Arab Muslim forces maintained control over the eastern side of the plain. Located in the foothills of Syria's coastal mountain range, the Ismaili strongholds of Maysaf and Abu Qubeis, and the Crusader fortress of Mirza, controlled the western side of the plain. Further south, Krak des Chevaliers is Syria's most celebrated fortress, designated a UNESCO World Heritage Site in 2006. Overlooking the town of al-Hosn, it is widely considered to be the largest and best preserved Crusader castle in the world.

The region is rich in archaeological remains that date back even further, including several Roman and Byzantine sites. These are highlighted by the ancient city of Apamea, known for its enormous theater and its broad colonnaded street that extends nearly two kilometers in length. Apamea was one of the most important cities in the Roman province of Syria Palaestina, reaching the height of its prosperity in the second century CE and remaining a major population center through the Byzantine period. The well-preserved remains of a Byzantine church can be found in the hilltop village of Deir al-Salib, while the still-functioning monastery of Deir Mar Jerjes was originally constructed in the sixth century CE. To the east of the cities of Homs and Hama, beyond the river valley of the Orontes, the landscape transforms to semi-arid desert. The remains of Qasr Ibn Wardan, a remarkable church and palace complex, and al-Andarin, an extensive Byzantine-era

حمص و حماة

Homs & Hama

settlement, can be found here. These sites also served a military purpose, defending the frontiers of Byzantine territory from Persian incursions. Even further east, the remote desert village of Athriya hosts the cella of a Roman temple that dates to the second century CE. Other important archaeological sites in the region include the Bronze Age cities of Qatna, near the modern town of al-Mishrafeh, and Qadesh, near the village of Tel al-Nabi Mando.

Homs is an undoubtedly ancient city, but it did not become prominent until the Roman era, when it was known as Emesa. It flourished by establishing close ties with the prosperous ancient city of Palmyra. Emesa's most famous resident was Julia Domna, the wife of Roman emperor Septimius Severus. Homs remained an important city in the decades following the Arab Muslim conquest, settled by many of the companions of Mohammed. During the later Ayyubid, Mamluk, and Ottoman periods, it was often overshadowed by its northern neighbor, Hama. By the early 20th century, the population of Homs had dwindled to roughly 5,000 people. Today, it is Syria's third-largest city, its inhabitants a diverse mix of Sunni Muslims, Alawites, and Christians. Homs is one of Syria's more liberal cities, and hosts one of the country's largest universities.

Homs was often overlooked by foreign travelers who visited Syria, with Hama becoming the preferred tourist destination. While the old city of Homs long suffered from neglect, its rich cultural heritage could be revealed with a little patient exploration. Many of the city's charming historic residences had been restored, with some having been converted into restaurants and cafes. Several attractive mosques and churches were hidden throughout the old city, which was surrounded by the remains of ancient fortifications. The traditional market, or souq, had recently been restored at the time of my visit. The fighting that engulfed Homs beginning in 2012 inflicted significant damage on the old city. After clashes subsided in 2014, Syrian authorities made the restoration of this area a high priority.

Hama was first settled in the Neolithic era, and was later part of Amorite and Hittite kingdoms when it was known as Hamath. It remained inhabited through the Aramaean, Assyrian, Persian, Greek, Roman, and Byzantine periods. It reached its highest prominence under the Seljuq and Ayyubid dynasties. While its prosperity declined during the later Mamluk and Ottoman eras, it remained a major population center. Today, Hama is Syria's fourth-largest city. Its inhabitants are predominantly Sunni Muslim, though it also has a small Christian community. Hama is known for being more conservative than its southern neighbor, a reputation it has held since the French Mandate period. While its population is more religious than most, it was a very comfortable and welcoming city that made a convenient base for exploring the spectacular archaeological sites in the surrounding countryside.

Hama is known throughout the country for the parks, gardens, and huge, ancient waterwheels that line the banks of the Orontes River as it flows through the city. The Great Mosque, built during the Umayyad period on the site of an earlier Roman temple, is one of the city's several remarkable mosques. Its historic residential quarters feature beautiful traditional architecture, highlighted by the Ottoman-era Qasr al-Azem. Internationally, Hama may be best known for its central role in the conflict between the Syrian government and the Muslim Brotherhood, culminating in the 1982 bombardment of the city by government forces. This resulted in the widespread destruction of Hama's old city, only a small portion of which survives today. Many of the city's historic buildings were carefully restored, however, preserving some of Hama's architectural heritage. The city has largely avoided becoming caught up in the violent conflict that has swept through Syria since 2011.

The two provinces of Homs and Hama are marked by broad demographic diversity. Both regions, including their urban centers, are predominantly Sunni Muslim. However, several sizable communities of religious minorities are found throughout the provinces. West of Homs, the region of Wadi al-Nasara has been an important center of Christianity since the Byzantine period. There are several other Christian communities in the towns and villages south and east of Homs. Northwest of Hama, the towns of Mhardeh and al-Suqeilbiyeh are predominantly Christian. The two largest Ismaili towns in Syria are located in the Hama province, with Masyaf to the west and Salamiyeh to the east. There are numerous Alawite villages in both provinces, particularly in the countryside of Homs and on the western side of Hama's al-Ghab Plain. This diversity always made my journeys throughout the region intriguing, as I encountered a wide variety of cultural traditions and perspectives in my interactions with the friendly and hospitable people throughout these two provinces.

Homs

حمص

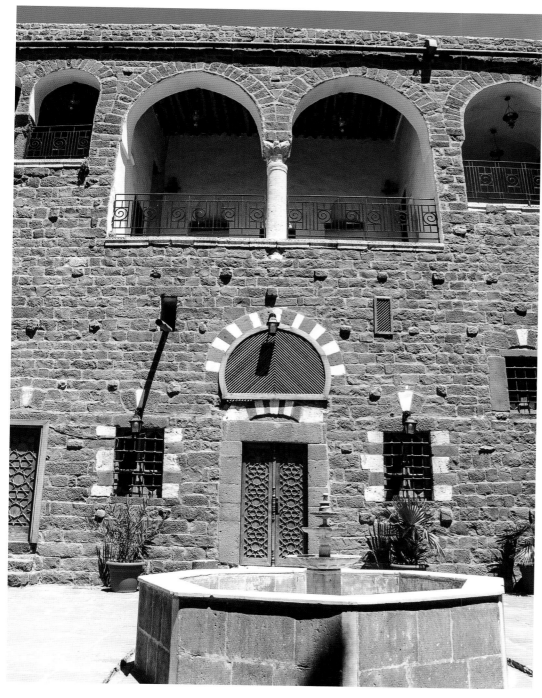

The old city of Homs is rich in attractive residential architecture, highlighted by Qasr al-Zahrawi. During my visits to Homs, this charming Ottoman-era home was being restored for public use. Further restoration has been undertaken more recently to repair damage inflicted by fighting in the city between 2012 and 2014.

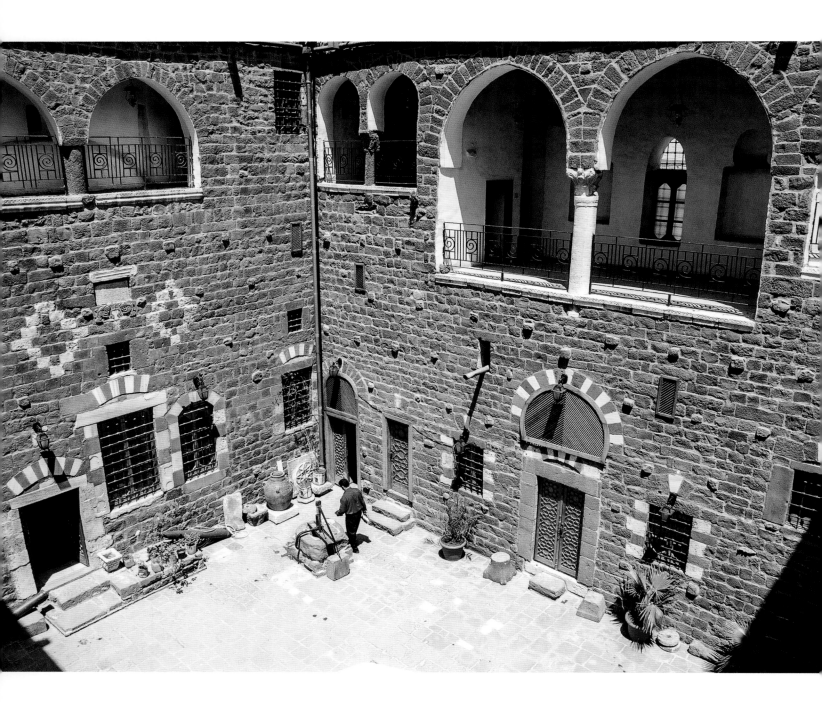

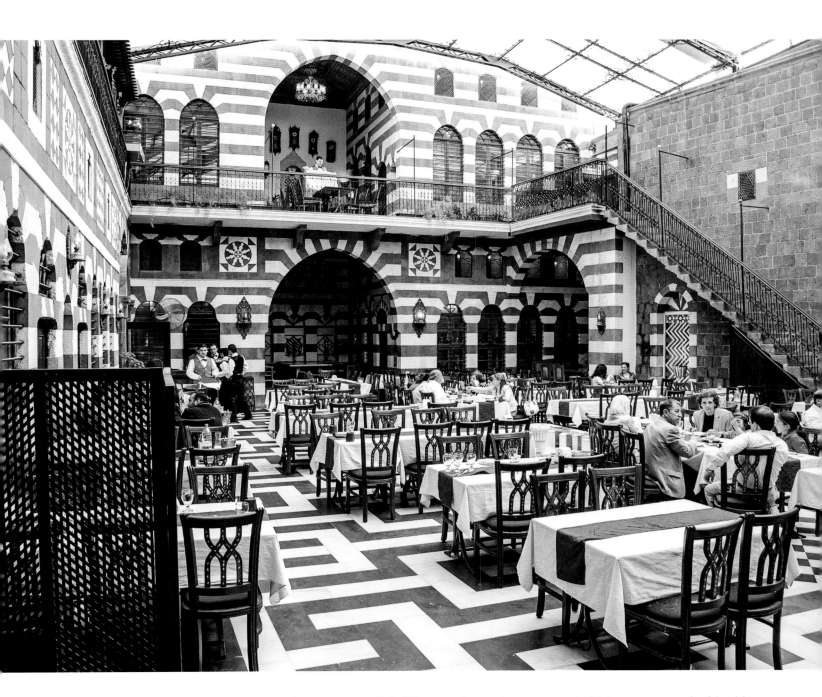

This stunning restaurant, Beit al-Agha, is one of several beautiful old homes that had been converted into restaurants in this old city neighborhood. It was built by combining two historic residences to create one large central courtyard. Unfortunately, it was badly damaged during fighting in the city.

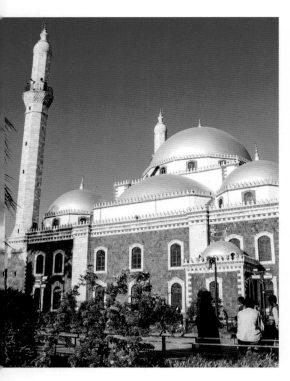

The Ottoman-era Khalid Ibn al-Walid Mosque is the best known monument in Homs. It houses the tomb of Khalid Ibn al-Walid, one of the companions of Mohammed and arguably the most important commander of early Muslim armies. The present mosque at the site was completed as recently as 1913, but the tomb inside it dates back to the 11th century.

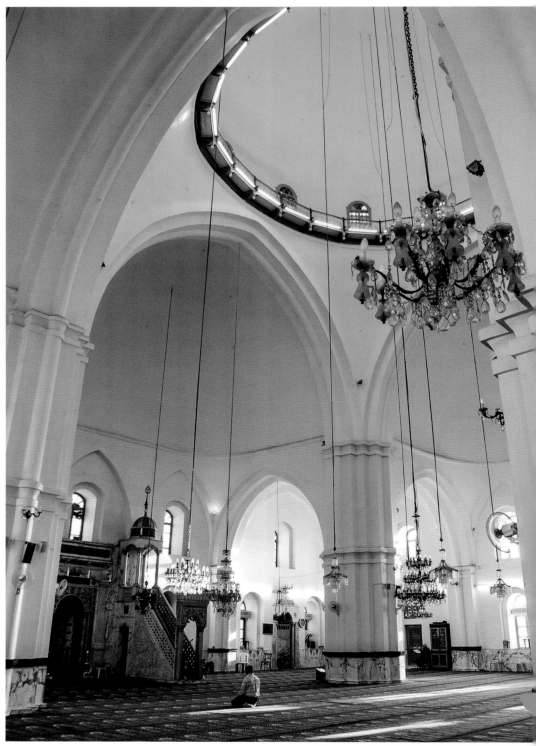

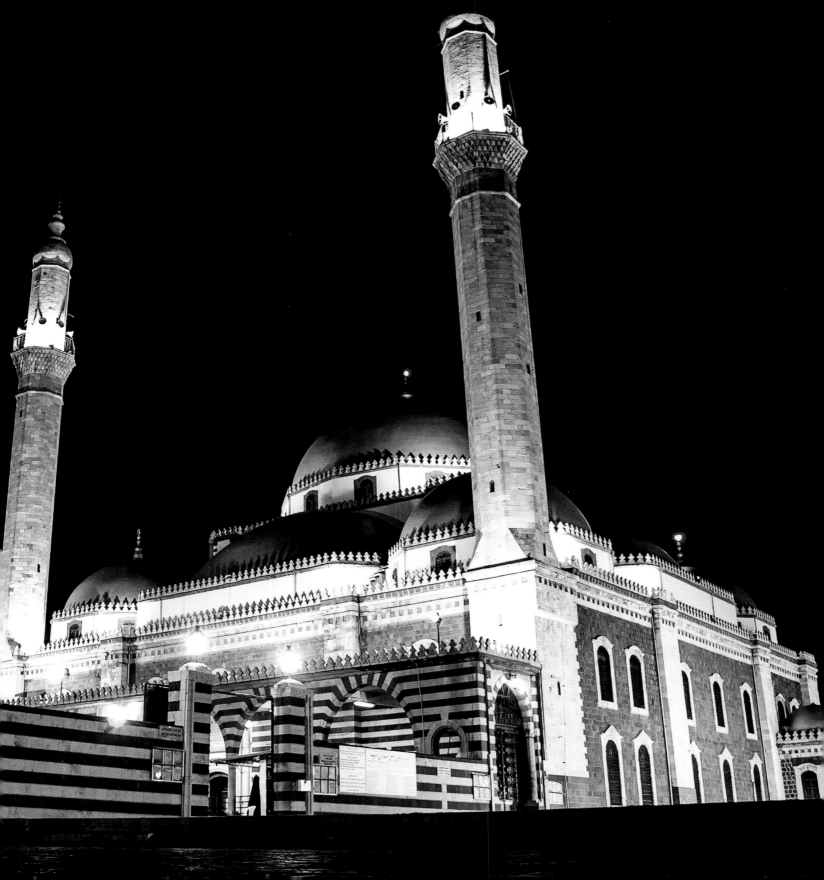

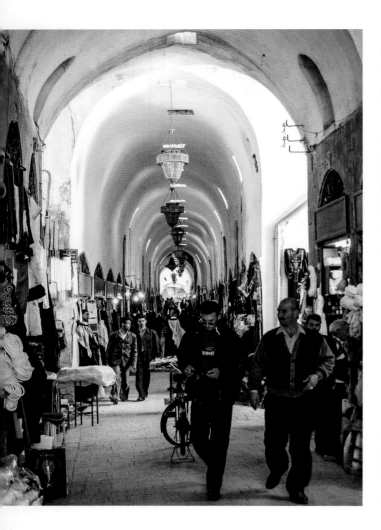

Homs also had an extensive traditional market, or souq, in the western district of the old city. It was heavily damaged during fighting between 2012 and 2014.

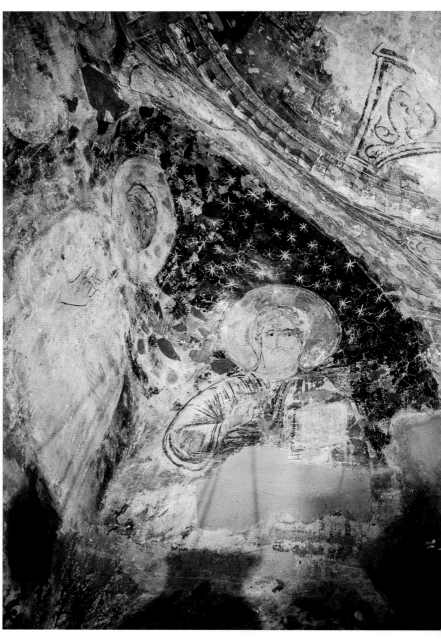

Homs has several historic churches that serve the predominantly Christian neighborhoods in the northeast quarter of the old city. The Roman Orthodox Church of St. Elian is the most interesting of these, noteworthy for its late 12th and early 13th century frescoes.

Deir Mar Jerjes

دير مار جرجس

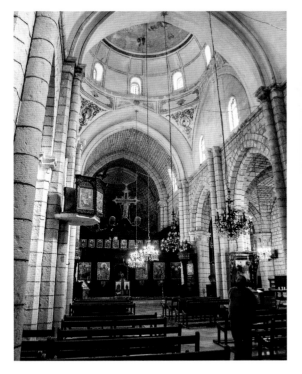

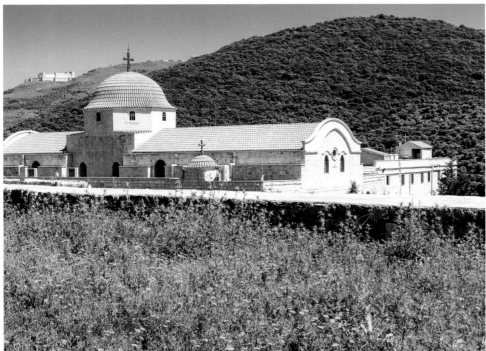

Wadi al-Nasara, or Valley of the Christians, is a region of several dozen Christian villages In the mountains west of Homs. The area has been a center for the Greek Orthodox Church since the Byzantine period. The beautiful Deir Mar Jerjes, or St. George's Monastery, was originally founded in the sixth century. It maintains an active monastic community that welcomes visitors to explore its 13th and 18th century churches.

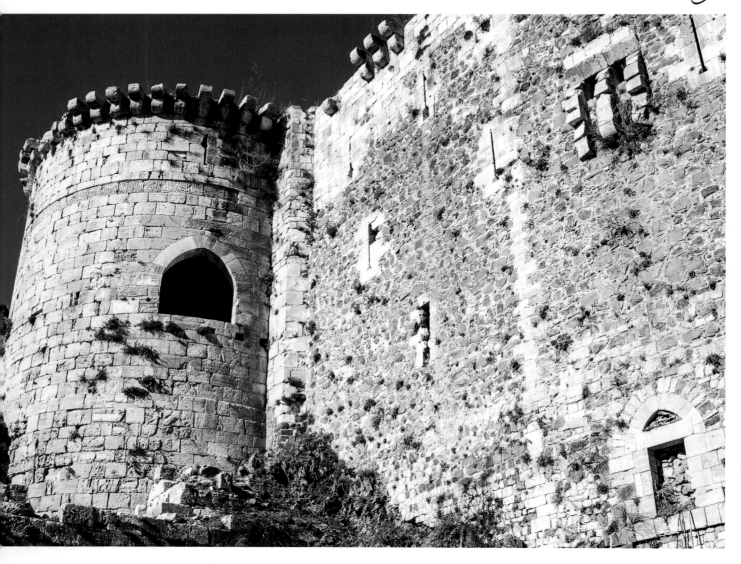

Most famously known as Krak des Chevaliers, al-Hosn Castle is the largest and the most impressive Crusader fortress in the world. First fortified by Kurds in the 11th century, the Knights Hospitaller took control of the site in the 12th century and constructed this spectacular castle. Its imposing defenses are without equal anywhere in the Levant, and survive in remarkably good condition.

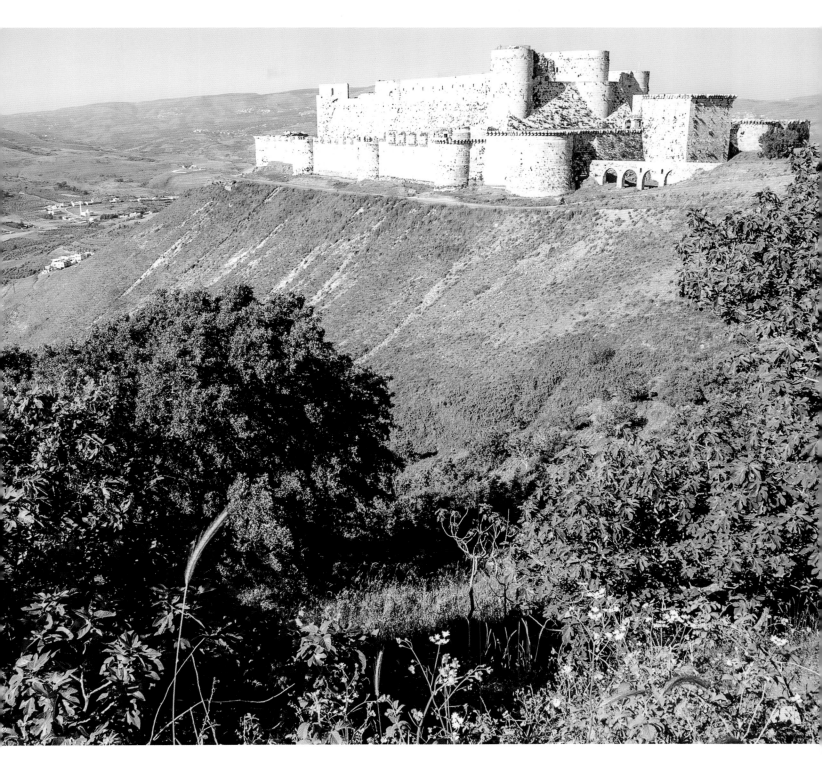

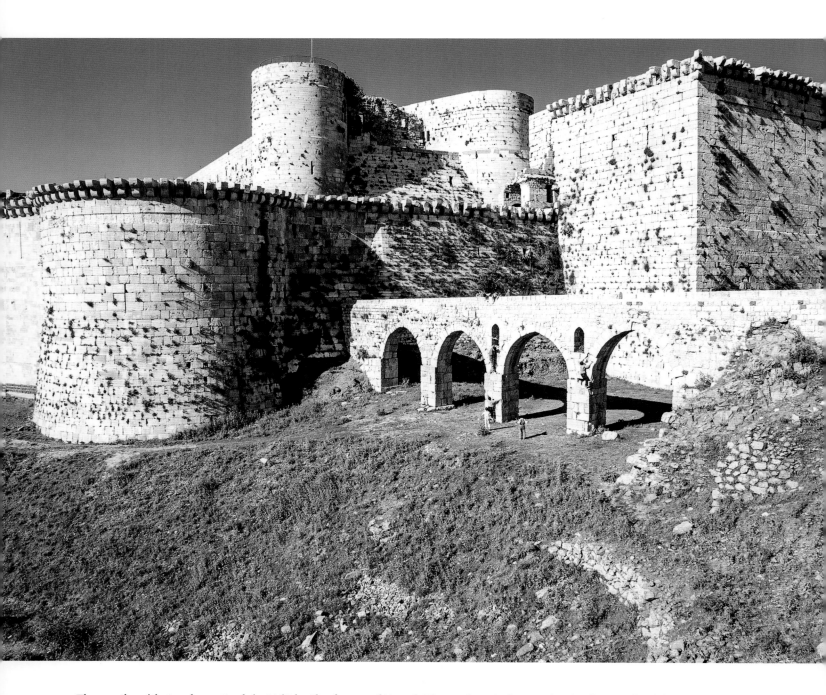

The castle withstood an attack in 1163 by the forces of Nur al-Din, and again in 1188 by the forces of Salah al-Din, who was successful in capturing several other Crusader strongholds. It remained in the possession of the Knights Hospitaller until 1271, when the Mamluk forces of Baibars penetrated its outer defenses and forced the garrison to surrender.

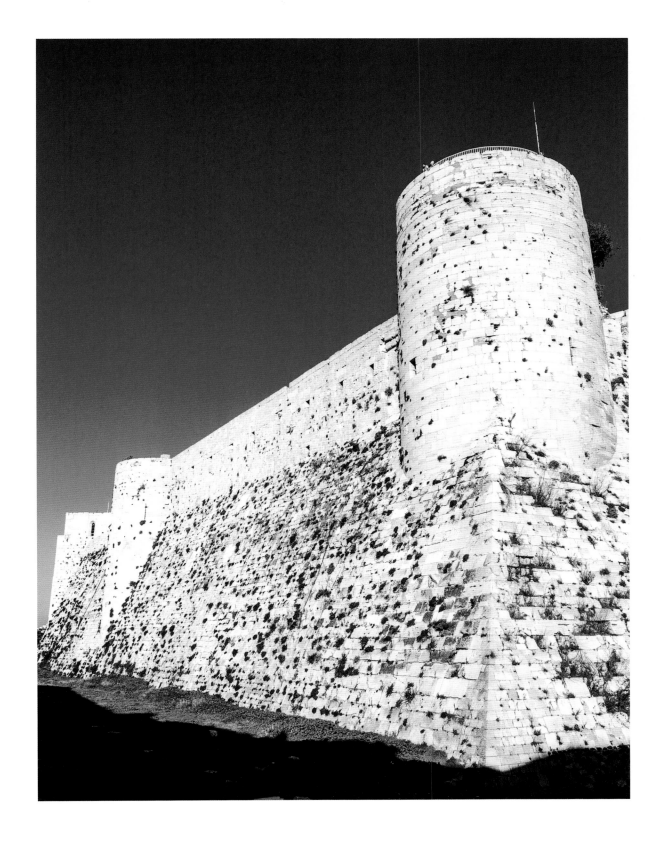

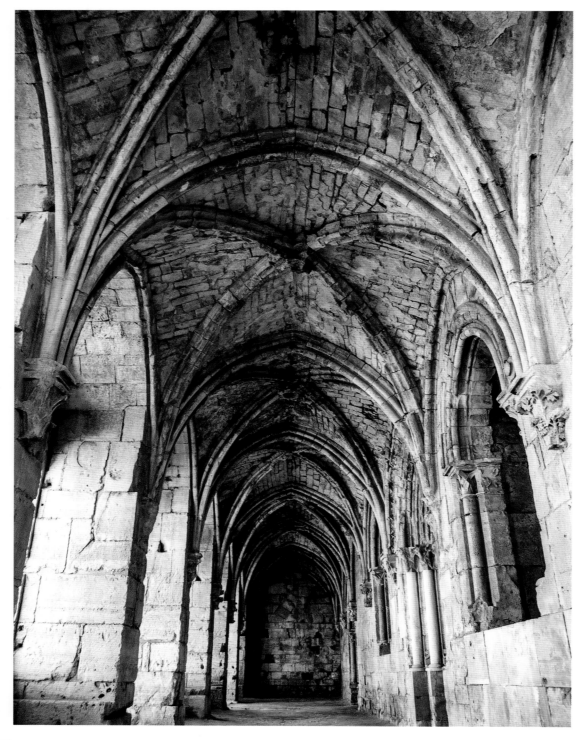

One of the most note-worthy architectural features of al-Hosn Castle is the colonnaded arcade that precedes the great hall. The Gothic style suggests it was constructed in the middle of the 13th century.

120

The modest chapel of the fortress dates to around 1170 and was converted to a mosque following the Mamluk victory over the Crusaders.

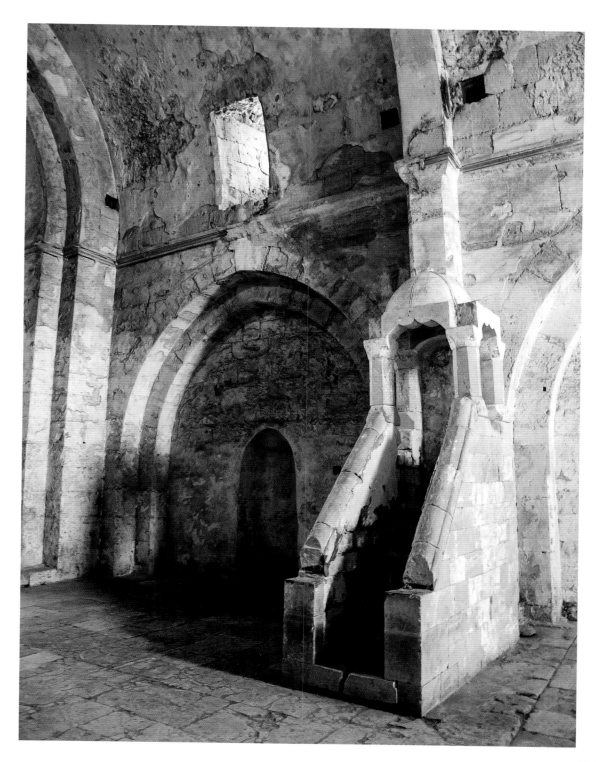

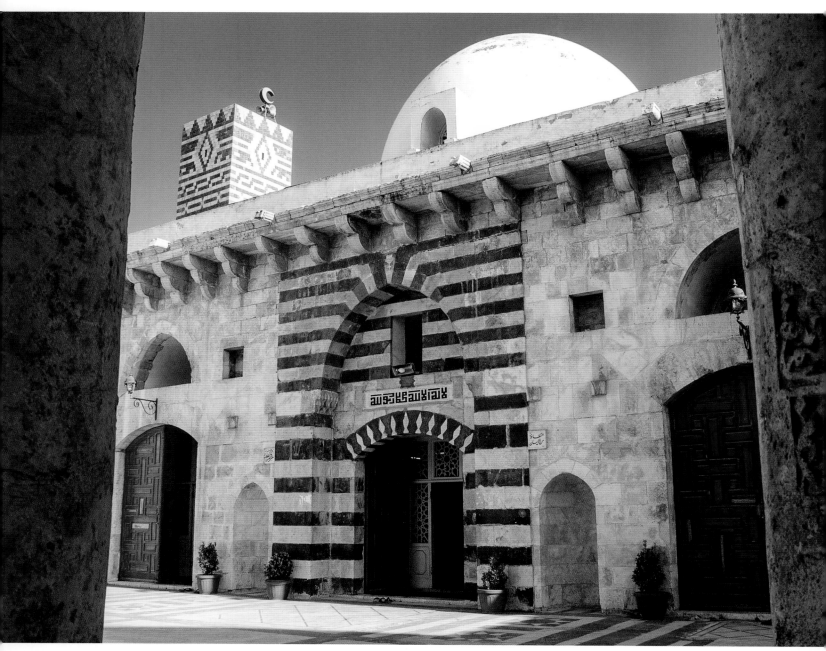

The Great Mosque of Hama is the most impressive religious monument in the city. Dating back to the seventh century, the mosque was converted from a Byzantine church during the Umayyad period. That sixth century church was itself converted from an even earlier Roman temple, originally constructed in the third century CE and dedicated to Jupiter.

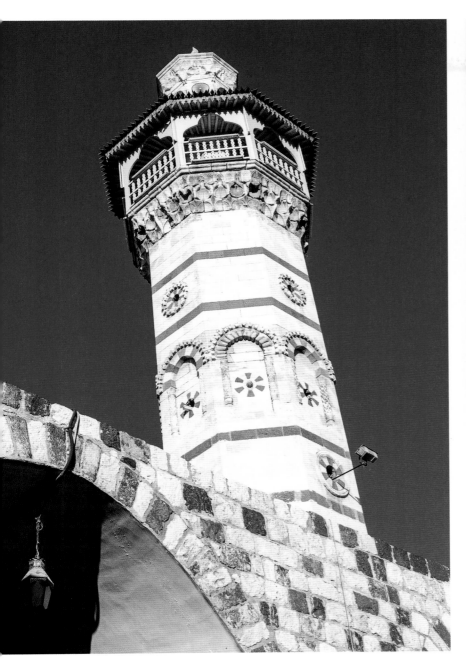

The mosque features two minarets. The eastern, square minaret was constructed in the Seljuq period and is dated by inscription to 1153. The northern, octagonal minaret was built during the Mamluk period in 1420. The complex also contains the tombs of two Ayyubid-era rulers of the city.

The mosque was almost completely destroyed during the 1982 conflict between the Syrian government and the Muslim Brotherhood. The building was carefully restored in subsequent years, maintaining its original design. The successful restoration of the Great Mosque of Hama could provide some optimism for the future of several historic buildings that have been damaged or destroyed in the ongoing conflict in Syria.

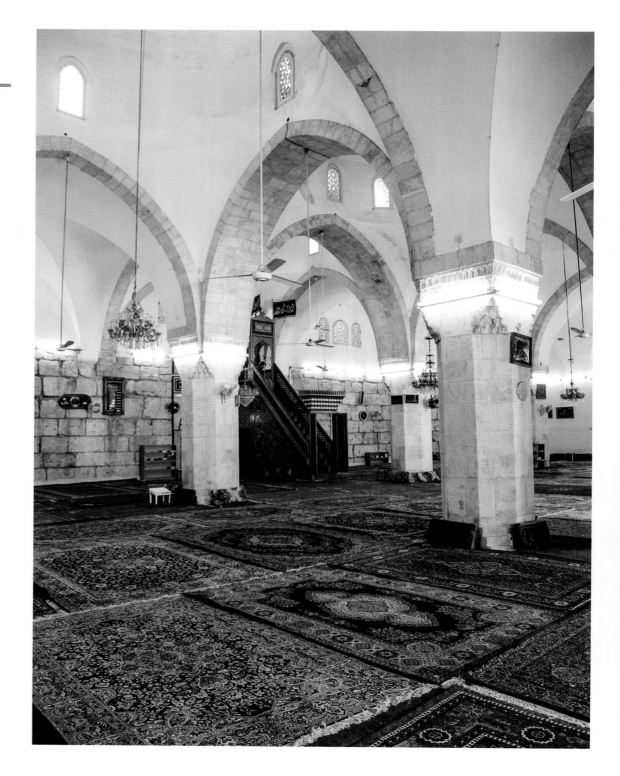

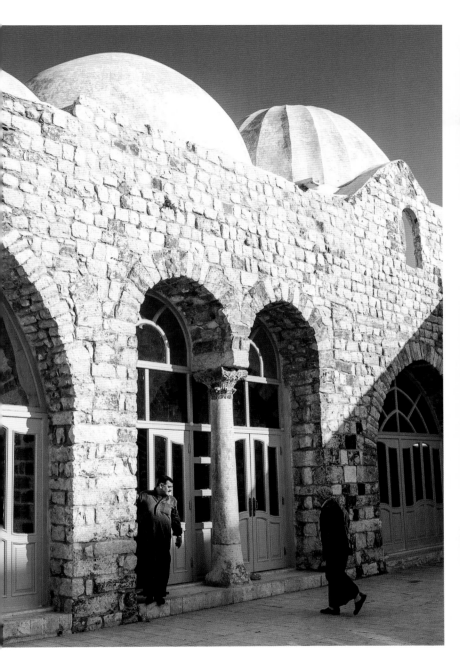

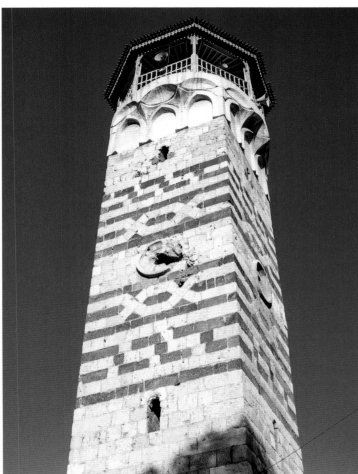

Al-Nuri Mosque was constructed during the reign of Nur al-Din, recognizing the important role that Hama played in establishing his rule over both Aleppo and Damascus. It was completed in 1163, part of efforts to rebuild Hama after an earthquake in 1157 inflicted major destruction upon the city. The mosque was expanded during the rule of Abu al-Feda in the early Mamluk period. It suffered major damage in 1982, but was subsequently restored.

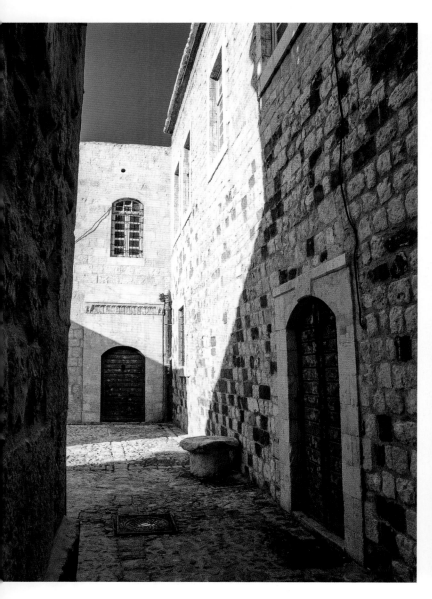
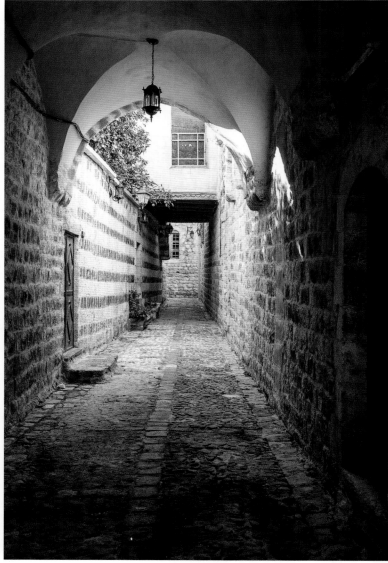

While substantial portions of Hama's old city were destroyed in the 1982 conflict, some residential neighborhoods survived and have since been restored. I found some of these old houses were being converted into art galleries, cafes, and restaurants. Wandering through Hama's old city and exploring its quiet and peaceful alleyways was always an enjoyable experience.

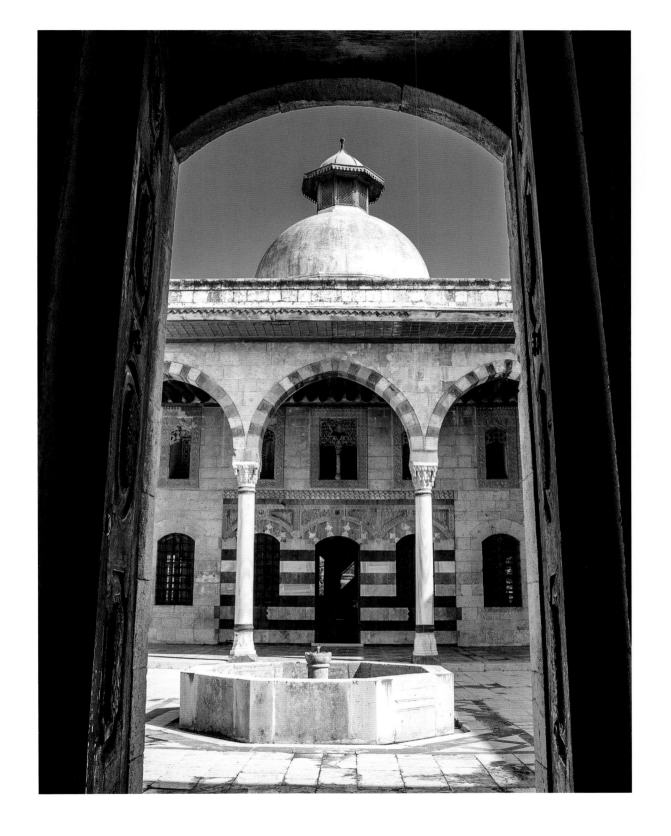

127

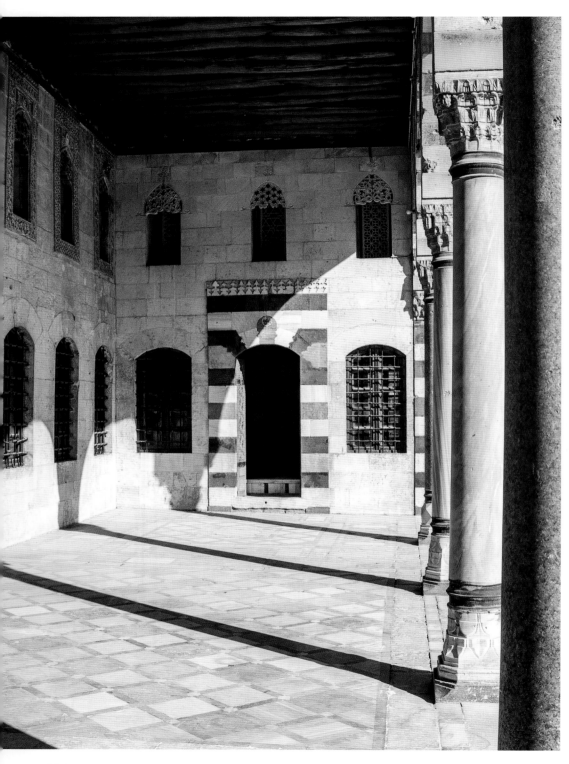

Hama's most remarkable historic residence is Qasr al-Azem, the mansion of an 18th-century governor of the city. Now serving as a museum of cultural tradition, this beautiful home represents one of the finest examples of Ottoman residential architecture in the country.

Hama is perhaps most famous for its ancient waterwheels, called norias, located throughout the city along the Orontes River. Designed to transport water along aqueducts to agricultural land in the countryside, they are believed to date back to at least the Byzantine period. The distinct creaking noise of these waterwheels can be heard throughout the old city.

131

Masyaf

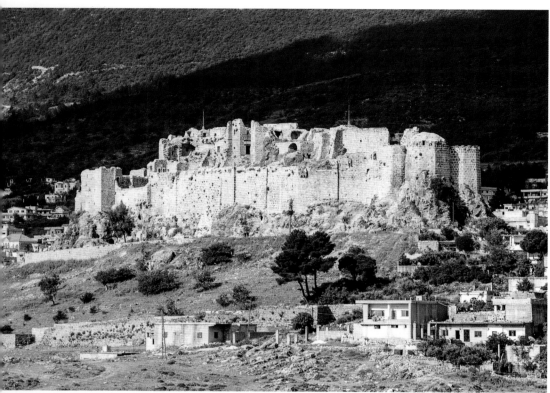

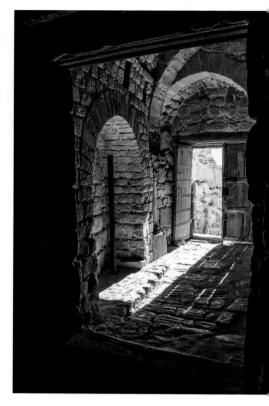

Masyaf's main attraction is its castle, the most well constructed and best preserved Ismaili fortress in Syria. The site has had strategic value since ancient times, and was utilized for defensive purposes during the Seleucid, Roman, and Byzantine periods. The Ismailis took control of the castle in 1141, built additional fortifications, and retained control of it for over a century. The town of Masyaf remains predominantly Ismaili, and its scenic location at the foothills of the coastal mountain range makes it a popular area to visit.

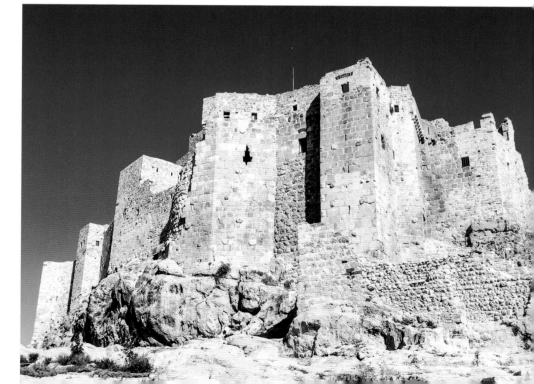

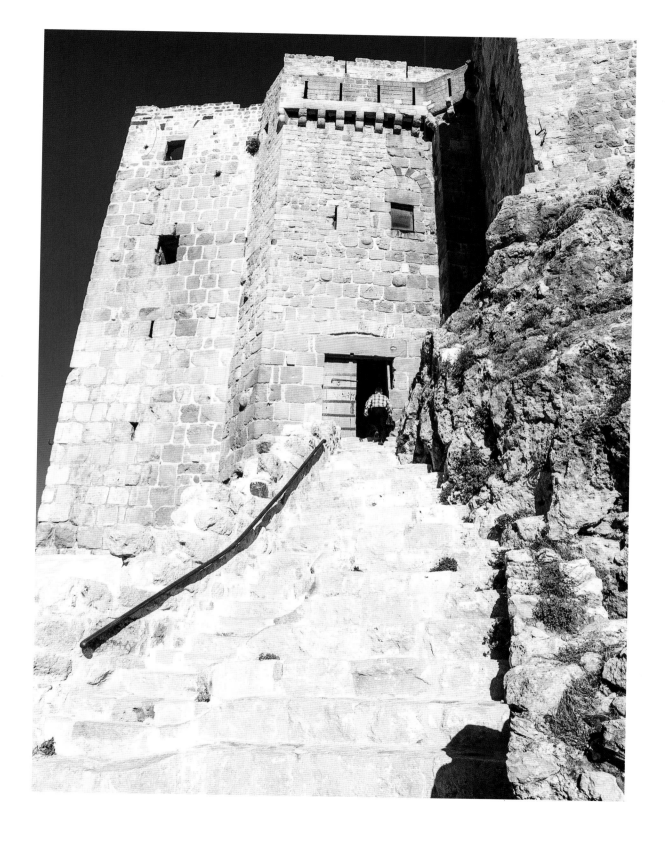

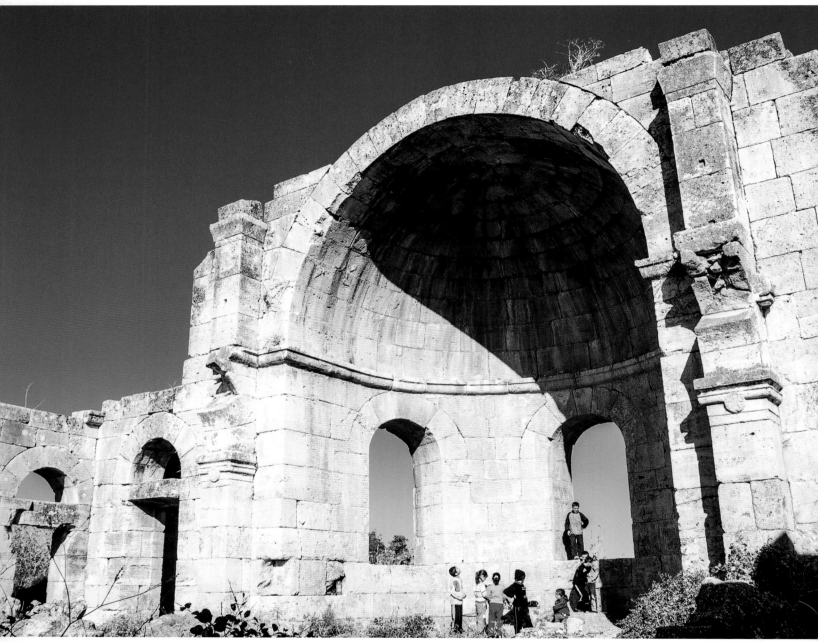

The peaceful and secluded Alawite village of Deir al-Salib, or Monastery of the Cross, hosts the remains of two Byzantine churches. One of these, estimated to have been built in the late fifth or early sixth century CE, survives in a well-preserved state. It was constructed on a surprisingly grand scale for such a remote location.

Mirza Castle

قلعة ميرزا

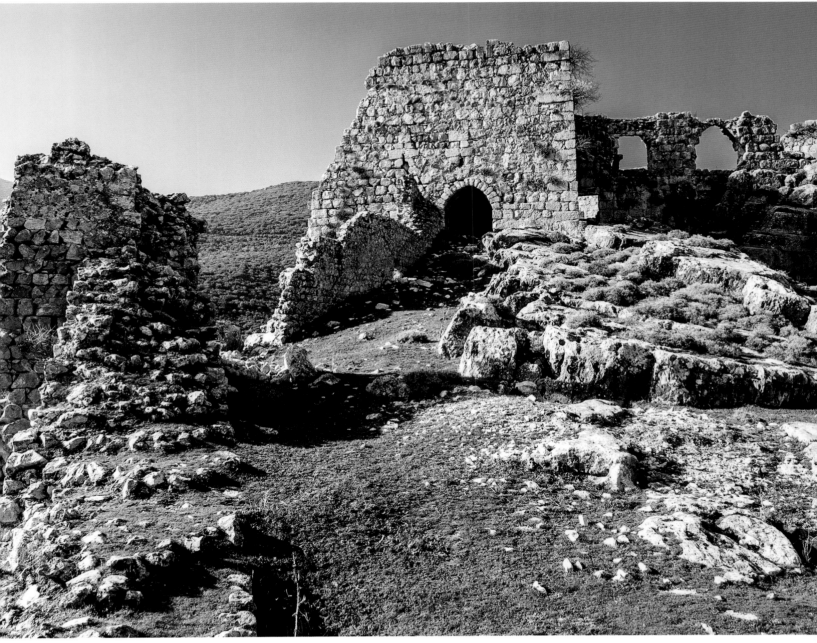

Mirza Castle is one of the most dramatically situated fortresses in Syria, with a commanding view over the plain of al-Ghab. Though badly ruined, this 12th-century Crusader castle is striking in its enormous scale. Until it was captured by Salah al-Din's forces in 1188, it was one of the Crusaders' forward defenses against Arab armies garrisoned on the opposite side of the valley.

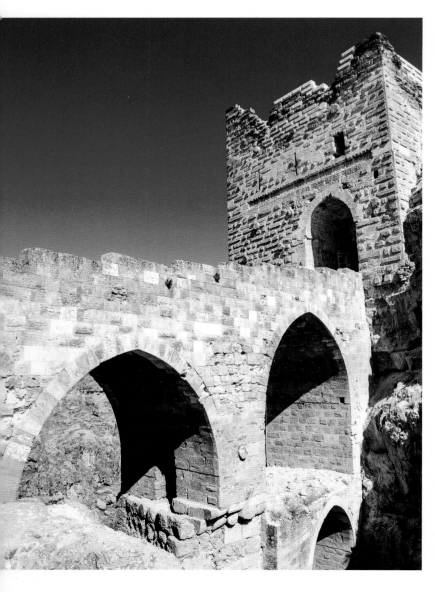
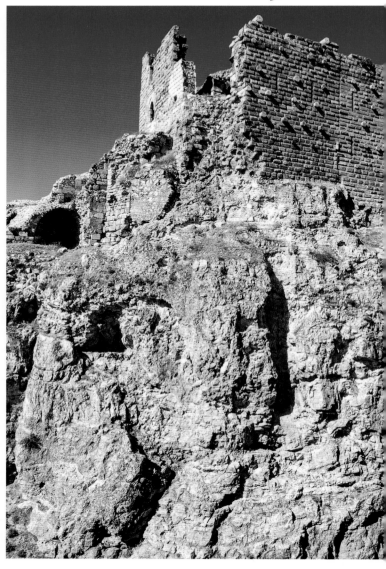

On a hilltop overlooking the Orontes River north of Hama is Sheizar Castle, one of the primary strongpoints in the Arab resistance to the Crusaders. The site may have been fortified as early as Hellenistic times, but the present remains date mostly to the Ayyubid and Mamluk periods. The castle has a remarkable monumental gateway, approached over a soaring, double-arched bridge.

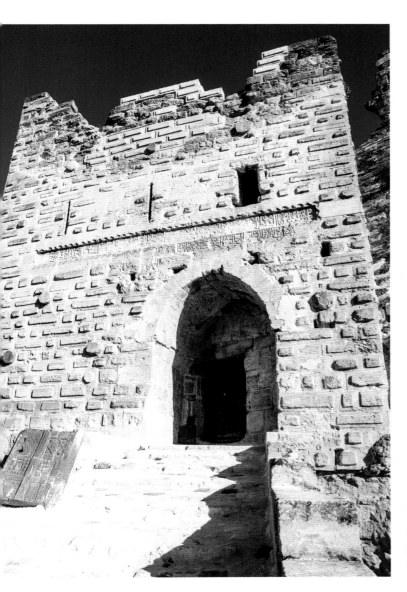

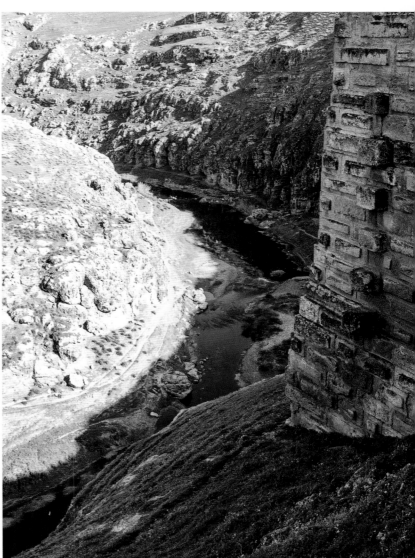

137

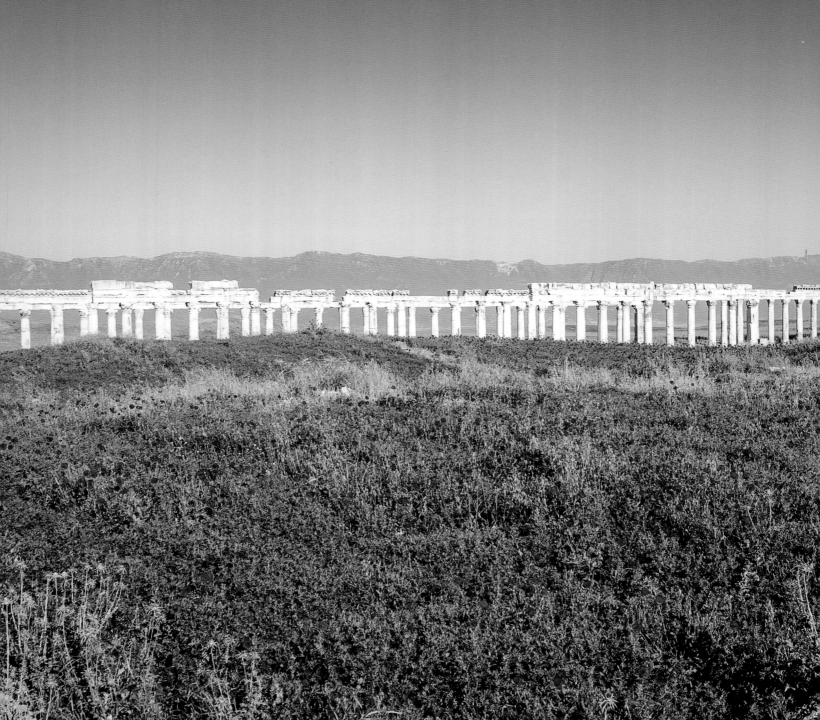

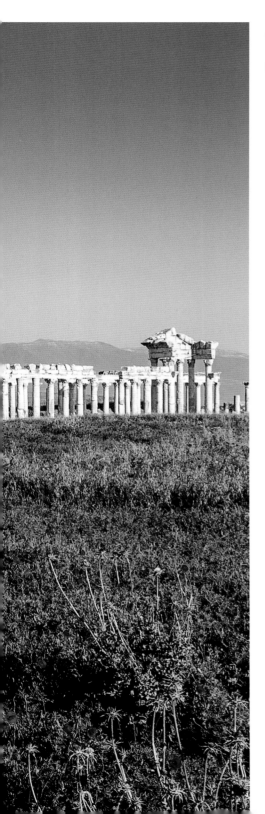

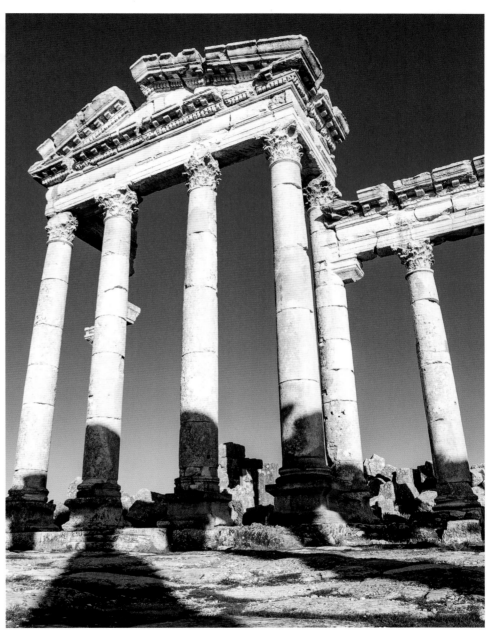

The Roman and Byzantine city of Apamea is the most notable archaeological site in the countryside of Hama. The sheer scale of this ancient city makes it one of the country's most memorable. Its exceptionally well-preserved colonnaded main street is nearly two kilometers in length.

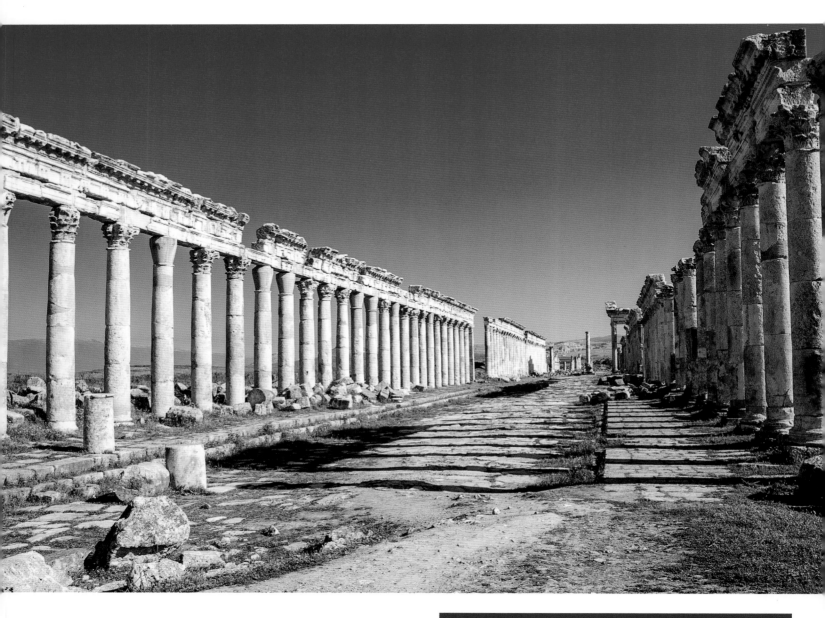

Apamea was founded during the Seleucid period, but reached the height of its prosperity in the second century CE under Roman rule. It was during this time that its theater, baths, and many temples and villas were constructed, and the main colonnaded street was completed.

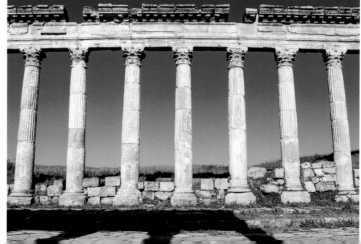

Apamea's importance declined after the Byzantine period, and over the centuries its population shifted towards the citadel to the west. An Ottoman-era mosque and khan, now a museum, can be found in this more modern settlement. Apamea was one of the first archaeological sites to suffer from the instability that has engulfed Syria since 2011, becoming the target of numerous illicit excavations and widespread looting.

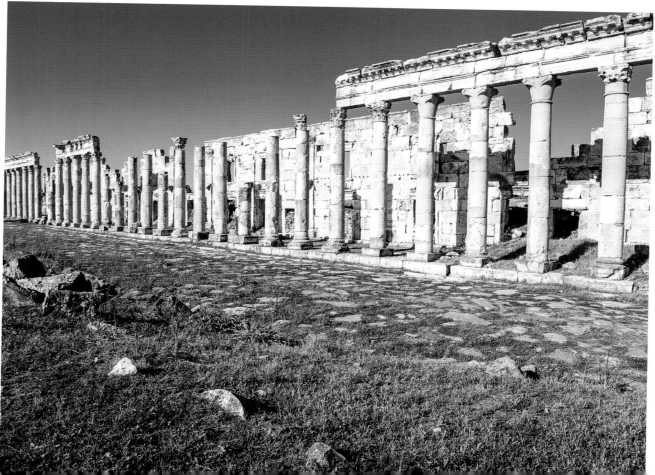

Salamiyeh

سلمية

The town of Salamiyeh, in the countryside southeast of Hama, is the largest population center of Ismailis in the Arab world. It is also an important pilgrimage site for the sect, with its Fatimid-era mosque containing the tomb of Imam Ismail. The town had earlier been prominent during the Byzantine period, when it was known as Salamias and was the seat of a bishop.

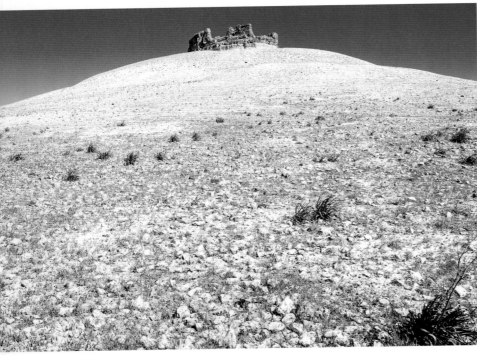

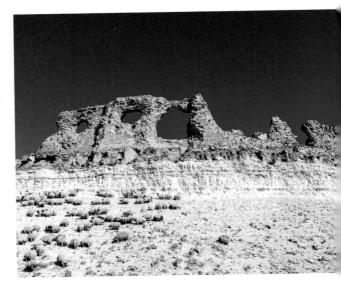

The ruined Ayyubid fortress known as al-Shamamis Castle is located just a few kilometers northwest of Salamiyeh. It was built by an Ayyubid prince of Homs in 1231 at the summit of an extinct volcano. While the remains are poorly preserved, the castle's setting is spectacular.

Sarouj

ساروج

Popularly known as "beehive houses," these traditional homes are constructed from dirt, mud, straw, and stone in a rounded conical shape. Designed to keep cool in the summer and warm in the winter, these distinctive structures are a common sight in the arid countryside east of Hama and Aleppo. While modern concrete buildings are rapidly replacing these traditional dwellings as homes, many of them have been preserved and are used for storage or, in the case of the village of Sarouj, for receiving guests.

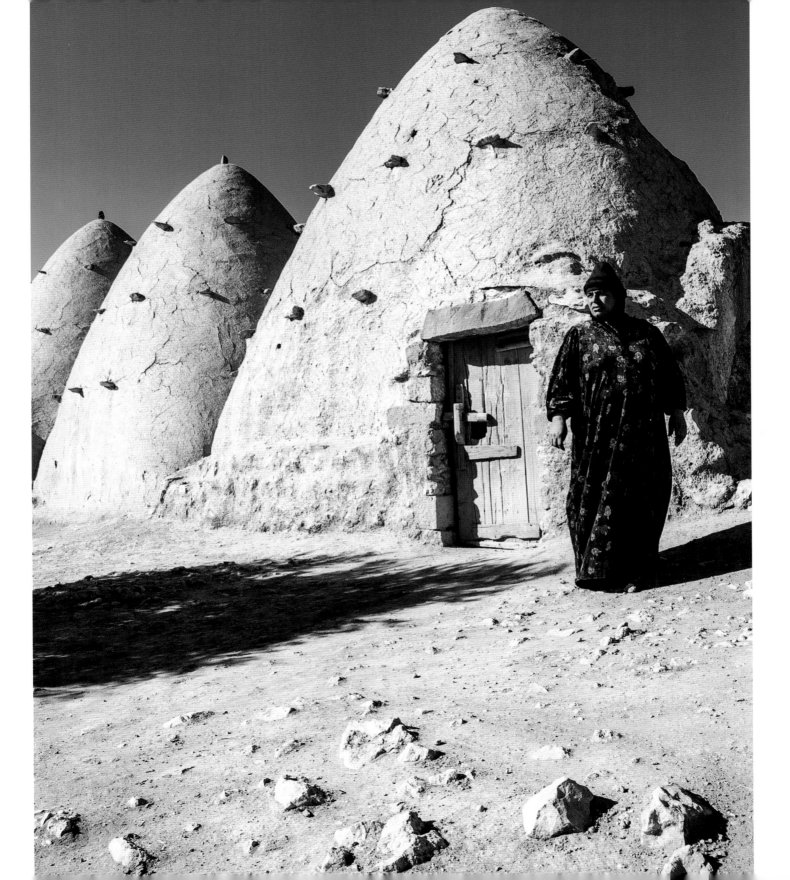

Qasr Ibn Wardan

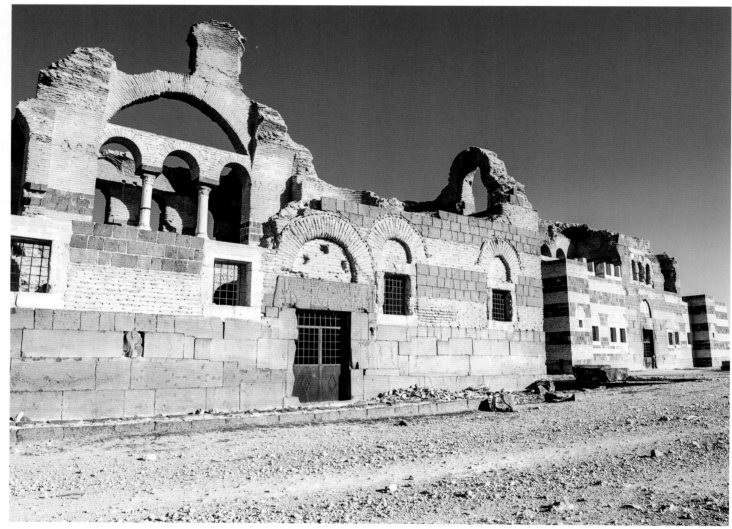

Qasr Ibn Wardan is a fascinating Byzantine church and palace complex located at the edge of the desert to the northeast of Hama. Built during the reign of Justinian and completed in 564 CE, the site supplemented other Byzantine fortifications such as Halabiyeh and al-Rasafeh, defending against the threat of Persians to the east. The complex was constructed with high quality materials and significant attention to architectural details.

Athriya

اثريا

Located where the desert road between Qinnesrin and Palmyra meets the road linking Salamiyeh to al-Rasafeh, the remote village of Athriya hosts a relatively well-preserved temple cella from the third century CE. The architectural style is similar to the temples found in Palmyra, to the southeast.

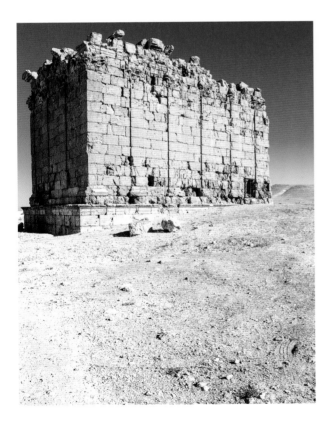

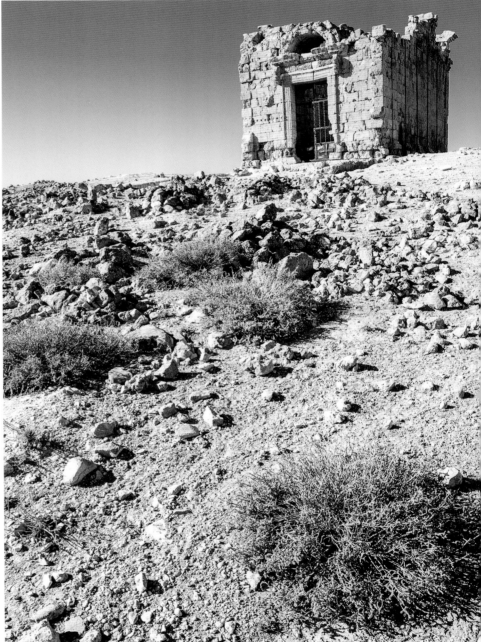

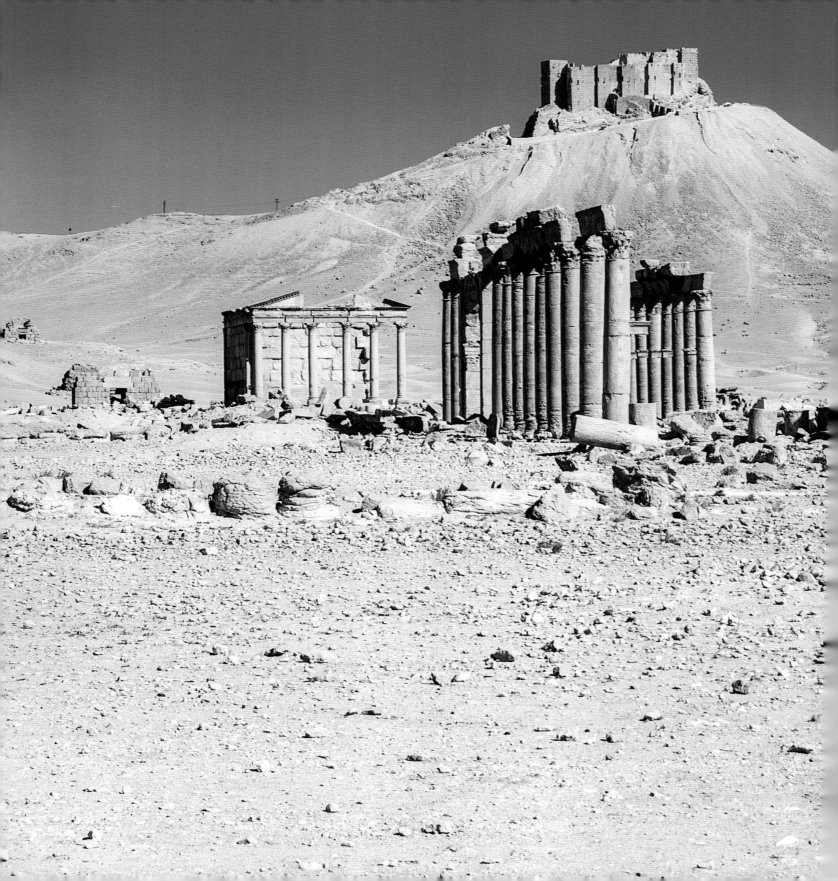

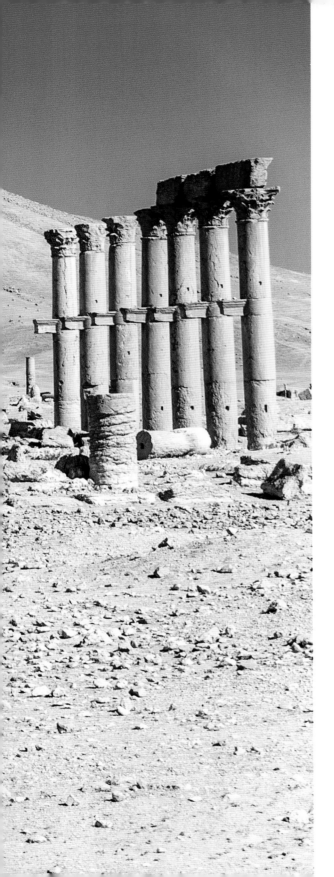

The landscape of eastern Syria is principally characterized by desert and arid mountain ranges, a vast expanse of largely undeveloped and unpopulated territory. Threaded through this barren terrain are the Euphrates and Khabur rivers, along whose banks the majority of the region's inhabitants reside. These river valleys have provided fertile land for farmers for many thousands of years, and the area is densely concentrated with rich archaeological sites as a consequence. Many of these sites date back to the early Neolithic period, the beginning of permanent settlement, agriculture, and animal domestication roughly 12,000 years ago. While these remains generally offer little to the casual visitor (or photographer), to archaeologists they represent a treasure trove of research opportunities. The region, part of the Fertile Crescent, has made invaluable contributions to our knowledge and understanding of the origins of human civilization.

Deep in the desert and far from these fertile river valleys is Syria's preeminent archaeological attraction, Palmyra. This extensive and hauntingly beautiful oasis city was founded in the early second millennium BCE and flourished during the Roman period. Designated a World Heritage Site by UNESCO in 1980, Palmyra featured monumental temples, wide colonnaded streets, a well-preserved theater, public baths, administrative buildings, and a sizable marketplace, or agora. The city was also notable for its extensive cemetery, or necropolis, that included distinctive tower tombs and large underground burial chambers. These Roman-era structures were elaborately decorated and extremely well constructed, exhibiting the finest craftsmanship. Towering above the vast, ancient city was a hilltop castle, constructed during the Ayyubid era, which offered sweeping views over the site and its surrounding countryside. Like most visitors, I marveled at Palmyra's high level of preservation, finely detailed architecture, and romantic desert setting.

The city was occupied by extremist militants from May 2015 until March 2016, and they deliberately demolished most of its major temples and tombs. Many of the magnificent structures that I had the privilege of exploring and documenting may have been permanently lost. The restoration of these monuments will pose a tremendous challenge for future archaeologists and cultural heritage specialists. When I last visited Palmyra in 2007, I could not have imagined that, after surviving for nearly two thousand years, these buildings would be

الشرق
The East

destroyed during my lifetime. Both Syria and humanity have suffered an immense loss. For many Syrians, Palmyra had come to symbolize their rich heritage and cultural identity. Beyond Syria, the city represented one of the most remarkable achievements of the classical period.

Several other noteworthy sites can be found throughout eastern Syria, and the fortified Byzantine-era cities of Halabiyeh and al-Rasafeh are among the most spectacular. Halabiyeh was constructed in the sixth century CE on the southwestern bank of the Euphrates, its massive walls extending from the river to a hilltop citadel. While remains of the city itself have largely vanished, its extensive fortifications remain dramatic and imposing. The contemporary site of al-Rasafeh is even more remarkable and is one of Syria's lesser-known treasures. Its nearly two kilometers of walls, towers, and gates defended the ancient city of Sergiopolis, a major settlement during the Byzantine period. The city was an important place of pilgrimage, commemorating a Roman soldier who was martyred in 305 CE, persecuted for his Christian faith. Several of the settlement's churches survive, including its striking Church of St. Sergius. Other remains include the city's enormous underground cisterns.

Many early Islamic monuments are found throughout the region as well. Qasr al-Heir al-Sharqi is a stunning Umayyad palace complex located in the remote desert. It features two separately fortified enclosures with a simple minaret (a later Ayyubid contribution) standing between them. The smaller, eastern enclosure, with its striking facade, served as either a palace or a khan. The larger western enclosure included more modest residential and service buildings and a congregational mosque. The main structures were built in the early eighth century under Caliph Hisham ibn Abd al-Malik, with additions made in the later Abbasid period. The Abbasids were particularly active in the east of Syria, where the city of al-Raqqa briefly served as their capital. Several structures from this period survive in al-Raqqa, including the remains of its Great Mosque and the southeastern city gate of Bab Baghdad.

The Seljuqs and Ayyubids later contributed to al-Raqqa's architectural heritage, and were also responsible for the construction of numerous fortifications in the wider region. These are highlighted by al-Rahbeh Castle, southeast of Deir al-Zur, and Jaabar Castle, west of al-Raqqa. Mostly constructed in the 13th century, al-Rahbeh Castle dominates the Euphrates valley near the modern town of al-Mayadin. Once located on an isolated hilltop, Jaabar Castle now sits on the shores of Syria's largest lake, formed by the construction of the nearby Tabqa Dam. Most of its remains date to the 12th century, including its cylindrical brick minaret.

The east of Syria fully encompasses the three provinces of al-Raqqa, Deir al-Zur, and al-Hasakeh, as well as the eastern extent of the Homs province, where Palmyra is located. The provincial capitals of al-Raqqa, Deir al-Zur, and al-Hasakeh are also its three largest cities, and its fourth largest, al-Qamishli, is an important town on the border with Turkey. This part of the country is predominantly Sunni Muslim, and a stronger emphasis is placed on tribal affiliations here than in other parts of the country. These regions tend to be more socially conservative, but the people demonstrated the same hospitality and kindness that I found throughout Syria. As a consequence of the country's ongoing conflict and the rise of extremist militants, many of the region's religious minorities, such as the Christian communities of Deir al-Zur and al-Raqqa, have been forced to flee. The northeastern province of al-Hasakeh, however, has largely avoided sectarian conflict and has remained relatively safe. This predominantly Kurdish (and Muslim) region has a significant indigenous Christian population, many of whom are native speakers of Aramaic and use it both as a liturgical language and within their community. The ethnic and religious diversity of the region made exploring it even more fascinating. Traveling in the eastern provinces was often more challenging and less comfortable than in other parts of Syria, but its rich archaeological and cultural heritage gave me many rewarding experiences.

تدمر

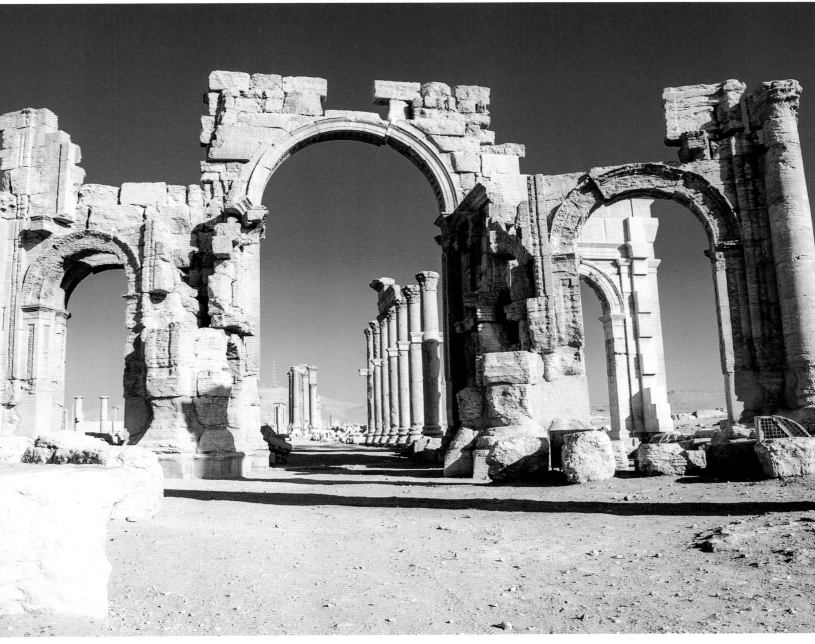

One of the most remarkable structures in Palmyra was its monumental arch, built during the reign of Emperor Septimius Severus (193 to 211 CE). The arch was richly decorated with stone carvings and elegantly concealed a thirty-degree turn in the city's main colonnade. It was severely damaged by explosives in October 2015.

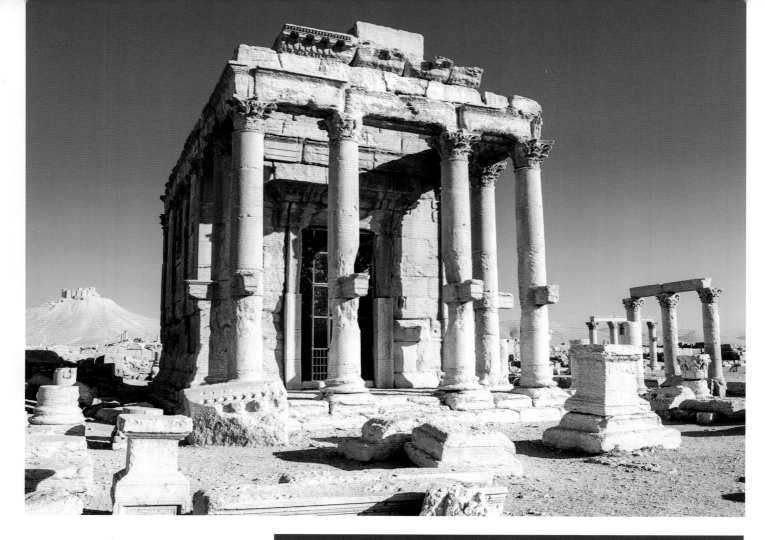

The Temple of Baal-Shamin was one of the most well preserved monuments in Palmyra. The shrine was dedicated to Baal-Shamin, the Palmyrene god responsible for rain and harvest. Portions of the temple complex were dated as early as 17 CE, while the cella was constructed in 130 CE. It was destroyed by explosives in August 2015, the first structure in the ancient city to be targeted for demolition by extremist militants.

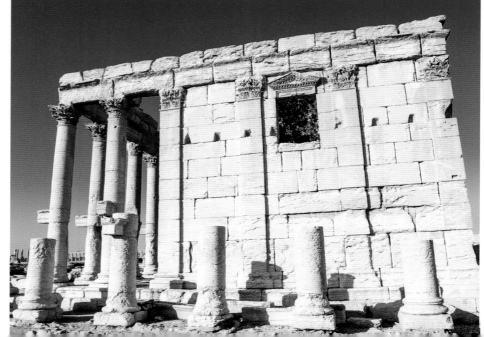

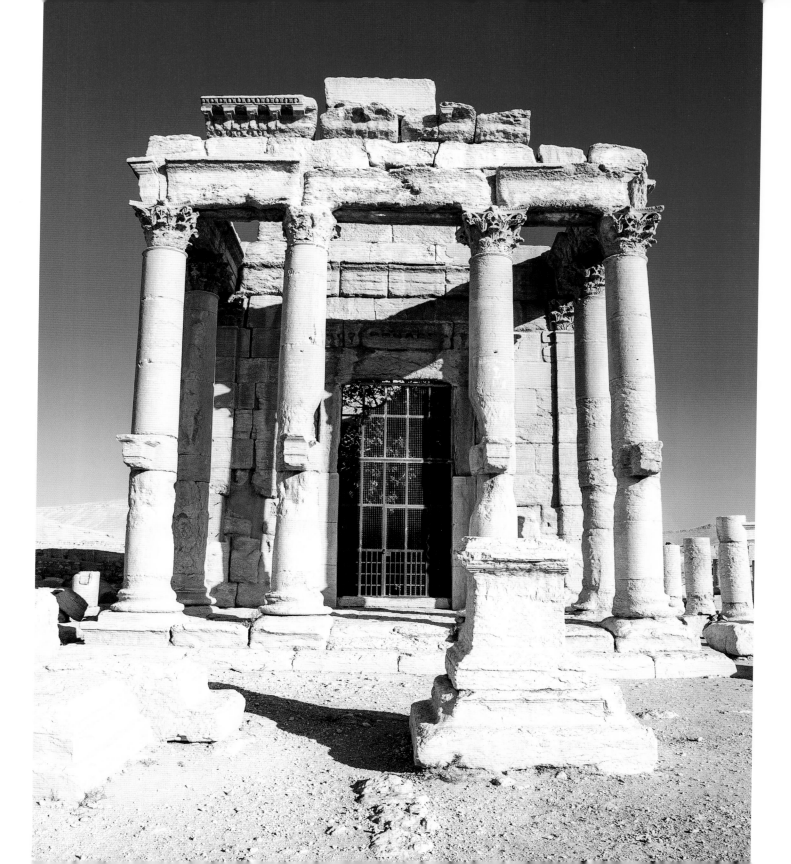

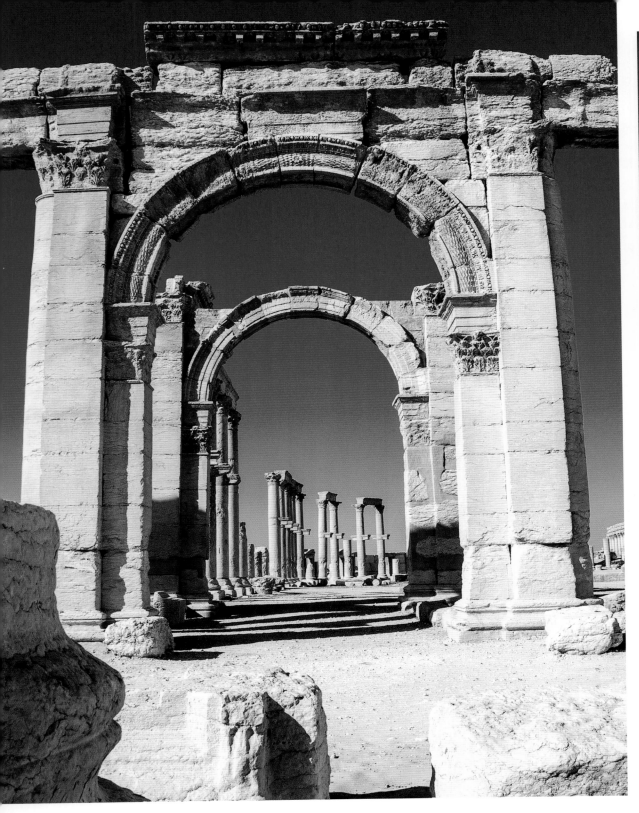

Many of Palmyra's monuments ran alongside the ancient city's main colonnade, extending northwest from the monumental arch. On the right was the city's public baths, while on the left was the Temple of Nabu, the senate, the theater, and the agora.

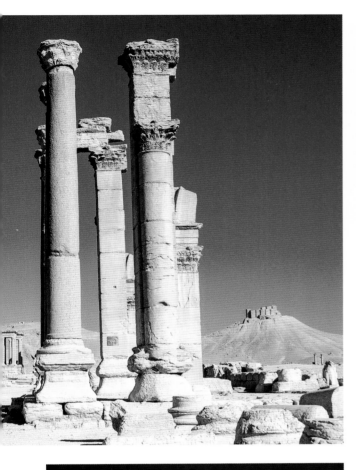

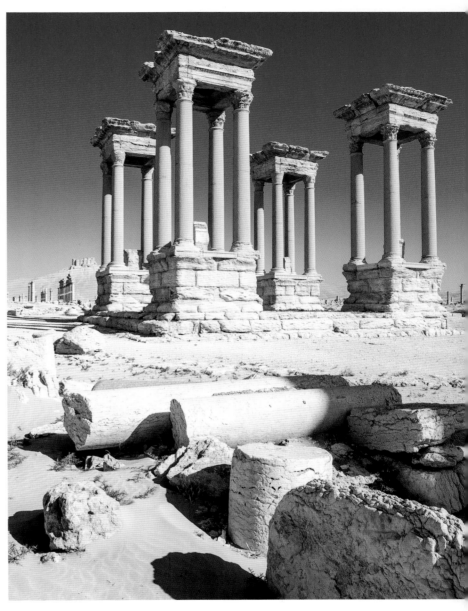

Four monumental tetrapylons mark an important intersection of the ancient city's main colonnade. Believed to have been constructed at the end of the third century CE during the reign of Diocletian, the original columns were carved from pink granite imported from Aswan, Egypt.

155

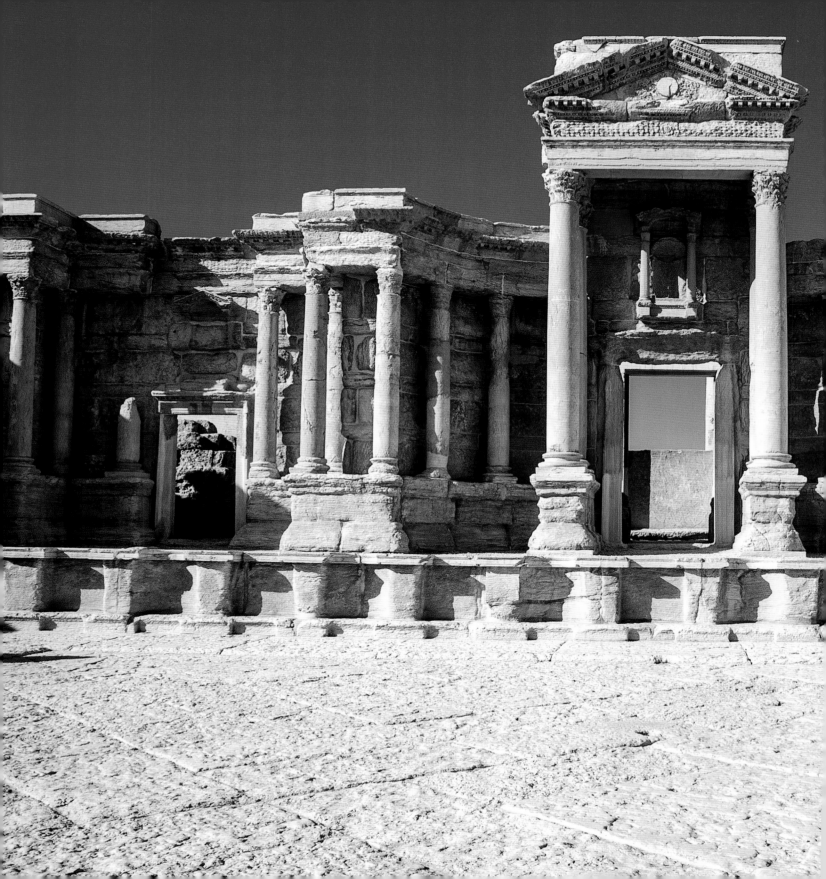

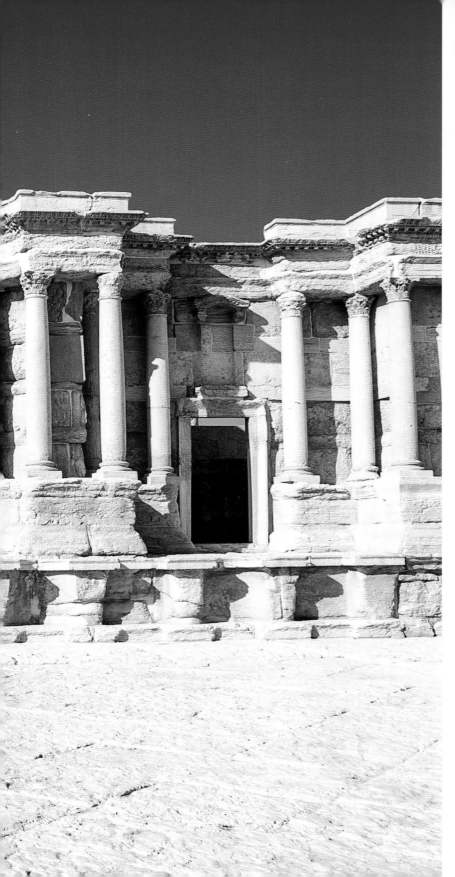

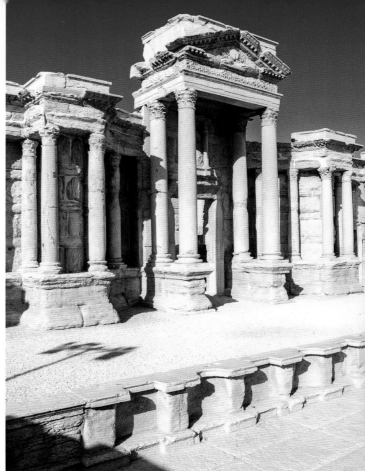

Largely buried under sand until the 1950s, Palmyra's theater was one of the most well preserved in Syria outside of Bosra. It is believed to have been constructed in the first half of the second century CE. Its stage had a beautifully decorated facade.

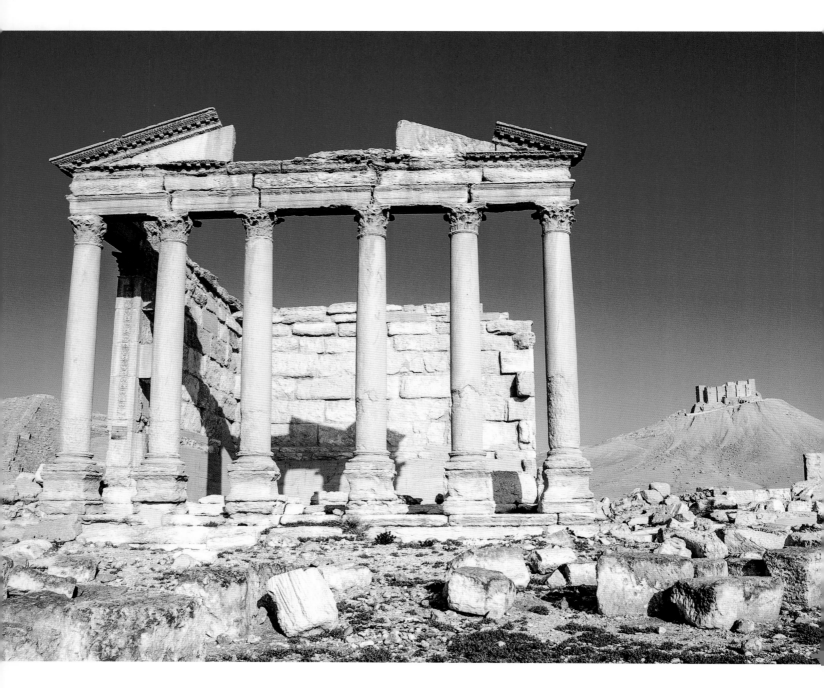

The northwestern end of the main colonnade terminated at an impressive funerary temple that is believed to date from the late second or early third century CE. It is the only tomb found within the city walls, suggesting it belonged to a particularly prominent Palmyrene family.

Surrounding the ancient city of Palmyra is a vast, sprawling necropolis featuring hundreds of Roman-era tombs. The most remarkable of these, constructed for the city's more prominent residents, featured complex architecture and detailed funerary art. The wealth and prosperity of this caravan city was reflected in the high quality craftsmanship of these funerary chambers, which were typically shared by entire extended families.

Several different architectural styles were used in Palmyra's tombs. Tower tombs were the earliest developed, often featuring several floors of burial chambers. The burial compartment of each individual would customarily be faced with a carved limestone relief of their portrait. Over the following centuries many of these were destroyed, though some remain preserved in museums.

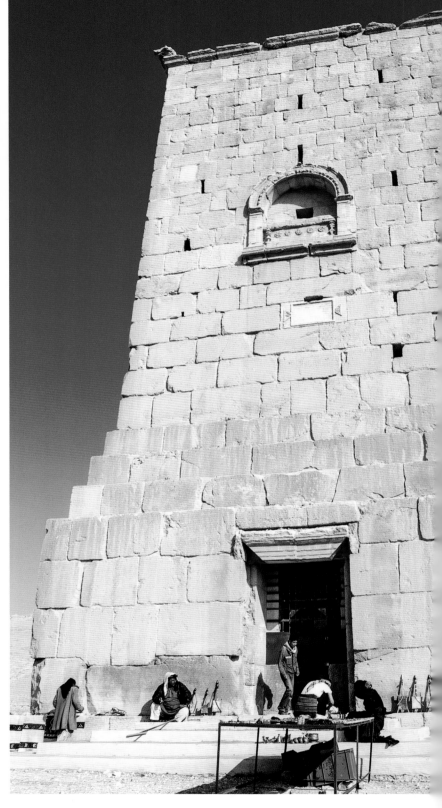

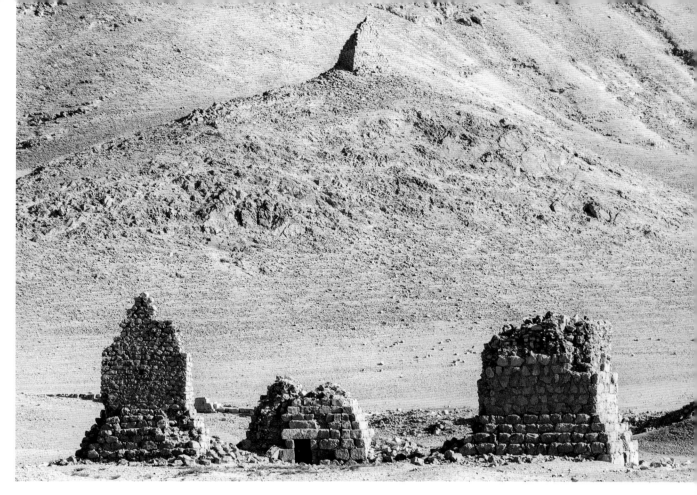

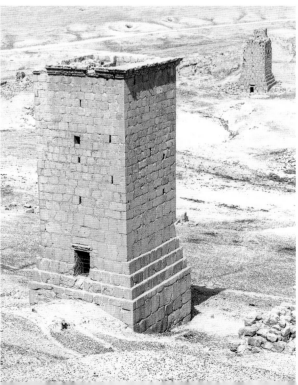

Palmyra's tower tombs were found primarily in the western necropolis, often referred to as the Valley of the Tombs. Some of these were constructed as far back as the Hellenistic period, with the most recent tomb dated to 128 CE. In the early second century CE, this form of entombment was abandoned in favor of underground burial chambers, or hypogeum, located primarily south and southeast of the ancient city. Sadly, extremist militants destroyed at least seven of the tower tombs in September 2015.

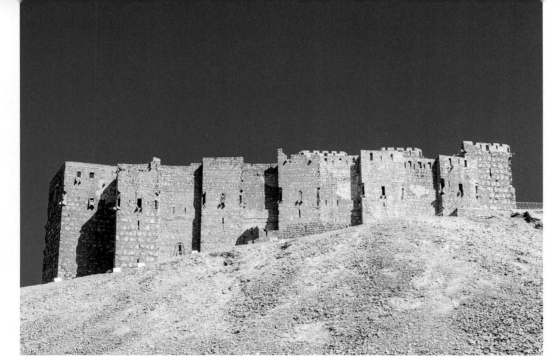

Located west of Palmyra, and constructed with stones from its ancient ruins, is the Ayyubid-era fortress known as Shirkuh Castle. Believed to have been constructed in the late 12th or early 13th century, the castle features seven towers and is surrounded by a deep moat. The fortress is also popularly known as Fakhr al-Din Castle, named after a Druze prince who challenged Ottoman authorities by capturing it in the early 17th century.

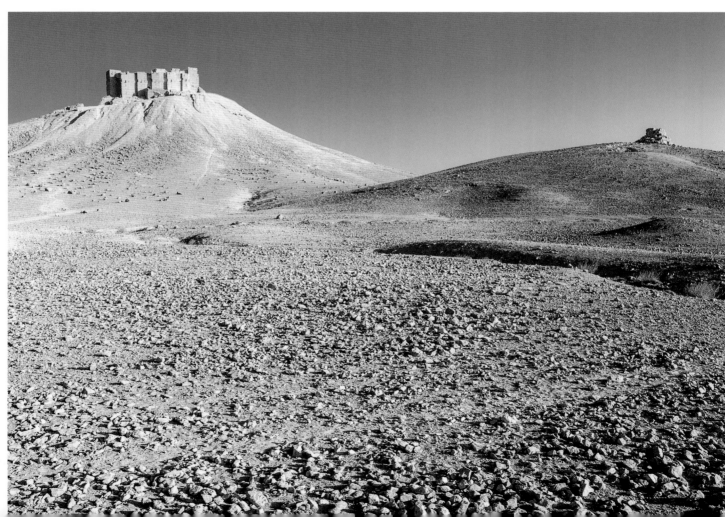

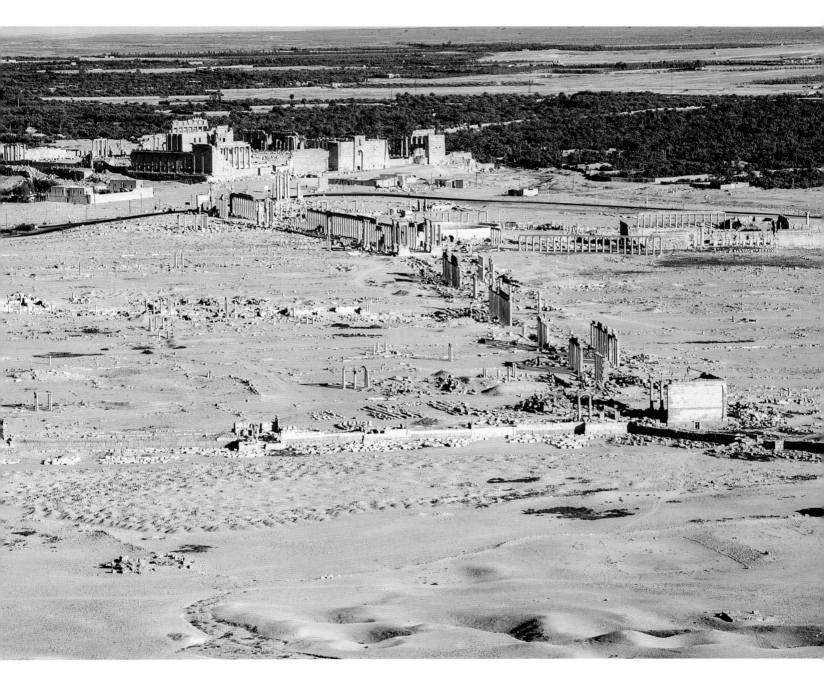

The castle afforded a commanding panorama of the surrounding countryside and a magnificent view of the ancient city of Palmyra.

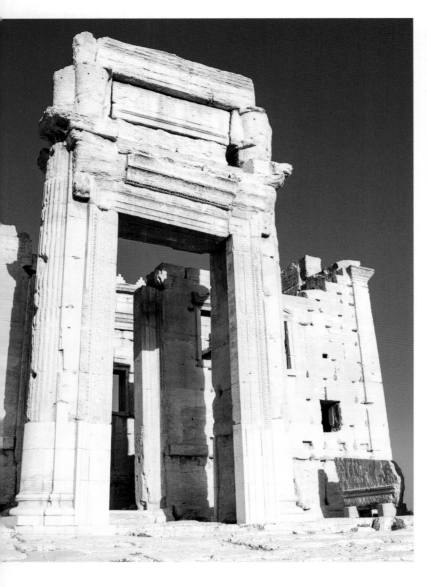
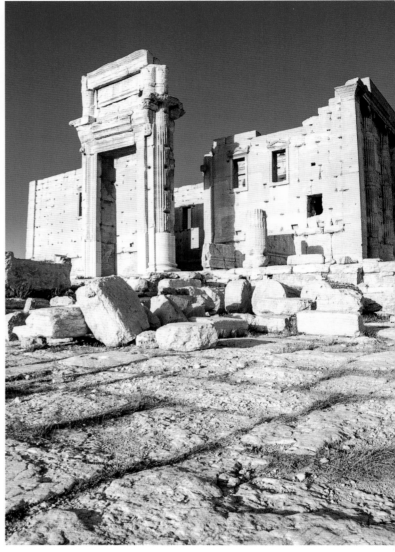

The massive Roman temple complex of Palmyra's Temple of Bel, located in the southeastern quarter of the ancient city, was one of the best preserved in the Middle East. Extremist militants destroyed the inner shrine, or cella, with explosives in August 2015.

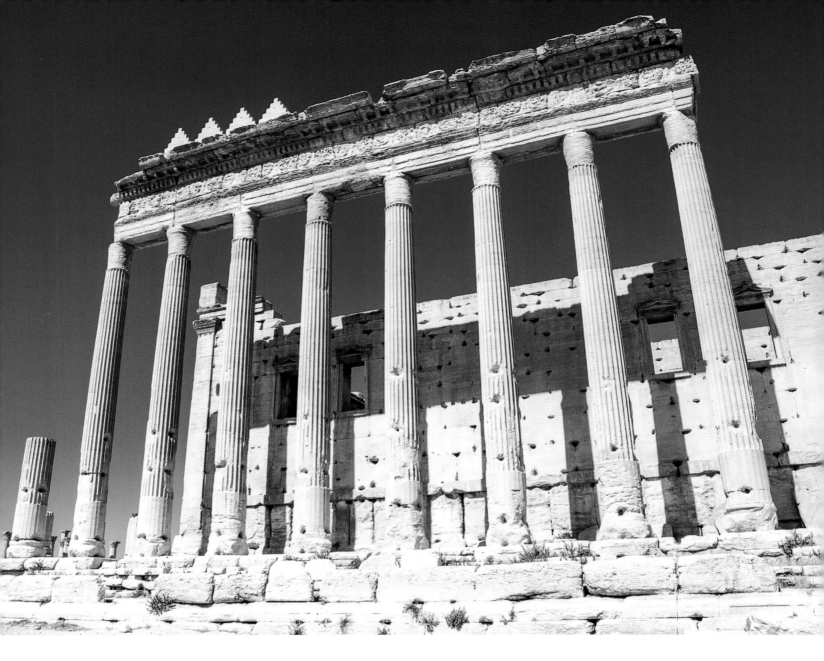

The Temple of Bel was dedicated during the reign of Emperor Tiberius in 32 CE after it had taken over a decade to construct. Between 80 and 120 CE, the temple was enlarged, and the double colonnaded porticos on the northern, eastern and southern sides were added. The western portico, along with its monumental gateway, was constructed in the late second century CE. The site of the temple had been used for religious purposes as far back as 2200 BCE. The temple's cella served as a village mosque as recently as 1929. This represents a remarkable span of over 4,000 years of use as a place of worship, rivaling the Umayyad Mosque in Damascus.

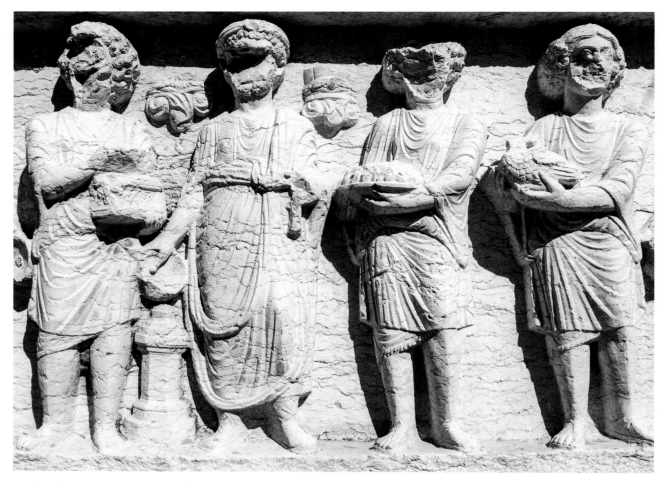

Palmyra's museum was founded in 1961, and contained educational exhibits and a collection of artifacts discovered in the area, include a unique collection of Palmyrene funerary art and statuary. Prior to the militant offensive against the city in 2015, dedicated museum officials were able to evacuate the majority of its collection. However, several larger statues were unable to be rescued and were subsequently destroyed.

Dura Europos

دورا آوروبس

Overlooking the Euphrates River, the ancient city of Dura Europos was founded by the Seleucids in 303 BCE to assert control over important trade routes. In subsequent centuries, the city fell under Persian and Roman control, but maintained a diverse, multicultural population. Inscriptions in nearly a dozen languages have been found at the site. In addition to temples dedicated to pagan gods, the city also hosted a Jewish synagogue and very early Christian church.

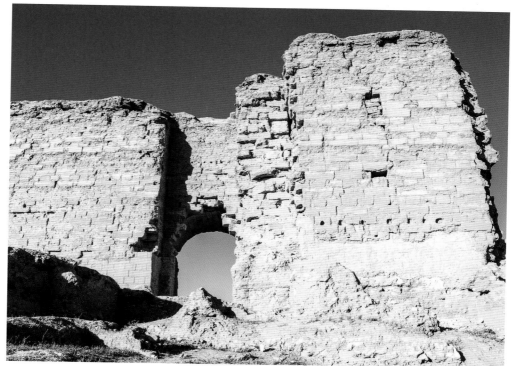

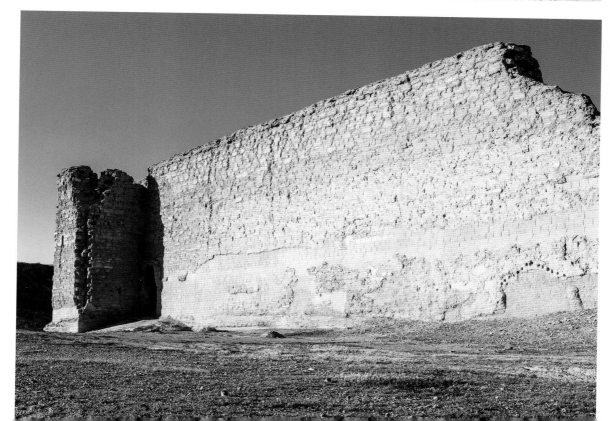

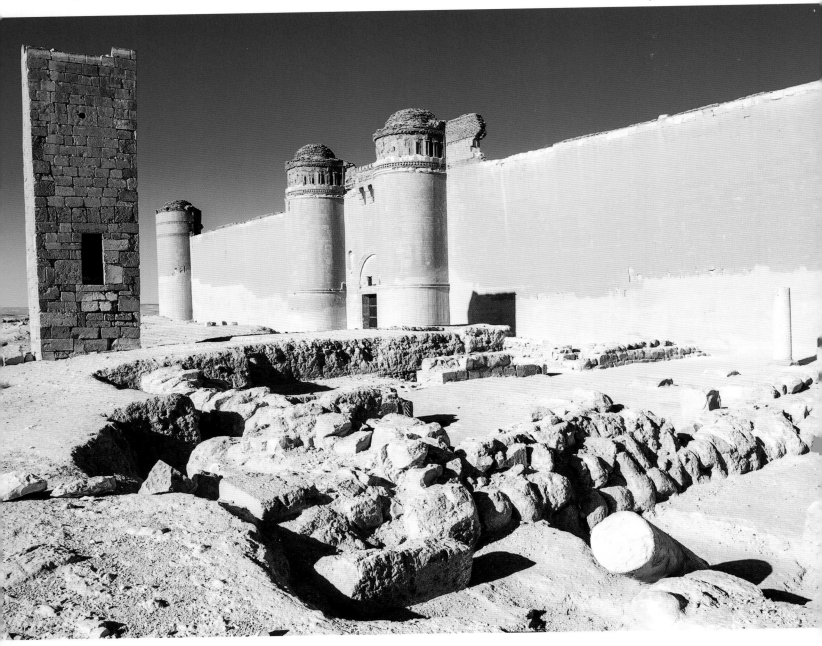

The early eighth century Umayyad-era settlement of Qasr al-Heir al-Sharqi is located in the remote desert between Palmyra and Deir al-Zur. The remains include this well preserved building that served as either a palace or a khan. To the west is a separate fortified settlement that included living quarters, administrative buildings, and a congregational mosque. Between them, a simple square minaret survives from a later Ayyubid occupation.

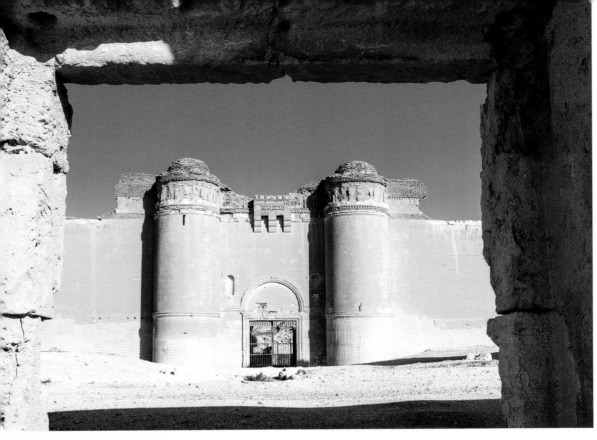

Families from sur-
rounding villages
would often visit the
site. This friendly
gentleman request-
ed I take a photo-
graph of him and
his daughter.

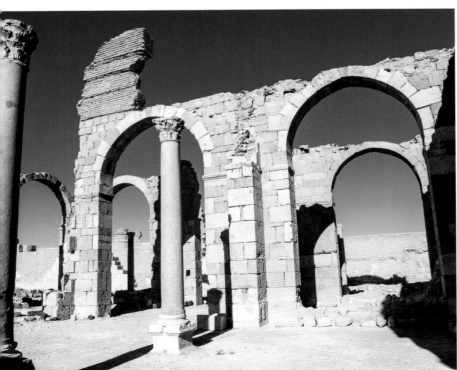

al-Rahbeh Castle

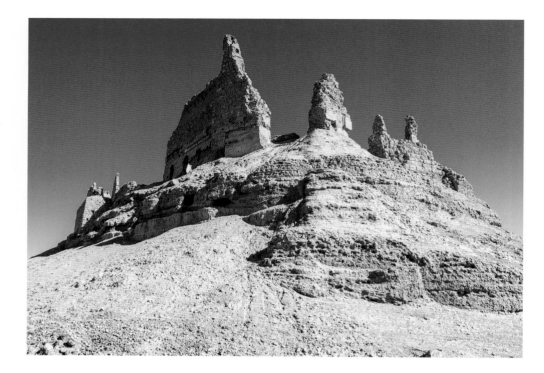

Southeast of the provincial capital of Deir al-Zur are the remains of al-Rahbeh Castle, a hilltop fortress originally constructed in the early ninth century. Most of the surviving structure dates to a late 12th century reconstruction during the reign of Nur al-Din, though the fortifications have significantly deteriorated over the centuries.

During my visit to al-Rahbeh Castle, local archaeologists were directing excavation and restoration efforts at the site. The team encouraged me to take their photograph.

Halabiyeh

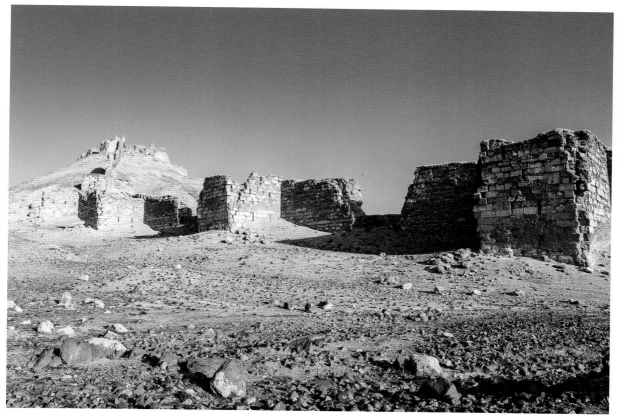

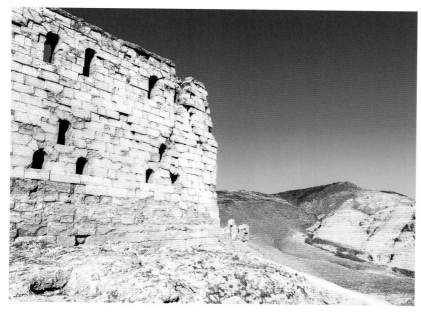

Located between Deir al-Zur and al-Raqqa, the site of Halabiyeh features the extensive remains of a large Byzantine fortress town. Most of the settlement dates to the sixth century CE rule of Justinian, when it defended the empire's eastern frontier and controlled movement along the Euphrates. Halabiyeh's imposing fortifications survive very well preserved.

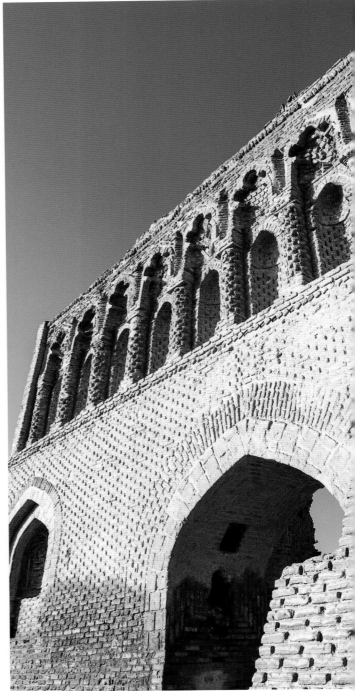

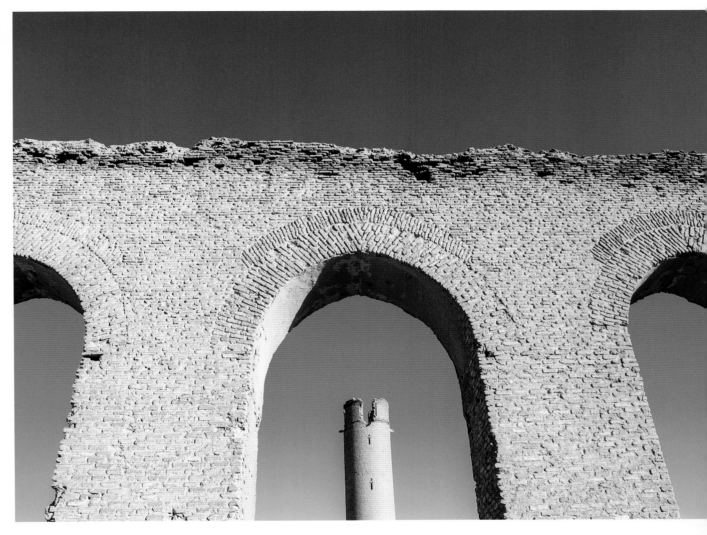

The provincial capital al-Raqqa was seldom visited by tourists, but it has a rich history and several interesting monuments. The city reached its height during the Abbasid era, when for a time it was second in importance only to Baghdad. Remains from the Abbasid period include the old city walls and gates, highlighted by Bab Baghdad, and the Great Mosque of al-Raqqa, largely ruined.

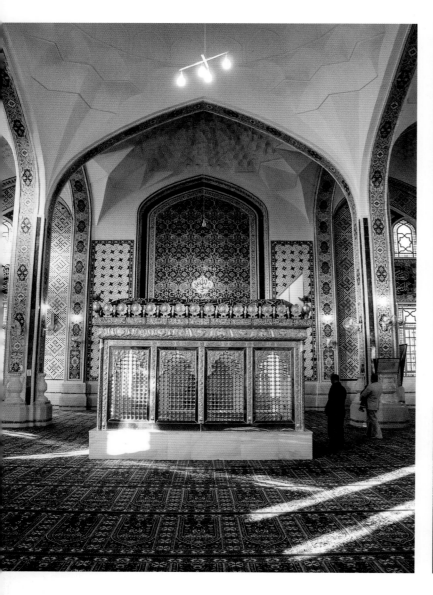
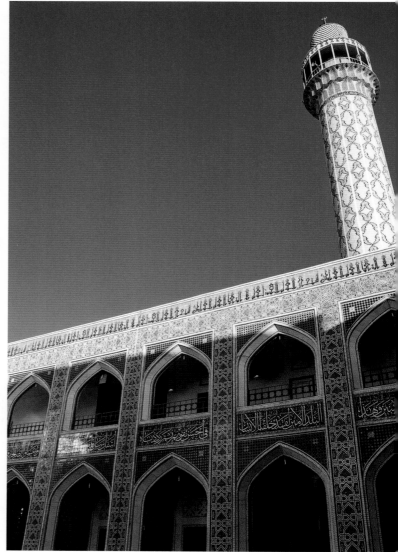

Uweis al-Qarni Mosque contained shrines dedicated to two prominent followers of Ali who perished in a historic battle near to the city in the seventh century. This modern mosque, financed by Iran, was completed in 2003 and replaced far more modest tombs. Extremist militants destroyed it in May 2014.

Jaabar Castle

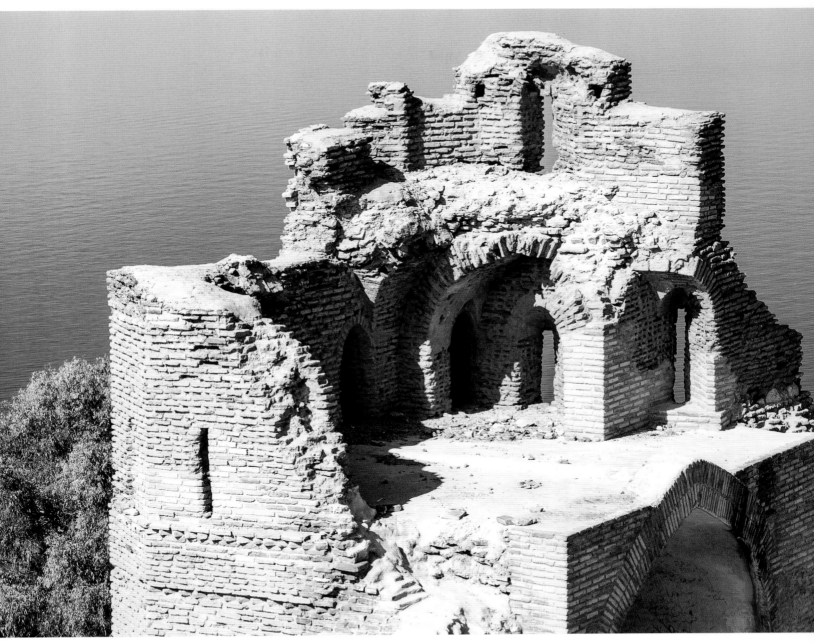

Jaabar Castle was originally built on a hilltop overlooking the Euphrates, possibly as early as the Byzantine period. Most of the building work visible today, including an impressive gateway, defensive towers, and a cylindrical minaret, dates to the 12th century rule of Nur al-Din. The construction of Syria's largest dam down river has dramatically altered the landscape: the fortress now sits atop a small island and offers sweeping views of the surrounding lake.

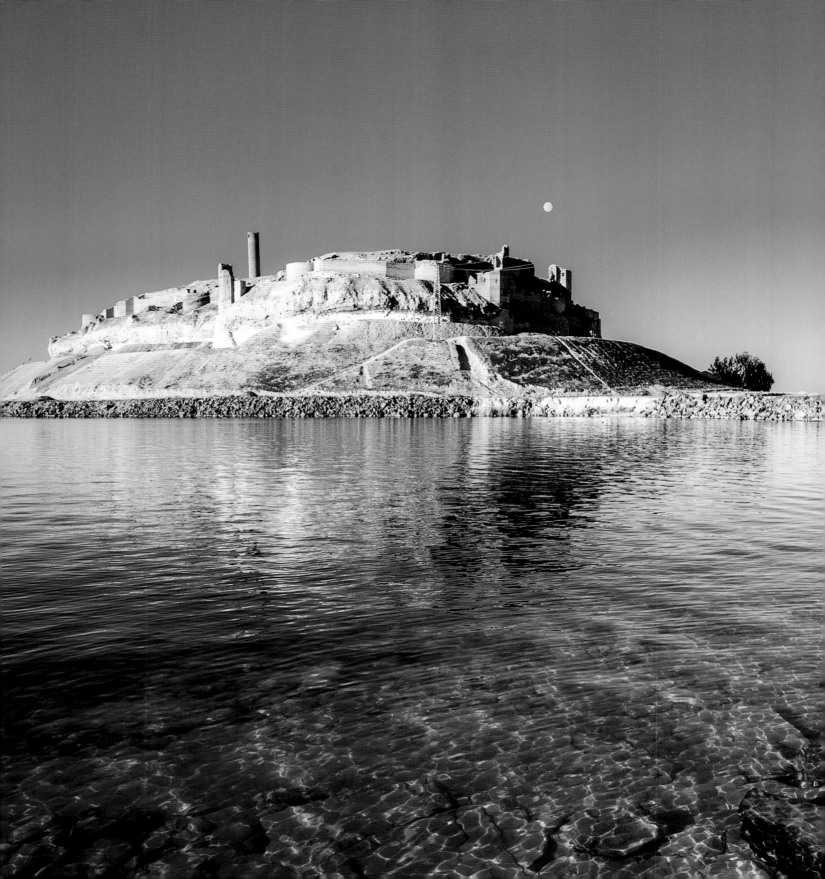

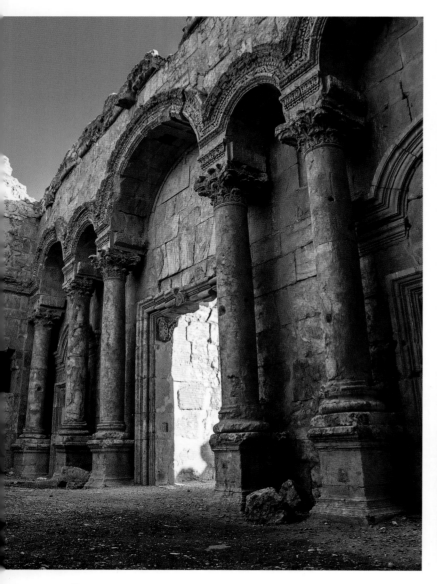

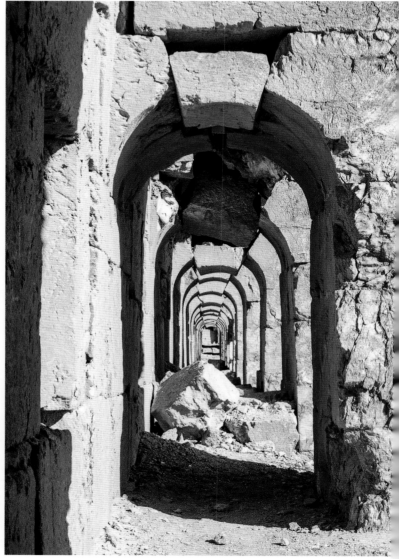

The ruined Byzantine city of Sergiopolis, known today as al-Rasafeh, is one of the most spectacular archaeological sites in Syria. The remains are massive in scale and feature several magnificent churches, enormous underground cisterns, and imposing walls, gates, and towers. The main entrance to the ancient city was its monumental northern gate.

The city's extensive fortifications, including 50 towers and nearly two kilometers of walls, were largely constructed in the sixth century CE. Sergiopolis was one of several settlements on the Byzantine frontier to be heavily fortified during the reign of Justinian in an attempt to fend off attacks from Persian armies to the east.

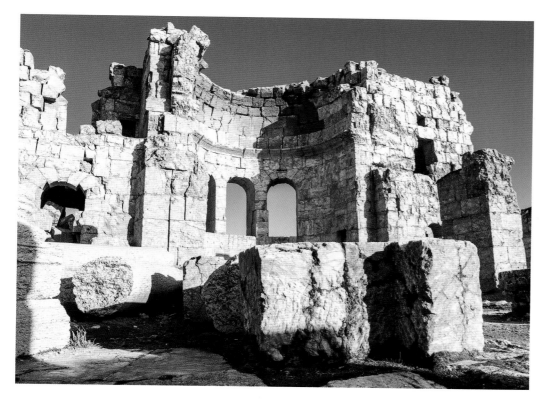

Named after Sergius, a Roman soldier martyred in 305 CE during Diocletian's persecution of Christians, the city became in important pilgrimage site. The centralized church is believed to have been constructed in the early sixth century CE.

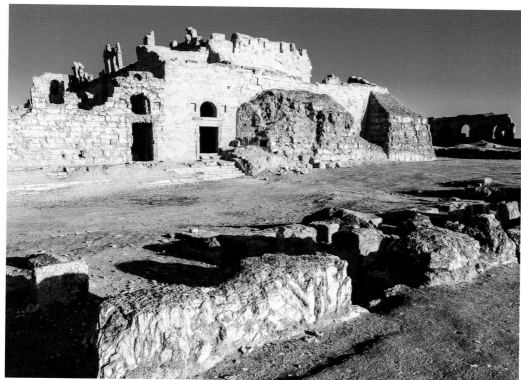

The central monument at the site, once a focal point of religious pilgrimage, is the impressive Church of St. Sergius, built at the end of the fifth century CE. It follows a traditional Byzantine basilica plan with two side aisles separated from the nave by three large semi-circular arches.

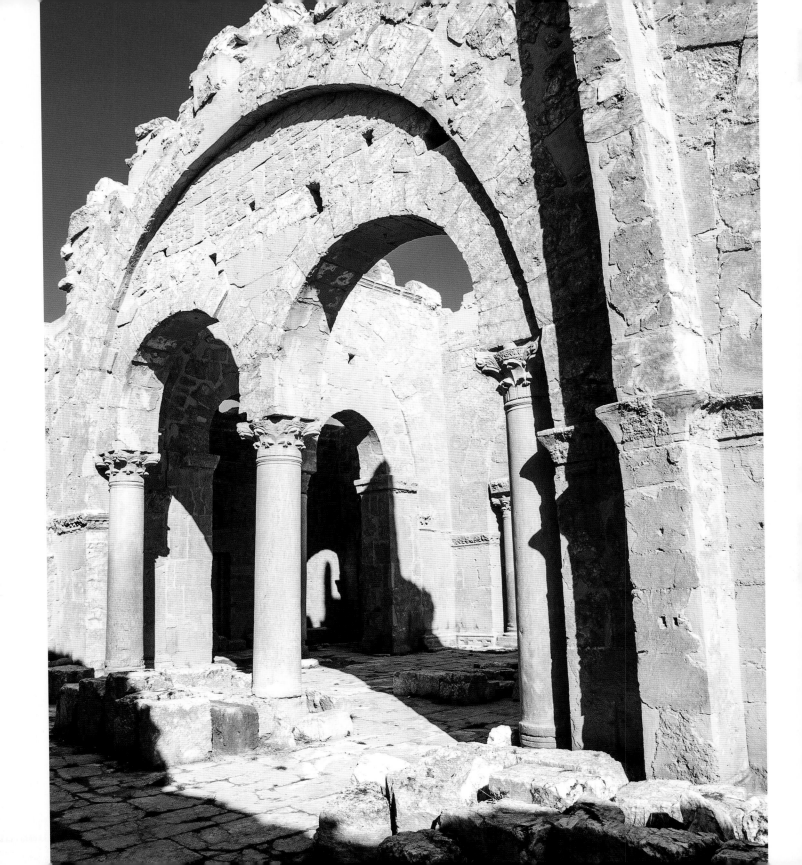

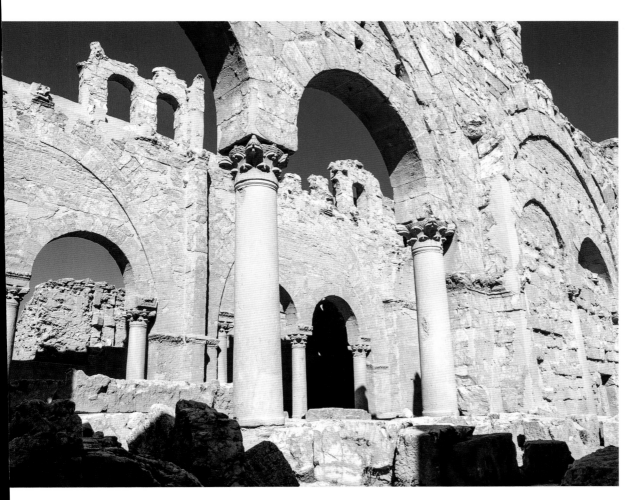

The city remained important under the Umayyads, but was neglected during the later Abbasid period. Further damage was inflicted on al-Rasafeh by a major earthquake in the late eighth century. The settlement continued to support a small population, including a sizable Christian community, until its last residents left in the 13th century.

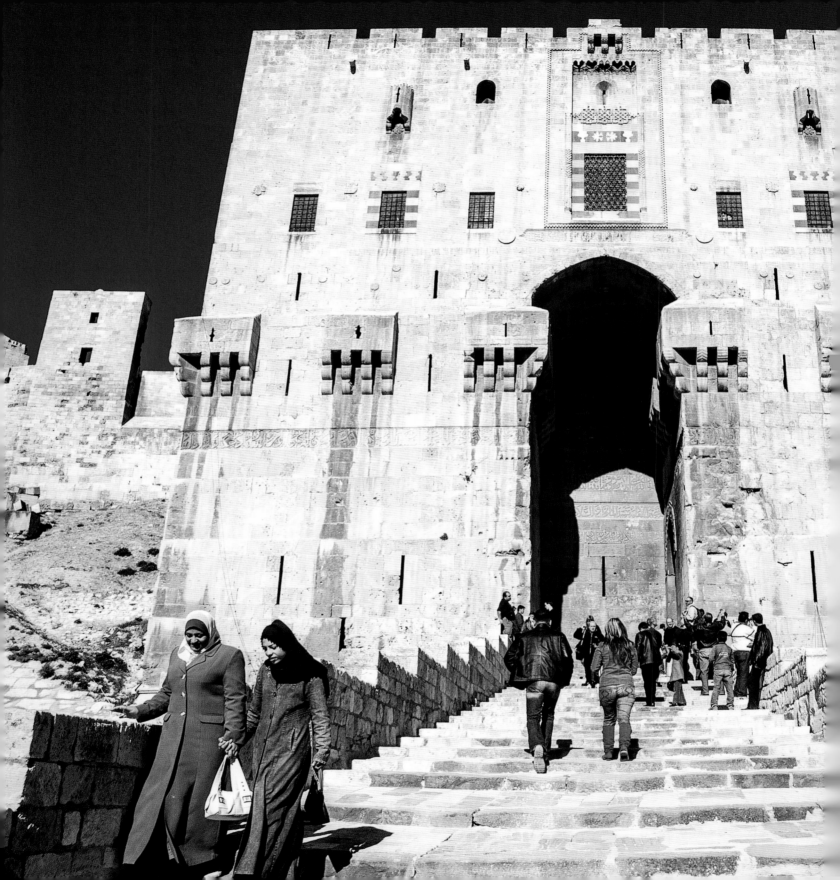

Aleppo rivals Damascus as being one of the oldest continuously inhabited cities in the world. First settled over 8,000 years ago, it has a documented history dating back to 2250 BCE. It was later ruled by a succession of kingdoms, including the Amorites, Hittites, Assyrians, Neo-Babylonians, and Persians. Aleppo was a prosperous city during the Seleucid Greek, Roman, and early Byzantine periods, at which time it was known as Beroea. Conquered by Arab Muslim forces in 637 CE, it became subordinate to Damascus and Baghdad for several centuries, but once again rose to prominence during the time of the Crusades. Seljuq and Ayyubid governors oversaw major development of the city beginning in the 12th century. They reinforced and expanded its fortifications and built several notable mosques and madrasas. In the 15th century, under the Mamluks, Aleppo became a significant trade center, leading to the establishment of its many markets and khans. The Ottomans continued this tradition, and also constructed many of the city's most beautiful mosques. Aleppo remained Syria's commercial capital, and its most populous city, until the outbreak of conflict that engulfed it in July 2012.

Aleppo was home to one of the most captivating old cities in the world. After passing through one of the monumental gateways that pierced its stone fortifications, visitors would find themselves navigating a labyrinth of stone alleyways. Wandering through these narrow streets inevitably led to entering the city's magnificent market, or souq. Totaling a remarkable seven kilometers (over four miles) in length, this market was one of the most extensive in the Middle East. Thousands of vendors sold a wide range of goods from small storefronts, with distinct areas of the market specializing in different products. Fragrant spices, fresh produce, locally made soaps, colorful textiles, and shiny gold and silver jewelry were among the items commonly for sale. Immersing oneself in the souq was the highlight of any tour of Aleppo, allowing the visitor to experience a mercantile tradition that had changed little over the centuries. The market was made even more intriguing by its cultural diversity, most vividly represented by the variety of traditional dress worn by villagers who would come to the city from the surrounding countryside.

حلب

Aleppo

Found throughout the old city's commercial hub were enormous khans that once served as hotels and distribution centers for large caravans of visiting merchants. In recent centuries, these were repurposed as offices, workshops, factories, and storage facilities for local businesses, but visitors could often gain access to admire their grandiose architecture. The dozens of historic mosques found throughout the old city were another major attraction. Constructed during several different periods, they reflected a wide range of architectural styles. The Seljuqs, Ayyubids, Mamluks, and Ottomans all left their mark on the city's places of worship. Many of these mosques featured delightful courtyards, graceful minarets, and elegantly decorated interiors. They provided tranquil and relaxing public spaces in a city that was otherwise often busy and congested. While the old city of Damascus had been largely transformed in recent times into a destination for leisure and entertainment, Aleppo's old city maintained its focus on trade and commerce. It was often crowded, noisy, chaotic, and even a bit dirty. That was part of Aleppo's charm, as any exploration of its streets, markets, khans, mosques, madrasas, and churches was an experience in living history.

Dominating Aleppo's old city is its massive and imposing citadel. Located on a hill east of the market, the site has been occupied since at least the third millennium BCE. It was already being used for defensive purposes when the Hittites conquered the city from the Amorites in the 16th century BCE. The Seleucid Greeks constructed fortifications at the site, as did the Romans and Byzantines. Most of what has survived to modern times, however, was based on a major reconstruction of the castle undertaken during the Ayyubid period. Between the 13th and 15th centuries, successive Mongol attacks inflicted significant damage on the citadel, but the Mamluks later repaired that damage. The castle's remarkable entrance gateway, approached by a massive stone bridge that spanned a surrounding moat, is one of the most spectacular fortifications in the Arab world. Within the citadel walls are the remains of the recently excavated Temple of Hadad (24th century BCE), two mosques (previously Byzantine churches), an Ayyubid palace and bath, and a Mamluk palace and throne room.

Many of Aleppo's churches were seized in the 12th century CE in retaliation for atrocities committed by the Crusaders. Some were then converted into mosques. Most of the city's Christian community resettled northwest of the city walls, founding the neighborhood of Jdeideh. This was one of the most charming and peaceful areas of the city to explore, a maze of narrow lanes and vaulted passageways. Hidden away behind its austere stone walls and modest doorways, the neighborhood featured many extravagant Ottoman-era residences, several of which had been converted into museums and attractive restaurants and hotels. The neighborhood was home to the city's oldest functioning churches, the earliest dating to the 15th century. One of my most memorable experiences in Aleppo was visiting the numerous churches of Jdeideh during the Easter celebrations of 2006.

I also found it interesting to explore the more modern neighborhoods of Aleppo, which often provided a dramatic contrast to the historic old city. Modern Aleppo was developing rapidly, with new shopping centers, nightclubs, concert venues, fashionable cafes, and restaurants opening regularly. European clothing stores, Western-style fast food joints, and crowded internet cafes lined the streets of the most trendy neighborhoods. Aleppo was a city trying to find its identity, balancing between conservative and progressive, traditional and modern. It was a socially, economically, religiously, and ethnically diverse city. While predominantly Sunni Muslim, Aleppo was also home to Syria's largest Christian population, once estimated to be as high as 250,000. That community itself was quite varied, with over a dozen different religious denominations represented. Many of Aleppo's Christian residents were of Armenian descent, and the city had maintained a sizable Armenian population for several centuries. Aleppo also had a substantial Kurdish population focused around the northern neighborhoods of al-Sheikh Maqsoud and al-Ashrafiyeh. Many of the city's Kurdish residents hailed from the northern part of the Aleppo province, a rural area with many predominantly Kurdish towns and villages.

The consequences of Syria's ongoing conflict have been devastating for Aleppo. More than one million people have been displaced from their homes and the old city has suffered catastrophic destruction. Tragically, few of Aleppo's historic monuments have survived the conflict unscathed. Several old city mosques have been entirely destroyed by underground tunnel bombs. Many others have seen considerable damage, with their courtyards and prayer halls struck by mortar fire and their minarets damaged by artillery. Similar destruction has been inflicted on many of the old city's historic residences, markets, khans, public baths, fortifications, and tombs, as well as the churches of Jdeideh. Aleppo's citadel has been a frequent target of artillery and mortars and has also suffered significant damage. Restoring the old city of Aleppo will present perhaps the greatest challenge in Syria's postwar reconstruction, and some of its greatest monuments may have been permanently lost.

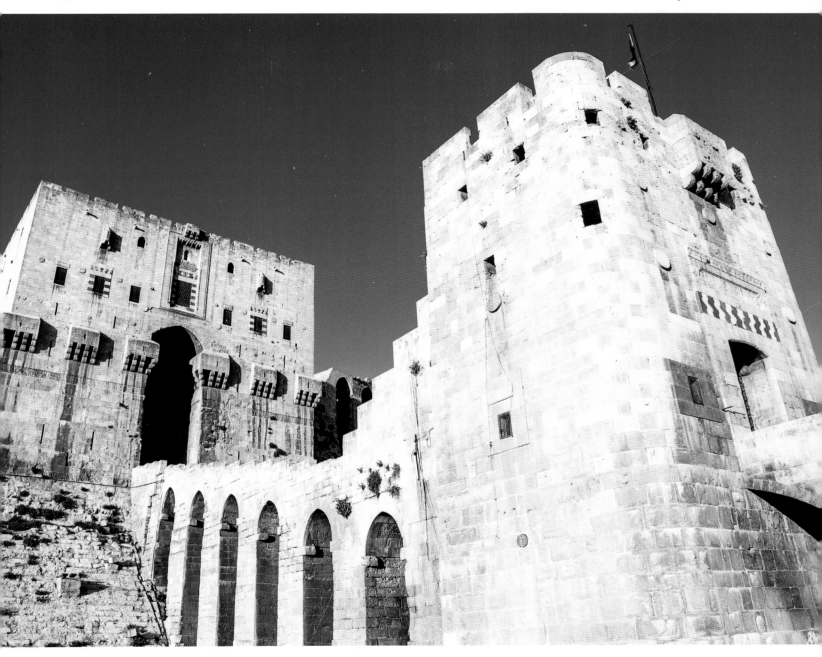

Aleppo's citadel, situated near the center of the old city, is its most spectacular monument. The hilltop site has been inhabited since at least the third millennium BCE: one recently excavated temple was dated to the 24th century BCE. The fortifications now visible were mostly constructed in the Ayyubid period, with significant additions made in the Mamluk era.

The castle's entryway was designed to make any assault on the main gateway exceptionally difficult: it contained several ninety-degree turns and was thoroughly exposed to defensive positions above it. The main gateway featured intricately carved calligraphic inscriptions and a remarkable metal reinforced door.

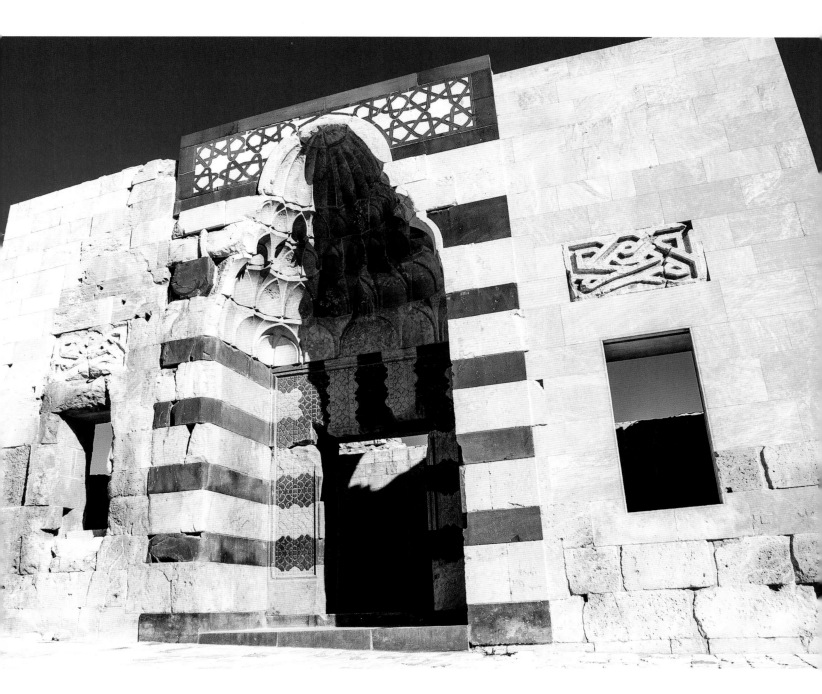

Within the castle walls are extensive remains of a throne room, palace, baths, mosques, and many earlier structures that were only partially excavated. The beautifully decorated facade of the Ayyubid palace remains well preserved, as do the castle's two mosques, converted from earlier Byzantine churches.

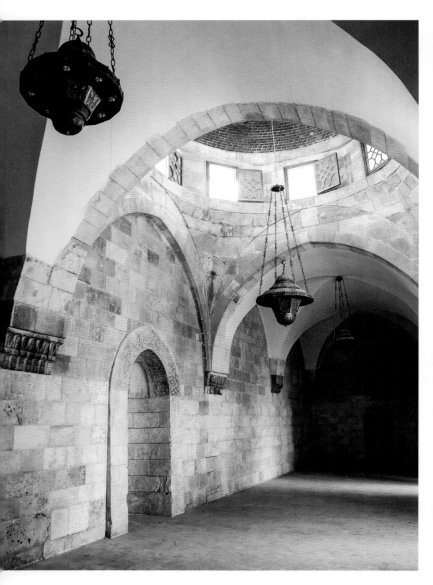
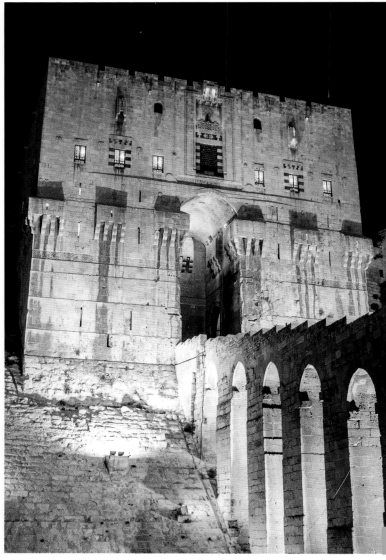

Perhaps the greatest threat to Aleppo's citadel in its nearly 5,000 year history has been the armed conflict that has engulfed the city since 2012. The castle has once again been put to military use, and as a result has been the target of several mortar and tunnel bombing attacks. As of publication the citadel, particularly its monumental gateway, remains at great risk.

Markets

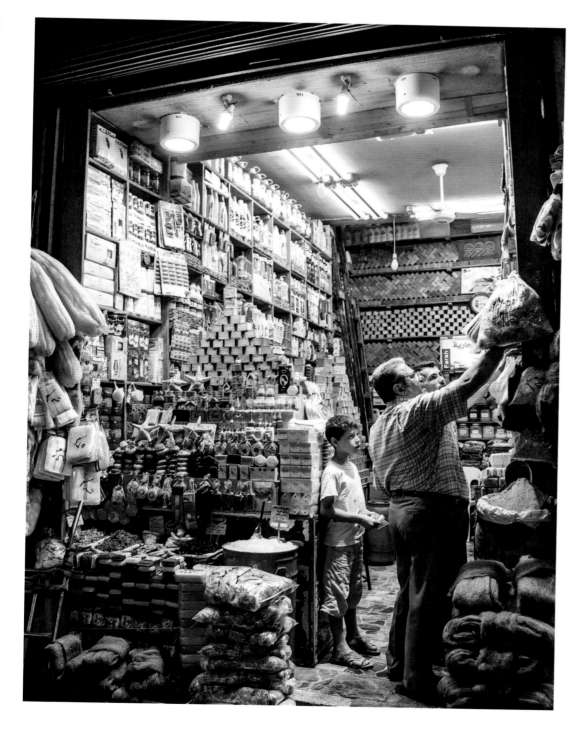

Aleppo's extensive maze of covered markets was the largest in the country, totaling a remarkable seven kilometers in length. This marketplace was central to Aleppo's status as the commercial capital of the country. Exploring the souq was long considered a highlight of any visit to Syria, leaving a lasting impression of the city.

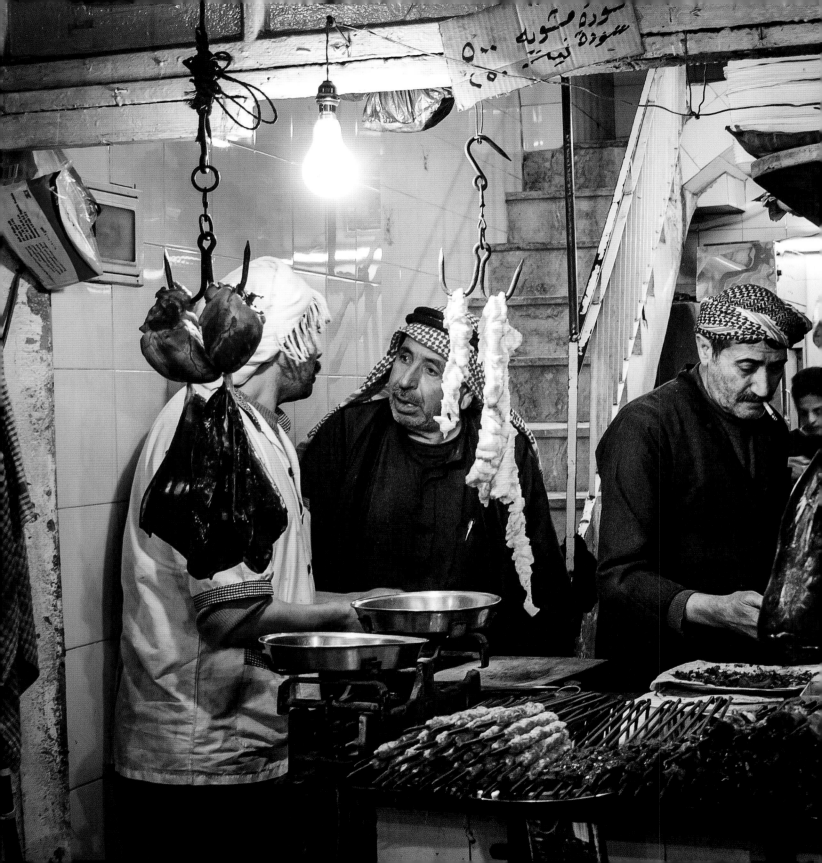

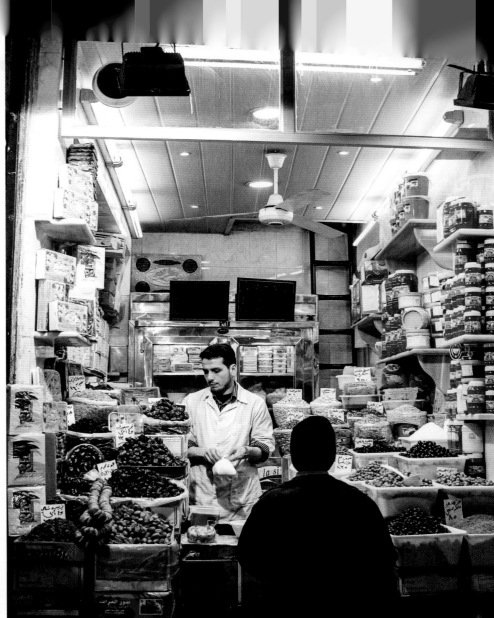

Separate areas of the market specialized in different kinds of products, whether textiles, carpets, gold and jewelry, spices, meat and produce, or locally made soap. Sandwich shops, fresh juice stands, bakeries, and modest eateries could also be found throughout the souq.

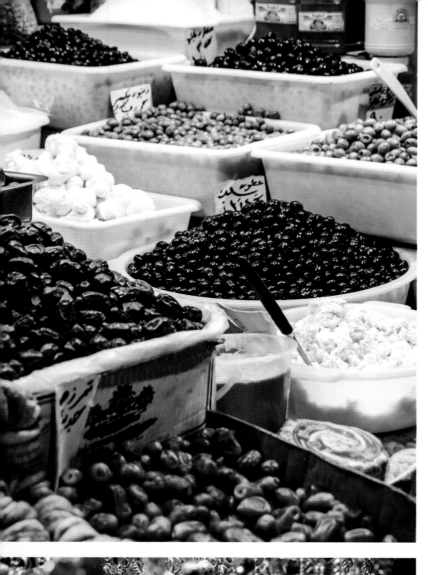
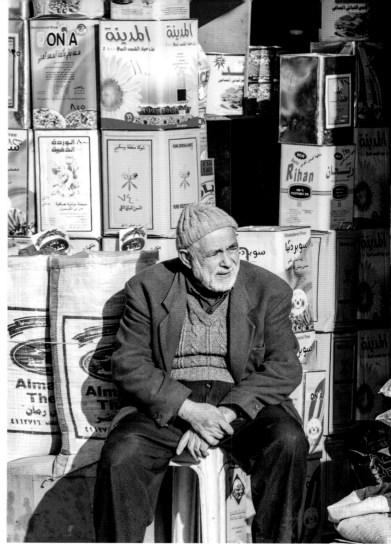

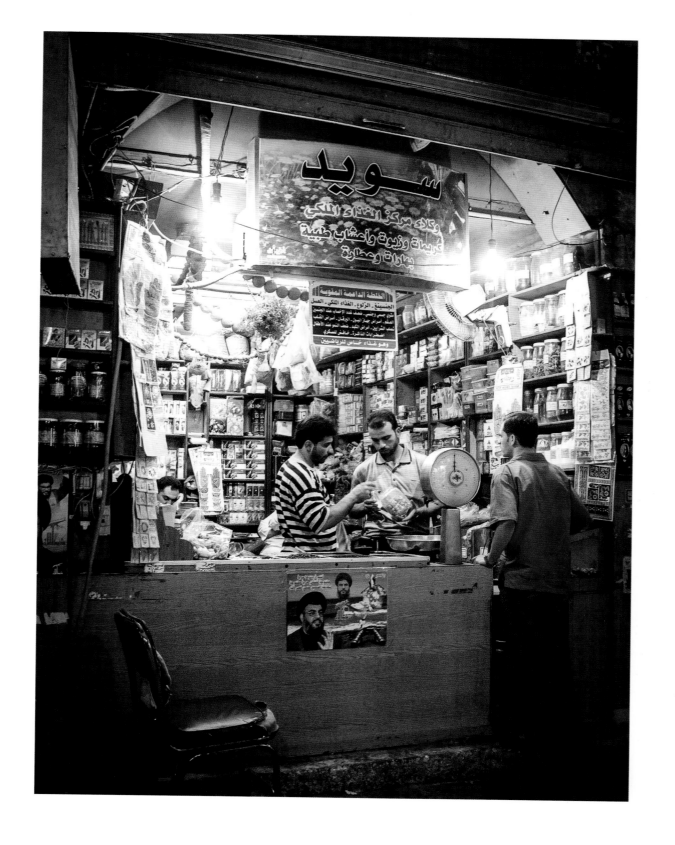

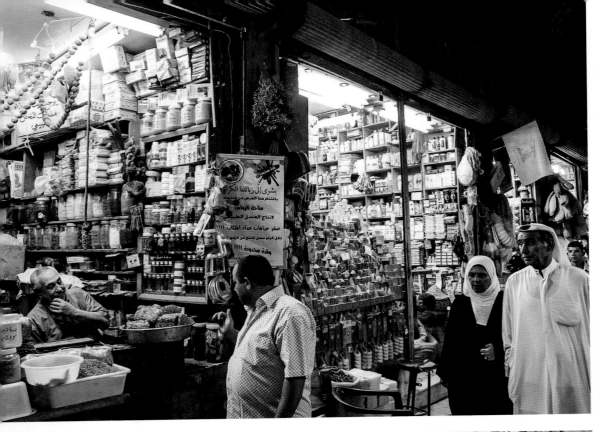

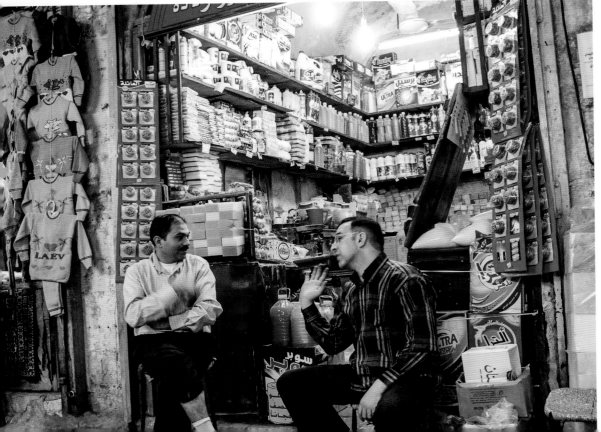

While Aleppo's market was frequently crowded, noisy, and chaotic, shopkeepers would still find time to relax when business was slow. With most shops being family-run for generations, there was a sense of community among the merchants, who would often spend their free time discussing the issues of the day.

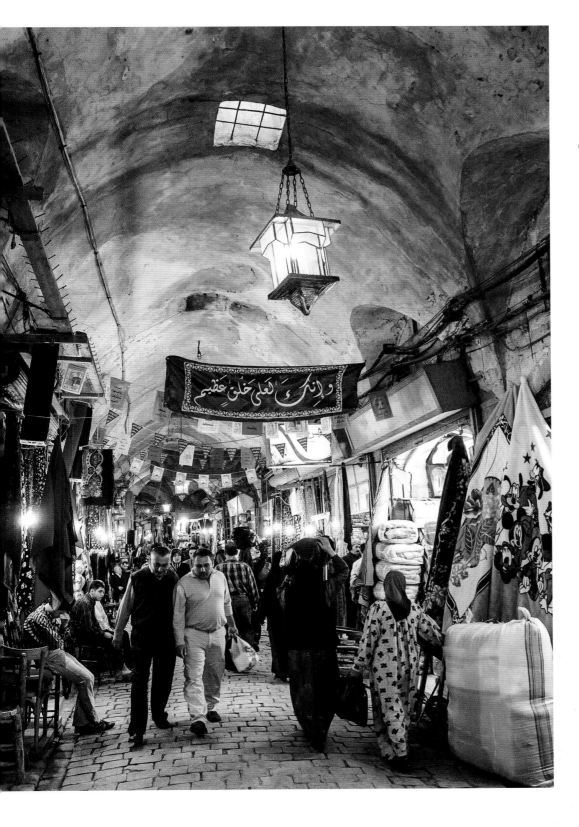

Aleppo's market has been heavily impacted by the armed conflict that has devastated the city since 2012. Extensive areas of it have been destroyed by fire, artillery, and tunnel bombing. Restoring the market to its prewar condition will be a tremendous challenge.

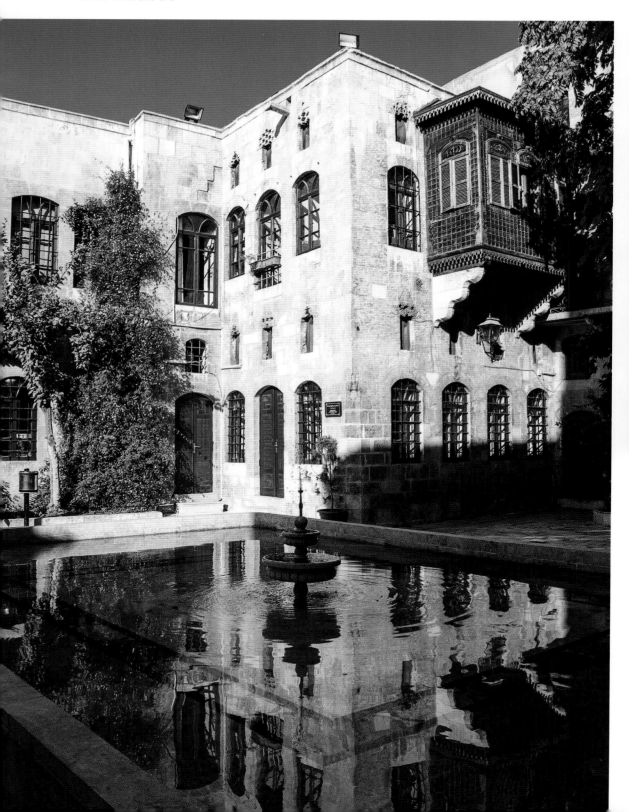

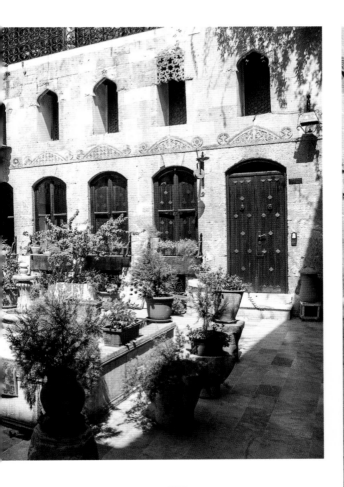

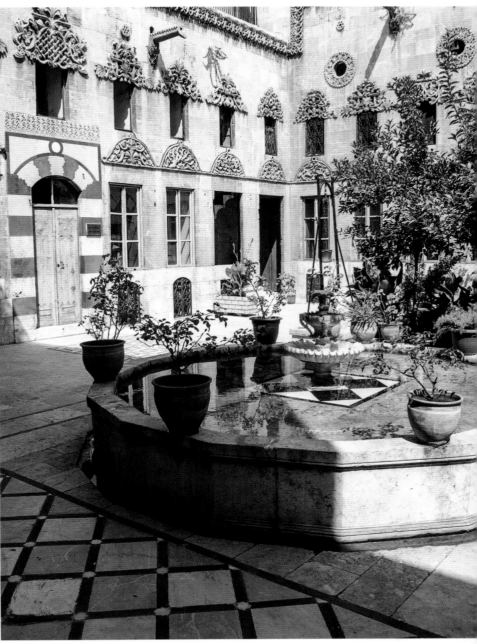

Aleppo has long been a prosperous city with a wealthy merchant class, and this is reflected in its lavish domestic architecture. In recent decades, many of these once private residences were converted to offices, museums, restaurants, and hotels, providing the public an opportunity to appreciate their beauty.

Jdeideh

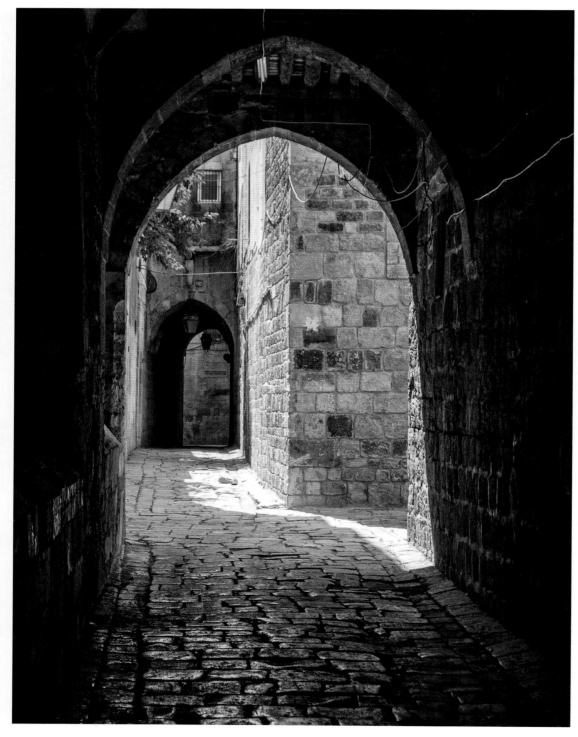

Exploring the maze of small alleyways in the city's historic neighborhoods, such as the predominantly Christian district of Jdeideh (seen here), was one of Aleppo's greatest attractions. Most of Aleppo's buildings were made of stone, providing a contrast to the mud and straw construction traditionally used in Damascus.

Armenian Orthodox Cathedral of the Forty Martyrs

كاتدرائية الأربعين شهيد
للأرمن الأرثوذكس

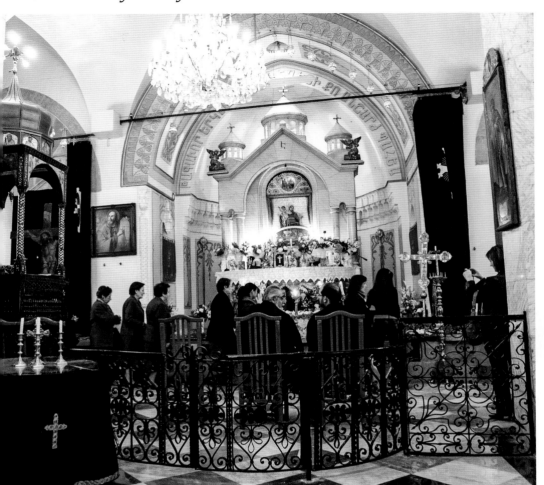

Aleppo's earliest churches were converted to mosques during the Crusader period, but several historic churches could be found in the Jdeideh district. The Armenian Orthodox Cathedral of Forty Martyrs, dating back to 1491, was one of the city's oldest functioning churches. It was badly damaged by mortar attacks during the ongoing conflict.

Syriac Catholic Church of St. Asia al-Hakim كنيسة مار اسيا الحكيم السريان الكاثوليك

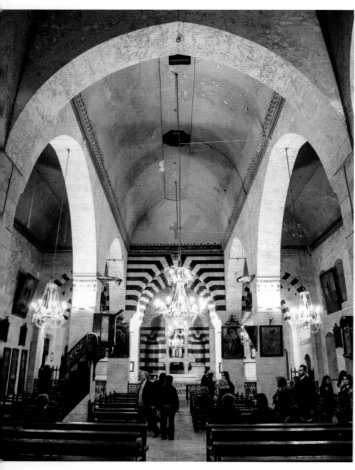

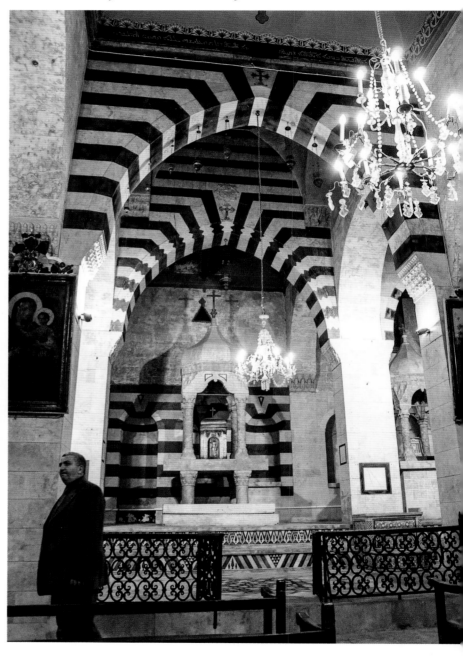

Not far away, the Syriac Catholic Church of St. Asia al-Hakim was constructed in 1500. With a simple architectural plan and restrained decoration, it is one of the most charming and attractive churches in the city.

Greek Catholic Church of Our Lady

كنيسة السيدة للروم الكاثوليك

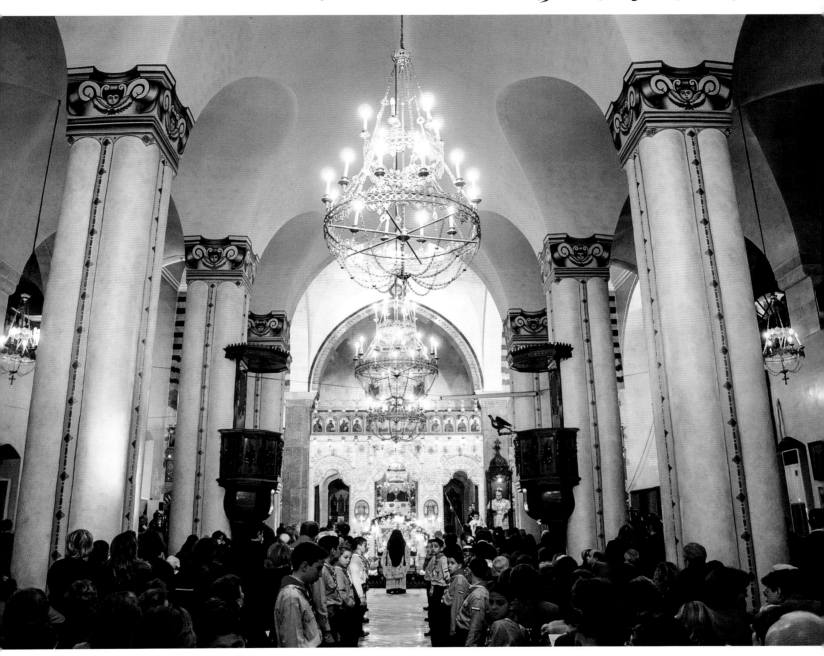

The relatively modern Greek Catholic Church of Our Lady, completed in 1843, is one of the largest churches in the Jdeideh district. It features an ornately decorated wall dividing the chancel from the nave.

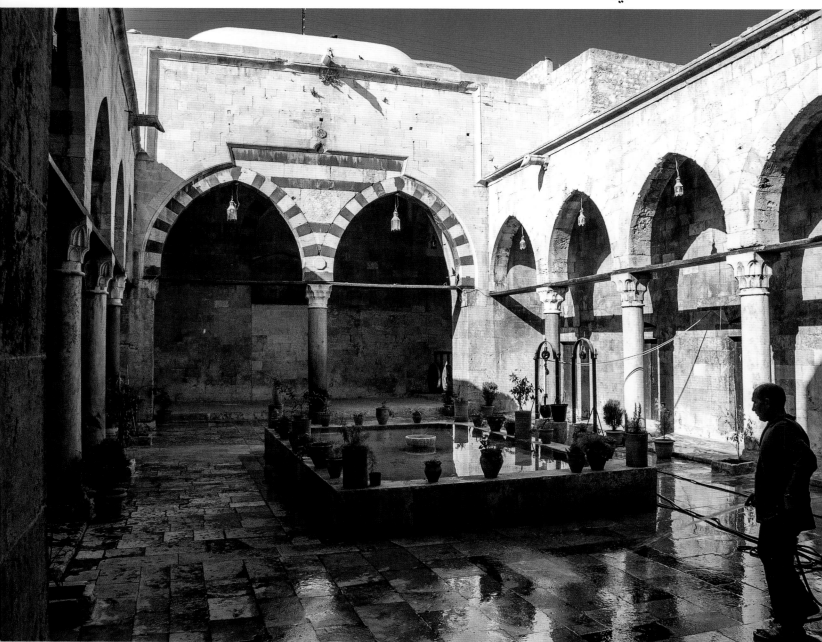

The fascinating Mamluk-era complex of al-Bimaristan al-Arghuni served as a psychiatric hospital from the 14th century until the early 20th century. Located in the old city, it provided care and treatment for individuals with a variety of mental illnesses. It features an elaborately decorated carved stone entryway.

Mashhad al-Saqat

مشهد السقط

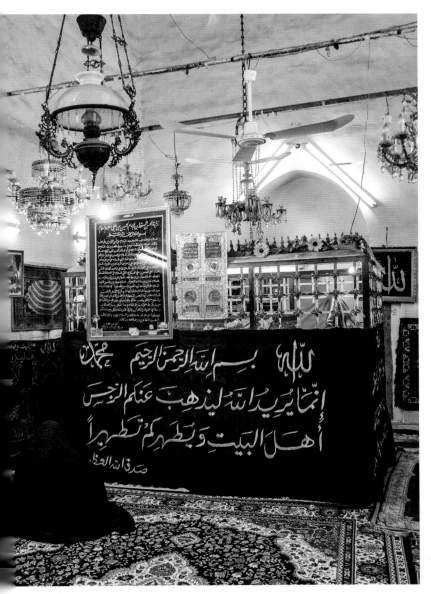

Mashhad al-Saqat, on the eastern slope of Jebel Joushan with magnificent views of Aleppo, was an important place of pilgrimage for Shiite Muslims. According to tradition, as the prisoners of the historic Battle of Karbala (Iraq) were being transported through Aleppo, one of the wives of Hussein had a miscarriage and the deceased child was buried at this site. The current shrine dates from the 12th and early 13th centuries.

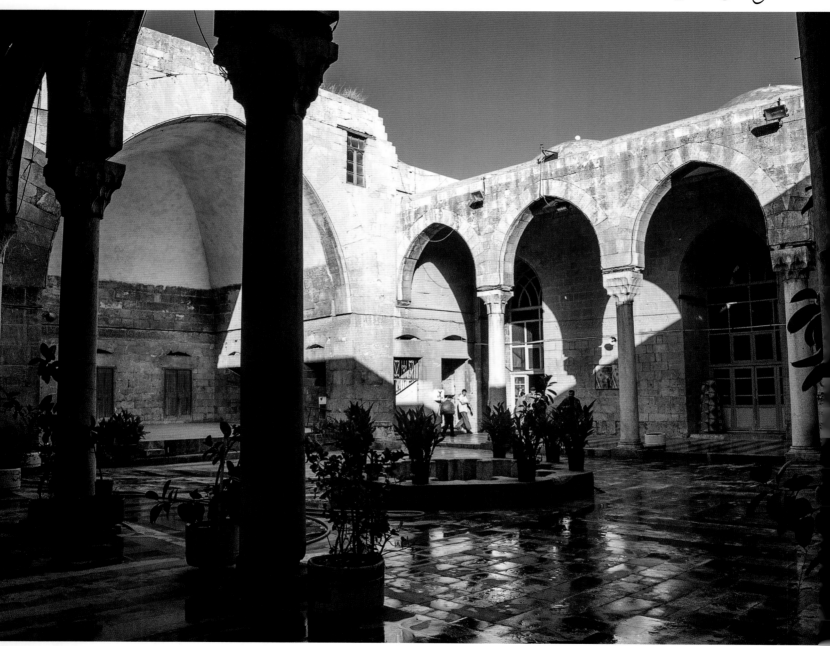

Al-Fardous Mosque, also a religious school, was constructed in the early 13th century. This attractive mosque featured a central courtyard and fountain with a large iwan on its northern side. The prayer hall, to the south, has a beautifully carved stone mihrab. Significant damage has been inflicted on the mosque during the ongoing conflict.

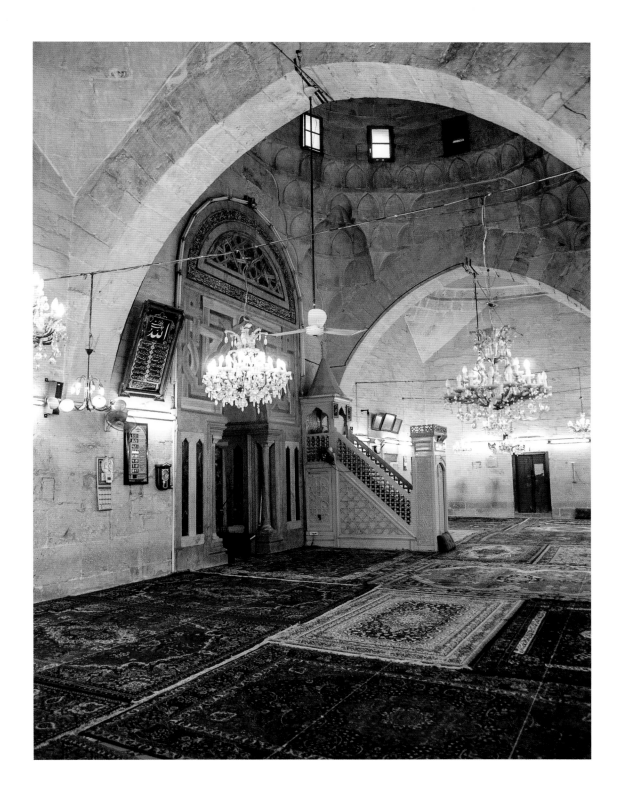

al-Othamaniyeh Mosque

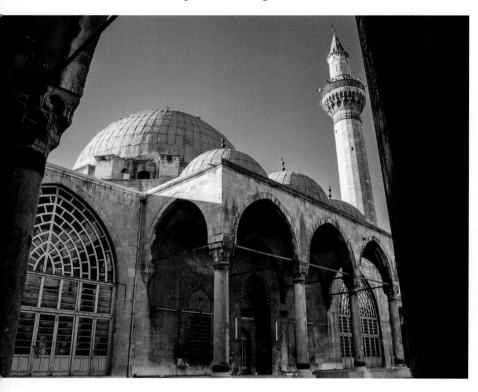

Al-Othamaniyeh Mosque is one of several places of worship constructed during the Ottoman era. Built in the 1730s, it was part of a larger complex that included a religious school. Student quarters surrounded the central courtyard on three sides, with the mosque to the south. The mosque's interior was particularly impressive.

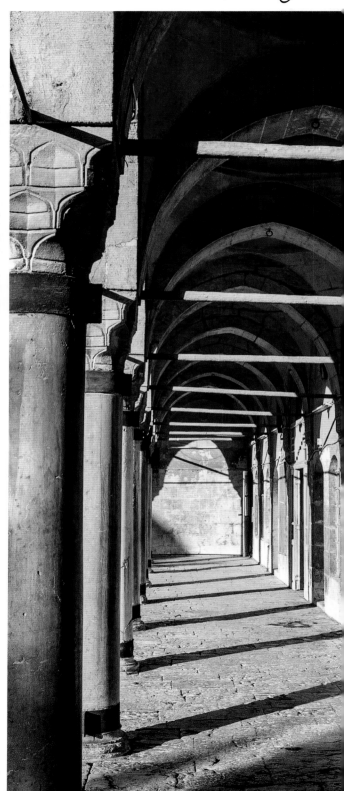

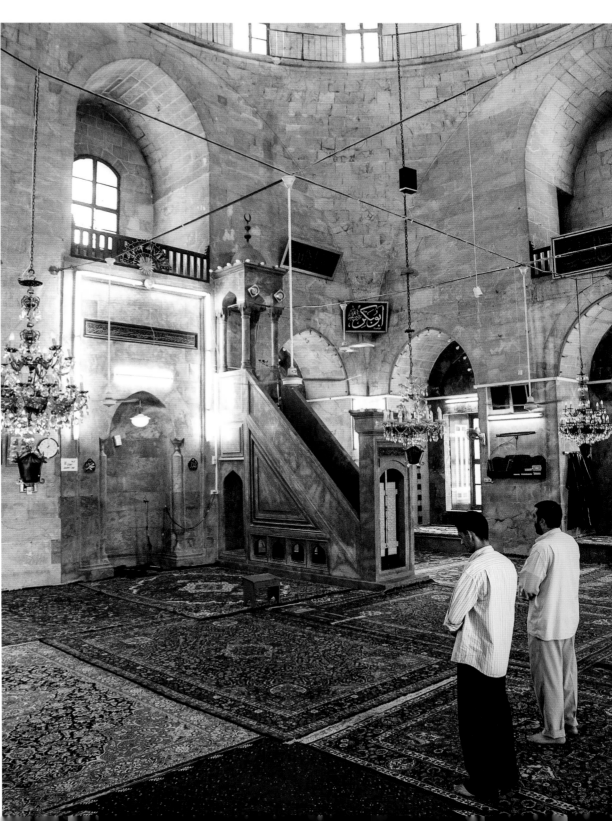

al-Atroush Mosque

Al-Atroush Mosque is one of the finest Mamluk-era mosques in Aleppo's old city. Built in the early 15th century, it has an austere but peaceful courtyard with a prayer hall to the south. The tall octagonal minaret was severely damaged during the recent fighting in the city, which completely destroyed its upper levels.

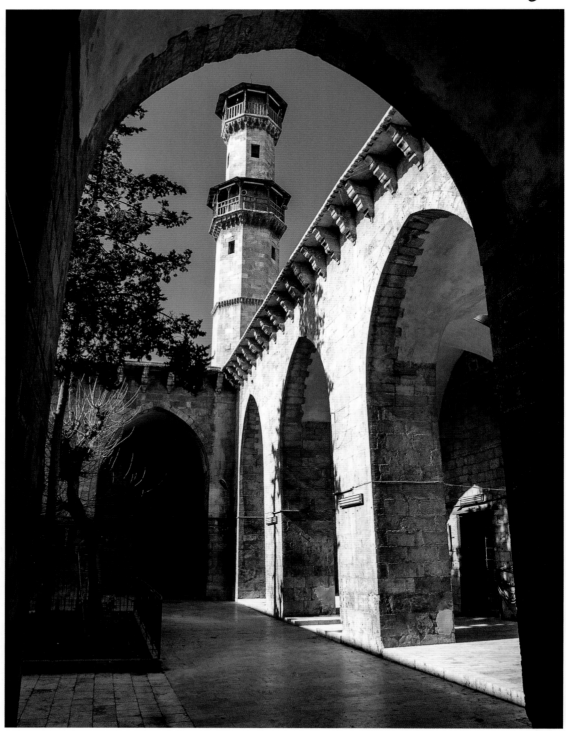

al-Sultaniyeh Mosque

<div dir="rtl">جامع السلطانية</div>

The small but charming al-Sultaniyeh Mosque was completed in the early 13th century and housed the tombs of an important ruling family of Aleppo during the Ayyubid period, the al-Ghazis. The mosque's prayer hall and mausoleum were completely destroyed by a tunnel bombing in December 2014.

al-Khosruwiyeh Mosque

المدرسة الخسروية

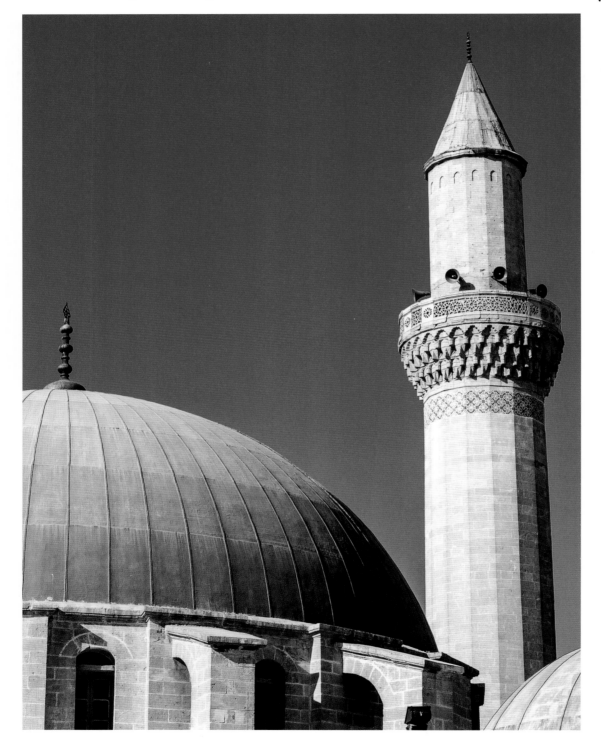

Al-Khosruwiyeh Mosque, also a religious school, was built in 1537 and was the oldest Ottoman-era mosque in Aleppo. Constructed in a distinctly Turkish style, the building featured a large, single-domed prayer hall preceded by a portico topped by five smaller domes. This beautiful mosque was entirely destroyed by a tunnel bombing in the summer of 2014.

al-Bahramiyeh Mosque

<div dir="rtl">جامع البهرمية</div>

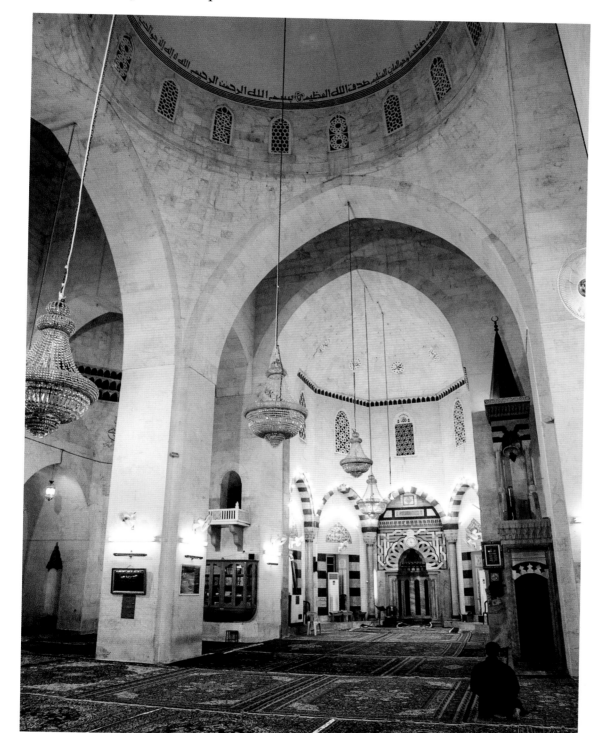

Al-Bahramiyeh Mosque was constructed in 1583 and featured perhaps the most attractive interior of all the Ottoman-era mosques in Aleppo.

al-Aadiliyeh Mosque

<div dir="rtl">جامع العادلية</div>

The nearby al-Aadiliyeh Mosque also has a beautifully decorated interior that includes a rare use of stained glass. It was built in the middle of the 16th century. The building suffered damage during the ongoing fighting in the city, with portions of the northern facade and the minaret having been destroyed by artillery fire.

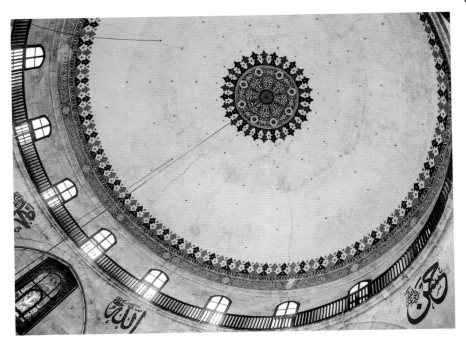

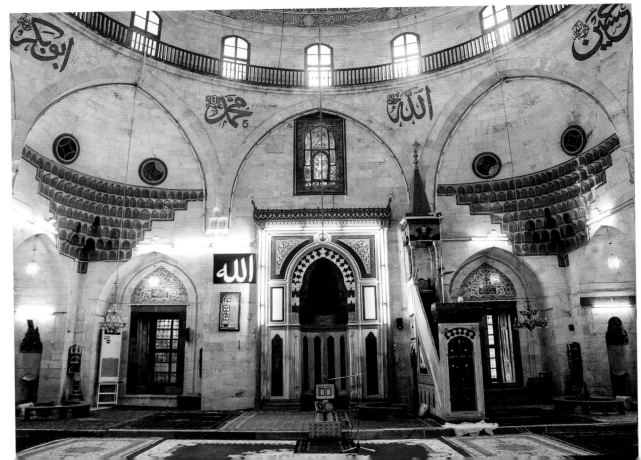

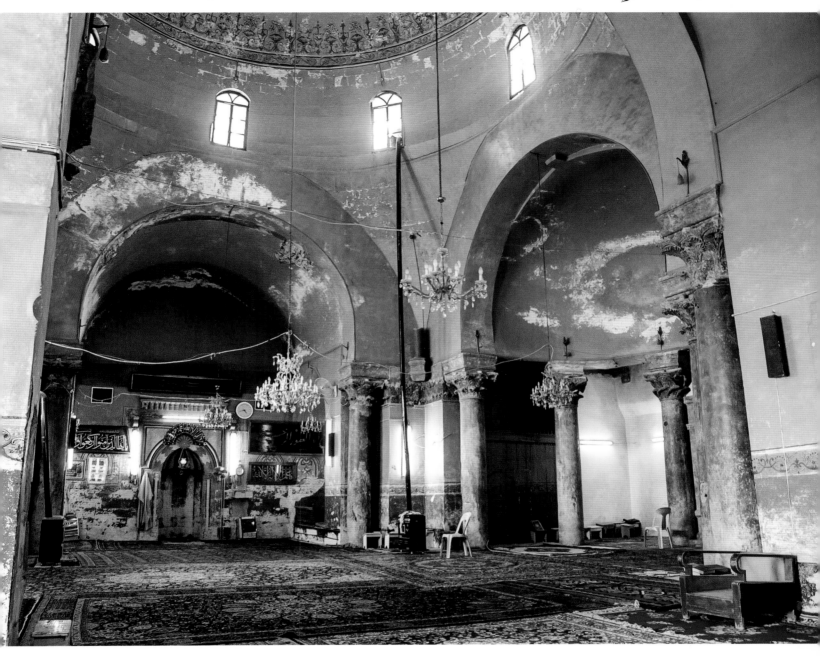

The Cathedral of St. Helen was originally constructed in the sixth century CE and remained in use for several centuries until being seized in 1124 under Nur al-Din. It was converted into a mosque and religious school, and is now known as al-Madrasa al-Halawiyeh. The interior still prominently features many Byzantine architectural elements.

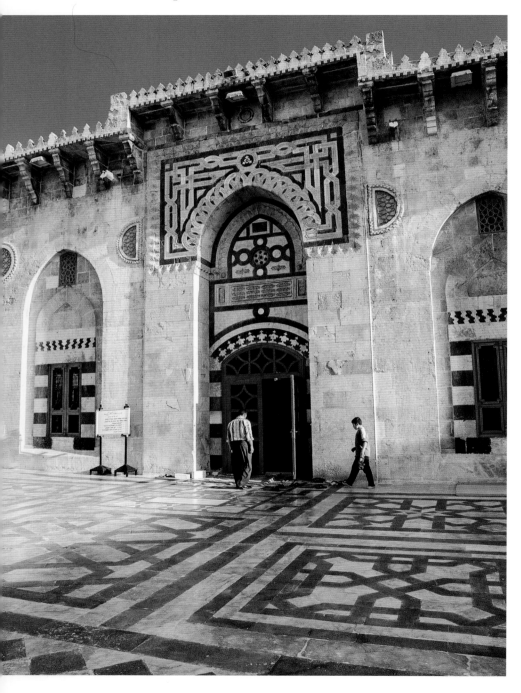

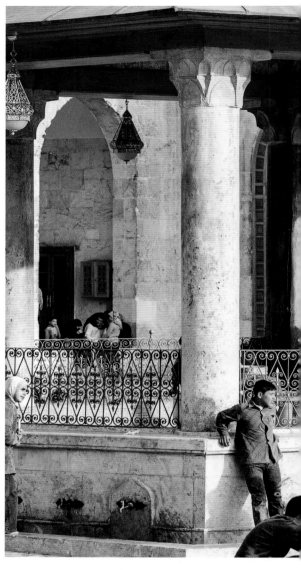

The Great Mosque of Aleppo is the largest and best known religious edifice in the old city. The first mosque at the site was constructed by the Umayyads in the early eighth century, but most of the present structure dates to the later Seljuq and Mamluk periods. Built around a broad rectangular courtyard, it features a large prayer hall to the south and arcaded halls on the remaining three sides.

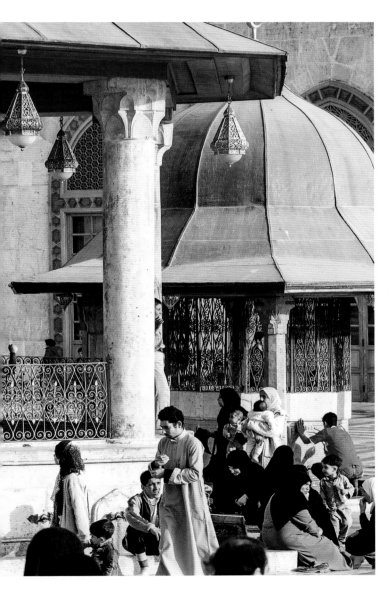

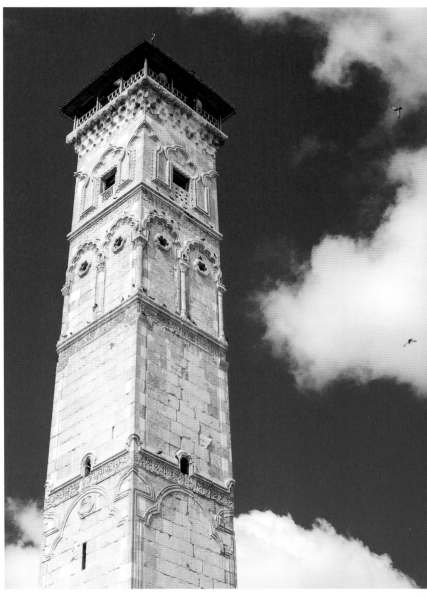

The Great Mosque featured a distinctive, intricately detailed minaret, designed by a local architect and constructed in the late 11th century. Minarets built during the later Ayyubid and Mamluk periods were frequently modeled after it.

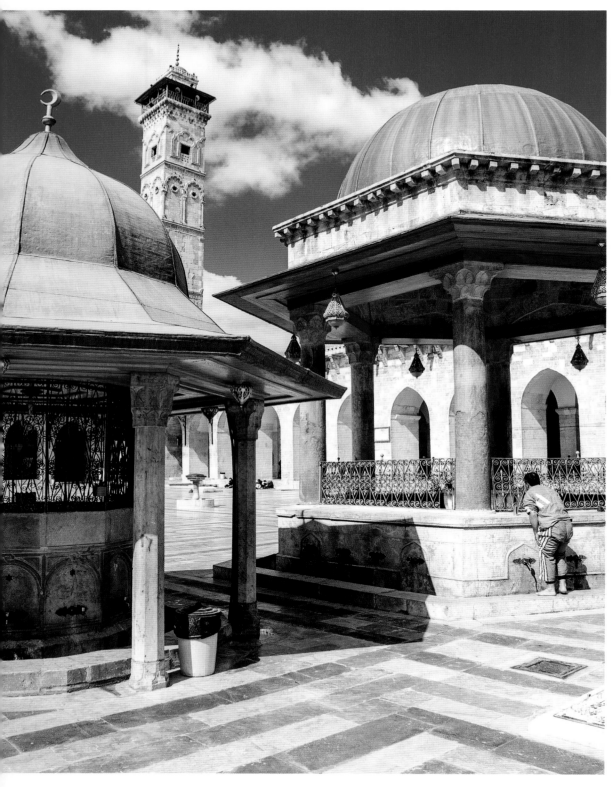

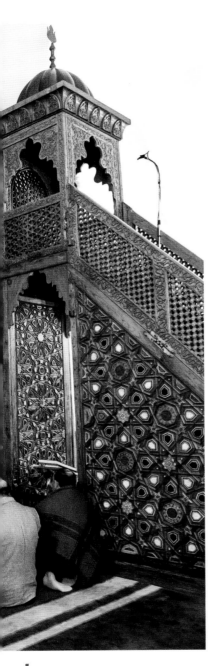

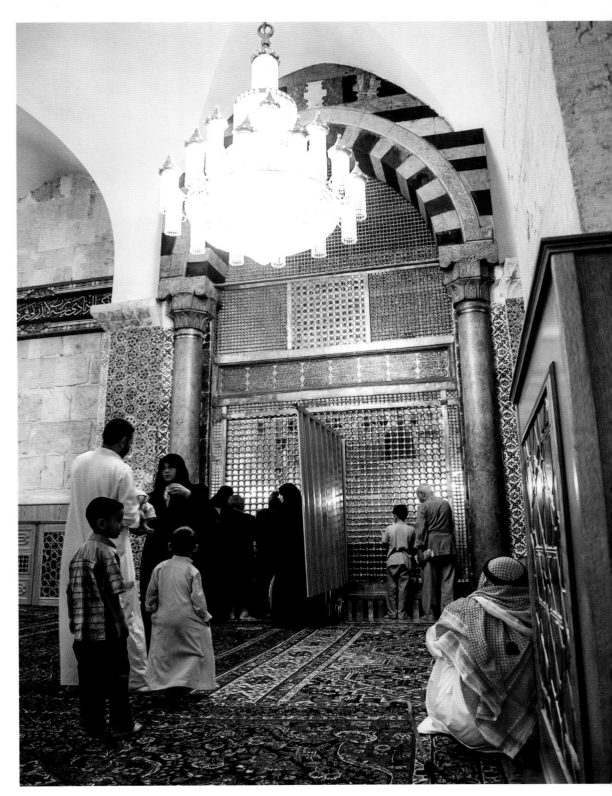

Inside the Great Mosque was a tomb that, according to local tradition, was the burial place of Zechariah, the father of John the Baptist. It also housed a beautifully carved wooden minbar dating to the 15th century.

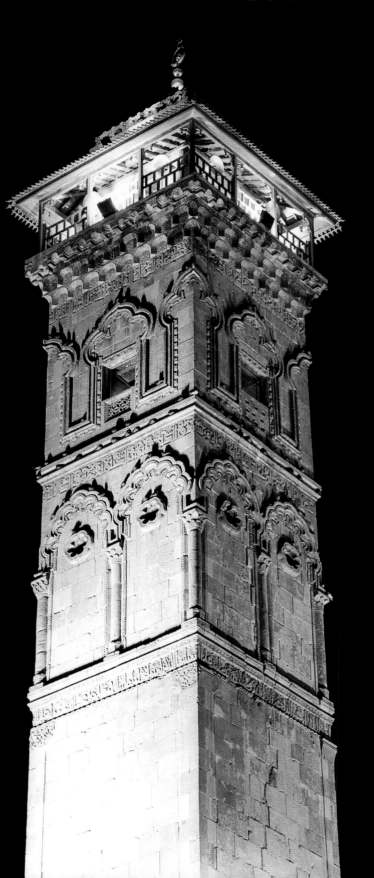

The Great Mosque of Aleppo witnessed serious clashes after the outbreak of violence in the city began in 2012. Its magnificent minaret was entirely destroyed in April 2013, and the prayer hall suffered damage from fire, artillery, and tunnel bombing. Restoring the mosque after hostilities have subsided will pose a substantial challenge.

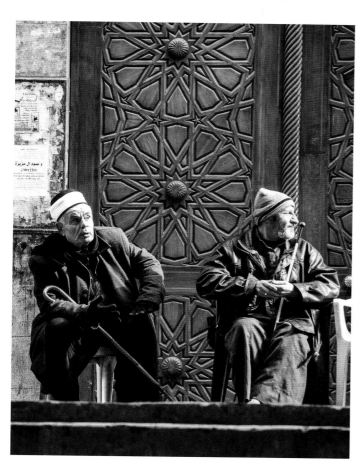

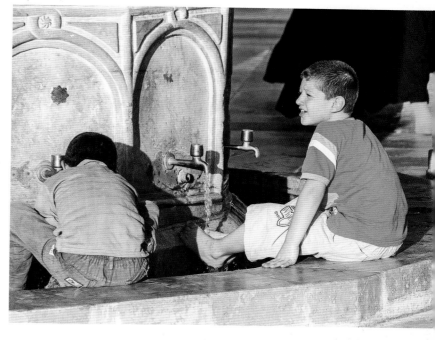

Syrians from nearby neighborhoods and from the more distant countryside would visit Aleppo's Great Mosque, making it an intriguing place to people watch.

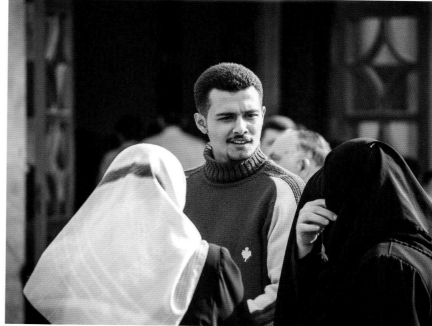

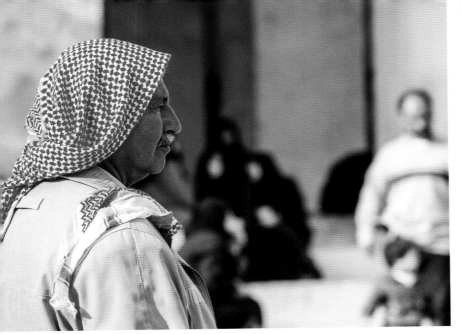
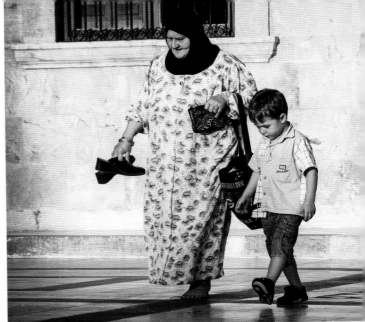

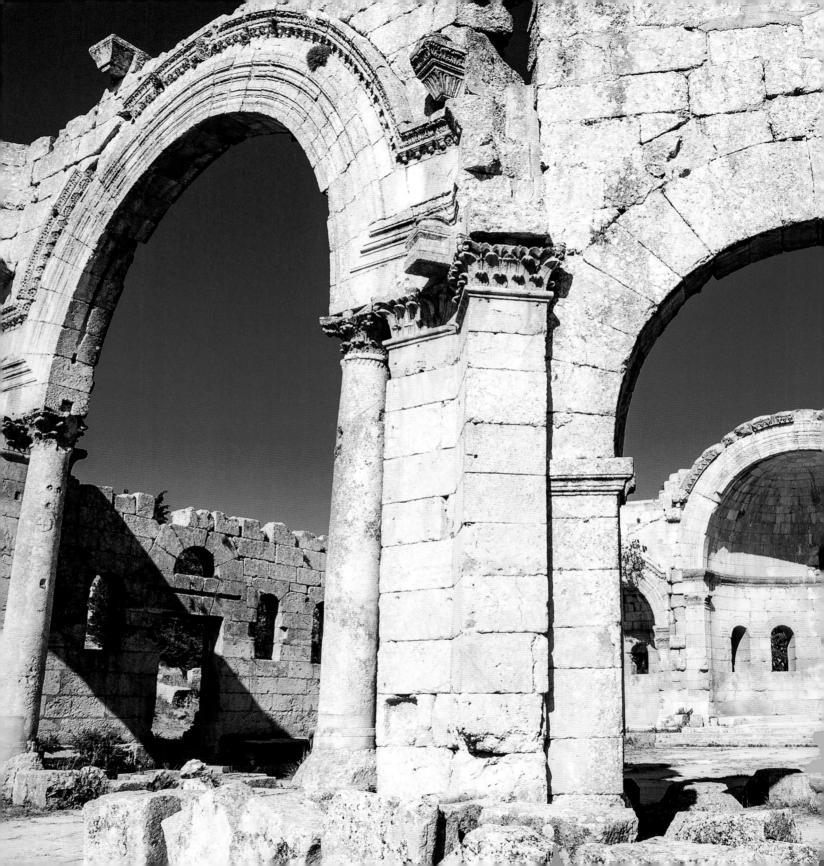

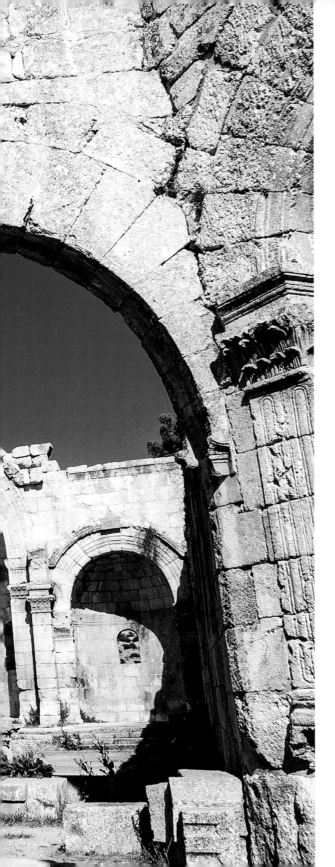

The countryside of Aleppo and the neighboring Idleb province contain a rich collection of archaeological sites. The most numerous and intriguing of these are the remains of hundreds of Byzantine-era towns, villages, churches, and monasteries that are popularly referred to as the Dead Cities. In 2011, they became a UNESCO World Heritage Site as the Ancient Villages of Northern Syria. These agricultural and monastic settlements were spread across several rocky mountain ranges and thrived by cultivating olive orchards among a patchwork of arable land. The growing demand for olive oil, produced in the region and sold throughout the Byzantine Empire, brought income that underwrote the construction of lavishly decorated churches, sizable villas, and elaborate tombs. Christianity played an important role in these communities, and even the most modest settlements featured a church or monastery. The Dead Cities flourished from the first century CE until, with the rise of the Abbasid Caliphate and the retreat of Byzantine forces from the region in the eighth century CE, they went into a gradual decline.

These ancient villages owed their high level of preservation to the fact that wood was relatively scarce. While only sparsely forested, these mountain regions were rich in limestone, and it became the preferred building material for all projects. Churches, meeting halls, workshops, cisterns, public baths, stables, tombs, and even the most modest residences were all built from stone. Thanks to this durable construction material, many villages survived nearly intact, appearing as if they were abandoned only within the last century, though most have been deserted for well over a thousand years! Of particular note in the Dead Cities area are the almost perfectly preserved village of Serjilla, the unique pyramid tombs of al-Bara, the intricately decorated church of Qalb Lozeh, and the spectacular St. Simeon's Monastery, where the ascetic St. Simeon Stylites spent nearly 40 years living atop a stone pillar, attracting pilgrims from far and wide.

While the archaeological remains of the limestone massif are northern Syria's most celebrated, there are many other notable sites in the two provinces. On the Euphrates River east of Aleppo are the remains of Najm Castle, one of the region's best-preserved Ayyubid fortresses. Further down the river is the archaeological site of Meskaneh, which boasts the ruins

الشمال

The North

of a Byzantine fortress and a beautiful brick minaret from the 13th century. North of Aleppo, near the Turkish border, are the extensive remains of the Roman city of Cyrrhus, known today as al-Nabi Houri. This site features a large theater, the remains of a castle, several ruined temples and churches, a necropolis, and two ancient bridges. The necropolis includes a distinctive Roman tower tomb that was later repurposed as a burial place and shrine dedicated to a local Muslim saint. Not far away, near the predominantly Kurdish town of Afrin, is the remarkable Hittite temple of Ain Dara that dates back to the ninth and tenth centuries BCE. Its walls are elaborately adorned with striking stone carvings of lions and sphinxes.

The province of Idleb has several large towns well worth exploring. The picturesque town of Harem is situated at the base of a mountain range, and its ruined Crusader castle offers sweeping views across the border into the valley of the Orontes River in Turkey. In the provincial capital of Idleb, I found an interesting museum devoted to archaeological finds in the region, including a rich collection of artifacts from the third-millennium BCE city of Ebla. Not far away, the scenic town of Ariha offers lovely views from several hilltop restaurants overlooking the town. Ariha is famed throughout Syria as a center for cherry orchards and also has a number of Ottoman-era mosques. Further south, toward Hama, lies Maarat al-Naaman, a large town with a wealth of interesting sites including a 12th-century mosque, two large Ottoman-era khans, and a ruined fortress on its outskirts. In the west of the province, toward Lattakia, is the town of Jisr al-Shaghur. Its name is derived from a Roman-era bridge that still serves its original purpose, spanning the Orontes River as it flows through the town. Jisr al-Shaghur also features khans, mosques, baths, and many residential buildings constructed during the Ottoman period. Nearby is al-Shaghur Castle, a small but remarkable Crusader fortress.

I found this region was one of the most friendly and hospitable in Syria. During my travels here, I was regularly invited into people's homes, offered food, drink, and a place to stay, and guided around the area. This fairly conservative region is predominantly Sunni Muslim, but there are several religious minorities of note. There is a small Druze community consisting of several villages in the mountain region of Jebel al-Aala, concentrated around the Byzantine site of Qalb Lozeh. The small Shiite communities of the region are centered in the villages of al-Zahraa and Nabl, northwest of Aleppo, and al-Fuaa and Kafriya, northeast of Idleb. There are several predominantly Christian villages in the mountains north of Jisr al-Shaghur. Northwest of Aleppo is a predominantly Kurdish region, focused around the town of Afrin. I found its people particularly welcoming, and excited to share their Kurdish language and culture with visitors. There is a small Yazidi community among this Kurdish population, following their ancient religion.

Throughout the ongoing conflict in Syria, the provinces of Aleppo and Idleb have been among the most hotly contested areas in the country. Both have seen extensive fighting. Only fragmentary surveys of the damage to archaeological and cultural sites have been possible. While it does not appear that heritage sites have been specifically targeted for destruction in these provinces, as they have in some others, there have been reports of damage to several of the sites covered in this chapter, along with looting and illicit digging. Like many other regions in Syria, the cultural heritage of the north remains under enormous risk.

Najm Castle

قلعة نجم

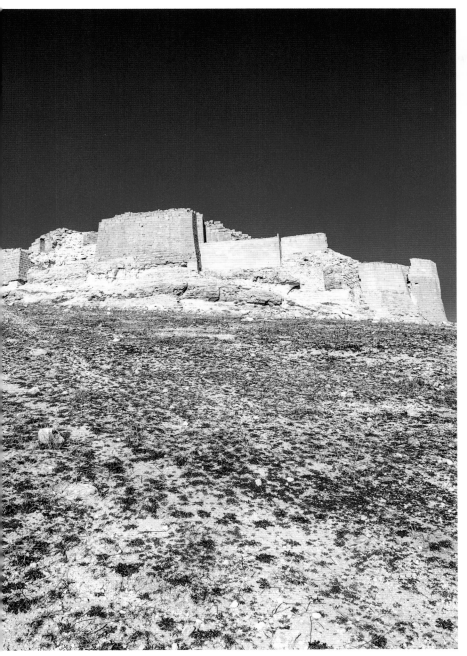

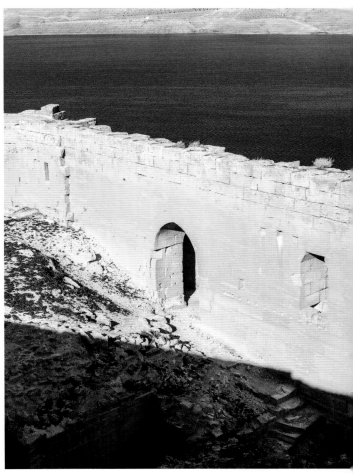

Najm Castle, overlooking the Euphrates River in the rural countryside east of Aleppo, is one of the better preserved fortresses in northern Syria. The existing remains date to the Ayyubid period, though historical records reach back to the seventh century. The castle features a charming palace complete with baths and a mosque, and numerous vaulted chambers and passageways.

225

Meskaneh

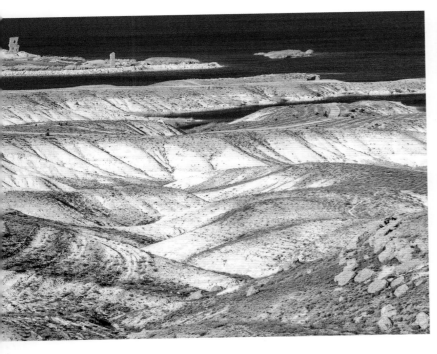

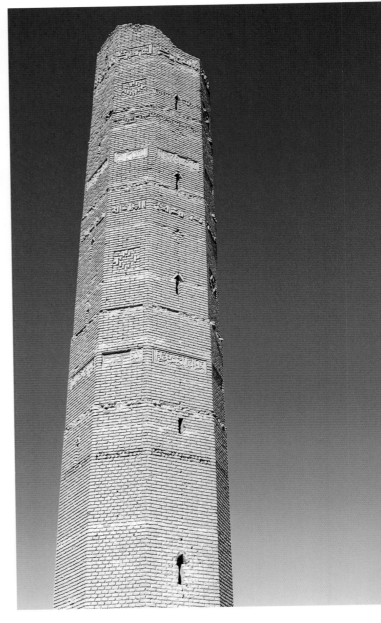

Further south along the Euphrates, on the shore of Syria's largest lake, is the archaeological site of Meskaneh. Known during the Bronze Age as Emar, the site later hosted Greek, Roman, Byzantine, and then Arab settlements. The 13th-century brick minaret offers commanding views over the area, including the remains of a Byzantine-era fortress.

226

al-Nabi Houri

النبي هوري

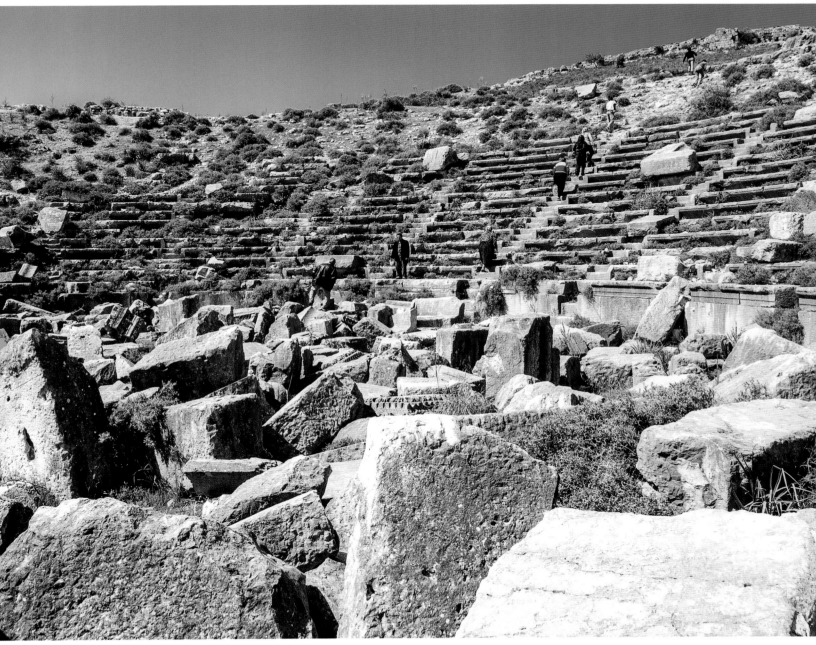

In the remote, predominantly Kurdish hill country north of Aleppo can be found the ruins of the ancient Roman city of Cyrrhus. The site is now known as al-Nabi Houri, named after a Muslim saint laid to rest in a Roman tower tomb of the ancient necropolis. Cyrrhus features one of the largest Roman theaters in the country, the remains of extensive fortifications and civic buildings, and two second-century CE bridges that are still in use.

227

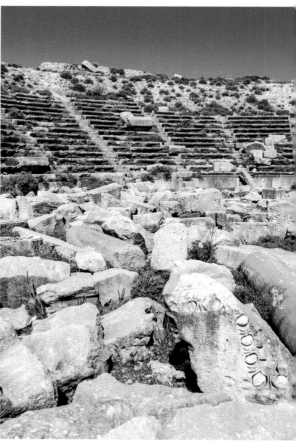

Ain Dara

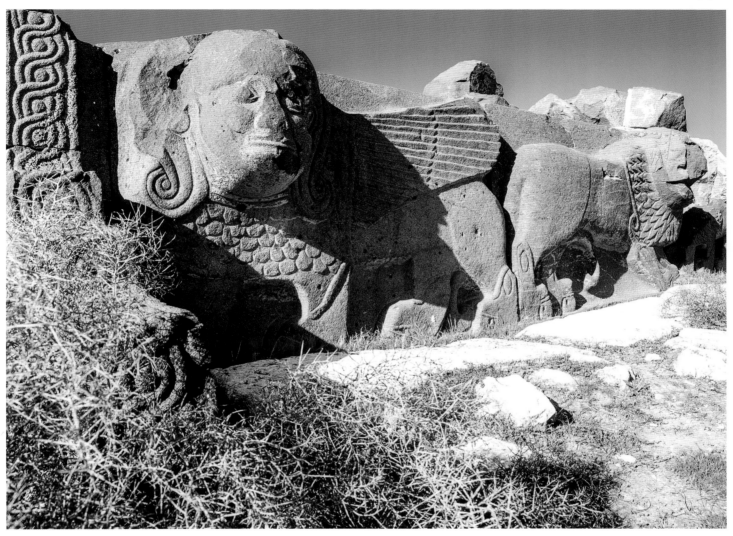

Located south of the predominantly Kurdish town of Afrin is the remarkable temple of Ain Dara, the best-preserved Hittite site in Syria. Constructed between the ninth and tenth centuries BCE on a small hill overlooking a river plain, the temple features distinctively carved statues of lions and sphinxes. Footprints found in the floor of the doorway are said to represent the presence of the god that once was worshipped here.

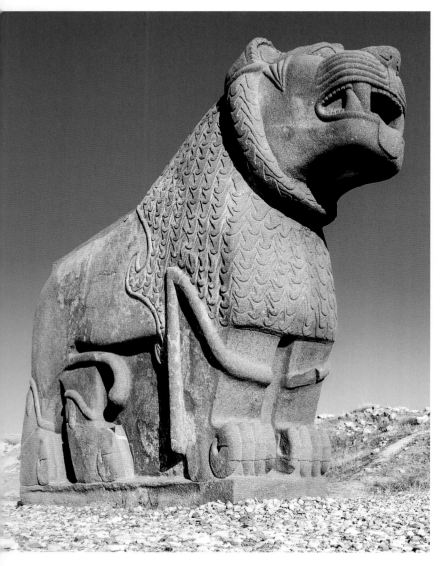

Sheikh Suleiman

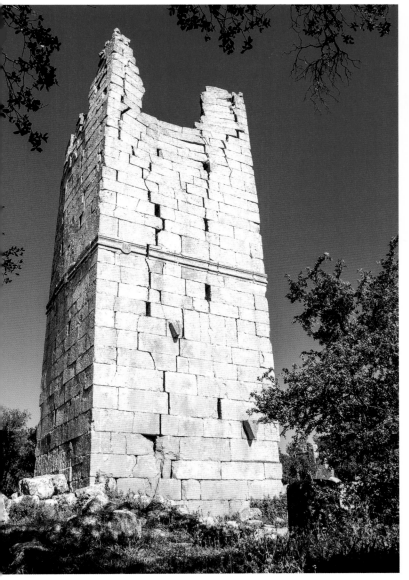

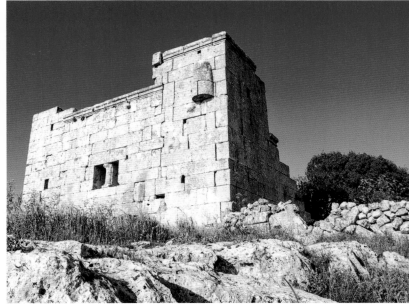

The small village of Sheikh Suleiman, at the southern end of the Jebel Samaan range, features several interesting Byzantine-era remains dating from between the fifth and seventh centuries CE. Two churches are fairly well preserved, as are several domestic buildings and an impressive monastic tower.

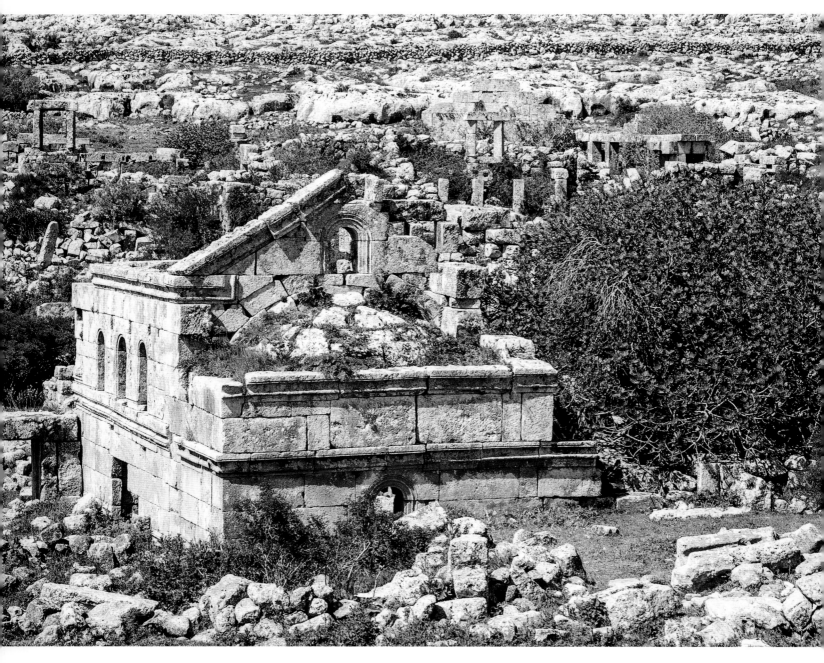

I enjoyed exploring the remote and isolated ruins of the Byzantine settlement of Sinkhar. This picturesque site features a very well-preserved sixth-century CE chapel, originally attached to a much larger fourth-century CE church. Dozens of other structures are scattered throughout the extensive site, but most of them are poorly preserved.

Serqaniya

سرقانيا

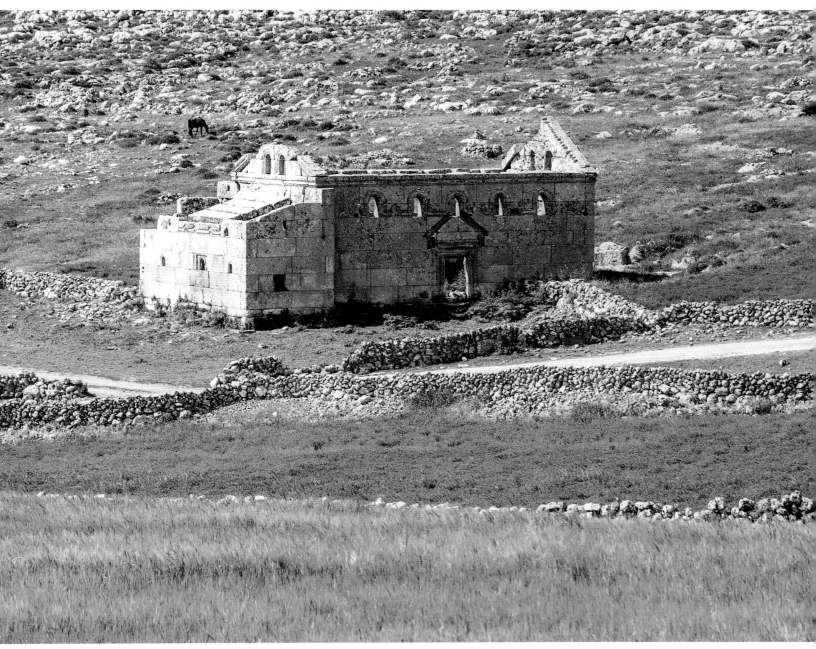

The moderately sized Byzantine settlement of Serqaniya features the remains of two churches and several villas and underground tombs. Situated in a small and fertile valley, the site is particularly charming in the spring. The ruins are a short walk south of the Kurdish village of Fafertin, whose residents cultivate the fields around the site.

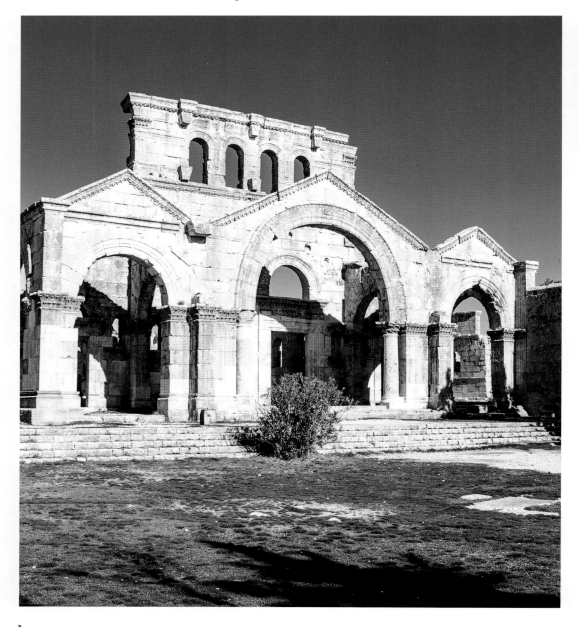

St. Simeon's Monastery, known locally as Qalaat Samaan, is the most impressive archaeological site in the countryside around Aleppo, and possibly the most remarkable Byzantine monument in the country. Constructed between 476 and 491 CE, this enormous church was dedicated to St. Simeon the Stylite, an ascetic who spent nearly 40 years living atop a stone pillar, devoting himself to religious observance and preaching to those who visited. The church complex was an important place of pilgrimage for Christians for several centuries. The site suffered moderate damage from an airstrike in May 2016.

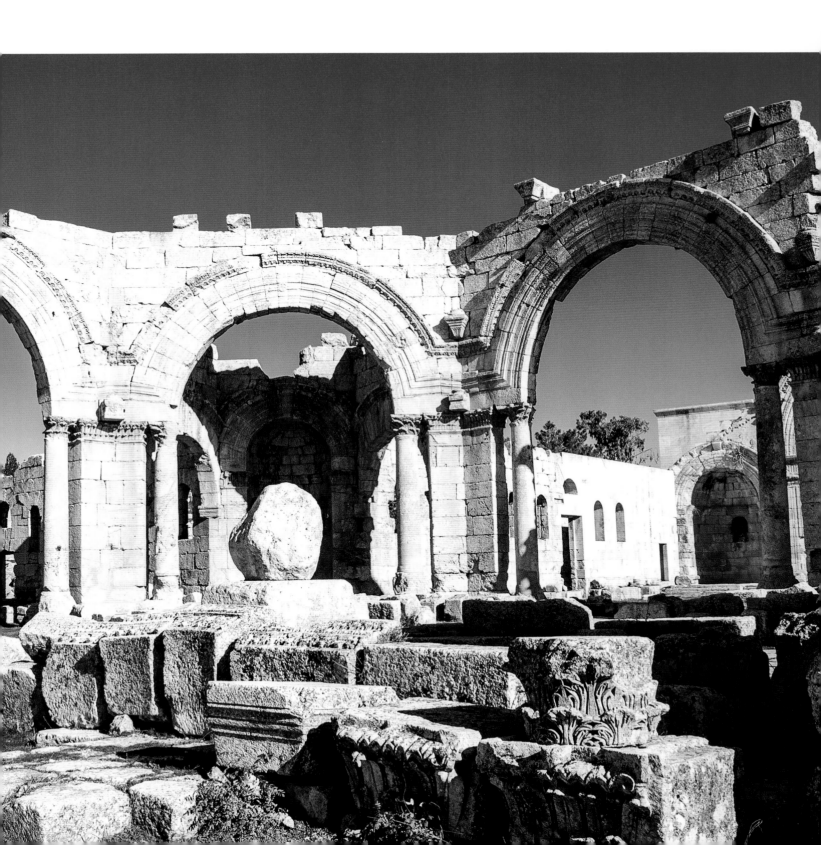

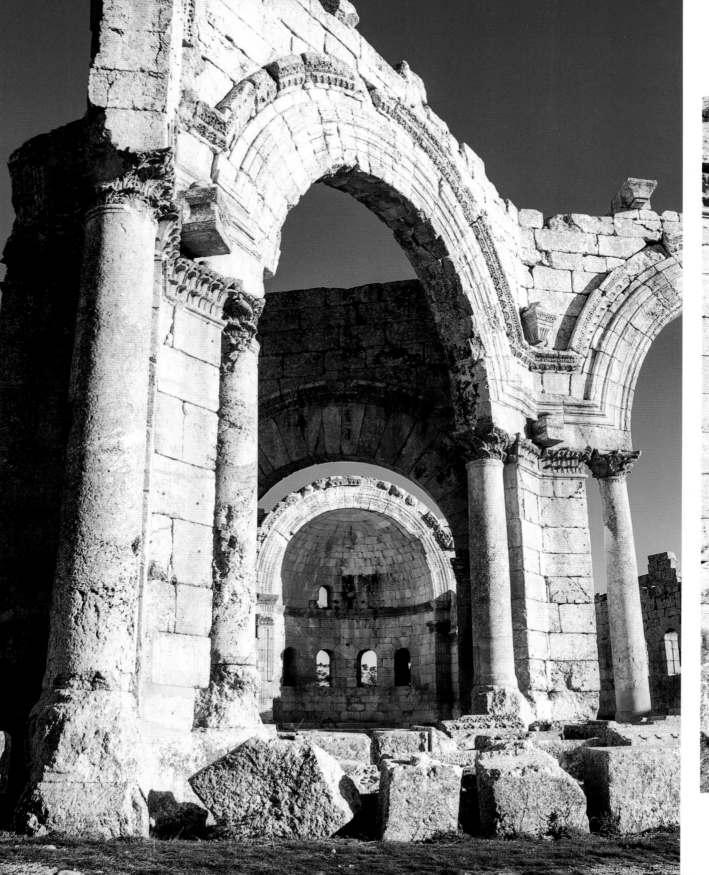

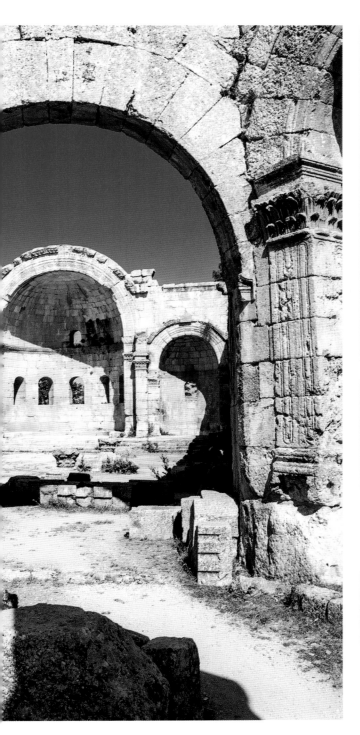

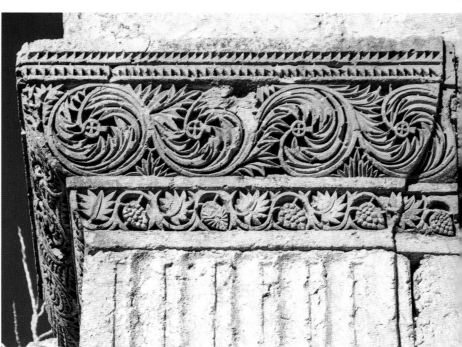

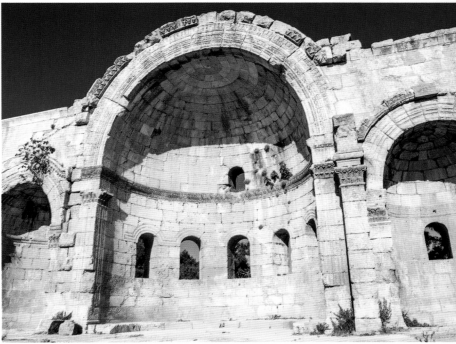

Deir Samaan

دير سمعان

Deir Samaan, now just a village, was an important pilgrimage center during the Byzantine period, accommodating large numbers of pilgrims traveling to the nearby St. Simeon's Monastery. The town was originally known as Telanissos. Its remains include several inns, churches, monasteries and other buildings. Most of the site dates to the fifth and sixth centuries CE, including this well-preserved church.

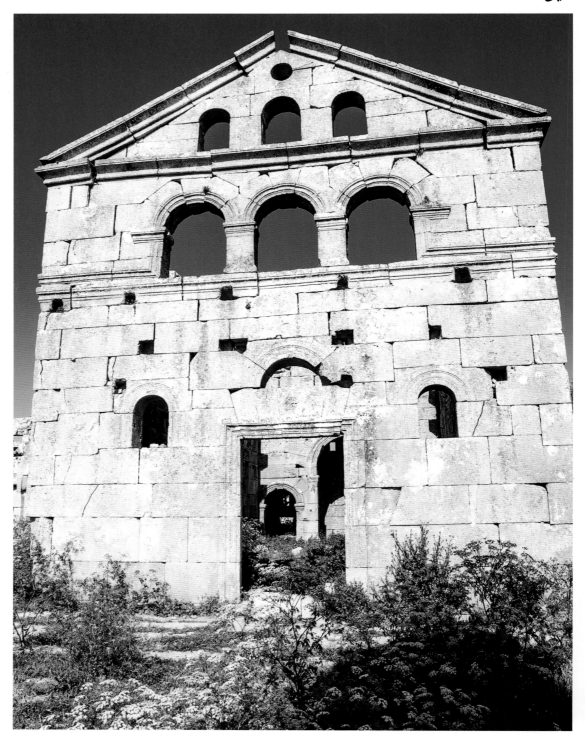

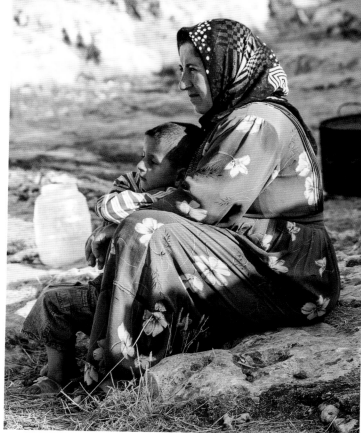

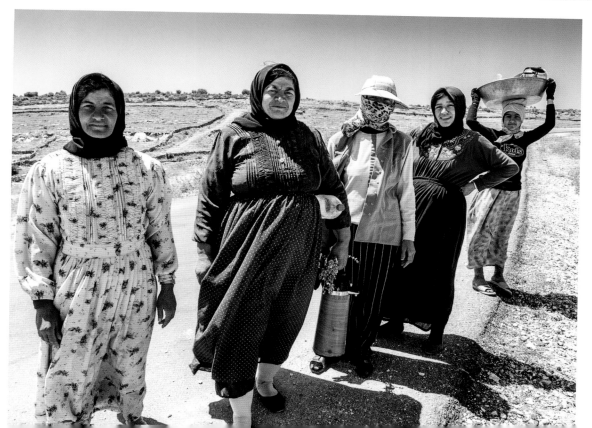

Most of the villages in the Jebel Samaan region, in the north-west of the Aleppo province, are now inhabited by Syria's Kurdish minority. I spent time in several Kurdish villages during my survey of the area, and I was always greeted with warmth and hospitality by local residents who seemed excited to tell me about their culture and language.

Baqirha

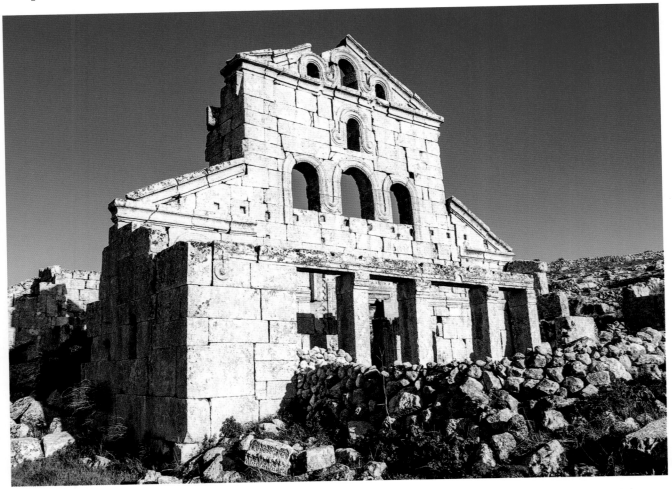

The nearby site of Baqirha contains buildings from both the Roman and Byzantine periods, making it earlier than most other sites in the region. The eastern church, dated by inscription to 546 CE, is heavily decorated. Further up the hill, a rare Roman temple has been dated by inscription to 161 CE.

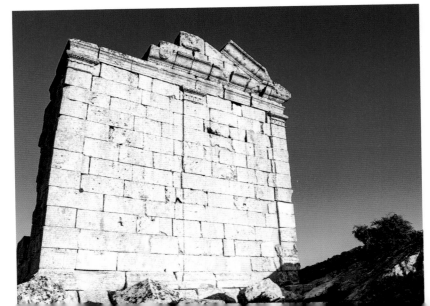

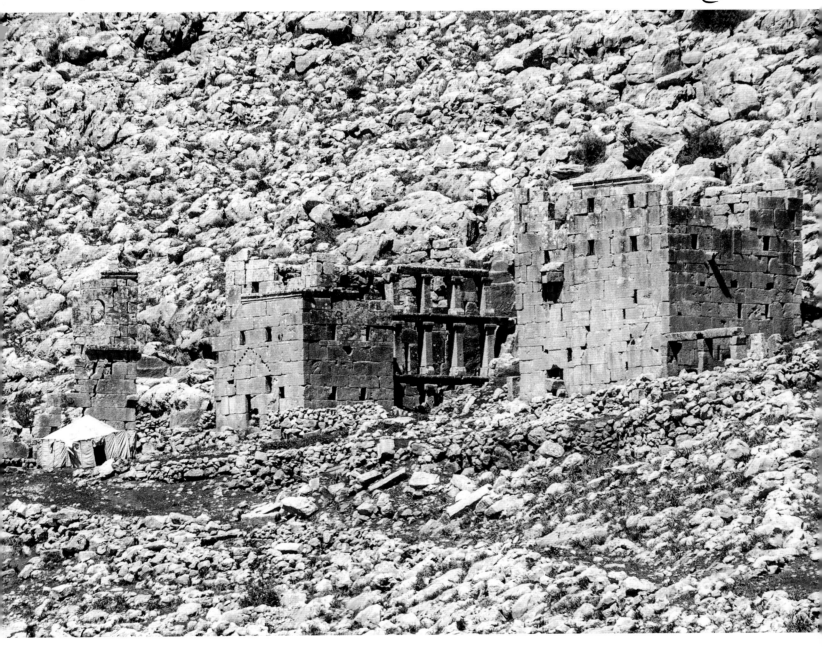

At the site of al-Breij, the late sixth-century CE Monastery of St. Daniel was partially carved from the mountainside on the eastern edge of Jebel Barisha. The complex, which includes three buildings, olive oil presses, cisterns, and a tomb, is in surprisingly good condition.

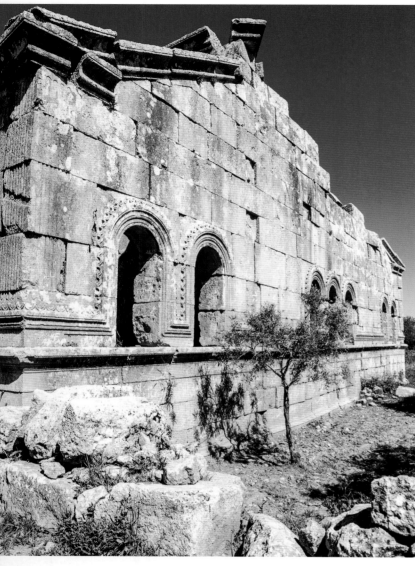

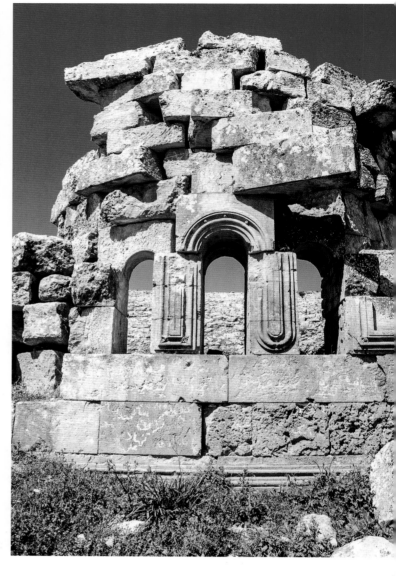

Maaz is an extensive Roman and Byzantine site in a fertile valley of Jebel Barisha. Its prominence in those periods probably stemmed from the large expanse of arable land around it. Little remains of the settlement's second-century CE agora and temple, but two sixth-century CE churches survive relatively well preserved.

Harem

حارم

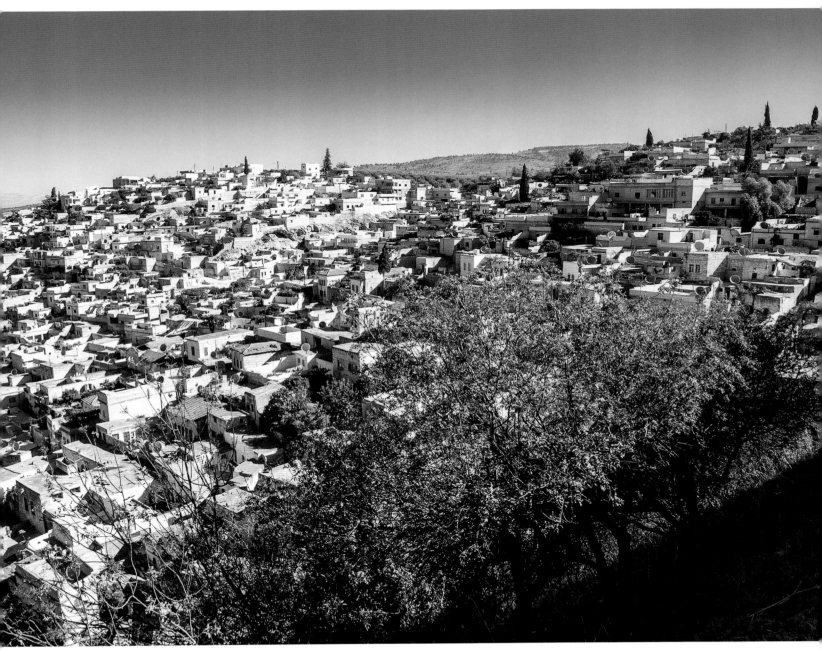

Harem is one of several large towns in the province of Idleb, and perhaps its most attractive. Located on the Turkish border, Harem is famous for its freshwater springs and its scenic riverside cafes and restaurants. A large but poorly preserved Crusader fortress offers beautiful views over the town.

Qalb Lozeh

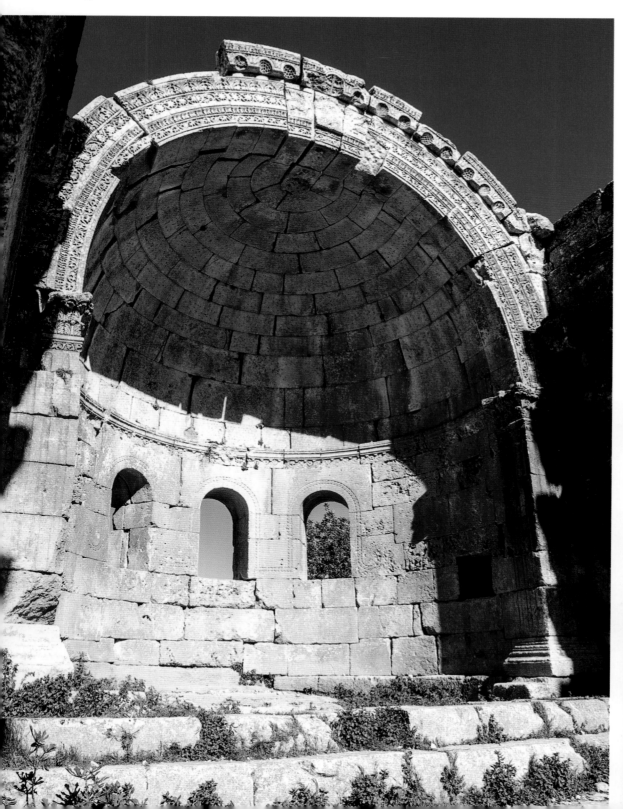

The best known monument in the Jebel al-Aala region is the Byzantine-era church of Qalb Lozeh (Heart of the Almond), located in a small Druze village of the same name. The three-aisled basilica, built in the fifth century CE, served as an important pilgrimage stop. It is remarkably well preserved, with a beautifully decorated apse, and is considered by many researchers to represent key developments in local architectural styles.

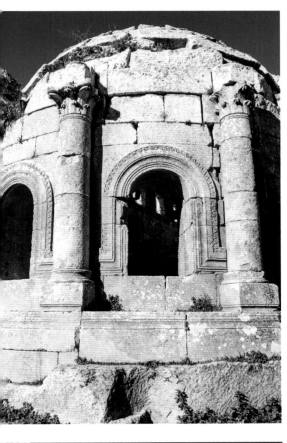

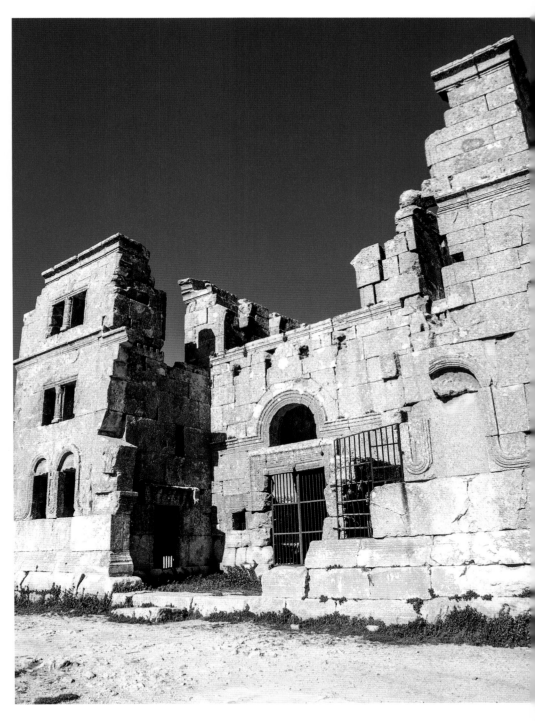

245

Hilltop restaurants overlooking the large town of Ariha offer beautiful vistas of the surrounding countryside. Ariha is known throughout Syria as a center for cherry cultivation. It also has a number of Ottoman-era mosques.

Shinshirah

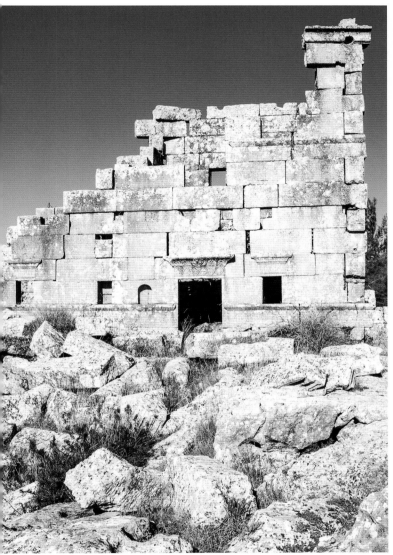
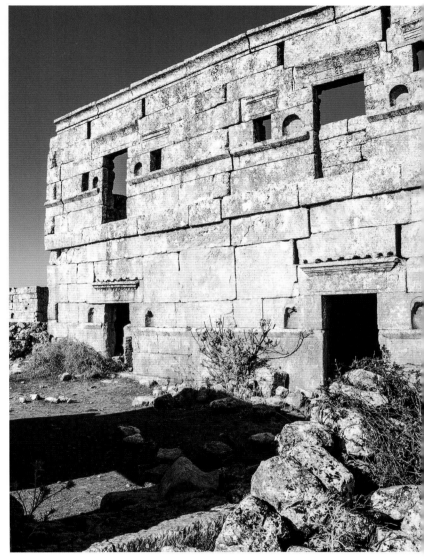

Shinshirah, also known as Khirbet Has, features the remains of dozens of large villas and several churches on a hilltop plateau. It is one of the most interesting and extensive Byzantine sites in the Idleb province. Few foreign tourists ever made it here, though it was a popular picnic spot with people from the nearby villages.

al-Bara

Al-Bara is one of the largest and most prominent archaeological sites in the Idleb province, with two monumental pyramid tombs, a monastery complex, a fortress, and the remains of dozens of other structures. The settlement boasted at least eight churches at its height in the fifth and sixth centuries CE, when it was a major center for the regional olive oil and wine industries.

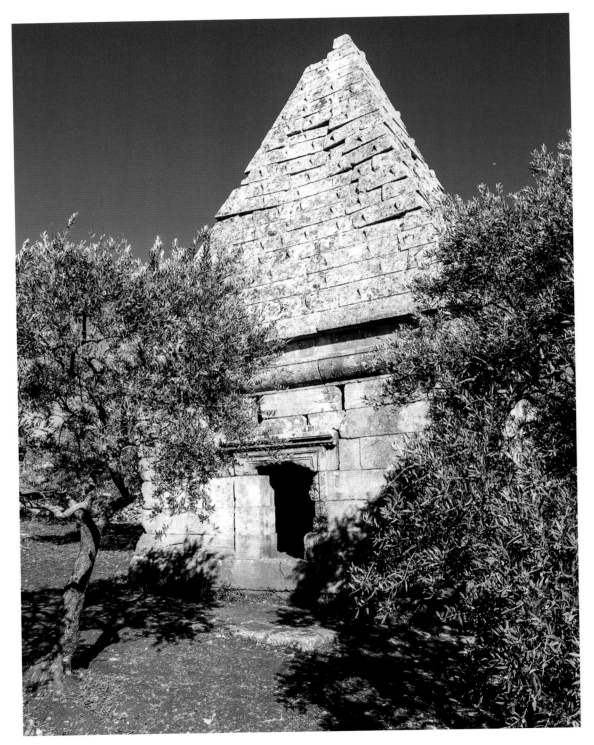

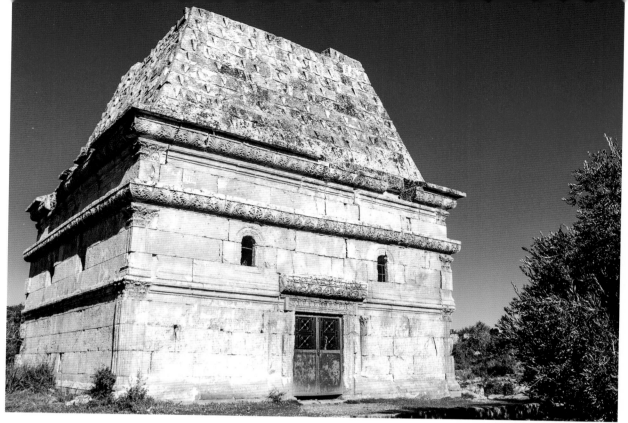

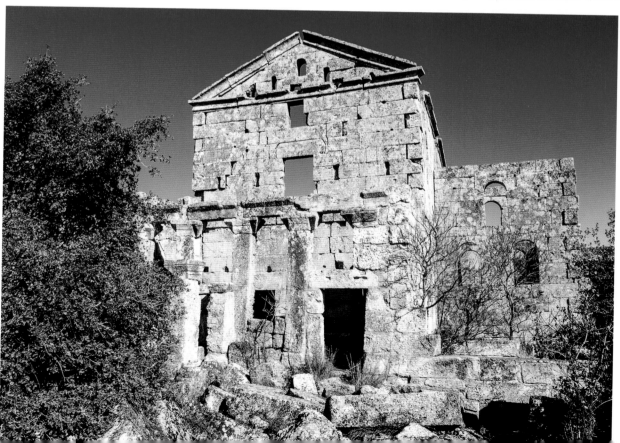

Serjilla

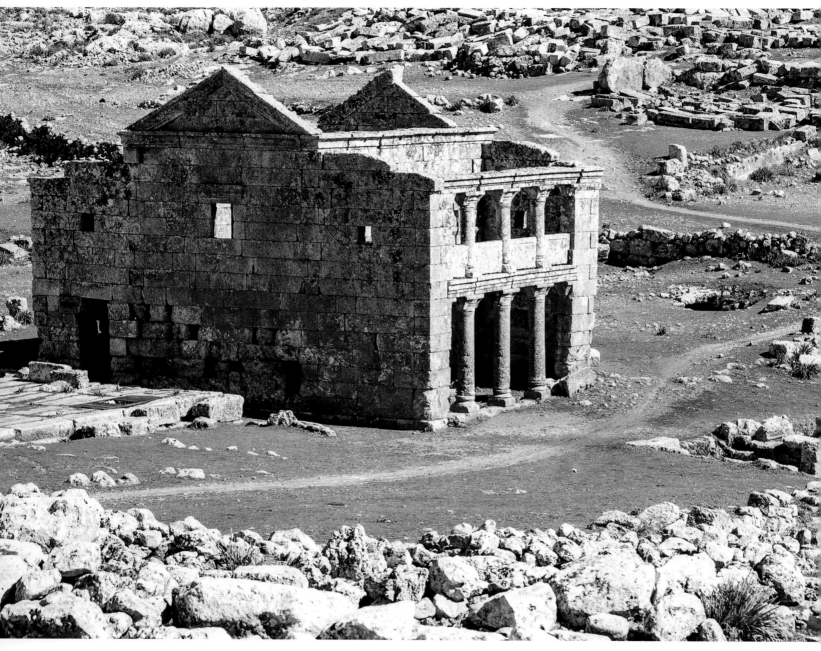

Serjilla is perhaps the most complete and well-preserved Byzantine site in the Idleb province. Exploring its remains gave me a sense of what daily life must have been like in these fourth- to sixth-century CE agricultural communities. The settlement includes a church, public baths, a meeting hall, several large villas, and a necropolis, all of which remain in remarkably good condition.

250

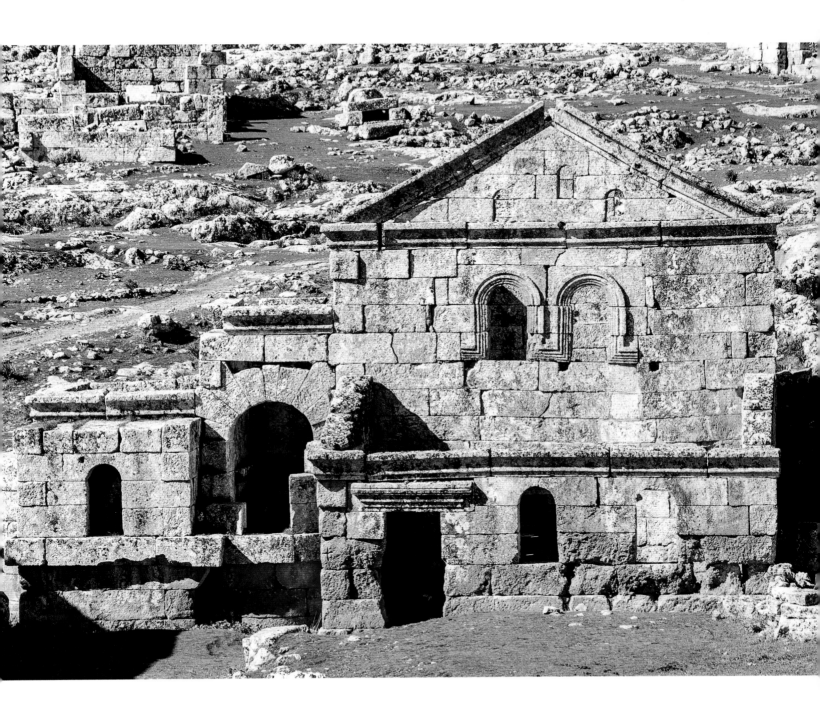

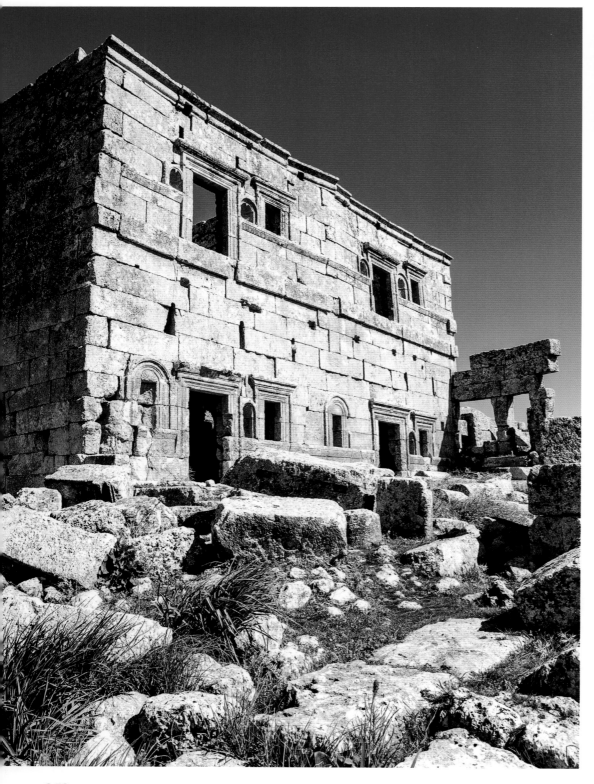

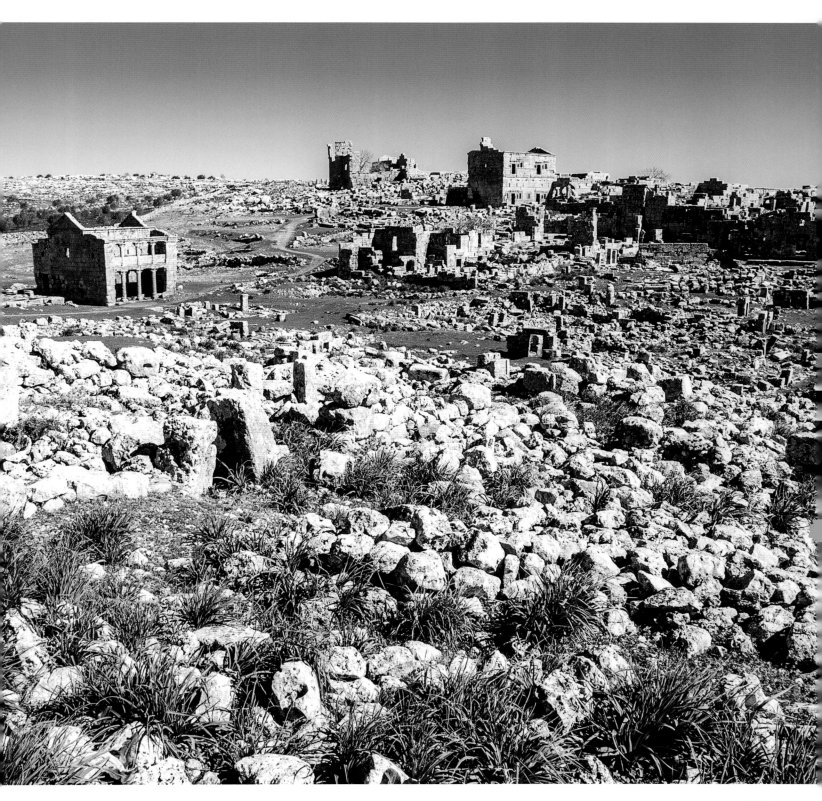

Maarat al-Naaman

معرة النعمان

The large town of Maarat al-Naaman sits on Syria's main highway between Aleppo and Hama, its history closely linked to both cities. It has been inhabited since at least the Hellenistic period, and is famous as the birthplace of the tenth–11th century philosopher and poet Abu al-Aala al-Maari, a rationalist and vegetarian who was highly critical of religion and the use of violence. The town was the scene of an infamous massacre during the Crusader period.

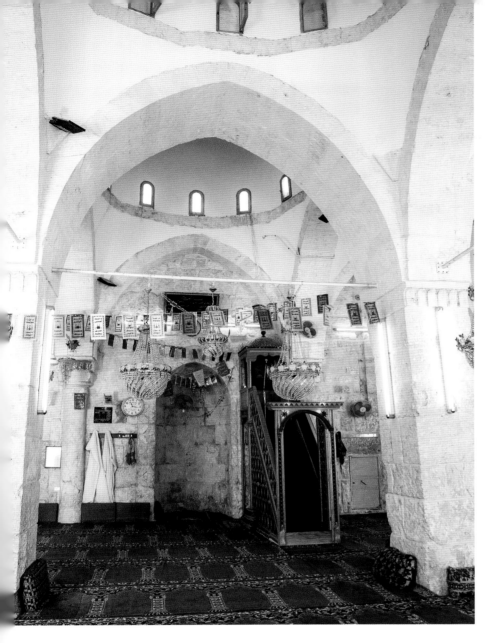

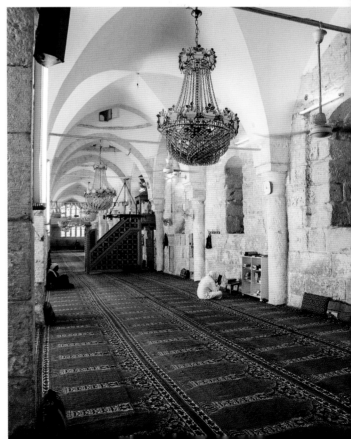

Maarat al-Naaman features several monuments of interest. These include the Great Mosque, constructed in the 12th century over the remains of earlier Roman and Byzantine structures, and a religious school, or madrasa, from the same era. The town's 16th-century khan is Syria's largest, and houses a museum with an extensive collection of mosaics. Many of these buildings have seen extensive damage from the ongoing conflict.

Jisr al-Shaghur has a long history dating back to Roman times. I enjoyed exploring the town's attractive residential quarters, bustling market, mosques, khans, and public baths that dated back to the Ottoman period. Jisr al-Shaghur is also known for its Roman-era bridge, spanning the Orontes River and still in use today.

al-Shaghur Castle

قلعة الشغور

The small fortress of Bakas (known today as al-Shaghur Castle) overlooks a deep canyon in the mountains northwest of Jisr al-Shaghur. It was first fortified during the Byzantine period. Later, it was rebuilt and expanded by the Crusaders, who held it until it was captured by Salah al-Din's forces in 1188. While little remains of the fortress today, the stunning views made it worth the visit.

With its mountains of pine and oak forests, a coastline of turquoise blue water, picturesque towns and villages, and modern, sophisticated cities, the coastal region of Syria is often more reminiscent of Mediterranean Europe than the Middle East. Best known for its beautiful nature, the region is also rich in history and cultural heritage. One of humanity's earliest alphabets was developed along these shores, which later hosted important Greek and Roman settlements. The region was a stronghold for the Crusaders for several centuries, and numerous impressive fortresses from that period still survive today. Syria's coastal mountain range provided a safe haven for religious minorities for thousands of years. Today, the two provinces that make up the coastal region, Lattakia and Tartus, both feature a diverse mixture of Sunni Muslims, Alawites, and Christians. Perhaps influenced by a long history of sea commerce dating back to Canaanite times, there is a general sense of openness found in these coastal communities. It is not unusual to meet cultured and well-traveled locals, many of whom have worked on cargo ships and speak multiple languages.

The provinces of Lattakia and Tartus are home to most of Syria's Alawite community. This religious sect is an offshoot of Shiite Islam that was founded in the ninth century, incorporating many traditions and beliefs indigenous to the region. The faith is believed to have originated with Ibn Nusayr, a companion and pupil of the 11th Shiite imam, Hasan al-Askari. Historically, observant Alawites kept their beliefs secret from outsiders and even from non-practicing segments of their community. They are thought to believe in a divine trinity, based on the three manifestations of God: the meaning, the name, and the gate. Their tenets include reincarnation, and traditionally their only religious structures have been tomb shrines. Members of the sect long suffered from discrimination and persecution, so they lived as poor peasants in remote mountainous regions for most of their history. The Alawite community's position improved with the rise of secular nationalist sentiment in the Arab world, culminating in the 1970 rise to power in Damascus of Hafez al-Assad, an Alawite from the village of al-Qardaha. Other Alawite populations are found in rural Homs and Hama, Damascus, northern Lebanon, and Antakya, Turkey.

السّاحل

The Coast

259

Lattakia is the most populous city on the coast, and one of Syria's most open and liberal. The country's largest seaport and a prominent university are both found here. While quite modern on its surface, Lattakia is an ancient city at its core, first settled over 3,000 years ago. It was a major town under the Greeks and Romans, even briefly supplanting Antioch as provincial capital. For centuries its control was disputed between the Byzantines, Turks, Crusaders, and Arab Muslims. In the 19th century, its population had declined to as few as 7,000 people, but today it is Syria's fifth largest city. The rapid growth of Lattakia has swallowed much of its ancient heritage, but several remnants survive throughout its urban landscape, including Roman-era columns and monuments stranded in the middle of traffic circles and in small parks. While crowded and noisy at times, Lattakia still captures the relaxing atmosphere of the Mediterranean. It has a vibrant cafe culture, and I found many friendly local residents ready to engage in discussion and debate over a cup of tea or coffee. In the late afternoon, the city's residents head to its seaside corniche to socialize, people watch, and enjoy the sunset. Lattakia often provided me with a comfortable base from which to explore the magnificent forests and castles of the surrounding mountains and the beaches and archaeological sites of the coastline.

The best-known archaeological site in the Lattakia province is Ugarit, where the remains of a 14th-century BCE city and royal palace of the Ugaratic kingdom can be found. This civilization, part of the Canaanite culture, is credited with developing one of humanity's earliest alphabets. Clay tablets inscribed with political, commercial, and religious texts from the extensive palace archives were unearthed at the site. Nearby, Ras Ibn Hani hosts an archaeological site contemporary with Ugarit, but the small peninsula is better known for hosting some of Lattakia's upscale beach resorts. More stunning coastline can be found further north, highlighted by the beaches of Burj Islam, Ras al-Basit, and al-Samra, near the charming Armenian town of Kassab. The mountains north and east of Lattakia are also known for their beautiful scenery that includes forests, lakes, and waterfalls. This rugged territory was also highly strategic during the Crusader period, evidenced by the numerous defensive points constructed throughout the area. Most remarkable of these is the 12th-century Salah al-Din Castle, one of the most romantically situated fortresses in the country. Others include the castles of al-Maniqeh, al-Mahalbeh, and Bani Qahtan. The ancient town of Jableh, south of Lattakia, also contains several noteworthy monuments. At its center is

an ancient amphitheater, one of the best-preserved Roman-era remains on the coast.

While generally living in the shadow of its larger northern neighbor, the city of Tartus has a distinctive character and unheralded charm. The city was founded by the Phoenicians, and in early times played a secondary role to the nearby island settlement of Arwad. This changed during the Byzantine era, when Constantine favored the Christian community at Tartus over the pagan inhabitants of Arwad. The city was frequently contested between the seventh and 13th centuries, and during the Crusades, it served as a stronghold for the Knights Templar. Often overlooked and underappreciated, Tartus rewards those with the patience to explore by revealing its hidden charms. Its cathedral, now housing an archaeological museum, is one of the finest examples of Crusader religious architecture. The remains of their once-great fortress were repurposed by local residents, the grandiose architectural elements incorporated into the modest homes, shops, and cafes of the old city. While rapid development may be changing the city's once quiet, sleepy seaside atmosphere, Tartus remains a convenient base for exploring some of the region's most fascinating sites. I found the city's inhabitants to be kind and hospitable, often extending invitations to join them in discussion over tea or coffee.

The countryside of Tartus has several impressive fortresses, most dating back to the time of the Crusades. The most noteworthy of these is al-Marqab Castle, an imposing Crusader stronghold overlooking the coastal town of Banias. Constructed from somber black basalt, it must have conveyed a sense of foreboding to any potential attackers. The attractive mountain town of Safita is overlooked by an enormous keep, the central tower of the now-ruined Crusader fortress of Chastel Blanc. Other defenses in the region include the Ismaili fortresses of al-Khawabi, al-Kahf, al-Ileiqeh, and al-Qadmous, and the Crusader castles of al-Arimeh and Yahmur. The province also features two remarkable religious sites of ancient times: Hosn Suleiman, a Greek and Roman temple constructed with enormous blocks of stone, and Amrit, the site of a Phoenician and Greek settlement that includes a distinctive temple complex and tombs. Another attraction of the province is the small, densely populated Mediterranean island of Arwad, itself inhabited since Phoenician times. The province also has several mountain resorts, such as Mashta al-Helou, with stunning scenery. Syrians would travel from across the country to enjoy the beaches and beautiful mountain towns of this region.

Lattakia

اللاذقية

This arched gateway from the Roman period has become a symbol of the city of Lattakia. Located in a small park surrounded by modern apartment buildings, it stands as one of the few reminders of the city's ancient past.

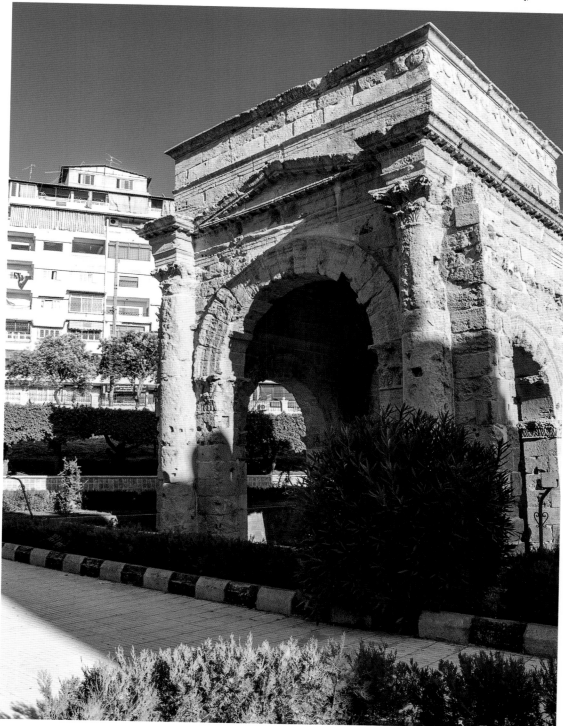

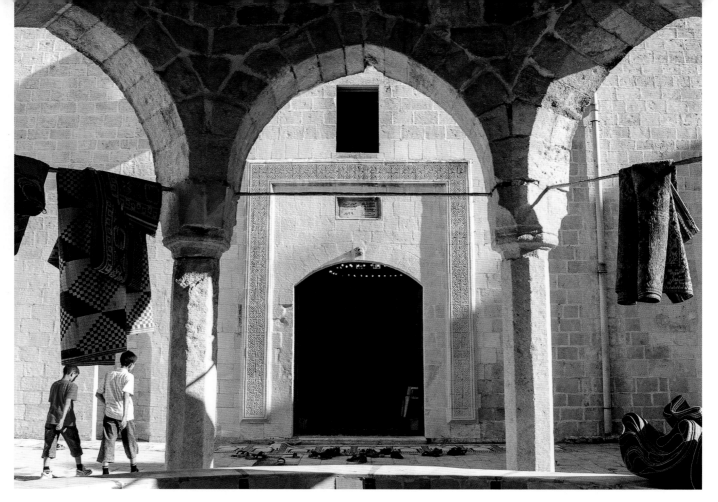

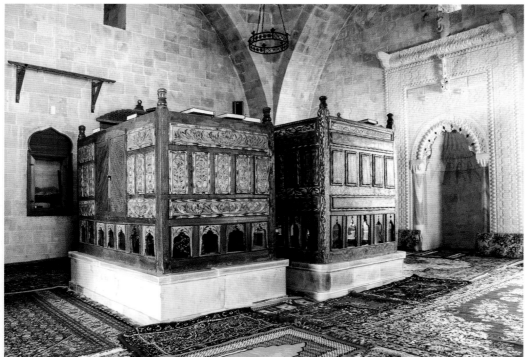

Lattakia's older neighborhoods contain several attractive and historic mosques. Smaller in scale than many mosques in Damascus and Aleppo, they nonetheless provide peaceful sanctuaries in an otherwise crowded and busy city.

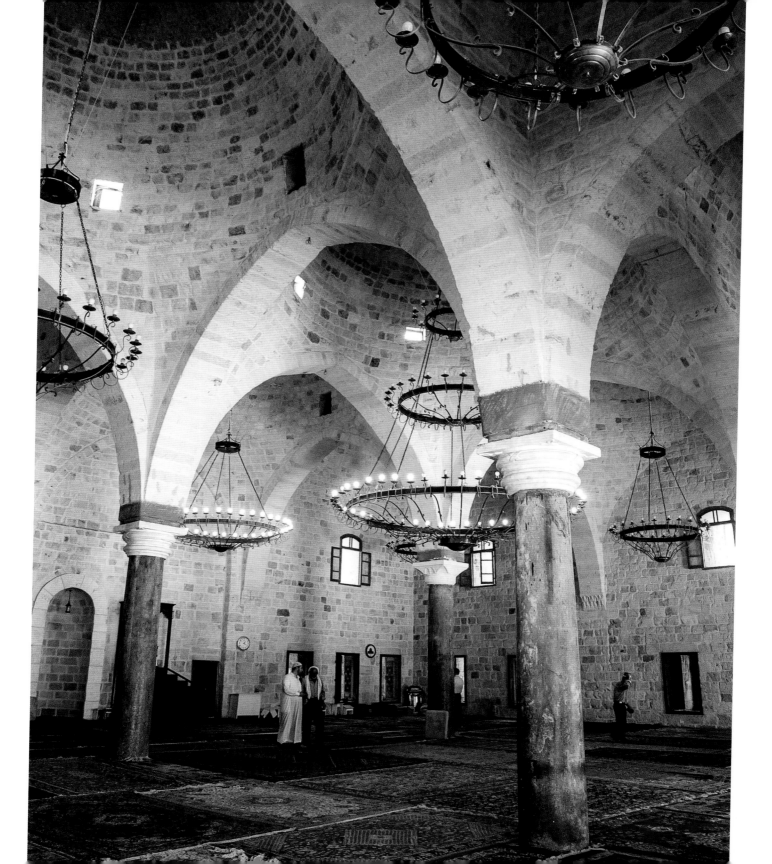

In the late afternoon and early evening, many Lattakia residents spend their time relaxing at the seaside corniche. I often found myself drawn to the area as sunset approached, sampling food from street vendors and enjoying the friendly family atmosphere.

Ugarit

<div dir="rtl">أوغاريت</div>

The Bronze Age city of Ugarit, north of Lattakia, is among the most important archaeological sites on the Syrian coast. One of the earliest known alphabets, Ugaritic, was developed here in the 14th century BCE. It was inscribed on hundreds of clay tablets that would be unearthed by archaeologists 3,300 years later. The ancient city's western gate and royal palace survive relatively well preserved.

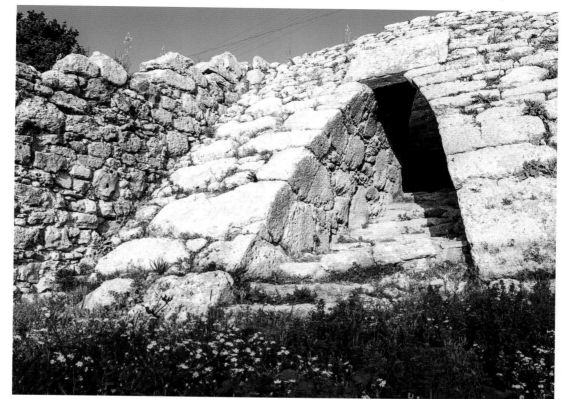

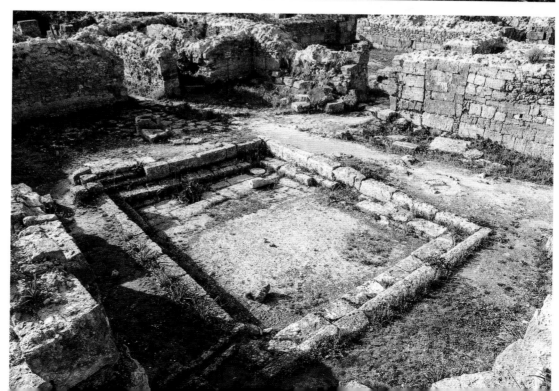

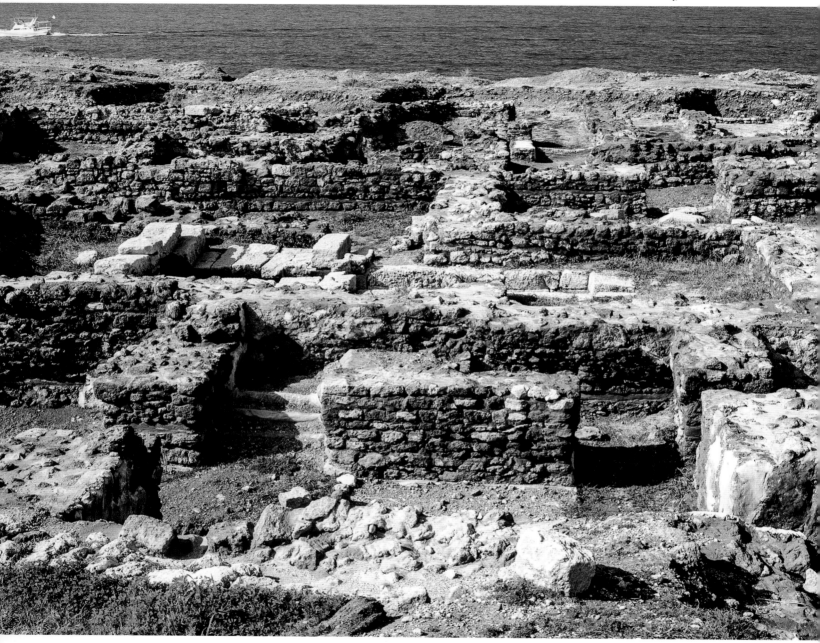

Ras Ibn Hani, a small peninsula to the north of Lattakia, features an archaeological site dating to the Bronze Age, contemporary with nearby Ugarit. It is also famous for its beaches, and many of Lattakia's wealthier residents own small vacation homes here.

Burj Islam

I discovered this stunning stretch of coastline near the village of Burj Islam. The turquoise waters provided a remarkable contrast to the white stone shore.

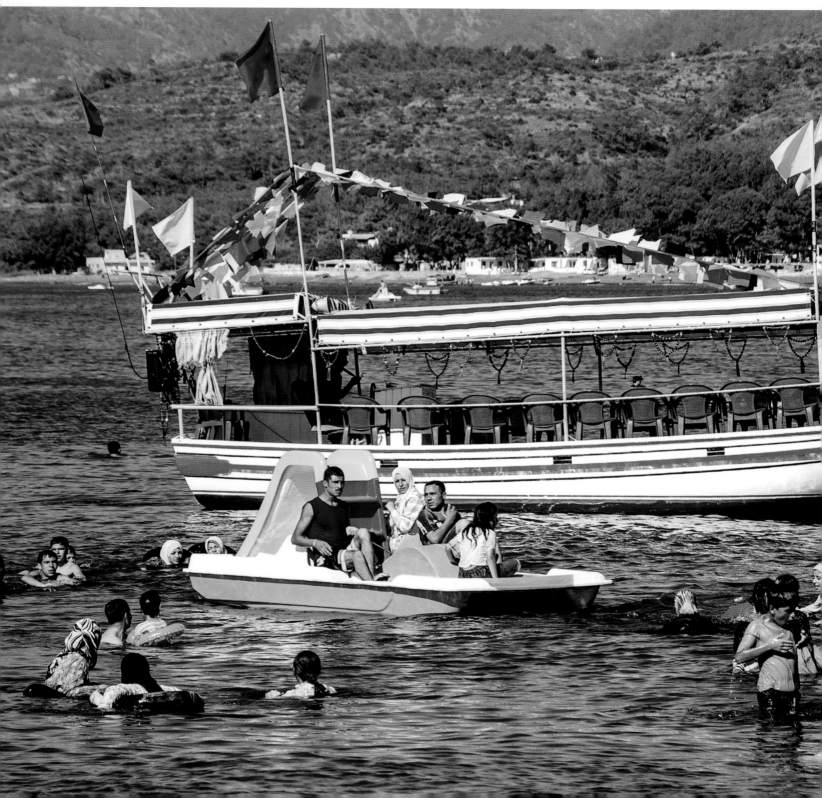

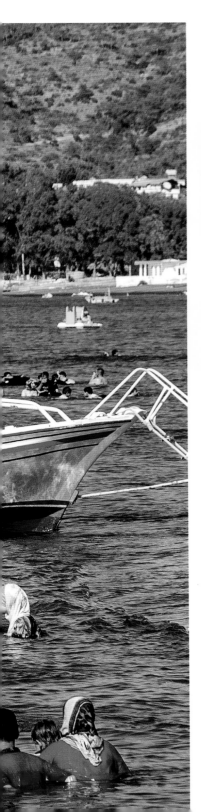

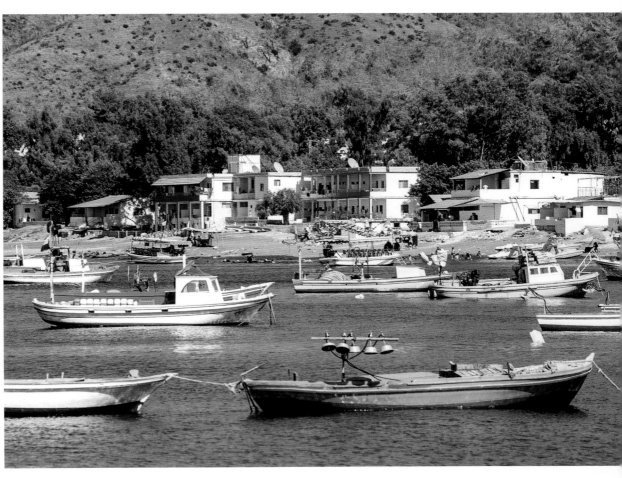

Ras al-Basit is one of Syria's best known beach resorts. Little more than a small fishing village in the off-season, during the summer months it became crowded with vacationing families.

Kassab

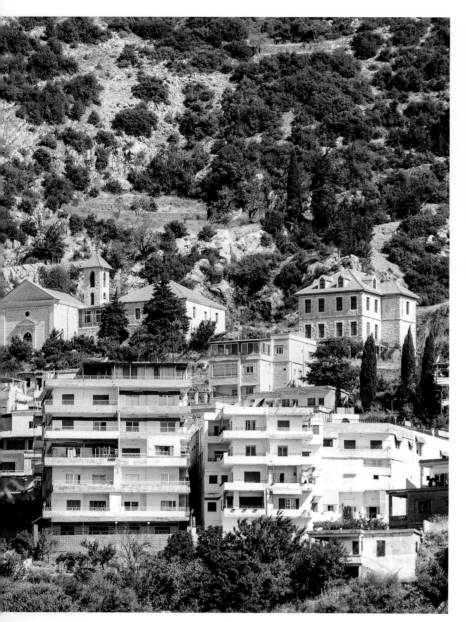

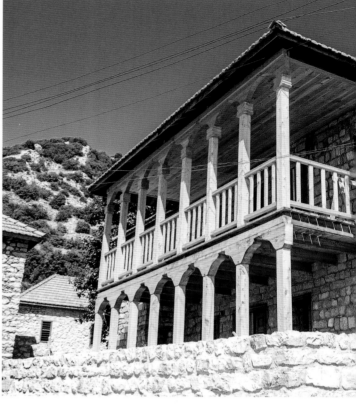

Kassab is a predominantly Armenian town just across the border from Turkey. Many residents are descendants of those who fled to Syria to escape the genocide of the 1910s. The area offers some of the most beautiful mountain scenery in the country, and has several charming old houses and churches.

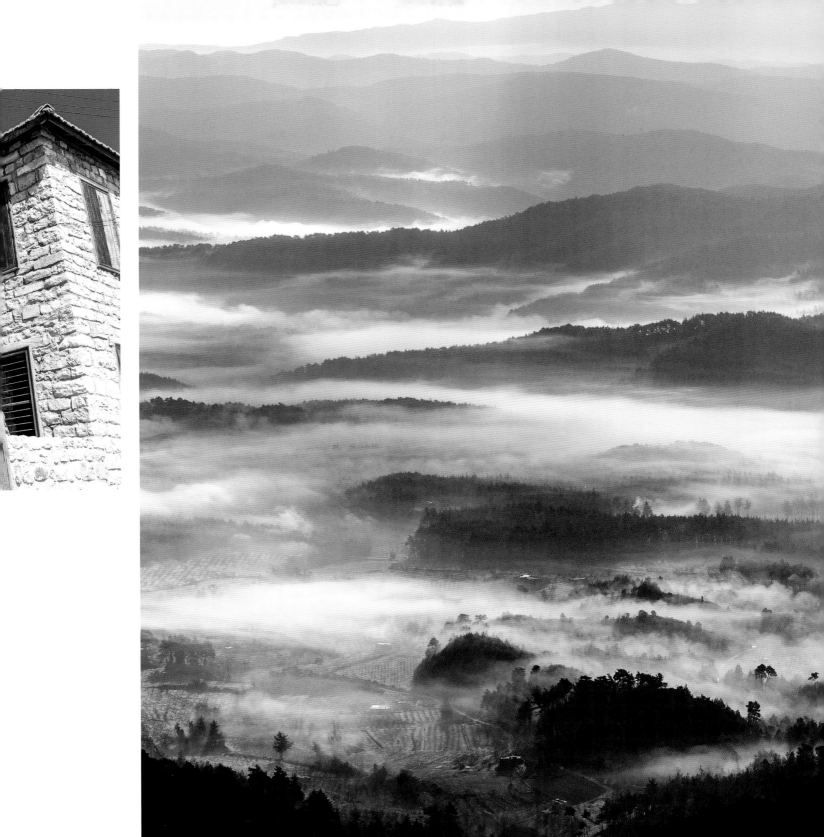

al-Samra السمرا

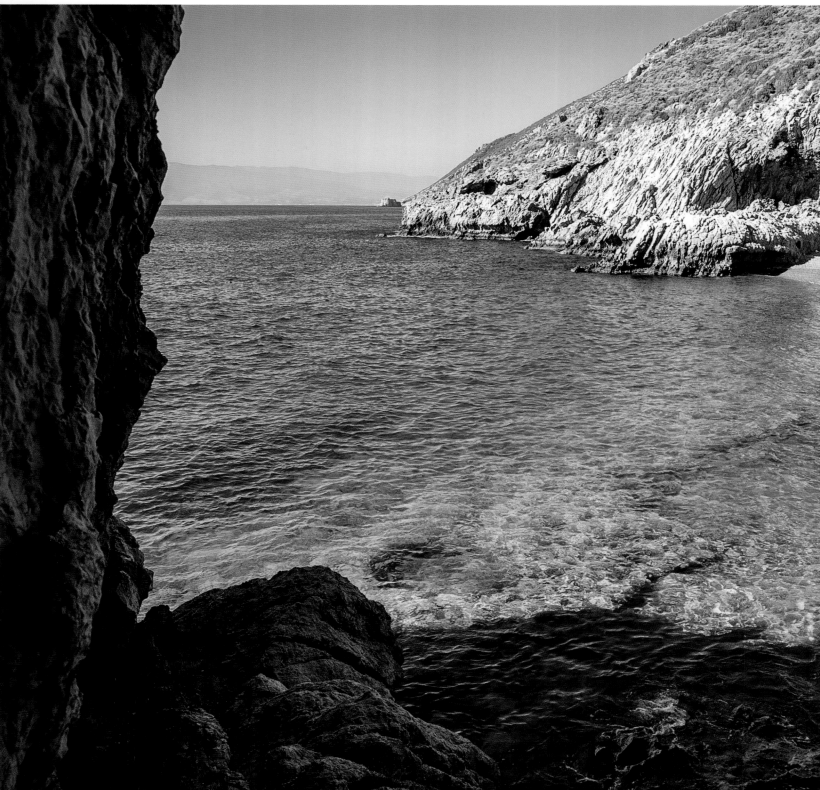

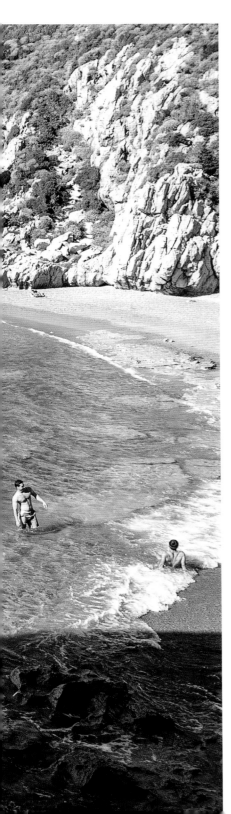

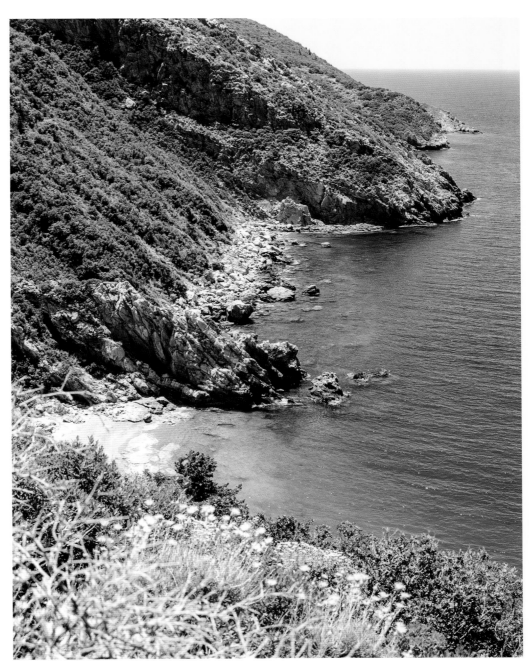

Not far away from Kassab is the secluded beach of al-Samra, possibly the most picturesque in Syria.

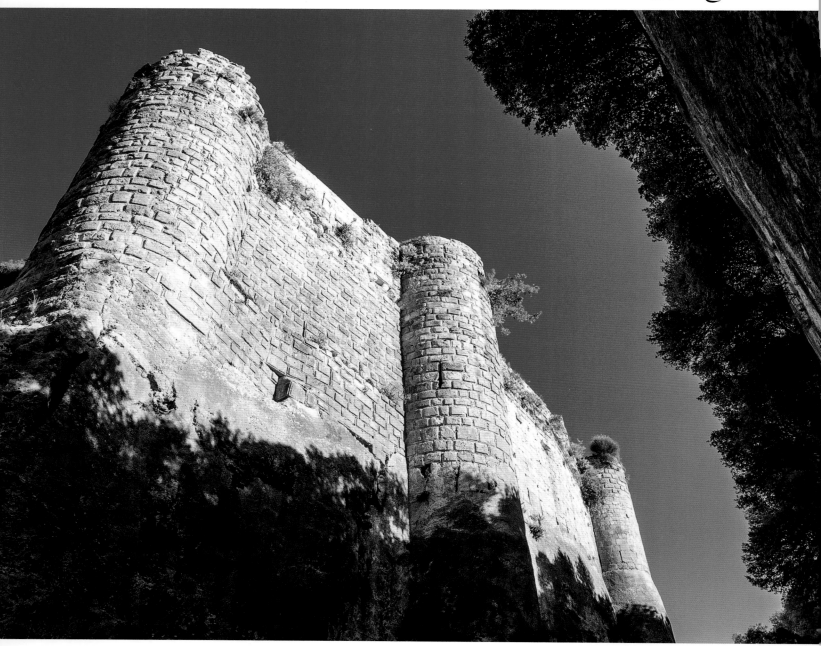

Salah al-Din Castle, known by the Crusaders as Saône, is located deep in the mountains east of Lattakia. Flanked by steep ravines on two sides and surrounded by pine forests, its dramatic setting makes it one of the most impressive fortresses in Syria. To strengthen defenses on the eastern side of the castle, originally on flat ground, a deep ditch was cut from solid rock.

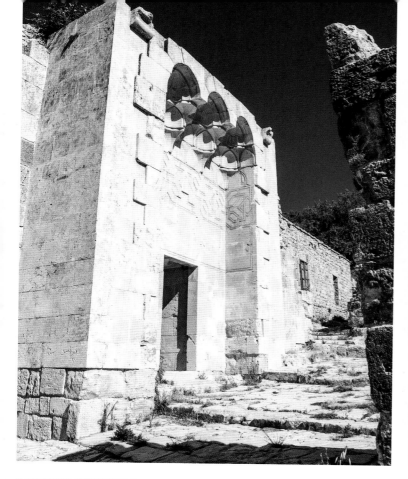

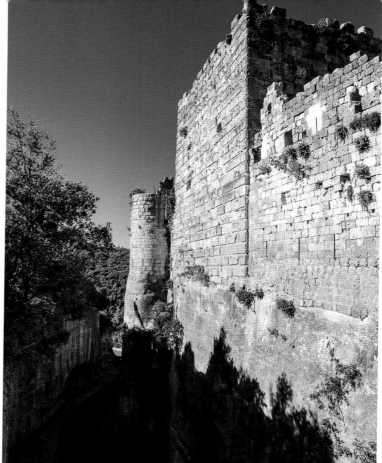

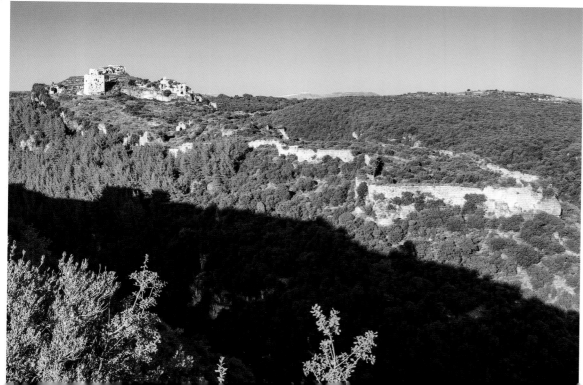

The castle's extensive walls guarded a wide area, supported by nearly a dozen defensive towers. Within the walls, I explored the remains of cisterns, stables, and a church, as well as a later mosque and palace complex that included a traditional bathhouse.

Jableh

جبلة

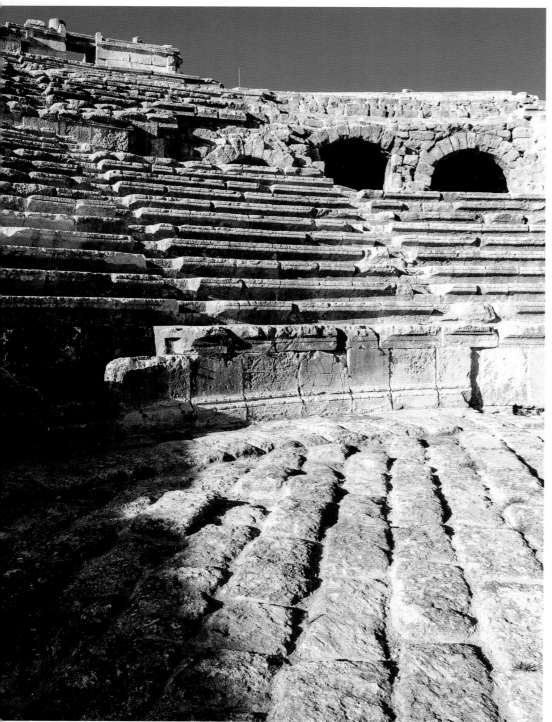

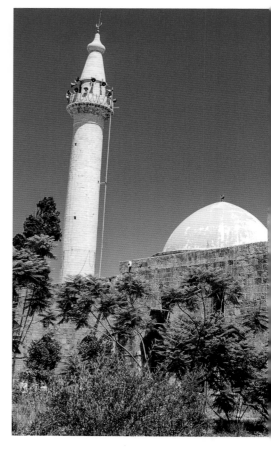

The town of Jableh, the third largest on Syria's coast, has a history dating back to the Phoenicians. Only traces of its ancient past survive, but this well-preserved Roman theater graces the town center. It was built in the late second or early third century CE and originally seated around 7,000 spectators.

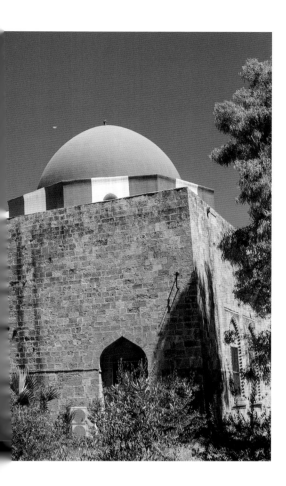

Next to Jableh's Roman theater is a charming mosque and mauso-leum complex. It houses the tomb of Ibrahim bin Adham, a promi-nent eighth-century Sufi ascetic. The building stands on the site of an earlier Byzantine church.

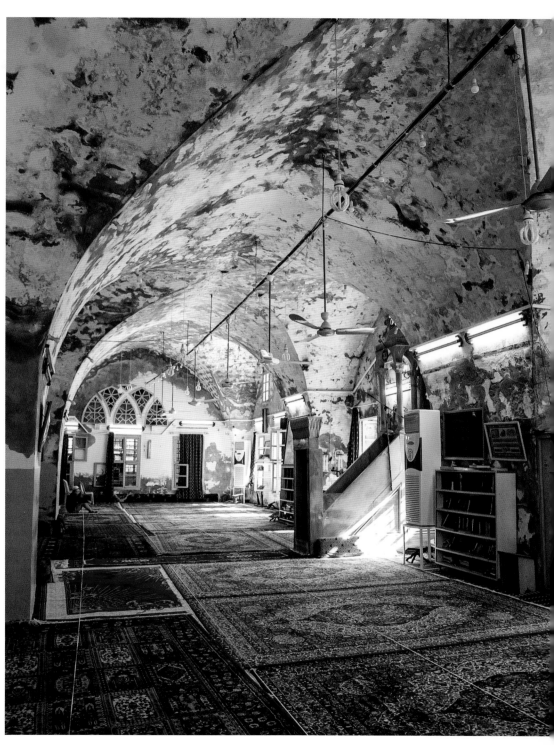

al-Maniqeh Castle

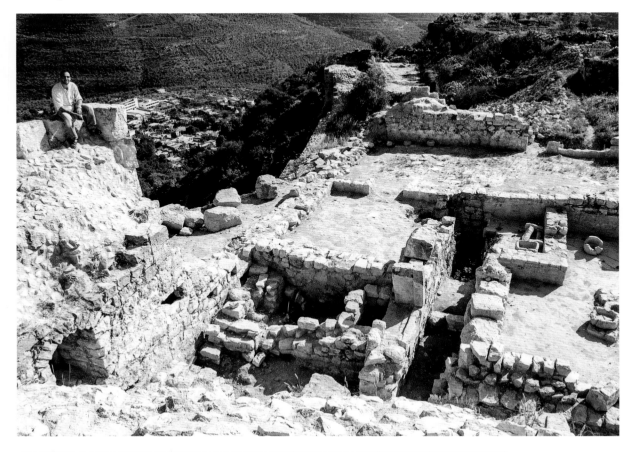

The remains of al-Maniqeh Castle overlook the mountain village of Wadi al-Qalaa. This Crusader fortress had seen better days, but archaeologists were busy working on restoration projects when I visited. The region's beautiful mountain scenery, including this waterfall, made for a rewarding excursion.

al-Marqab Castle

قلعة المرقب

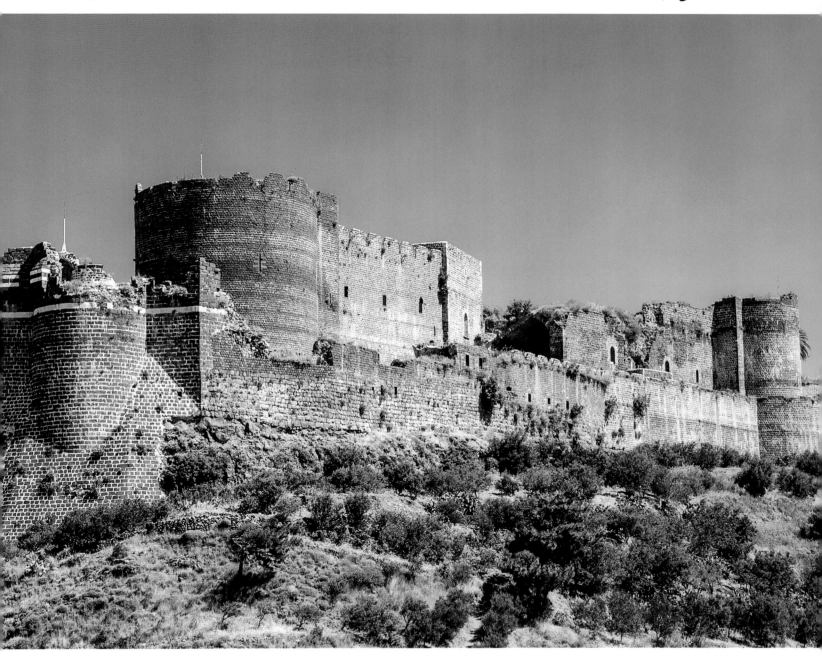

Once a Crusader stronghold, al-Marqab Castle overlooks the small, ancient port town of Banias. The Knights Hospitaller constructed its imposing defenses in the late 12th century. The massive size of the castle, and the dark hue of its heavy, volcanic stone, gives it a forbidding aspect.

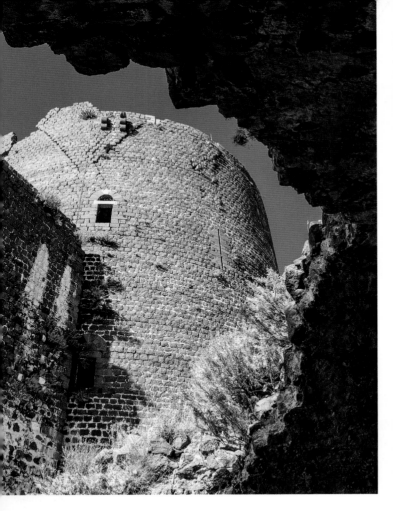

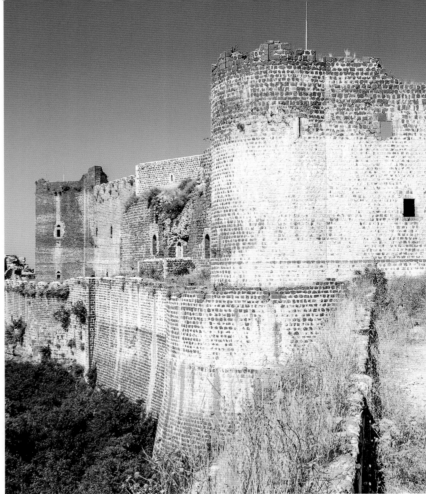

The most heavily fortified section of al-Marqab Castle was its monumental keep, constructed in the late 12th century. Though the castle long upheld a reputation for being impregnable, the tunnels of besieging forces ultimately breached it.

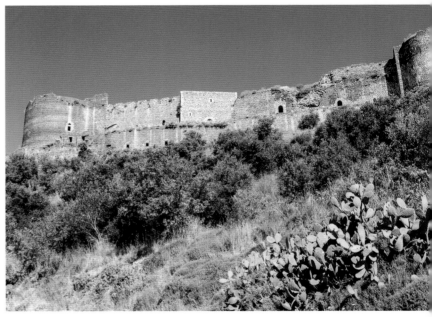

The castle's chapel, inspired by early Gothic architecture, is located at the southern end of the main courtyard. The interior, with its vaulted ceilings, remains remarkably well preserved. Note the mihrab on the southern wall, indicating subsequent use as a mosque.

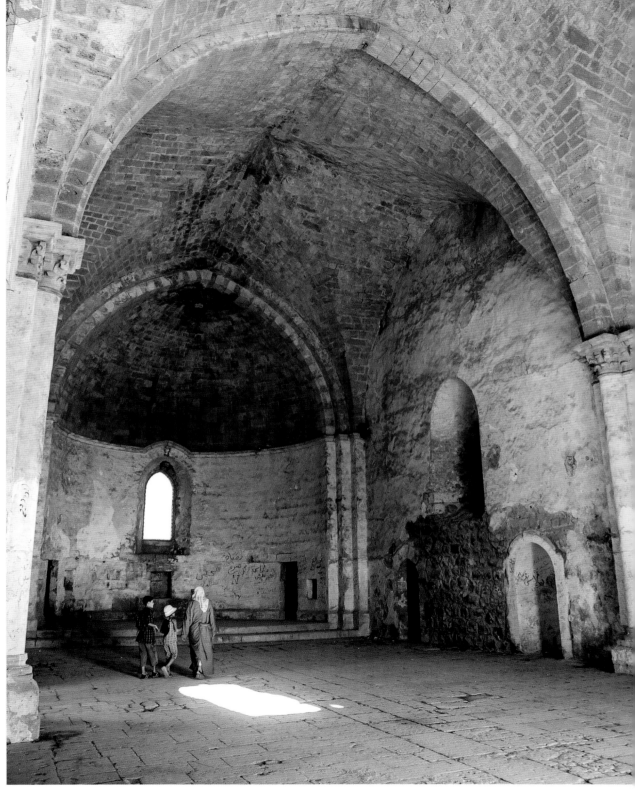

281

Tartus

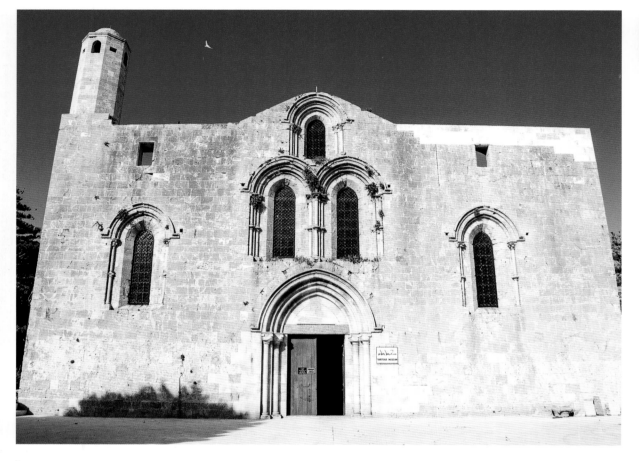

The Cathedral of Our Lady of Tortosa is considered to be one of the best-preserved examples of Crusader religious architecture. It was constructed in the 12th century over the remains of an earlier Byzantine church. When I visited Tartus, it housed the city's museum, which boasted an impressive collection of finds from the region's archaeological sites.

282

While walking around the old city of Tartus, I was approached by these two children who insisted I take their photograph. The older child then took his turn with my camera, photographing everything in sight until my memory card was full.

The Crusaders built a large fortress in the city, which they held until 1291. The old city of Tartus is contained within these walls, with houses and shops constructed into its remains in recent centuries. The area was intriguing to explore, as elements of castle architecture had been repurposed for residential use.

قلعة الكهف

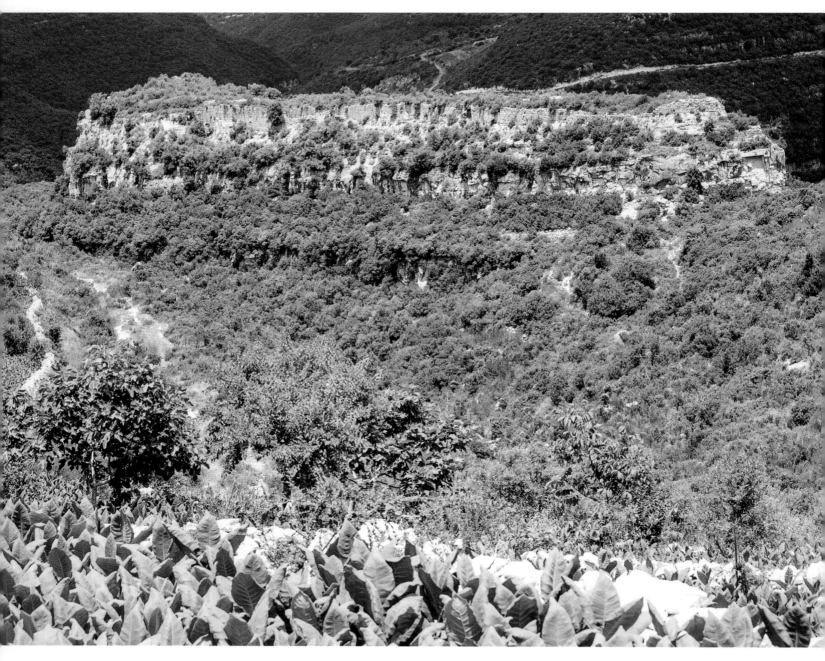

Al-Kahf Castle was the 12th-century stronghold of the Ismaili sect under the rule of Rashid al-Din Sinan. The fortress was hidden so deep in the coastal mountains that it would have presented an enormous obstacle for any attacking forces. I hiked for several hours from the nearest town to reach the castle and was rewarded with some of the most magnificent mountain scenery in the country.

The entrance to al-Kahf Castle was carved from solid rock. Note the decorative Arabic calligraphy above the doorway.

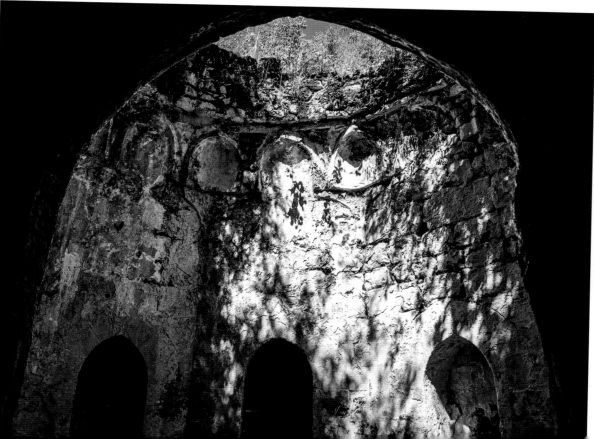

The castle also featured extensive and luxurious baths that survive in good condition.

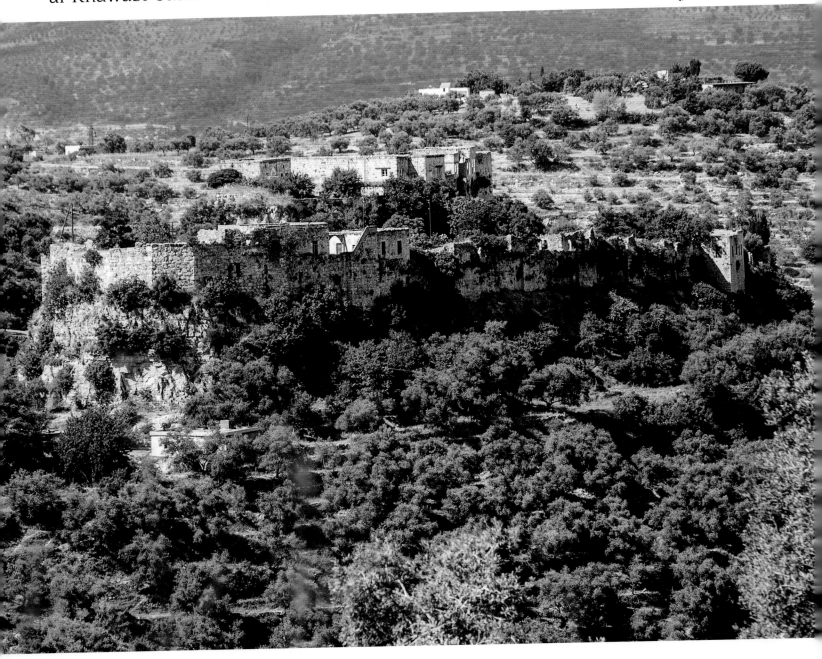

Another 12th-century Ismaili fortress, al-Khawabi Castle, can be found in this secluded mountain range. Several families were still residing within the castle's walls during the time of my visit, having built homes among the remains.

Mashta al-Helou

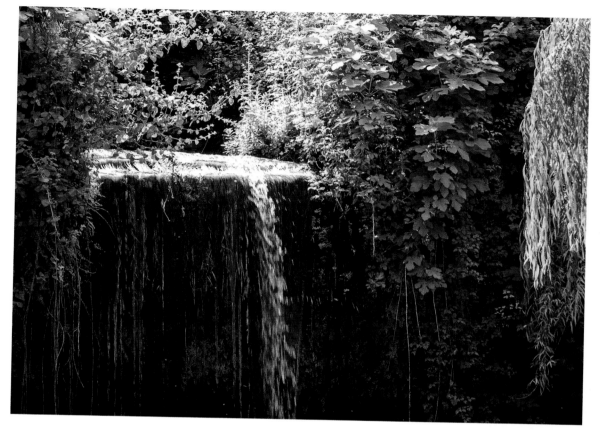

The mountain resort of Mashta al-Helou is a popular summer destination for many Syrian families. The town features several creekside restaurants, and the nature of the surrounding countryside includes waterfalls, caves, pine forests, and (in season) an abundance of colorful wildflowers.

Safita

صافيتا

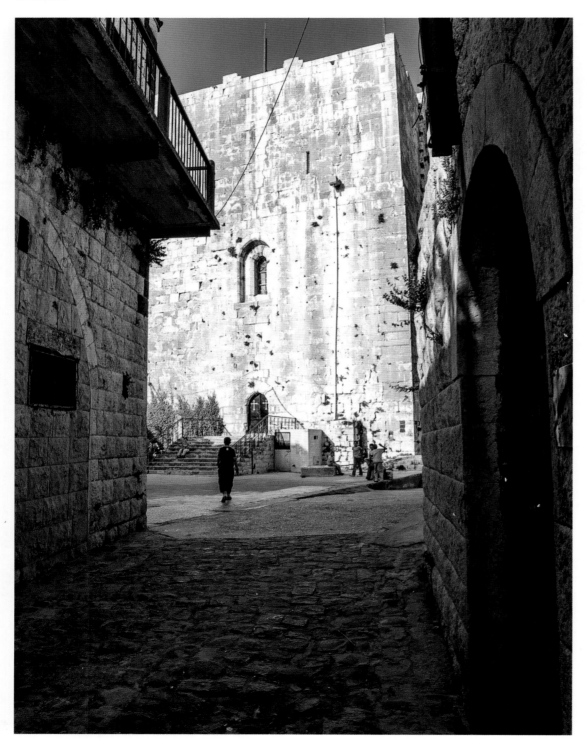

There are few places in Syria more picturesque than the mountain town of Safita, overlooked by a hilltop keep that was once part of a much larger Crusader castle. This mixed Christian and Alawite town has a historic neighborhood containing traditional stone houses with distinctive red tile roofs.

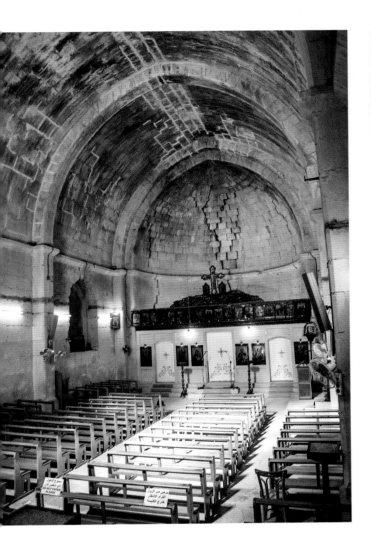

The interior of Safita's Crusader tower, historically known as Chastel Blanc, features a large chapel on its ground floor. It was still used for religious services by the town's Greek Orthodox community at the time of my visit.

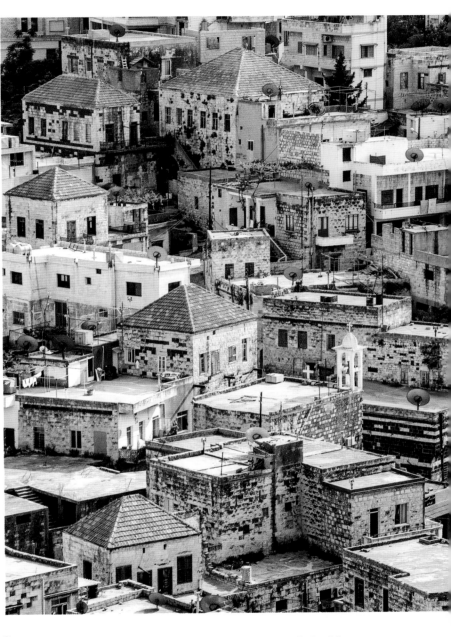

After climbing to the top of the tower, I was rewarded with commanding views over Safita and the surrounding countryside. During the medieval period, points such as these maintained vital lines of communication between fortresses.

Hosn Suleiman

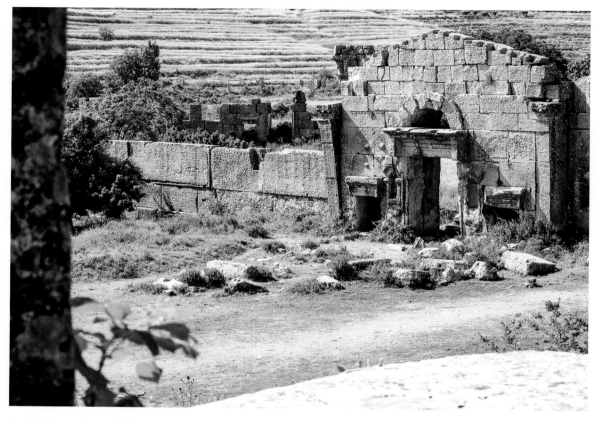

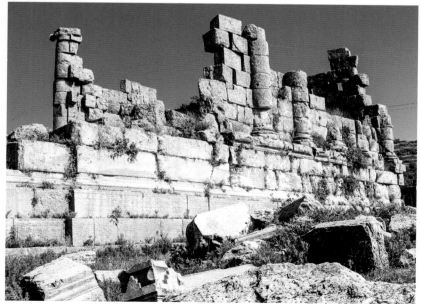

This stunning Roman temple complex, built from cut stones of enormous size and weight, lies near the remote Alawite village of Hosn Suleiman. It was first used as a place of worship during the Persian and Seleucid periods, and remained a place of pilgrimage for early Christians. It is the most impressive religious site in Syria's coastal mountain range.

Amrit

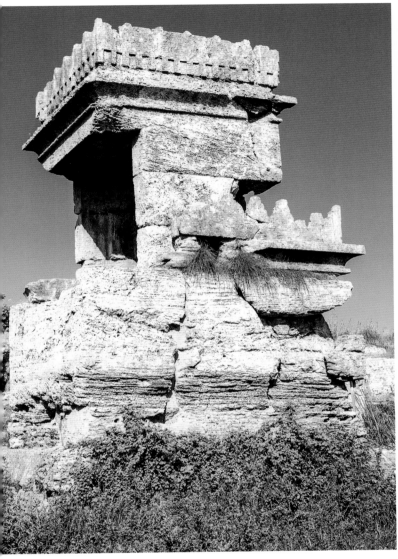

One of my favorite archaeological sites in Syria is the Phoenician and Hellenistic city of Amrit. Featuring a remarkable temple, tower tombs, a large stadium, and other remains, the architectural styles seen here are not found preserved anywhere else in the country.

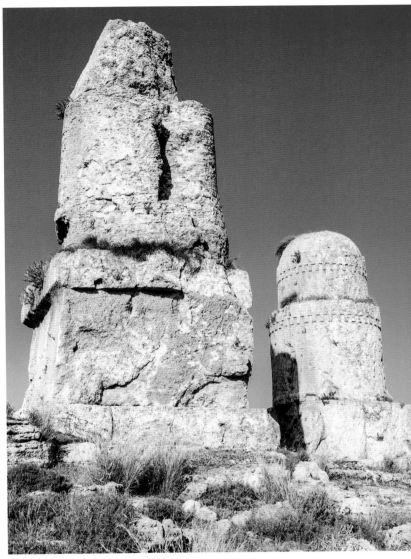

Located on a small hilltop overlooking the Mediterranean, these monumental towers date to the fourth century BCE and marked the site of underground burial chambers. These tombs presumably belonged to Amrit's more prominent families.

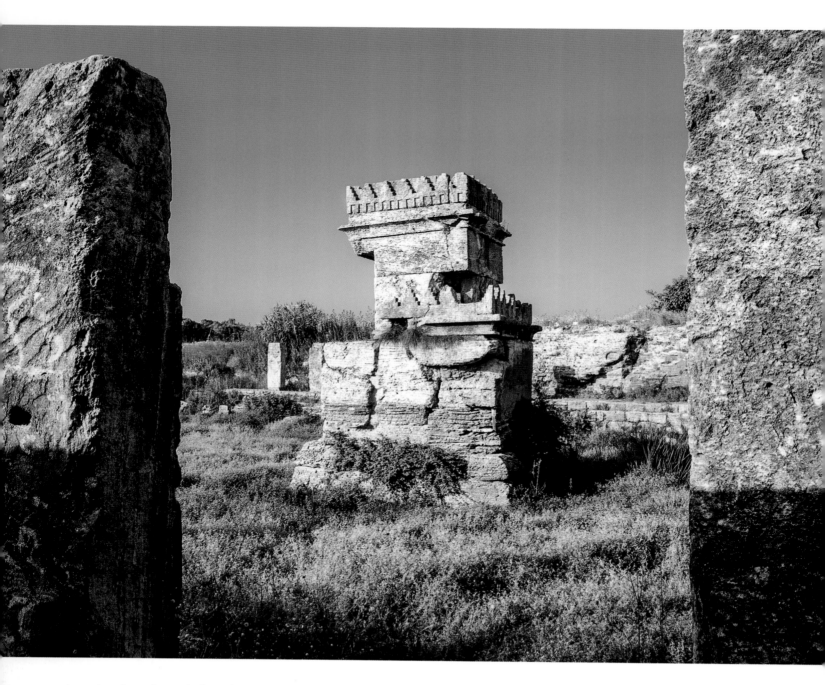

A pool and a colonnaded portico surround Amrit's temple, also dated to the fourth century BCE. The entire complex was carved from solid rock, intriguingly incorporating architectural features from both Egyptian and Mesopotamian traditions.

Arwad

Located just three kilometers off the coast of Tartus is the small, densely populated island of Arwad. First settled by the Canaanites, it later became an important base for the Phoenicians. It was the last Syrian territory to be held by the Crusaders, who were forced to abandon it in 1302. The island is now home to about 4,500 residents and features a maze of narrow alleyways surrounding a central fortress that dates back to the Crusader period. It took me several trips to fully explore the fascinating labyrinth of this island's residential quarters.

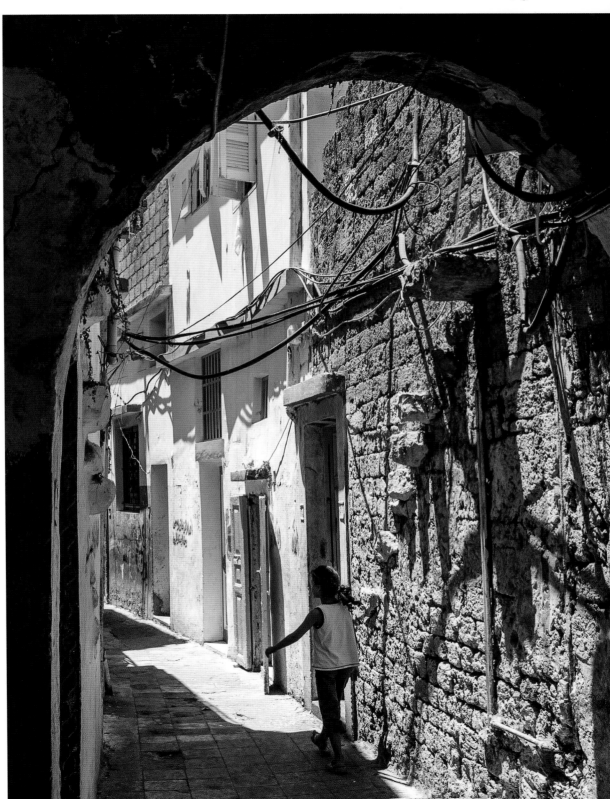

For centuries, the economy of Arwad Island has relied on fishing and shipbuilding. These remained the most important industries on the island at the time of my visit, with many fishermen supplying seafood to the restaurants catering to local tourists.

The beaches south of Tartus are popular for swimming and sunbathing. As sunset approached at the end of a hot summer day, I captured this couple cooling down in the Mediterranean, with Arwad Island on the horizon.

Glossary

Abbasids: a dynasty of Muslim rulers (caliphs) seated in Baghdad that governed most of the Islamic world beginning in the eighth century; its influence in Syria declined in the early 11th century, becoming subordinate to the Seljuqs; claimed descent from Abbas, uncle of Mohammed.

agora: an open public space, typically a marketplace, central to civic life in ancient Greek and Roman cities.

Alawites: members of the Alawite religious sect, a syncretistic offshoot of Shiite Islam founded in the ninth century; as many as three million Alawites live in Syria, mostly in its coastal mountain regions.

Amorites: an ancient Semitic-speaking and largely nomadic people, living in Syria and parts of Iraq from 2400 BCE until around 1200 BCE; later became absorbed by the Aramaeans.

apse: the eastern end of a Christian church, usually enclosing an altar; often a semicircular recess covered by a half-dome.

Aramaeans: a Semitic-speaking people that emerged around 1200 BCE, they ruled several kingdoms that often came into conflict with neighboring Assyrians; the culture persisted into Greek, Roman, Byzantine and Arab times, and some of Syria's modern Aramaic-speaking Christian community trace their ancestry to this ancient population.

Aramaic: a group of Semitic languages spoken since ancient times, modern dialects of which remain native to several indigenous Christian communities of Syria, Iraq, southeast Turkey, and northwest Iran.

Armenians: an ethnic group descended from the ancient Armenian kingdoms, 321 BCE to 428 CE, that once ruled most of modern-day Turkey and Armenia; most of Syria's Armenians reside in urban areas, particularly Aleppo.

Assyrians: an ancient Semitic-speaking people that formed independent kingdoms as early as the 24th century BCE and had three periods of empire, between 1813-1750 BCE, 1365-1020 BCE, and 911-605 BCE, in the historic region of Assyria (modern provinces of Nineveh, Iraq, and al-Hasakeh, Syria); many of Syria's modern Aramaic-speaking Christian community identify as Assyrian, tracing their ancestry to this ancient population.

Ayyubids: a Sunni Muslim dynasty founded by Salah al-Din al-Ayoubi, a Kurdish commander from Tikrit, Iraq; they ruled Egypt and Syria for most of the 12th and early 13th centuries, supplanting the Fatimids and Seljuqs.

bab: Arabic term for a door or gateway, often referring to the gates of a walled city.

basilica: a hall or building with double colonnades and a semicircular apse, used in ancient Rome as a court of law or for public assemblies; the design was later replicated in Byzantine church architecture.

bimaristan (or maristan): an Arabic term for a hospital or treatment center.

Byzantines: successors to the Roman Empire, the Byzantine Empire was based in Constantinople (modern Istanbul, Turkey) and adopted Christianity as its official religion; ruled Syria from

the end of the fourth century CE until the seventh century, maintaining power in Constantinople until the 15th century.

caliphate: an organization or state led by a figure considered to be a spiritual successor to Mohammed, that claims authority over the entire Muslim community.

Canaanites: a broad grouping of ancient Semitic-speaking peoples, including the Phoenicians, who inhabited the regions of Israel, Palestine, Lebanon, and western Syria.

cella: the central chamber of an ancient temple enclosure.

chancel: part of a church preceding the altar, reserved for the clergy and choir.

Chechens: an ethnic group originating in the North Caucasus, they speak the Chechen language and are predominantly Sunni Muslims.

Christians: followers of the Christian religion, a monotheistic faith based on the teachings of Jesus Christ; indigenous to the Levant, spread widely and rapidly beginning in the first century CE.

Circassians: an ethnic group originating in the North Caucasus, they speak the Circassian language and are predominantly Sunni Muslims.

colonnade: a row of columns supporting a roof or arcade, often found alongside prominent streets of major Roman and Byzantine cities.

Corinthian: one of the classical orders of ancient Greek and Roman architecture, it is the most ornate, characterized by fluted columns and capitals decorated with acanthus leaves and scrolls.

Crusades: a series of invasions made by armies of European kingdoms into predominantly Arab Muslim territories of the Middle East, including Syria, in the 11th through 13th centuries, intending to ensure Western Christian control of the region.

deir: Arabic term for a Christian monastery or convent.

Druze: members of the Druze religious sect, an offshoot of Ismailism that developed in the 11th century; as many as 800,000 Druze live in Syria, mainly in the province of al-Suweida, the Damascus suburb of Jaramana, and the Israeli-occupied Golan Heights.

Fatimids: an Ismaili Muslim dynasty that ruled Egypt in the 10th and 11th centuries; their influence in Syria was focused on the southern portions of the country.

Greeks: an ancient culture and grouping of city-states based in Greece whose power extended throughout most of the Mediterranean and into Central Asia at their height in 383 BCE; they were absorbed into the Roman Empire in the second and first centuries BCE.

Greek Catholic: followers of the Greek Catholic Church affiliated with Rome, also known as the Melkite Church; their communities are found predominantly in Syria, Lebanon, Jordan, Israel, and Palestine.

Greek Orthodox: followers of the Greek Orthodox Church, one of several Eastern Orthodox branches of Christianity, carrying on the culture and traditions of the Byzantines; they form the largest denomination of Christians in Syria.

hammam: Arabic term for a traditional public bathhouse.

iwan: a rectangular space, often vaulted, walled on three sides with the fourth typically open towards a courtyard; commonly found in Arab religious and residential architecture.

jebel: Arabic term for mountain.

khan: a large inn, often with a central courtyard, built to provide accommodation to large trade caravans.

Kurds: an ethnic group that inhabits northern Syria, northern Iraq, northwestern Iran and southeastern Turkey; they speak the Kurdish language and are predominantly Sunni Muslim, with a Yazidi minority.

Levant: a broad region, also known as Greater Syria, that includes the modern states of Syria, Lebanon, Jordan, Israel, and Palestine.

madrasa: Arabic term for school, often referring to an Islamic religious school.

Mamluks: originally a class of slave soldiers in Muslim armies, they seized power in the 13th century and formed the Mamluk Sultanate; based in Cairo, Egypt, it ruled most of the Levant until the early 16th century.

mashhad: Arabic term for a religious shrine, typically containing a tomb or relic of a Shiite religious leader.

mausoleum: a building housing one or more tombs, typically for a prominent individual or family.

medina: Arabic term for the commercial heart of a city.

Mesopotamia: the historical area of the Tigris-Euphrates River system, most of which corresponds with modern Iraq.

mihrab: central niche in the prayer hall of a mosque, indicating the direction of Mecca.

minaret: the tower of a mosque.

minbar: pulpit in the prayer hall of a mosque, situated to the right of the mihrab.

Mongols: an ethnic group from East Central Asia, they emerged as one of the world's most powerful empires in the 13th century under Genghis Khan and his successors; they launched several devastating invasions of Syria.

mosque: a place for communal worship for Muslims; typical architectural features include a minaret, mihrab, minbar, and courtyard, often with a fountain used for ablutions before prayer.

muezzin: an individual who performs the Muslim call to prayer, traditionally from the high platform of a minaret.

Hellenistic: specific period of ancient Greek history after the conquests of Alexander the Great in 330 BCE until the the Battle of Actium in 31 BCE.

Hittites: an ancient ethnic group based in Anatolia (modern Turkey) that ruled over an extensive empire from 1600 BCE through 1180 BCE, then was slowly absorbed into other cultures; they ruled over much of northern Syria and challenged the Egyptians at the Battle of Qadesh in 1274 BCE.

hypogeum: the underground burial chambers of an ancient Greek, Roman, or Byzantine tomb.

Ismailis: members of the Ismaili religious sect, an offshoot of Shiite Islam that developed in the eighth century and reached its height during the Fatimid period; in Syria, their community is focused on the towns of Salamiyeh and Masyaf in the Hama province.

Muslims: adherents of the religion of Islam, a monotheistic faith that follows the teachings revealed to Mohammed in seventh century Mecca; Islam came to Syria soon after its founding and has been continuously present there ever since; it is now the world's second most widely practiced religion.

Muslim Brotherhood: an Islamist political movement founded in Egypt in 1928 that formed branches and offshoots in other predominantly Arab Muslim countries; in Syria, the movement was banned in 1963 and turned to militancy in the late 1970s, prompting a violent crackdown by the Syrian government in 1982.

Nabataeans: an ancient Aramaic-speaking people of northern Arabia and the southern Levant, they founded the Nabataean kingdom based in Petra, Jordan, in the fourth century BCE, which briefly extended into southern Syria (Damascus, Bosra); they were later absorbed into the Roman and Arab cultures.

nave: the central part of a church building, typically rectangular, intended to accommodate most of the congregation.

necropolis: the cemetery of an ancient Greek, Roman, or Byzantine city.

Neo-Babylonian: an ancient empire, also known as the Chaldean Empire, that was based in Mesopotamia between 626 BCE and 539 BCE and ruled Syria for this brief period; later absorbed by the growing Achaemenid Empire.

Neolithic: a period in the development of human technology that began in about 10,200 BCE with the first use of farming techniques such as the systematic planting and irrigation of crops and the domestication of animals.

Ottomans: a Turkish-ruled multinational empire founded in 1299 that at its height in the 16th and 17th centuries governed most of the Levant, North Africa, and the Balkan region; the empire ended in 1923, after its defeat in World War I.

Persians: an ancient people, based in the historic region of Persia, that formed several significant empires between 550 BCE and 651 CE that were often in conflict with the Greeks, Romans, and Byzantines over control of Syria; they remain the predominant ethnic group of modern Iran.

Phoenicians: an ancient Greek term for the Canaanite people who inhabited the coastal regions of Syria and Lebanon and were organized into numerous city-states; their seafaring civilization spread across the Mediterranean from 1500 BCE to 300 BCE.

qalaa: Arabic term for castle or fortress.

qasr: Arabic term for palace.

Romans: an extensive empire ruling from Rome, Italy, that dominated much of Europe and the Mediterranean from the first century BCE through the fourth century CE.

Seleucids: the Hellenistic (Greek) dynasty that ruled over Syria and Mesopotamia from 312 BCE to 63 BCE.

Seljuqs: a Muslim dynasty based in Iran, Turkey, and northern Syria and Iraq, its height coming in the ninth to 12th centuries.

Shiites: members of the Shiite branch of the Islamic faith, that traces its origins to Ali, the son-in-law of Mohammed, and Ali's son, Hussein; Shiites are a small minority in Syria, but represent a majority of Muslims in Iraq and Iran and are the largest religious group in Lebanon.

souq: Arabic term for a market.

Sufis: Muslims who adhere to a more mystical interpretation of the faith, traditionally ascetic but often incorporating dance, music, and poetry; organized into different orders, each associated with a grandmaster claiming a direct chain of teachers back to Mohammed.

sultan: a sovereign Muslim ruler.

Sunnis: members of the predominant branch of the Islamic faith, Sunni Muslims believe that Mohammed's companion Abu Bakr was his proper successor; Sunnis make up the majority of Syria's population.

tetrapylon: in ancient Roman architecture, a monument of four pillars grouped together; sometimes found decorating intersections of colonnaded streets.

turba: Arabic term for a tomb or burial place.

Turkmen: an ethnic group of Turkic ancestry found in Syria (mainly in the north), Iraq, Iran, and Turkey; they speak the Turkmen language.

Umayyads: the first Islamic caliphate, based in Damascus from 661 until 744; in Syria, they were succeeded by the Abbasids, but they reestablished themselves in Cordoba, Spain from 756 until 1031.

wadi: Arabic term for a valley or watercourse.

Yazidis: members of an ancient religious sect practiced by a minority of Kurds, primarily in Iraq, with some adherents in Syria.

Acknowledgments

Special thanks to:

The hundreds of Syrian people who guided me along my journey throughout the years, giving directions, offering advice, providing rides, sharing meals, and welcoming me into their homes. It was their kindness, warmth, generosity, and hospitality that ultimately inspired this work.

My wonderful wife, Rasha, for her patience and encouragement during work on this ambitious and incredibly time-consuming project. She generously devoted many hours of her time assisting me with research and translation.

Salam al-Sharif of Damascus for his dedicated friendship. I would have been lost without his companionship and support during my time in Syria.

Mohammed Ziadeh of Safwan Hotel in Lattakia for his friendship and valuable assistance in covering sites in Syria's coastal regions.

George Mazaher, George Moussally, and Jad Batri for their friendship and support in covering the more obscure sites in the countryside of Aleppo.

Sajid Osman for his help and hospitality during my visits to document the Roman and Byzantine sites of Jebel Barisha, Idleb.

Majd Steti and Rima Sawah for fielding my numerous inquiries about sites in and around Homs.

Riad Lakmes and Abdullah of Riad Hotel in Hama for their guidance in covering the sites in the Homs and Hama provinces, and for always providing a comfortable place to stay.

Abdullah, Hashem, Eman, Hossam, Ahmad, and all the other wonderful staff, past and present, of al-Haramein Hotel in Saroujeh, Damascus.

Zeid Hashem for introducing me to many hidden treasures of Damascus, and sharing with me his passion and enthusiasm for the city and its history.

The late Father Frans van der Lugt for his inspirational work of promoting interfaith dialogue, bringing together Syrians from diverse backgrounds to celebrate their country's remarkable beauty and heritage. His kindness, generosity, and commitment to the Syrian people will be deeply missed.

Ross Burns for sharing his wealth of knowledge and research in support of my efforts, for his advice and encouragement, for contributing the map in this book, and for his exceptional work in *Monuments of Syria*, a guidebook that was indispensable during my travels in the country.

Joshua Landis for kindly agreeing to author the foreword of this book.

Finally, all those who have worked to protect Syria's antiquities, historic monuments, and archaeological sites throughout the ongoing conflict, risking their lives to ensure this rich cultural heritage is preserved for future generations.

About the Author

Daniel Demeter was born and raised in Los Angeles, California. With a desire to travel and explore from a young age, he undertook several journeys abroad starting at age seventeen. During the next decade, he traveled independently to more than 35 countries throughout Europe, the Middle East, the Indian subcontinent, and Southeast Asia. He found himself particularly captivated by Syria, developing a deep appreciation for the country's rich culture, history, and archaeological heritage, and its kind and hospitable people. He then spent more than three years exploring the country in depth, combining his passion for photography with his desire to share the beauty of Syria with the world. He currently resides in San Luis Obispo with his wife and cat, pursuing a degree in cultural anthropology and maintaining a website dedicated to Syria's cultural and historic sites.